ART IN BERLIN
1815-1989

This book is published
on the occasion of the exhibition
ART IN BERLIN 1815-1989
organized by the
High Museum of Art
Atlanta, Georgia
November 14, 1989-January 14, 1990

Copyright 1989 High Museum of Art
 All rights reserved
Published by the High Museum of Art
 Atlanta, Georgia

Distributed by the University of Washington Press
 Seattle and London

Edited by Kelly Morris and Amanda Woods
Managed by Margaret Miller
Designed by Jim Zambounis
Type set by Katherine Gunn
Printed in Great Britain by Balding + Mansell
 International Ltd.

Library of Congress No. 89-85714
ISBN 0-939802-59-7 (hard cover)
ISBN 0-939802-60-0 (soft cover)

Cover: George Grosz, *The Street* (detail, cat. no. 40)

ART IN BERLIN
1815-1989

High Museum of Art

Distributed by
University of Washington Press
Seattle and London

Sponsors of the Exhibition

Principal sponsor:

Lufthansa German Airlines. Official airline of the exhibition.

Additional support has been provided by:

Ministry of Foreign Affairs of the Federal Republic of Germany; Department for Cultural Affairs, Bonn
Senate for Cultural Affairs, Berlin
Goethe-Institut Head Office, Munich
Goethe-Institut Atlanta
State of Georgia
City of Atlanta, Bureau of Cultural Affairs
High Museum of Art Exhibition Fund
Siemens AG Berlin/Munich
Siemens Energy & Automation, Inc.

and

Deutsche Bank Berlin, AG
The Georgia Humanities Council and the National Endowment for the Humanities
Amoena Corporation
Dornier Medical Systems, Inc.
Leopold Freiherr von Diergardt Verwaltungs, KG
Mr. Joachim Herz
Schwartau of America, Inc.
Branch and Associates
Industrie- und Handelskammer zu Berlin
American Jewish Committee, Atlanta Chapter
Anonymous

Table of Contents

Sponsor's Statement

There are cities in the world which stand out as centers of commerce. There are cities filled with history, as well as those where new political trends emerge and change our lives. There are cities which hold some of the world's greatest art treasures, and still others where new and innovative art forms are born.

But there is only one Berlin.

Berlin is all of these—a vibrant economic hub, a place of fascinating historical dimensions, a political crossroads between East and West, and, certainly not least, one of the world's leading cultural capitals. The city is alive with artistic activity, from its museums, to its theaters, opera, and orchestras, to its ateliers, galleries, and literary cafés on the fringe of mainstream culture.

The story of Berlin and its people has been shaped by tremendous changes in the nineteenth and twentieth centuries. Although marked at times by tragedy and upheaval, this story is worthy of closer study as an example of the strength of a city and the courage of its citizens to overcome great odds. From the ashes of destruction, Berlin has rebuilt to create a dynamic, energetic city with a hard-won respect for artistic freedom and open expression.

Art in Berlin 1815-1989 invites the museum visitor to experience the city's modern history through the art created in these two turbulent centuries. This is an ambitious project, but it is not surprising that an American museum has accepted the challenge. Americans have a special relationship with Berlin. From the days of the Berlin Airlift, to President John F. Kennedy's historic visit, Americans have identified themselves with the struggles of the Divided City.

We hope that this exhibition will deepen the understanding between people on both sides of the Atlantic, and also help Americans to better understand the Germans living on both sides of the Wall.

Lufthansa is proud to have made this exhibition possible. As the national flag carrier of Germany founded over sixty years ago in Berlin, Lufthansa has long served the cause of cultural exchange between the United States and our country through its support of events like this one. We are especially grateful to the High Museum of Art for this project, which will promote a widening dialogue about Berlin.

Heinz Ruhnau
President, Lufthansa German Airlines

Acknowledgments

I wish to express my deepest appreciation to colleagues in Germany and the United States for their interest and their valuable help in making the exhibition possible with loans from their respective institutions.

In West Berlin I received meaningful cooperation from Prof. Dr. Wolf-Dieter Dube, Prof. Dr. Dieter Honisch, Dr. Peter Krieger and Dr. Angela Schneider, Prof. Dr. Alexander Dückers, Prof. Dr. Jörn Merkert, Dr. Ursula Prinz, and Frau Ingrid Andruck, Prof. Dr. Jürgen Julier, Prof. Dr. Helmut Börsch-Supan and Dr. Winfried Baer, Prof. Dr. Rolf Bothe and Dr. Dominik Bartmann, and Prof. Dr. Karl H. Bröhan and Dr. Ingeborg Becker; in Frankfurt, Prof. Dr. Klaus Gallwitz and Dr. Hans-Joachim Ziemke, and Dr. Luminita Sabau; in Mainz, Dr. Bertold Roland; in Düren, Dr. Dorothea Eimert; in Stuttgart, Prof. Dr. Peter Beye, Dr. Christian von Holst and Frau Gertrude Otterbeck, and Dr. Johann-Karl Schmidt; in Nuremberg, Prof. Dr. Gerhard Bott; in Munich, Dr. Armin Zweite and Dr. Helmut Friedel; in Hannover, Dr. Hans Werner Grohn and Dr. Bernd Schalicke; in Hamburg, Prof. Dr. Werner Hofmann; and in Bremen, Dr. Sigfried Salzmann and Dr. Bernhard Decker. I wish to acknowledge the help of Dr. Mario Andreas von Lüttichau, among other German scholars.

German collectors and artists were generous in providing important works, and the dealers Galerie Hasenclever, Galerie Nierendorf, and Bernd Schultz were most helpful with loans. To my great regret, it was not possible for us to obtain loans from the very rich holdings in the German Democratic Republic.

Americans were also generous in lending works; in New York museums we received collaboration from John Elderfield, Audrey Isselbacher, Beatrice Kernan, Cora Rosevaer, Tony Troncale, Diane Waldman, and Claudia Defendi; in Boston, Dr. Edgar Peters Bowron and Dr. Peter Nisbet; in New Haven, Mary Gardner Neill; in San Francisco, Dr. Lynn Orr, Marion C. Stewart, and Dr. Lorenz Eitner; in Los Angeles, Stephanie Barron and Timothy O. Benson; in St. Louis, Dr. James D. Burke; and in Dallas, Dr. Richard Brettell.

American collectors were most generous, especially Nelson Blitz, Jr., and Catherine Woodard and Marvin and Janet Fishman. I am also in debt to Timothy Baum, Allan Frumkin, Robert Kashey, and Jill Newhouse.

In assembling the works, problems of availability forced compromises in some cases, and in a few even brought failure to secure the right representation. Thus one of the fascinating figures of the first half of the nineteenth century, Karl Blechen, is regrettably missing from this exhibition.

I wish to thank the essayists, Dr. Kurt Forster, the Getty Center for the History of Art; Dr. Françoise Forster-Hahn, University of California at Riverside; Dr. Charles W. Haxthausen, University of Minnesota; Dr. Peter Jelavich, University of Texas; Dr. Clark V. Poling, Emory University, guest curator of the early twentieth century section of the exhibition; and Prof. Dr. Eberhard Roters, guest curator of the post-war section. Dr. Roters was also instrumental in securing many of the German loans. I must also thank Dr. Haxthausen for his advice in the early stages of the exhibition and catalogue development.

Funding of this exhibition required exhaustive work, and I wish to recognize our development associate for corporate gifts, Sally Fulton, for her resourcefulness in finding support. She was ably assisted by Betsy Hamilton. We were given valuable advice by Justus Martin, a member of our Board, who introduced us

to his business associates, including Alex Branch of Branch and Associates, who proved himself an effective fundraiser. Of great importance were Consul General Alexander von Schmeling and his staff, who provided highly important contacts for us in Atlanta's German business community. From the inception of this project, the Goethe Institut was essential in developing material and ideas for the exhibition and programs of events and I am deeply grateful to its director, Henner Oeppert, and his staff for their enthusiastic cooperation.

The Georgia Commissioner of Industry and Trade, George Berry, was generous in his encouragement in the business community. I am grateful to Mayor Andrew Young's chief administrative officer, Shirley Franklin, and the Commissioner of Parks, Recreation and Cultural Affairs, Betsy Baker, for the City of Atlanta's special grant.

In Germany I am very indebted to the Senate for Cultural Affairs in Berlin and to Jörg-Ingo Weber, in charge of the office of Cultural Affairs, for establishing contacts with the museums in the city and for the Senate's generous financial support. We also received a substantial grant from the Federal Government of Germany through the efforts of Dr. Bartold C. Witte of the Foreign Office of the Federal Republic.

Our deepest appreciation goes to the principal sponsor of the exhibition, Lufthansa German Airlines, who provided free transportation of all German loans and related services. We are deeply indebted to the company's president, Heinz Ruhnau, who has consistently supported exhibitions of German art in the United States. Uwe Hinrichs, Lufthansa's vice president, USA-South, and his manager of public relations, Dan Lewis, deserve my special thanks.

Our project was met with particular interest by the vice-president of Siemens AG Berlin, Joachim Putzmann, who made possible the financial support of his company both in the Federal Republic and in the United States. Mr. Putzmann also succeeded in developing the interest of German companies in the exhibition, which resulted in significant grants. I would like to thank especially Kurt Kasch of the Deutsche Bank in West Berlin and Gunter Braun of Berlin's Chamber of Industry and Trade.

The High Museum's staff was central to the realization of the exhibition. Kelly Morris, the editor, and his associates Margaret Walker Miller and Amanda Woods provided strong guidance in the production of the catalogue. I am especially grateful to Ms. Miller for her tireless work on the project from the very beginning. My assistants Gail Harris and Kate O'Day have dealt effectively with the extensive correspondence and administrative details and Frances Francis, the Museum's registrar, deserves special credit for managing the crucial details of insurance and the transportation of the works of art. Credit for the extensive program of lectures and related events belongs to Ellen Dugan, chief curator of education. The final effort, the planning of the installation of the exhibition and the presentation of its context was carried out by Marjorie Harvey, manager of exhibitions, and Dr. Paula Hancock, curator of research.

To our Board for giving me the freedom I needed to develop this exhibition, to the Museum staff for their unfailing professionalism, to the lenders for their most generous collaboration, and to the sponsors for their faith and support go my heartfelt thanks and appreciation.

Gudmund Vigtel

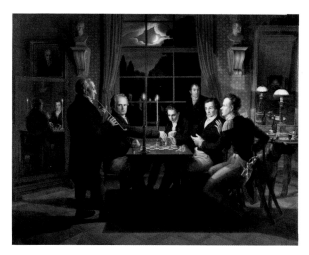

Fig. 1: Johann Erdmann Hummel, *The Chess Party*, ca. 1818/19, oil on canvas, Niedersächsisches Landesmuseum, Landesgalerie, Hannover.

History has run its course in the great cities, to a large degree, and taken its cue from their collective energies. It is from these centers of creative thought and action that decisions and strategies crucial to the direction of humanity have emanated, and much of the world's artistic energy has taken root there. Berlin has had a relatively short history of international cultural and political impact—two centuries, perhaps. Yet few other great cities have been the stage for such dramatic developments in international affairs. Inevitably such an atmosphere attracts great talent and nourishes a concentration of creativity.

It seemed a good opportunity, therefore, when the Goethe Institut in Atlanta suggested that the High Museum respond to the celebrations of Berlin's 750th anniversary with an exhibition honoring the city's cultural achievements. Other than a few projects covering short periods of Berlin's culture, such as *Berlinart*, the Museum of Modern Art's 1987 exhibition of contemporary painting, there were no major plans in the works. We concluded that the beginnings of the cohesive national movement in Germany after the defeat of Napoleon would be a logical point of departure for our exhibition and that we should carry this study to the immediate present. Berlin, capital of Prussia, the largest German state, had been occupied by the French Imperial Army in 1806. Nowhere in the German principalities was this humiliation felt more keenly, and nowhere was the sense of renewal and hope more acute after the French forces were evicted.

K. F. Schinkel's awe-inspiring *Cathedral* of 1811 (cat. no. 1) is a splendid symbol of deep national awareness and of hope for the future of a united Germany. Schinkel's genius formed much of the official character of the royal capital, and in spite of the devastations of World War II, much of his work still stands. Nevertheless, this seminal artist is virtually unknown in the United States. The same is true of Adolph von Menzel, a nineteenth-century painter and illustrator with a genius for translating his penetrating understanding into visual expression. There were other highly gifted nineteenth-century artists active in Berlin who are unknown to the American public, such as the brilliant *veduta* painter Eduard Gaertner (cat. nos. 4 and 5) and J. E. Hummel, who could depict the effects of different light sources and the dichotomous play on perspective through mirrors with remarkable skill (fig. 1). The Berlin exhibition seemed a good way to introduce these artists to our public.

As shown in the essays in this catalogue, Berlin's unparalleled growth attracted intellectuals from other parts of the world who took an active part in weaving the cultural fabric of the city. A major influence was the young Norwegian painter Edvard Munch, who had been invited to exhibit his work in Berlin by the artists' association Verein Berliner Künstler in 1892. The group had not expected Munch's work to be so challenging to their artistic precepts or so offensive to public standards of decency. The press made the exhibition an unseemly scandal, and the president of the association, Anton von Werner, a popular illustrator and court painter (cat. no. 109) forced a vote among the members, who by a narrow majority were obliged to close Munch's exhibition. The opposition, however, was so outraged by von Werner's narrow-minded actions that they formed a new association, which became the Berlin Secession a few years later. The most brilliant among them, Max Liebermann, Lovis Corinth, and Max Slevogt, are still not well represented in this country. Munch,

in the meantime, took an active part in the bohemian life of the city and during this period created some of his most significant graphic work, which became a powerful influence on the young expressionists who emerged in the first decade of the twentieth century.

Berlin's industrial development had a profound impact on its economy and population growth and resulted in wrenching social and political upheavals. Before mid-century August Borsig had formed the world's largest locomotive factory (cat. no. 7). Discoveries in chemistry and electricity led to the development of Berlin businesses which became international leaders. In 1847, the young engineer Werner Siemens (fig. 2) organized a company for the construction of telegraphic services which grew into the great Siemens firm. (While still in the army Siemens had served a prison term for acting as a second in a duel, time which he used to invent a way to galvanize gilding and silvering.) The Siemens company became a major presence in Berlin and achieved a position of world leadership during its founder's lifetime. In northwestern Berlin, the company created "Siemensstadt," a city within a city with housing for workers as well as production and administration facilities. Siemensstadt is in operation to this day (fig. 3).

Berlin had a long tradition of pragmatic liberalism before the last war. In an effort to expand the city's economic base in the seventeenth century, the Prussian ruler had invited Jews and Huguenots to establish themselves in the city's businesses and trades. King Frederick the Great introduced new humanitarian laws in the mid-eighteenth century, and Napoleon's occupation had reinforced a liberal nationalism which led to unification movements among the numerous independent German states. It is interesting to note that the February Revolution of 1848 in France brought these liberal tendencies to the fore in Germany, nowhere more urgently than in Berlin. The Prussian king had not been out of tune with the sentiments of advocates for civil rights, but when his power was threatened he used force. Over two hundred citizens of Berlin lost their lives in the 1848 revolution, and the triumphant freedom flag planted on the barri-

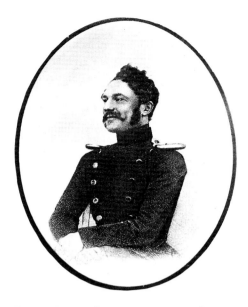

Fig. 2: Werner Siemens, ca. 1842, Siemens Aktiengesellschaft, Munich.

Fig. 3: Anton Scheuritzel, *Siemensstadt*, ca. 1930, oil on canvas, 62¼ x 124 inches, Siemens Aktiengesellschaft, Berlin.

Fig. 4: Eduard Gaertner, *The Barricade in Breitenstrasse*, 1848, watercolor on paper, Märkisches Museum, Berlin, GDR.

cades in Gaertner's watercolor (fig. 4) is silent testimony to the liberal uprising.

To be sure, that liberal nationalism turned into anti-liberal chauvinism during the Empire. When the Empire fell in 1918, political power was in the hands of the socialists. After the armistice the communists staged a bloody revolution in Berlin which continued to flare up intermittently until the fall of democracy in 1933. It is noteworthy that Hitler nurtured an unrelenting hatred for Berlin and its leftist intelligentsia, whose international liberalism became a major target of his persecutions.

During the Weimar period bloody strife, merciless inflation, and the world-wide economic crash made life harsh in Berlin. The 1920s were a time of escapism, and Berliners frequented the many music halls, cabarets, concert halls, and theatres. Experimentation and originality were the mark, social criticism the message. The young leftist Bertold Brecht (1898-1958) (fig. 5) was among the inspired commentators and playwrights of the time. His most famous work, *The Three-Penny Opera*, was given its first performance in Berlin in 1928. Some seven thousand actors were living in Berlin during this volatile time. As one of them said, "Berlin was the high point for all of us."

It was also the high point for the expressionists, who indulged in anything but escapism. They threw themselves into the fray, and their contemptuous rejection of political and artistic conservatism earned Hitler's implacable enmity and led to a deep artistic freeze during the twelve years of dictatorship.

When the war ended after the destruction of Berlin, the artists emerged slowly from the dark and over the next several years tried to regain their artistic powers and self-reliance. Meanwhile the city was divided by two competing ideologies, a division marked in 1961 by the construction of the Berlin Wall. Significantly, the old Berliner preoccupation with figurative expression and critical comment has again come to the fore in the protests against established systems by *die jungen Wilden*.

It is our hope that this exhibition and the catalogue will shed light on the intellectual, social, and political forces that shaped and transformed Berlin, as revealed by its artists' explorations of the tensions between romantic fantasies and the realities of the metropolis, and between nationalism and internationalism. The essays examine Berlin as the focus of a new sense of German nationhood and as a growing commercial power; Berlin as a city of immense

Fig. 5: Bertold Brecht, ca. 1928, collection of Fotomuseums im Münchner Stadtmuseum, Munich.

industrial expansion and burgeoning social conflicts; Berlin as a magnet for artists and thinkers, and as a center for art which expressed social alienation and attacked corruption and greed; and finally, Berlin as the center of fascism and as a poignant symbol of international political division. The driving dynamism of the city in large measure shaped its art.

Gudmund Vigtel
Director, High Museum of Art

Berlin's Path to Modernity

Peter Jelavich

Perhaps no other city in the world—certainly none in Europe—has experienced the excitement and the vicissitudes of modern history in more concentrated form than Berlin. A relatively insignificant town until the late seventeenth century, by 1900 it had evolved into the European center of industrial and commercial modernity, a lively metropolis that spawned a middle-class culture of consumerism and entertainment. At the same time, this capital of Prussia and (after 1871) a united Germany became the site of some of the most traumatic political developments of the twentieth century. The collapse of the monarchy in 1918 gave rise to an unstable parliamentary democracy, which could not contain a radical polarization in the early 1930s. The victory of the National Socialists in 1933 made Berlin the capital of a regime bent on war and committed to the extermination of many of its own subjects. Ever since, the city has paid heavily for the events of those years. Largely reduced to rubble by 1945, it became the most visible site of the postwar division of the world into capitalist and communist camps. In short, it took less than half a century for Berlin to experience a monarchical regime, then parliamentary rule, followed by a totalitarian dictatorship, Four-Power occupation, and forcible separation into two ideologically hostile halves. In a city with such a concentration of historical change, the arts could not fail to reflect the elation and the trauma of modernity.

Although Berlin celebrated its 750th birthday in 1987, the actual date of the city's founding is unknown. Located on an island in the Spree river, Berlin and the adjoining village of Cölln were settled by Germans during the twelfth century. At the time, that area of Brandenburg had a predominantly Slavic population, and the name "Berlin" probably derived from a Slavic word meaning marshland. However, it soon became associated with its German homonym, *Bär*, and the bear accordingly appeared on the town's early seals. The first documentary reference to Cölln dates from 1237—hence the fictitious "birthday" of the city; Berlin is mentioned in a text seven years later. Cölln and Berlin prospered as market centers in the thirteenth century because they lay along important north-south and east-west trade routes. By both land and water, grain, wood, fish, salt, spices, and clothes passed through the hands of Berlin's early merchants, and from the late thirteenth up to the fifteenth century the town was a member of the Hanseatic league.

In the early fourteenth century the prosperity of the villagers was threatened by the forays of a number of brutal and unscrupulous robber barons, the ancestors of what would become the Junker class. Order was restored in 1415 when Brandenburg passed into the hands of the Hohenzollern family, which would rule Prussia and ultimately Germany until 1918. The seeds of Berlin's future importance were planted in the fifteenth century, when the Hohenzollerns built a castle in Cölln (completed in 1451) which became their primary residence in 1486. The presence of the Electors of Brandenburg entailed a loss of municipal rights vis-à-vis the court, and the Berliners staged a futile revolt against their new rulers in 1447. For the next five hundred years, the Berliners would continue to harbor ambivalent feelings toward the potentates in their midst. While they might complain about their subservience, many of them enjoyed the wealth and prestige that emanated from the court.

The Electors of Brandenburg—who acquired the Duchy of Prussia in 1618—

took pragmatic and ultimately tolerant stances during the religious wars that wracked Christendom in the early modern period. In 1539 the citizens of Berlin adopted Lutheranism, and Joachim II soon followed suit. Johann Sigismund's conversion to Calvinism in 1613 led to tensions within Berlin, but Friedrich Wilhelm, the "Great Elector" (1640-88), issued an edict of toleration for Lutherans and Calvinists in 1664. Soon other religious groups were welcomed as well. Like the rest of Central Europe, Berlin suffered a decline during the Thirty Years' War (1618-48). Although it was spared from sacking (unlike some neighboring towns), it lost half of its population during these years. With only six thousand inhabitants left at mid-century, the Great Elector inaugurated a policy of encouraging the immigration of skilled and talented outsiders to Berlin. Whereas all Jews had been expelled from Brandenburg in 1573, he invited fifty wealthy Jewish families driven from Vienna to settle in his territories in 1671. Some twenty of these families came to Berlin, and formed the nucleus of what would become Germany's largest Jewish community. After 1685, when Louis XIV revoked the Edict of Nantes, the Prussian ruler welcomed some six thousand Huguenot refugees to his capital. Fifty years later, the city took in two thousand Czech Protestants, mainly weavers, fleeing religious persecution in Bohemia.

The Huguenot, Jewish, and Bohemian refugees played important roles in Berlin's economic and cultural resurgence in the eighteenth century. In 1701 the Elector Friedrich III was crowned Friedrich I, King of Prussia, and Berlin's concomitant elevation to capital of a kingdom created a demand for ostentatious consumption. The Huguenots, who enjoyed many legal and economic privileges denied to other Berliners, founded manufactures for gobelins, silk, gold and silver lace, and other luxury items, as well as more practical enterprises, such as an oil press and a paper factory. The Jews, in contrast, suffered many legal restrictions (high taxes, prohibitions from employment in handicrafts), but they nevertheless provided indispensable services in banking and wholesale and retail trade. When Friedrich Wilhelm I, the "Soldier King" (1713-40), rejected the ostentatious expenditures that had marked his father's reign and instead channeled resources to the army, many businesses were able to retool and accommodate the great demand for soldiers' and officers' uniforms. The Bohemian weavers proved to be especially useful in these enterprises.

By the eighteenth century the Hohenzollerns' policy of courting religious refugees was paying not only economic but also cultural and intellectual dividends. The Academy of Arts (Akademie der Künste) was founded in 1696, and the philosopher Gottfried Wilhelm Leibnitz inaugurated the Society of Sciences (Societät der Wissenschaften) four years later. Berlin's French citizens played disproportionately important roles in both of these institutions. Although the reign of Friedrich Wilhelm I marked an intellectual lull, the avowedly Francophile Friedrich II (1740-86) encouraged cultured discourse. Known as Friedrich "the Great" already in his own lifetime, he saw himself as a model of enlightened absolutism. He revived the Academy of Sciences in 1744, and appointed Maupertuis, a famous French physicist and mathematician, its president. In the nearby city of Potsdam—which had been embellished with palaces ever since the Great Elector had chosen it as a second residence—Friedrich entertained Voltaire for three years (1750-53), as well as the *philosophe* La Mettrie, who had been expelled from Holland for his atheist views. The king's principle of religious toleration was summed up in his famous declaration that "religions must all be tolerated and the state must only keep an eye on the fact that none shall impinge upon another, since everyone here must find happiness and salvation in his own manner."

Although Friedrich preferred the isolation of the Sanssouci palace in Pots-

dam, he embellished Berlin with elegant classical buildings that continue to define its historic center. At the beginning of Unter den Linden—a wide boulevard flanked by linden trees planted in the days of the Great Elector—he ordered the construction of the Forum Fridericianum, which became the cultural heart of Berlin (see Gaertner, *View from the Roof of the Friedrichswerder Church*, cat. no. 4). Georg von Knobelsdorff (1699-1753), the architect of Sanssouci (1747), designed the new opera house (1743) for the capital (fig. 6). Other buildings of the forum were the St. Hedwig Cathedral (1773), a Catholic church modelled on the Roman Pantheon, the Royal Library (1780), and the Prince Heinrich Palais (1766), which later housed the university. Unlike his father, Friedrich again encouraged the production of luxury goods, and the world-famous Royal Porcelain Manufacture dates from his reign (1763).

For all his enlightened rhetoric, Friedrich the Great waged major (and financially crippling) wars that turned Prussia into a Continental power equal to France, Austria, and Russia. He tolerated no overt opposition and despised critics of his military adventures, political despotism, and Francophile cultural proclivities. In particular, he was notably hostile to the two citizens who best embodied the Berlin enlightenment: he blocked Lessing's appointment as director of the Royal Library, and annulled Moses Mendelssohn's election to the Academy of Sciences.

As playwright and literary critic, Gotthold Ephraim Lessing (1729-81), who resided in Berlin intermittently from 1748 to 1767, challenged the rules of French Neoclassicism and the predominance of French culture in general. In plays such as *Miss Sara Sampson*, *Minna von Barnhelm*, and *Emilia Galotti*, Lessing demonstrated that the middle classes (rather than only rulers and heroes) could be the subject of tragedy, and he advocated peace and attacked princely immorality and injustice (in opposition to the warfare and absolutism of his age). Lessing's ardent defense of religious freedom found expression in his play *Nathan the Wise*, whose title character was modelled after his friend Moses Mendelssohn (1729-86). A noted enlightened philosopher who wrote treatises on metaphysics and religion, Mendelssohn was also instrumental in integrating Jews into German intellectual life. At a time when Christian prejudice and Orthodox Jewish practice posed great barriers to dialogue, Mendelssohn appealed to Christian readers to grant full social equality to Jews. To his Jewish coreligionists, he argued against conversion to Christianity, but he sought to replace traditional Orthodox Judaism with an enlightened form of Jewish religiosity, in keeping with the rationalist currents of the day. Mendelssohn's efforts laid the basis for the integration of Jews into Berlin's cultural life. Indeed, by the end of the eighteenth century, the centers of intellectual discourse in Berlin were the salons of Henriette Herz (1764-1847) and Rahel Levin (1771-1833), whose guests included the Humboldt brothers, the Schlegel brothers, and the philosopher Friedrich Schleiermacher, among many others.

In 1793, two years after its completion, the Brandenburg Gate was crowned with Johann Gottfried Schadow's sculpture of a quadriga steered by Victory (fig. 7). That goddess did not always bless Prussian arms, however, inasmuch as Napoleon led his troops through the Gate thirteen years later, and transported the quadriga as a war trophy to Paris (where it remained until 1814). After hesitating to take sides during the numerous wars against revolutionary France, Prussia had come into direct conflict with Napoleon's forces at the battle of Jena and Auerstedt on October 14, 1806. Berlin's citizens were informed of the outcome by posters proclaiming: "The King has lost a battle. Remaining calm is now the primary duty of the citizenry [*Jetzt ist Ruhe die erste Bürgerpflicht*]." Friedrich Wilhelm III (1797-1840) fled with the court to his eastern provinces,

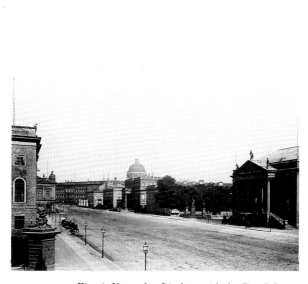

Fig. 6: Unter den Linden, with the Royal Opera House in the right foreground, photograph by Hermann Rückwardt, 1886, Bildarchiv Preussischer Kulturbesitz.

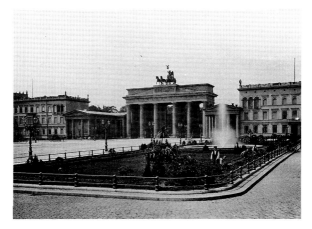

Fig. 7: The Brandenburg Gate, photograph by Hermann Rückwardt, 1886, Bildarchiv Preussischer Kulturbesitz.

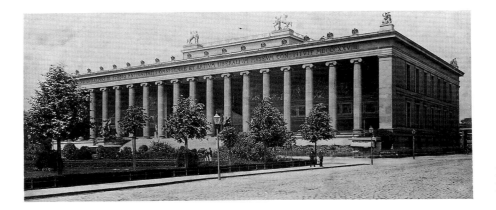

Fig. 8: The Royal Museum (now Altes Museum), photograph by Hermann Rückwardt, 1886, Bildarchiv Preussischer Kulturbesitz.

and Prussia became one of Napoleon's client states.

Many citizens initially welcomed this turn of events, because they believed that the French might bring "liberty, equality, fraternity" in their wake. Instead, they found the occupation oppressive, financially and otherwise. Equally disgusted at the cowardice of the king, the injustices and inefficiencies of the Prussian state, and the despotism of Napoleon, a number of Berlin's citizens sought to liberalize and revive their country so that it might cast off the French yoke. In 1808 Johann Gottlieb Fichte (1762-1814), then the preeminent philosopher of post-Kantian idealism, held a series of "Lectures to the German Nation," which called upon German youth to cultivate a sense of German (as opposed to narrowly Prussian) patriotism. While Fichte wanted the young to steel their minds, Friedrich Ludwig Jahn (1778-1852) wanted them to harden their bodies: he opened Germany's first athletic grounds in Berlin in 1811, hoping thereby to strengthen young men for a future fight against Napoleon. Fichte's nationalist rhetoric and the sports and athletics movement inaugurated by "*Turnvater*" Jahn would soon exert great influence on the German nationalist movements of the nineteenth century.

Such individual efforts at political rejuvenation were matched by reforming Prussian bureaucrats. Between 1807 and 1814 the ministers Stein and Hardenberg sponsored a series of measures that granted Prussians many of the rights won by the French in their Revolution: serfdom was abolished, guilds lost their monopoly over many occupations, Jews were emancipated from previous restrictions, and cities were granted a certain degree of self-government. In addition, Wilhelm von Humboldt designed a series of educational reforms, including the establishment of a university in Berlin (1810). The first "modern" university, whose faculty was pledged equally to teaching and research, it attracted some of Germany's leading scholars: Fichte (its first rector) in philosophy, Schleiermacher in theology, Friedrich Karl von Savigny in jurisprudence.

Following Napoleon's catastrophic Russian campaign of 1812, Prussia turned against the French forces, which finally were defeated at the battle of Leipzig (October 16-18, 1813). This marked the end of the Prussian reform movement as well. Many citizens, especially students, had hoped that the defeat of Napoleon would pave the way for more political liberalization and, ultimately, German unity. The restored rulers of the Central European states had other ideas. Friedrich Wilhelm III now regarded the reforms which had strengthened Prussia against Napoleon as threats to his own power, and he proceeded to implement numerous reactionary decrees (e.g., reestablishing restrictions upon Jews). Calls for national unity were harshly punished: Jahn was imprisoned without trial for several years, and printed editions of Fichte's "Lectures to the German Nation" were banned.

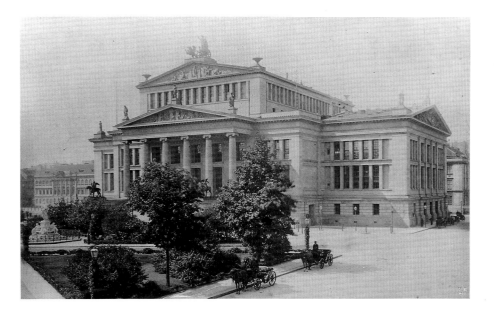

Fig. 9: The Theater on the Gendarmenmarkt, photograph by Hermann Rückwardt, 1886, Bildarchiv Preussischer Kulturbesitz.

During the *Vormärz*, the three decades of reaction prior to the revolutions of 1848, most middle-class Berliners turned away from political involvement. The so-called *Biedermeier* culture, marked by bourgeois introversion and domesticity, came to characterize the Prussian capital, as it did so many other German towns. This age saw important landmarks added to Berlin, many of them designed by Karl Friedrich Schinkel (1781-1841): the New Guardhouse (1818) on Unter den Linden, the Theater on the Gendarmenmarkt (1821), the Palace Bridge (1823), the Royal (now "Old") Museum (1830), and numerous churches and residential palaces (figs. 8 and 9). The buildings of Schinkel's mature and elegant classicism became favored motifs for painters of Berlin (see Gaertner, *The Palace Bridge*, cat. no. 5; Brücke, *View of the Neue Wache in Berlin*, cat. no. 95; and Hintze, *The Royal Museum*, cat. no. 3).

The coziness of Biedermeier domestic life and the serenity of the "Schinkel style" could not, however, mask more troubling socioeconomic developments. By 1800 Berlin was already the sixth largest city of Europe, after London, Paris, Vienna, Amsterdam, and St. Petersburg. Between 1815 and 1848 it doubled in size, advancing from 200,000 to 400,000. Three-quarters of this growth was attributable to immigrants, many of whom sought employment in the new enterprises that appeared with the industrial revolution. The destruction of guild monopolies in 1809 and the abrogation of Prussia's internal tariffs in 1818 freed the economy in time to appropriate the new technologies that were being developed in England. At the beginning of the century, the Royal Iron Foundry was created by the state because no individual was willing to establish such an enterprise in Berlin; in 1816 it even built the first (albeit very faulty and unemployable) locomotive constructed on the European continent. By the 1830s, in contrast, private entrepreneurs were leading the way. The first Prussian railroad line, from Berlin to Potsdam, was opened on October 29, 1838, and Berlin soon became the hub of Central Europe's railway network. One person who met this new demand was August Borsig, whose firm, founded in 1837, had the largest factory complex in Berlin within a decade; in 1858, it produced its thousandth locomotive (see Biermann, *Borsig's Machine Hall in Berlin*, cat. no. 7, where a new locomotive is being drawn by horses at the center right). The predominant industries in Berlin continued to be textiles and garment-working, which now were geared toward a mass market, not just the army.

In the wake of economic expansion, Berlin saw the rapid growth of what came to be called the proletariat. The workday ranged from twelve hours in machine construction to seventeen hours for weavers. Free trade gave rise to the modern business cycle, which resulted in decennial recessions and depressions, times of unemployment and general hardship for laborers. Housing conditions were deplorable for workers at all times; they lived in crowded and unsanitary structures, hastily erected by speculators hoping to profit from the city's burgeoning population. Bettina von Arnim (1785-1859), a Romantic author who had spoken out for women's rights, appended descriptions of the horrid living conditions of Berlin's working poor to a book published in 1843. The title—*This Book Belongs to the King*—was intended to direct the monarch's attention to this pressing social problem. The king wrote a thank-you note to the author, but remained unmoved by the work.

It had been hoped that the accession of Friedrich Wilhelm IV (1840-61) would inaugurate a more liberal era, but these hopes were left unfulfilled. The mounting social and political discontent burst forth in the revolution of 1848, which involved both the middle and the lower classes. The educated bourgeoisie (*Bildungsbürgertum*) had chafed too long under political authoritarianism. Heretofore cafés had been corners of Biedermeier sociability (see Taubert, *In the Berlin Reading Café*, cat. no. 2); now they also became centers of political discourse. At venues like the Café Stehely, citizens discussed the need for basic freedoms—of speech, the press, association—as well as constitutional rule and democratization. Certain sectors of the student population were especially radical, in particular the members of the "Young Hegelian" movement. In 1818 Georg Wilhelm Friedrich Hegel (1770-1831) had joined the faculty of Berlin's university as successor to the deceased Fichte. He had received the approval of Prussian officials who believed that his political philosophy justified the Restoration. After his death, however, certain dimensions of his thought were pushed in radical directions by younger thinkers. Some took his reformulation of Christian precepts into more "rational" philosophic categories as a blueprint for atheism; others believed that his vision of history, tracing the progress of human freedom, implied a radical critique of existing conditions (even though Hegel himself was quite content with the Prussian state as a guarantor of individual liberty). Bruno and Edgar Bauer, as well as Max Stirner, were the more outspoken Young Hegelians in Berlin. Eventually their ideas were revolutionized even further by Karl Marx, who studied at the university there (1836-41), and Friedrich Engels, who frequented radical discussion circles while stationed in the capital for his year of military service (1841-42). Marx and Engels had little impact on Berlin during their lifetimes, but by the eve of World War I, that city had become the center of a massive Marxist movement, the Social Democratic Party.

While the lack of basic rights angered broad sectors of the bourgeoisie, the working population was radicalized simply by the struggle to survive. The years 1846 and 1847 were especially catastrophic: bad harvests sent food prices skywards, and a recession led to extensive unemployment (e.g., Borsig dismissed four hundred men, a third of his workforce). In 1847 there was a major food riot and a calico workers' strike in the capital. The following spring, news of the February Revolution in Paris, and especially the flight of Metternich from Vienna in early March, gave Berliners a signal to act. On March 18 some ten thousand citizens assembled in front of the Royal Palace and demanded basic freedoms. Friedrich Wilhelm IV agreed to lift censorship and call a parliamentary assembly. Thereafter, however, he ordered his soldiers to clear the square, and when two shots were fired into the crowd, a revolution erupted. Barricades

were erected throughout the city, and over two hundred citizens were killed in the fighting overnight. The next day the king was able to restore order only by ordering his troops out of the capital and allowing a citizens' militia to be formed. In the ensuing days he rode through town wearing the colors of the revolution—black, red, and gold—and he paid his respects to the fallen citizens at their common burial. He even proclaimed that "henceforth Prussia is subsumed into Germany."

By the summer, however, the monarch was already plotting to reconquer his capital and restore his power. He was aided by the increasing disunity of the revolutionaries. In the Prussian Assembly, meeting in Berlin, and the German National Assembly, convened in Frankfurt, delegates feuded over the lengths to which democracy should be instituted and the degree to which Germany should be united. Although class divisions seemingly had been overcome in the early days of the March Revolution—Borsig had marched at the head of four hundred of his employees, now citizens-in-arms—they now reappeared, as workers made social and economic demands that the middle classes found unacceptable. The worst incident occurred on October 16, when striking canal workers who had destroyed a machine pump were fired upon by the citizens' militia, leaving eleven dead.

The bloody reconquest of Vienna by Emperor Franz Joseph's troops at the end of October encouraged Friedrich Wilhelm IV to follow suit. On November 10 the king ordered his soldiers into Berlin and imposed martial law. Not wishing to suffer the fate of the Viennese, the Berliners wisely did not put up a fight. To be sure, the king also promulgated a constitution, but he retained extensive powers, and the franchise for the new Prussian parliament gave greatly disproportionate representation to the wealthy classes. When the Frankfurt Assembly sought to proclaim him German Emperor in April 1849, he declined, not wishing to owe such a position to a democratic body. Another generation was to pass before the Reich could be formed.

The 1850s, like the Vormärz, were generally a period of authoritarian governmental policies matched by public depoliticization. That trend shifted dramatically in the ensuing decade, and Berlin again became a center of liberal agitation. When the new monarch, Wilhelm I (1861-88), was unable to persuade the Prussian Assembly to approve reforms that would have greatly strengthened the standing army, he named Otto von Bismarck as his chancellor. The tough Junker politician simply promulgated the reforms without parliamentary approval, an act which provoked a constitutional crisis. Despite calls for a tax boycott and other measures of civil disobedience, the parliament was unable to assert its rights. In the ensuing years Prussian victories in three successive wars—with Denmark (1864), Austria (1866), and France (1870)—seduced many liberals into placing nationalism above political rights. When Bismarck finally forged a united Germany in January 1871, he could count on the support of these so-called National Liberals, even though the new Empire's parliament, the Reichstag, had greatly restricted power. Berlin, however, continued to remain a bastion of left liberals, who persisted in demanding democratic reforms. In the Reichstag elections of 1871 all of Berlin's six Reichstag seats went to members of the Progressive Party, and ten years later Bismarck was still complaining that the city was dominated by a "progressive clique." Two of Bismarck's most outspoken opponents in the Prussian Assembly and the Reichstag were professors at the Berlin university: the physician Rudolf Virchow (1821-1902) and the historian Theodor Mommsen (1817-1903).

The proclamation of the Reich in 1871 marked a new phase in Berlin's development. While it remained the capital of Prussia, it now was also the

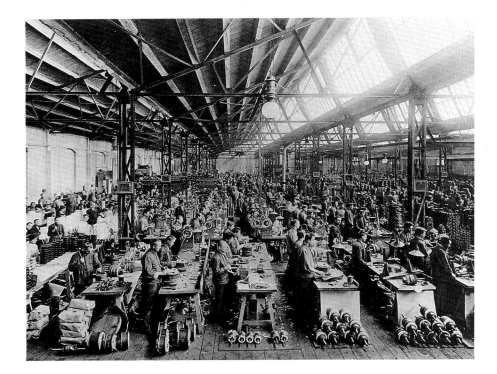

Fig. 10: Assembly of electric motors at the AEG, ca. 1900, Bildarchiv Preussischer Kulturbesitz.

capital of a united German Empire. In 1878 ten percent of the city's employed population served the state, whether in the civil service, the judiciary, or the military. That was, however, only one side of Berlin. Formerly, in the eighteenth and early nineteenth centuries, it had been primarily a royal residence, a city in which the court defined its character and importance. Yet by 1871 economic and demographic developments had turned it into a true *Weltstadt*, an industrial, commercial, and banking metropolis of global significance. As Berlin increasingly became Europe's "capital of modernity," members of the court looked upon it with increasing distaste: to them it was a city of industrial parvenus, left-liberal bourgeois, and Marxist workers. Bismarck had Berlin in mind when he proclaimed: "Big cities must disappear from the face of the earth."

Much of Berlin's modernity was determined by its economy. After the civil service, the largest occupational sectors in 1878 continued to be garment-working and retail trade, each accounting for 9 percent of the employed population. Occupations that had been generated by the "first industrial revolution" of iron, coal, and steam—metalworking, textile mills, and machine construction—remained important. By the end of the century, however, Berlin could attribute most of its global economic clout to the fact that it helped pioneer important sectors of the "second industrial revolution," which was based upon chemicals and electricity. The chemical and petrochemical industries initially led the way with new dyes, pharmaceuticals, artificial fertilizers, and synthetic products like celluloid and linoleum. Two important enterprises in this sector were the pharmaceutical factory of Ernst Schering (1864) and Agfa (1871), founded as a joint-stock corporation for aniline dye production (Aktiengesellschaft für Anilinfabrikation). It was electricity, however, that most caught the public's imagination. Werner Siemens (1816-92), who had founded a telegraph construction company in 1847, discovered electrodynamic principles in 1866 which allowed him to manufacture electric motors. This discovery revolutionized industrial production as well as everyday life; among other things, it allowed Berlin to replace its horse-powered streetcars and steam-driven municipal railways with electric engines at the turn of the century. Siemens's company

also produced new consumer products like lightbulbs and telephones. Next to Siemens, Berlin looked to Emil Rathenau (1838-1915) for electrical innovation. In the 1880s he founded the AEG (Allgemeine Elektricitäts-Gesellschaft), which generated electricity and provided electric lighting, in addition to manufacturing motors and other products (fig. 10). Once again Berlin benefitted from these developments, as electric streetlamps began to be installed in 1888. The AEG turbine assembly hall designed by Peter Behrens (1909), with its long steel and glass facades and polygonal concrete pediment, became the most widely praised example of modern industrial architecture in prewar Berlin (fig. 11).

Fig. 11: Turbine assembly hall of the AEG, designed by Peter Behrens, Bildarchiv Preussischer Kulturbesitz.

Much of Berlin's dominance in the second industrial revolution was attributable to the fact that the efforts of energetic entrepreneurs and inventors received the backing of banks and research institutes. The Reich capital became Germany's financial capital, and major banks supported the new industries: for example, the Deutsche Bank backed Siemens, and the AEG received financing from the Berliner Handels-Gesellschaft. It is also significant that the state educational system encouraged scientific and technological research. Berlin's Technical University, founded in 1876, specialized in teaching and research on machine construction and electrodynamics, which played such an important role in Berlin's economy. The Kaiser-Wilhelm-Gesellschaft (1911) founded numerous research institutes in the natural sciences and supported the work of world-renowned physicists like Max Planck and Albert Einstein.

The Wilhelmine era was an age of astounding changes, and depending on his or her class, the citizen of Imperial Berlin could experience the excitement or the horror of modernity. A primary fact of life in Imperial Berlin was a population explosion. Berlin's population doubled between 1849 and 1871, when it reached 826,000; it topped one million in 1877, two million in 1905—and that did not include outlying suburbs. The city's first detailed census revealed an acute housing crisis already in 1861. Over forty percent of Berlin's population lived in one-room units. They housed 4.3 people on average, but tens of thousands of individuals lived in rooms that each harbored 7 or more occupants. Despite the outcry, the official response was anything but helpful. In 1862 James Hobrecht's plan for city expansion was promulgated. The work of a young and inexperienced civil servant, it projected broad streets and boulevards for Berlin's peripheral expansion, in emulation of Haussmann's designs for Paris. What made this project one of the worst examples of city planning in modern history was the fact that the new streets quadrangulated exceedingly large blocks, which covered four to ten times the area of the older inner-city blocks. The new neighborhoods consequently were filled with huge, five-to-seven-story apartment complexes, broken up by small, dark interior courtyards. Imperial Berlin thus became the capital of the "rental barrack" (*Mietskaserne*), which perpetuated the crowded and unhealthy conditions uncovered in 1861 (fig. 12). Heinrich Zille, a popular graphic artist who portrayed the life of the poor, noted: "You can kill a person with a tenement as easily as with an axe." Disease was rampant, owing to the lack of ventilation, light, and adequate sanitary facilities. In 1905 infant mortality in Wedding, a working-class district, was a staggering forty-two percent. Tuberculosis was the major killer of the city's working class, and it was appropriate that a Berlin scientist, Robert Koch, discovered the bacillus that caused it in 1882.

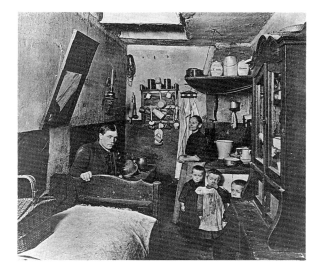

Fig. 12: Working-class housing: a single room serves as kitchen and bedroom, 1904, Bildarchiv Preussischer Kulturbesitz.

Conditions at home and at work hastened the radicalization of Berlin's working class. In 1862 Ferdinand Lasalle, an early organizer of the German labor movement, began addressing workers in Berlin's machine industries. A united German working-class party, heavily influenced by Marxist thought, was formed in 1875. In the Reichstag elections of 1878 the socialists received fifty-

two percent of the vote in Berlin's six electoral districts. In that same year the Reichstag passed Bismarck's package of anti-socialist laws, which initiated twelve years of repression. After the repeal of that legislation in 1890, the workers' party—now named the Social Democratic Party of Germany (SPD)—expanded its electoral base in Berlin even more. In 1912, when the socialists received thirty-five percent of the national vote, they won seventy-five percent of the ballots cast in the capital.

Although the SPD was officially a Marxist party with revolutionary aspirations, in practice it took a pragmatic course: it hoped to use agitation, persuasion, and the ballot box to democratize the political system by granting voting rights to women, reforming the unequal franchise for the Prussian parliament, and expanding the Reichstag's powers vis-à-vis the crown. At the turn of the century Eduard Bernstein (1850-1932), the son of a Berlin craftsman who became a leading socialist theoretician, openly called upon his party to renounce its revolutionary rhetoric and to adopt an outspokenly reformist course. Such a policy not only would have been more congruent with the reality of SPD politics, but also might have facilitated parliamentary coalitions with liberal parties that were scared away by revolutionary rhetoric. Bernstein's ideas were rejected by the SPD's leadership, however, and the party suffered political isolation until the end of the monarchy.

To be sure, Berlin was not exclusively a "red" city; indeed, for a few years in the 1880s, it was the center of an anti-Semitic movement. Many citizens suffered in the wake of the financial crash of 1873, which inaugurated a prolonged period of economic depression. In particular, members of the lower middle class—small shopkeepers, independent craftsmen—were scared: small producers suffered increasingly from the competition of large industry, and petty retailers could not stand up to the marketing capabilities of the new department stores. The percentage of self-employed people in Berlin's working population fell from thirty-two percent in 1882 to just under twenty percent in 1907. The socialists argued, of course, that this was the inevitable result of free trade and capitalism. But many small producers, who abhorred socialism as a threat to private property, chose to listen instead to a new, politically updated brand of anti-Semitism (which opponents dubbed the "socialism of fools"). Its spokesmen argued that Jews were to blame for the "little man's" miseries: according to this theory, Jewish industries, backed by Jewish bankers, produced goods for Jewish department stores that undersold Christian craftsmen and shopkeepers, while Jewish newspapers hushed up the whole conspiracy. Berlin's anti-Semites liked to point their fingers at prominent local Jewish businessmen: although relatively few industrialists were Jewish—Emil Rathenau was an exception—many of Berlin's banks, department stores (e.g., Wertheim, Tietz, Jandorf), and publishing houses (Mosse, Ullstein) had been founded by members of Jewish families.

The most "prestigious" spokesman of anti-Semitism in Berlin was Heinrich von Treitschke (1834-96), a staunchly nationalistic historian at the university. In 1879 he published an article which asserted that East European Jews arrived in Germany as "trouser salesmen" and ended up controlling the German stock exchange and publishing industry. Treitschke concluded by coining a phrase that the Nazis would make their own: "The Jews are our misfortune [*Die Juden sind unser Unglück*]." Among Berlin's academics, Treitschke stood relatively alone; indeed, he was vigorously opposed in a series of articles penned by another Berlin historian, Theodor Mommsen. The political success of the Berlin anti-Semitic movement was due instead to the efforts of a pastor, Adolf Stöcker (1835-1909). In the late 1870s he sponsored inner-city missions that were supposed to wean workers away from socialism and back to Christianity. After

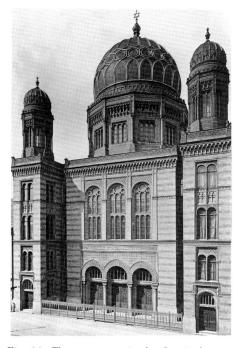

Fig. 13: The synagogue in the Oranienburger Strasse, photograph by Hermann Rückwardt, 1886, Bildarchiv Preussischer Kulturbesitz.

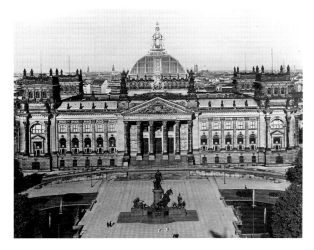

Fig. 14: The Reichstag, photograph by Hermann Hoeffke, 1929, Bildarchiv Preussischer Kulturbesitz.

1. Karl Scheffler, *Berlin: Ein Stadtschicksal* (Berlin: Erich Reiss, 1910), p. 267.
2. Arthur Eloesser, "Gedanken in einem Grill-room" (1912), reprinted in *Die Strasse meiner Jugend: Berliner Skizzen* (Berlin: Arsenal, 1987), pp. 78-80.

this effort failed miserably, he redirected his attention to the lower middle classes, which he approached with anti-Semitic arguments. Here he had much more success: indeed, a coalition of right-wing and anti-Semitic groups gained up to thirty percent of the Berlin vote in the Reichstag elections of the 1880s. The movement subsided in the 1890s as economic conditions improved, and seemingly lay dormant for a generation.

Although the socialists on the Left and the anti-Semites on the Right deplored the conditions generated by Berlin's commercial and industrial capitalism, the public image of the city exuded boundless confidence. To be sure, much of the public architecture of the Wilhelmine era seemed to belie the capital's modernity. Eduard Knoblauch's splendid Moorish synagogue (1866) (fig. 13), the Renaissance design of the Arts and Crafts Museum by Martin Gropius (1881) and the Reichstag of Paul Wallot (1894) (fig. 14), the Rhenish Romanesque style of Franz Schwechten's Kaiser Wilhelm Memorial Church (1895), and the Baroque forms of Julius Raschdorff's monumental cathedral (1905) exemplified the proliferation of epigonic styles during the heyday of historicism. It is important to note, however, that this eclecticism was considered the "modern" style during the last half of the nineteenth century, a symbol of an age that could freely appropriate the past because it regarded itself as the culmination of historical development. Such appropriation was also reflected (quite literally) in the numerous museums founded during the Imperial era, richly endowed by both the state and private citizens. The collections on the central "Museum Island" and elsewhere presented not only works of European culture, but also archaeological and ethnographic treasures, often acquired as by-products of European commercial and military imperialism.

Although such buildings and institutions defined the "official" public image of the capital, one needed to look elsewhere to discover the distinctive modern culture that was arising in Berlin. If anything characterized that age, it was continuous, all-pervasive change. It was then that Berlin became, in the words of the critic Karl Scheffler, a city that "was damned to perpetual becoming, never to being."[1] In 1912 Arthur Eloesser, who penned numerous vignettes of city life, noted that "Berlin used to have a physiognomy when it still had been poor, when it had consisted of philistines, officers, civil servants, and academics." But now "everything is provisional, and whoever was born in Berlin finds himself less at home there than a newly arrived inhabitant, who does not have to cast off any inhibiting memories or troublesome sentiments in order to jump into the flowing present and swim toward a shoreless future."[2] Much of the change was physical and geographic: as the population exploded, new neighborhoods were created, and social classes were increasingly segregated. While industries and their attendant proletariat moved to the periphery, the heart of Berlin developed increasingly specialized centers of administration (Wilhelmstrasse), banking (Behrenstrasse), shopping (Leipziger Strasse), and entertainment (Friedrichstrasse). Moreover, by the turn of the century a "push to the west" was well under way. The Tauenzienstrasse and the Kurfürstendamm became new centers of shopping and after-hours diversions, while further west, rich villas were arising in the Grunewald neighborhood.

To connect the various segments of the burgeoning metropolis, newer and faster methods of transport were needed. Horse-drawn streetcars, introduced in 1865, were replaced by electric ones at the turn of the century. A municipal railroad system was begun in 1882, and the first subway was inaugurated twenty years later. A proliferation of transportation and traffic became one of the signs of the hectic tempo of the new Berlin. Photographers captured the confusion at major intersections like the Potsdamer Platz and the Alexanderplatz (fig. 15).

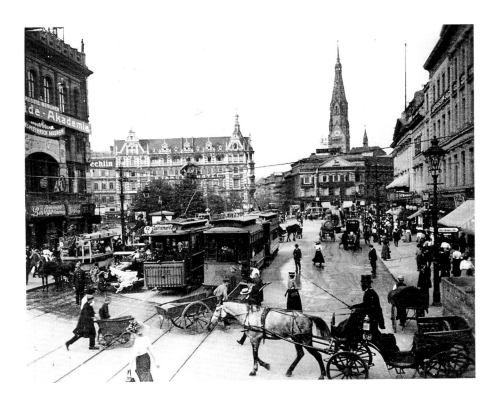

Fig. 15: The Alexanderplatz, photograph 1911, Bildarchiv Preussischer Kulturbesitz.

This combination of vitality and chaos was also portrayed in paintings like *The Railroad Tracks at the Jannowitz Bridge* by Julius Jacob and Wilhelm Herwarth (cat. no. 107), wherein pedestrians, horse-cabs, and streetcars cross a bridge, municipal trains steam by in the distance, and sightseeing boats and a scull ply the waters.

The life-style nurtured in the new Berlin was defined by novel urban forms of consumption and entertainment such as the department store, the variety show, and the cabaret. Born of the hectic life of the modern city, they provided an excess of commodities and a multiplicity of sensations. The temple of this culture was the department store. In particular, the Wertheim building on the Leipziger Strasse (1896), designed by Alfred Messel (1853-1909), attracted the admiration of contemporaries. Functionally efficient, internally spacious, and filled with light, it presented the consumer with the wonders of modern mass production (fig. 16). For the worker toiling in the factory or the small shopkeeper losing his clientele, it might have symbolized voracious commercial capitalism. But for the bourgeois with money to spend, it was a paradise of consumerism, catering under one roof to the most refined and most banal of needs. The essayist Franz Hessel, a self-proclaimed *flâneur* and perceptive observer of modern Berlin, noted: "In luminous atria and winter gardens we sit on granite benches, our packages in our laps. Art exhibitions, which merge into refreshment rooms, interrupt the stocks of toys and bathroom furnishings. Between decorative baldachins of silk and satin we wander to the soaps and toothbrushes."[3]

Just as the department store presented an abundance of commodities, a multitude of attractions could be found under one roof in new forms of popular entertainment. In place of theaters presenting multi-act plays, Berliners were drawn increasingly to variety shows, and ultimately cabarets and revues. *Variété* became the major form of urban entertainment in the last third of the nineteenth century. At variety theaters like the lavish Wintergarten (fig. 17), one could sip drinks at a table and watch a "variety" of unconnected numbers, primarily songs, comic skits, acrobatic stunts, and animal acts. Some observers argued

3. Franz Hessel, *Ein Flaneur in Berlin* (orig. ed. 1929; Berlin: Arsenal, 1984), pp. 32-33.

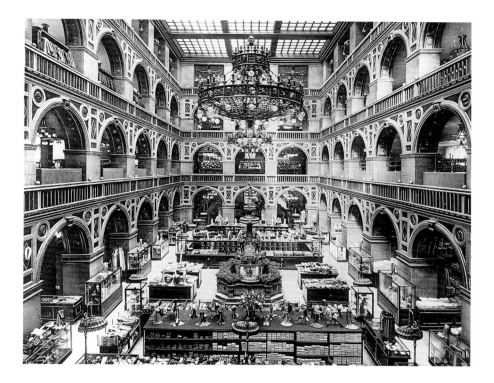

Fig. 16: Atrium in the Wertheim Department Store on the Leipziger Strasse, Bildarchiv Preussischer Kulturbesitz.

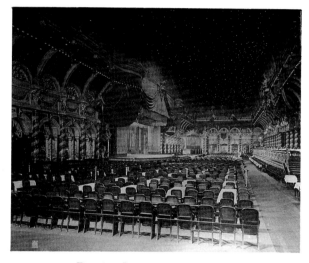

Fig. 17: Interior of the Wintergarten Variety Theater, ca. 1900, Bildarchiv Preussischer Kulturbesitz.

that variety shows were a quintessentially modern art-form, a logical and inevitable outcome of urban life. The hustle and bustle of the modern city, with its crowds and traffic, its constant variation of sights and sounds, fragmented consciousness and shattered all sense of stability and continuity. Ernst von Wolzogen—the founder of the Überbrettl (1901), Berlin's (and Germany's) first cabaret—noted that vaudeville's popularity was "a sign of our nervous, precipitate age, which finds no repose for long and prolix entertainments. We are all, each and every one of us, attuned to aphoristic, terse and catchy tones."[4] Another founder of an early Berlin cabaret, Otto Julius Bierbaum, also noted that vaudeville responded best to the psychological state of modern urbanites: "The contemporary city-dweller has vaudeville nerves; he seldom has the capacity of following great dramatic continuities, of tuning his senses to the same tone for three hours. He desires diversity—*Variété*."[5] The fragmentation of sense experience in everyday metropolitan life transformed the perceptual apparatus of modern urbanites to such an extent that they were no longer capable of the continuous attention demanded by conventional drama. Consequently, cabarets—"upscale" variety shows that had higher literary and artistic aspirations, as well as a modicum of political satire—were founded by Wolzogen, Bierbaum, and others as a means of catering to the mentality of the urban consumer.

The paramount chronicler of the commercial culture generated in Berlin was Georg Simmel (1858-1918), a brilliant sociologist whose lectures were popular among both students and the general public. In *The Philosophy of Money* (1900)—his answer to Marx's *Capital*—and essays like "The Metropolis and Mental Life" (1903), Simmel contended that "the psychological foundation" of individuals in the metropolis was "the intensification of nervous life, which proceeds from the rapid and uninterrupted fluctuation of external and internal impressions." In contrast to "the slower, more customary, more uniformly flowing rhythm" of small-town life, the modern metropolis confronted its inhabitants with a dizzying variety of sensations. "With every walk across the street,

4. Ernst von Wolzogen, "Vom 'Ueberbrettl zum rasenden Jüngling,'" *Vossische Zeitung*, October 31, 1900.
5. Otto Julius Bierbaum, ed., *Deutsche Chansons (Brettl-Lieder)*, 3rd ed. (Berlin: Schuster & Loeffler, 1901), pp. xi-xii.

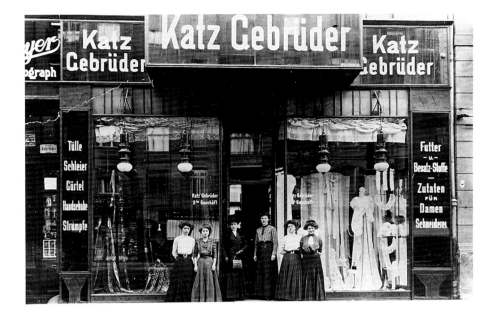

Fig. 18: Women's accessories store of the Katz brothers, ca. 1910, Bildarchiv Preussischer Kulturbesitz.

with the tempo and multiplicity of economic, professional and social life,"[6] human consciousness came to be shaped in a uniquely metropolitan manner. The modern urbanite no longer found hectic and disjointed surroundings disturbing, but required strong enticements to attract his or her attention, distracted as it was by the plethora of stimuli.

One response to this mentality was modern advertising, which gave commodities an aesthetic and eye-catching quality in an attempt to attract the urbanite's scattered attention. According to Simmel, in situations where the supply of commodities exceeded the demand, goods were required to have not only use-value, but also an "enticing exterior": they needed to be fashioned, packaged, and displayed in an aesthetic manner to increase their "external appeal," since "internally" there often was little differentiation among competing products. The "shopwindow-quality" (*Schaufenster-Qualität*) of commodities came to supersede their practical utility for the consumer. Simultaneously, "ordinary advertisement . . . advanced to the art of the poster,"[7] as ever more extreme means were required to attract the attention of the shopper. As commodities and their advertisements acquired aesthetic traits, shopping and "window-shopping" became forms of entertainment. Many photographs from the turn of the century attest to the increasing elegance of shopwindow displays (fig. 18), as well as the proliferation of eye-catching art nouveau posters on the circular "Litfass columns" that presented advertisements throughout the city (fig. 19; see also Hoeniger, *The Spittel Market*, cat. no. 29, where a Litfass column with bright posters appears in the center foreground). Simmel's observations and the photographers' plates underscored the fact that by the turn of the century, Berlin already had generated the hectic consumerist culture which has become associated with the Weimar era.

As the tempo of everyday life in the metropolis sped up, and as commodities and entertainments exemplified ever more rapidly changing fashions, experimentalism came to characterize many of the "higher" arts as well. To be sure, the first modern movement in Berlin reflected the underside of the new age. Naturalism in literature, theater, and the visual arts constituted an attempt to depict realistically the conditions of various social classes, especially the proletariat. Independent theater clubs—such as the "Freie Bühne" (founded in 1889) and the Social Democratic "Freie Volksbühne" (founded in 1890), which

Fig. 19: The Anhalter Bahnhof, with Litfass column in the left foreground, ca. 1902, Bildarchiv Preussischer Kulturbesitz.

6. Georg Simmel, "Die Grossstädte und das Geistesleben," in *Jahrbuch der Gehe-Stiftung zu Dresden* (1903), 9:188. English translations of this important essay, "The Metropolis and Mental Life," may be found in *The Sociology of Georg Simmel*, ed. by Kurt H. Wolff (New York: Free Press, 1950), as well as in *Georg Simmel: On Individuality and Social Forms*, ed. by Donald Levine (Chicago: University of Chicago Press, 1971).
7. Simmel, "Berliner Gewerbe-Ausstellung," *Die Zeit* (Vienna), 25 July 1896, p. 60.

Fig. 20: The Siegesallee: monument to Margrave Albrecht II, photograph 1901, Bildarchiv Preussischer Kulturbesitz.

offered inexpensive subscriptions to a large working-class public—performed contemporary dramas with an edge of social criticism. Gerhart Hauptmann (1862-1946) wrote many of the outstanding plays of this movement, including *Die Weber*, his powerful dramatization of a weavers' strike in 1844. When it was staged by Otto Brahm's Deutsches Theater in 1894, the Kaiser was so incensed that he cancelled his box there. In 1898 he likewise refused the recommendation of the jury of the Berlin Art Exhibition to grant a gold medal to *The Weavers*, a Hauptmann-inspired series of etchings created by Käthe Kollwitz, a graphic artist known for her moving and compassionate portrayals of the working class. The Kaiser's own aesthetic predilections were best exemplified by his "gift" to Berlin: Reinhold Begas (1831-1911), his favorite sculptor, was commissioned to design statues of all the rulers of Brandenburg since the twelfth century, and these were placed along a seven-hundred-meter "Avenue of Victory" (Siegesallee) (fig. 20).

Wilhelm II (1888-1918) expressed his aesthetic proclivities during a speech at the inauguration of the Siegesallee: "Art should also give the lower classes the opportunity to raise themselves up to ideals after hard labor and exertion. . . . It can do this only when it is uplifting, not when it descends to the gutter [*Rinnstein*]." Although nearly all serious artists scoffed at the Kaiser's attacks on *Rinnsteinkunst* and *Rinnsteinliteratur*, only a minority subscribed to naturalistic tenets. Indeed, by the end of the 1890s that movement had largely died. Naturalism was superseded by less realistic and more experimental tendencies in the arts. In theater, Max Reinhardt (1873-1943) became the outstanding avant-garde director. At first an actor with Otto Brahm, he soon rebelled against the "untheatrical" character of naturalistic performance. After directing a cabaret (Schall und Rauch, 1901-02), he turned to full-length dramatic productions marked by a totally novel sense of vitality and theatricality. The addition of visual and gestural elements drawn from variety shows and cabarets—song, dance, pantomime—made his performances of Shakespeare, the Greek and German classics, and contemporary works highly palatable not only to Berliners, but also to audiences throughout Europe and North America.

A new affirmative spirit could be seen in the visual arts as well, even though Kollwitz, Hans Baluschek, Heinrich Zille, and Franz Skarbina continued to produce paintings and graphics depicting industrial and working-class life (see

Skarbina, *Railroad Tracks in Northern Berlin*, cat. no. 19). Under the leadership of Max Liebermann (1847-1935), the Berlin Secession (founded in 1898) became a forum for innovative painting, particularly of the impressionist school (e.g., Lovis Corinth, Walter Leistikow, Max Slevogt, Lesser Ury). Like their Parisian counterparts, they tended to depict subjects drawn from middle-class experience in the metropolis. As early as 1888 Lesser Ury had captured the hectic tempo and disorder of the city in his painting *At the Friedrichstrasse Station* (cat. no. 108), a nighttime scene of trains, horse-drawn buses, cabs, pedestrians, and vendors rushing past each other. While some German impressionists expanded upon such themes (e.g., Hoeniger, *The Spittel Market*, cat. no. 29), most preferred to evoke the serenity of nature in the "villa districts" around the lakes of Western Berlin (see Leistikow, *Lake Grunewald*, and Liebermann, *House on the Wannsee*, cat. nos. 20 and 21). It was the expressionists who became the outstanding celebrants of the modern city on the eve of World War I. Poets like Georg Heym and Gottfried Benn, and painters like Max Beckmann, Ludwig Meidner, and Ernst Ludwig Kirchner delighted in the dynamism and frenzy of the metropolis (e.g., Meidner, *The Church of the Good Shepherd*, cat. no. 34). For all its barbaric harshness—Heym saw a "gigantic sea of stone" (*Riesensteinmeer*)—Berlin exuded a forceful and fascinating vitality. The chaotic city and its citizens seemed to teeter on the verge of an apocalyptic outburst of energy.

When the apocalypse finally came, it had a different countenance, and it revealed its most fearful visage on the fields of northern France. In August 1914 many Berliners, like citizens of all the Great Powers embarking on war, were caught up in the wave of nationalist and militarist hysteria. Even the Social Democratic leadership, despite its pacifist rhetoric, voted for war credits, since it was led to believe that Germany was fighting a defensive war against autocratic Russia. What was to have been a short, swift conflict dragged on for months, then years, and claimed hitherto unthinkable numbers of lives. Faced with the loss of loved ones and diminishing rations of food and fuel, many Berliners found their military enthusiasm waning. Starting in 1916 there were sporadic walkouts and demonstrations in Berlin. The most outspoken opponent of the war was Karl Liebknecht, a socialist Reichstag deputy who cast a sole vote against war credits as early as December 1914. He was arrested on May 1, 1916, for addressing an anti-war rally on the Potsdamer Platz, and sentenced to four years in jail. While the SPD leadership continued to support the war effort, more and more socialist deputies began to adopt militantly pacifist stances, and they formed the Independent Social Democratic Party (USPD) in April 1917. Their call for an immediate end to hostilities was echoed by the participants in the massive strike of January 1918, in which some 500,000 Berliners—many of them workers in munitions factories—took part.

The collapse of Germany's western front in August 1918 heightened the desire to end the war as swiftly as possible. A mutiny of sailors in Kiel at the end of October soon spread to Berlin, and workers' and soldiers' councils were formed, in part along the model of the Russian "soviets." On November 9, faced with strikes and mutinies, the last Imperial chancellor, Max von Baden, announced the abdication of the Kaiser and handed power to Friedrich Ebert, the leader of the SPD. That afternoon another socialist, Philipp Scheidemann, proclaimed the German Republic from a balcony of the Reichstag. An interim government was formed, consisting of three members each of the SPD and the USPD, which was to maintain order until elections for a constituent national assembly could be held. Deep divisions split the leftist parties during the ensuing weeks, however. While Ebert and the "majority" SPD wanted to

postpone all substantive decisions until the assembly could be convened, many members of the USPD and the grass-roots council movement desired the immediate socialization of major industries, the expropriation of the Junkers' estates, and the purging of monarchists from the civil service and judiciary. In December several bloody clashes occurred between regular army troops backing the SPD and various groups demonstrating for more radical reforms. By the end of the year the three USPD representatives had resigned from the coalition government.

On New Year's Eve members of the ultra-left "Spartakus" group—including Karl Liebknecht and Rosa Luxemburg, the brilliant activist and theoretician—founded the German Communist Party (KPD). Against the advice of their leaders, some followers of the new party staged a revolt at the beginning of January: they declared the government deposed, and they forcibly occupied some buildings in the center of Berlin. Since the regular army was in disarray, the SPD called in Freikorps units—right-wing paramilitary groups consisting of demobilized officers and soldiers—to put down the insurrection. After a few days of fighting, in which over a hundred insurgents were killed, the "Spartakus revolt" was suppressed. Liebknecht and Luxemburg had been captured alive, but on January 15 they were murdered while in the custody of Freikorps officers. Although the SPD had no direct involvement in this atrocity, it cemented the hostility between the communists and the socialists, a split that would have dire consequences for the future of the Republic.

In the elections to the national assembly on January 19, Berlin again proved that it was a leftist city: thirty-six percent voted for the SPD, and twenty-seven percent for the USPD (the KPD boycotted the election). Nationally, however, the USPD won only eight percent of the votes. A moderate republican majority controlled the assembly, which proceeded to draft a constitution in Weimar, since conditions in Berlin were too unsettled. At the beginning of March, some members of the KPD and USPD, disheartened by the moderate turn in national politics, called a general strike and stormed police stations, shops, and other buildings in Berlin. Freikorps units were called in again, and Gustav Noske, the SPD minister of defense, ordered that anyone caught bearing arms be shot. In the ensuing "March Days," which lasted over a week, the insurrection was brutally suppressed: well over a thousand Berliners were killed, many of them executed after being captured alive. A year later the right wing was equally unsuccessful: the "Kapp Putsch" of March 1920, backed by six thousand Freikorps soldiers, succeeded in chasing the government out of Berlin for a few days, but a general strike that crippled the city soon forced the putschists to abandon their endeavor.

The Kapp Putsch was the last of the outright political revolts, but Berlin continued to witness other acts of violence. In June 1922 Walter Rathenau, the foreign minister, was killed in the Grunewald by nationalist and anti-Semitic assassins. More generally, numerous strikes were called to protest the mounting inflation, a product of the government's policy of printing paper money to pay off war debts and other domestic obligations. In the fall of 1923, at the height of the hyperinflation, shops were plundered by desperate citizens. Some of the excesses against Jewish stores had clear anti-Semitic overtones, which indicated that the right-wing tendencies of the 1880s had resurfaced with even greater virulence. The stabilization of the currency at the end of that year put a temporary end to these disturbances.

The ensuing years of "relative stabilization" (1924-29) gave rise to the myth of the "Golden Twenties," even though serious problems persisted beneath Berlin's glittering surface. The creation of "Gross-Berlin" in 1920, through the

incorporation of adjoining suburbs, made it the third largest city in the world, after New York and London. With some four million inhabitants, Berlin continued to have a major housing problem, especially since few new structures had been built from the beginning of the war to the end of the inflation. When construction resumed in mid-decade, the dominance of socialists in municipal and state government brought about new housing policies. The erection of the monstrous rental barracks that had characterized Imperial Berlin was finally outlawed in 1925. Many of the great architects and planners of the era (e.g., Bruno Taut, Martin Wagner, Walter Gropius, Hans Scharoun) contributed to the design of new housing projects like the Siemensstadt (fig. 3), "Uncle Tom's Cabin" in Zehlendorf, and the "horseshoe settlement" in Britz (fig. 21). To be sure, the cost of these projects, which were financed by unions and municipal housing corporations, entailed rents that only white-collar workers could afford. Nevertheless, they attracted worldwide attention due to their incorporation of modern household amenities, efficient use of interior space, and provision of parks and greenery.

For citizens with adequate incomes and open minds, the Golden Twenties were truly exciting. Despite the loss of the war and the economic dislocations brought about by the Treaty of Versailles, Berlin was still the capital of a great power and a major center of industry and mass communications. By the end of the decade there were nearly a hundred daily newspapers in the city. Of the major prewar press houses, those of Mosse and Ullstein supported the Republic, while the conservative Scherl papers opposed the new democracy, especially after they were purchased by Alfred Hugenberg, a powerful and outspoken right-wing industrial magnate. In the middle of the decade a fourth major press conglomerate, devoted to leftist and communist causes, was formed by Willi Münzenberg. Other forms of communication developed as well. In October 1923 Berlin was the site of the first radio broadcast in Germany. The new medium soon attracted hundreds of thousands of listeners, and the Radio House in the Masurenallee (1931), designed by Hans Poelzig, provided up-to-date programming studios. The introduction of new methods of communication was matched by new modes of transportation: Berlin became the hub of the European airway system after the opening of the Tempelhof airport in 1923.

The arts responded to the dramatic events of these years as well. Numerous artists had become politicized by the war, whether or not they served at the front. The seeming betrayal of the revolution by the SPD could encourage both sympathy with extreme leftist causes, and disillusionment and cynicism concerning the efficacy of political involvement. Such was the case with Max Beckmann, as exemplified by his series of graphics collectively entitled *Hell* (cat. no. 134). While "Martyrdom" is a cry of horror at the murder of Rosa Luxemburg, "The Ideologists" sceptically questions the proponents of political change, whatever their persuasion. The other works in the series constitute a catalogue of images that populate many other works of the Weimar era: while the wealthy dance and sip champagne, war cripples go begging, the poor stare at empty kitchen tables, and civil war rages in the streets. A decade later this iconography would find its culmination in Otto Dix's *Metropolis* (cat. no. 148), a triptych whose central image of decadent bourgeois party-goers is framed by panels depicting rich courtesans, poor prostitutes, war cripples, and beggars.

Even harsher statements, combining bitter humor and profound cynicism, could be found in the works of many dadaists. Dada had originated among an international group of pacifist artists in Zurich in 1916 and had spread to Berlin within a year. Operating in a multiplicity of media—the visual arts, prose, poetry, and provocative presentations that prefigured more recent "happenings"

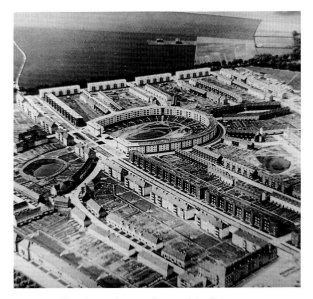

Fig. 21: The "horseshoe settlement" in Britz, photograph ca. 1930, Bildarchiv Preussischer Kulturbesitz.

and performance art—the Berlin dadaists created works marked by randomness, anarchy, absurdity, often downright banality. These attributes were deemed appropriate to an age when idealist rhetoric promoted the most brutal of wars, when socialist politicians sent right-wing death-squads into working-class neighborhoods, and when a technologically advanced metropolis could be a jungle of brutal violence and subsistence poverty. The dadaists sought to incite the middle classes by laying bare such contradictions at events like the First International Dada Exhibition, held in Berlin in June 1920.

Such provocations were continued throughout the decade by George Grosz, the outstanding satirical artist of the age. He was brought to trial and fined three times, on charges of defaming the army (1921), obscenity (1923), and blasphemy (1928). His brutally blunt caricatures of scarred square-jawed officers, fat capitalists, benighted bourgeois, and exploited workers have literally defined the visage of the Weimar Republic for future generations (see cat. nos. 40, 41, 122-126). Beyond such thematic radicalism, the dadaists engaged in important formal experiments, most notably photomontage. Hannah Höch and Raoul Hausmann brought montage and collage to great artistic heights while fashioning images that captured the dadaist spirit (see cat. nos. 42-44, 127-131). Ultimately, photomontage was put to effective political use by John Heartfield, who overcame the cynicism of dada by devoting his art wholeheartedly to communist and anti-fascist causes (see cat. nos. 129, 152-154).

Montage forms came to dominate the arts of Berlin more generally in the 1920s. Already at the turn of the century, Simmel and others had pointed to the fragmentation of consciousness in the metropolis and the public's consequent desire for a juxtaposition of multiple stimuli in the department store, the variety show, and the cabaret. A generation later, numerous other artistic media adopted montage techniques to replicate the simultaneity of impressions generated by "big city life." Photomontage did this deliberately and directly, but similar principles could be put to work on canvas. Whereas Lesser Ury had used a relatively realistic technique to depict the hustle and bustle of Berlin in 1888 (cat. no. 108), Otto Moller's futurist *City* of 1921 (cat. no. 141) fractures and recombines images of streetcars, automobiles, pedestrians, buildings, and words drawn from newspapers and billboards to create an icon of urban experience. Likewise, stage sets such as those for Erwin Piscator's socially critical productions could juxtapose film clips, projected photographs, statistical charts, and banners with political slogans. Even literature adopted montage forms: the outstanding modernist novel of the age, Alfred Döblin's *Berlin Alexanderplatz* (1929), sought to evoke the complexity of the city by interspersing seemingly random newspaper clippings, statistical summaries, and political exhortation throughout the fractured narrative. These techniques contributed to *Neue Sachlichkeit*, the "New Objectivity" or "New Sobriety" that replaced expressionism and dada as the dominant modernist mode in the early 1920s.

One of the most memorable and compelling uses of montage to create an image of Berlin was Walter Ruttmann's film *Berlin, The Symphony of the Big City* (1927). Without plot or narrative structure, it evoked the life of the metropolis from dawn until midnight by juxtaposing images of Berliners from all social classes, at work, at rest, and at play. Film was not only the ultimate montage-medium, but also the newest and most influential art form to come into its own in the 1920s. Berlin was the undisputed center of the film industry of Weimar Germany. Indeed, the world's first public showing of a projected film had taken place in Berlin on November 1, 1895, as part of the evening's entertainment at the Wintergarten variety theater. Initially, short films were a mere diversion amid other acts at variety and fairground theaters. That changed, however, with

the spread of specialized movie houses and the distribution of feature-length films. Within a generation cinema became the most popular form of mass entertainment; indeed, its triumph was so complete that it drove all but a few variety theaters out of business. Veritable movie palaces were erected along the Kurfürstendamm, some designed by outstanding modern architects like Hans Poelzig and Erich Mendelsohn (fig. 22). Production companies sprouted up throughout Berlin and outlying suburbs like Babelsberg. Generally they cranked out movies that sought to appeal to the masses on a national and even international scale: comedies, soupy love stories, spy and detective thrillers, nationalistic historical extravaganzas. But some companies produced more serious works that dealt with life in Berlin. Downward social mobility, unemployment, crowded housing, poverty-induced crime, and backroom abortions are some of the themes of F. W. Murnau's *The Last Laugh* (1924), Piel Jutzi's *Mother Krause's Journey to Happiness* (1929), Hans Tinter's *Cyankali* (1930, based on a play by Friedrich Wolf), and Slatan Dudow's *Kuhle Wampe* (1932, scripted by Bertolt Brecht). Other serious films were less accusatory: like Ruttmann's *Berlin*, Robert Siodmak's *People on a Sunday* (1930, scripted by Billy Wilder) provided more neutral vignettes of Berlin by showing the weekend experiences of five young people.

After film, the most popular entertainments in Berlin were cabaret and revue. The first major postwar cabaret was a revived Schall und Rauch, again sponsored (but this time not directed) by Max Reinhardt. Early performances involved some dadaists like Grosz and Heartfield, as well as two men who were to become the major writers of cabaret lyrics in the twenties: Walter Mehring and Kurt Tucholsky. Their satirical poems ridiculed the foibles of politicians of all ideological persuasions; they also made light of social fads and commercial fashions, as did the verses of Erich Kästner later in the decade. Alongside serious cabarets like Schall und Rauch, Rosa Valetti's Grössenwahn, and Trude Hesterberg's Wilds Bühne, there arose "cabaret-revues" whose performances had more of a plot line, but consisted essentially of a series of satirical numbers. Rudolf Nelson, Friedrich Hollaender, and the team of Marcellus Schiffer and Mischa Spoliansky were the undisputed masters at composing such works. The use of satirical political songs spread to other forms of theater as well. Bertolt Brecht, who moved to Berlin in 1924, not only wrote the lyrics for many songs for his plays, but also teamed with the composer Kurt Weill to create socially critical musicals like *The Threepenny Opera*, *Happy End*, and *Mahagonny* (see Schlichter, *Bert Brecht*, cat. no. 47).

The biggest entertainment hits of the mid-twenties in Berlin were, however, the revues of Harry Haller, Erik Charell, and James Klein. These directors competed against each other to produce the most extravagant show in town, each season offering more lavish production numbers, an ever-greater lineup of stars from stage and screen, and ever-longer kicklines of what the Germans called "Girls" (in honor of their American provenance). Unlike the cabarets, these revues included only a modicum of political satire, since their producers did not want to alienate any sector of their wide audience. Just as the department store and the variety show had symbolized the metropolitan experience at the turn of the century, analysts and observers of Berlin society in the Weimar era regarded the revue as its most complete expression. Ernst Bloch noted that Berlin appeared to be "a city that is perenially new, a city built around a hollow space, in which not even the mortar becomes or remains hard."[8] The revue seemed to be the art most congruent with such a perpetually transmutable city, since revues were "one of the most open and unintentionally honest forms of the present, a cast of that hollow space. . . . The appeal of the revues comes

Fig. 22: The Universum Movie Theater on the Kurfürstendamm, designed by Erich Mendelsohn, 1928, Bildarchiv Preussischer Kulturbesitz.

8. Ernst Bloch, "Berlin: Funktionen im Hohlraum," in *Erbschaft dieser Zeit* (orig. ed. 1935; Frankfurt am Main: Suhrkamp, 1962), p. 212.

precisely from the sensual power and turbulence of loosely-structured scenes, from their ability to change and to transform themselves into one another."[9] Likewise, Siegfried Kracauer noted that there was a tendency in Berlin "to fashion all presentations into revues." He concluded: "The Berlin public behaves in a profoundly truthful manner when it increasingly shuns [conventional forms of high art] . . . and shows its preference for the superficial luster of stars, films, revues and production numbers. Here, in pure externality, it finds itself; the dismembered succession of splendid sensory perceptions brings to light its own reality."[10] For Bloch and Kracauer, revue was a cultural form that gave expression to a city marked by constant dynamism, a producer and product of consumerist and mass-cultural trends.

Berlin's Golden Twenties gave way to the most tragic period of its history. The New York Stock Exchange crash of October 1929 affected Germany severely, since its economic recovery had been aided by short-term American loans. When these were called in, many businesses failed and unemployment rose dramatically. By April 1932, 603,000 Berliners were out of work. The economic crisis drove many citizens into the arms of the KPD, which became the dominant party in the proletarian neighborhoods located in the northern and eastern sections of Berlin. The communists' animosity toward the ruling authorities had already been exacerbated by May Day disturbances in 1929, when clashes between communists (whose demonstrations had been banned) and the police left twenty-four workers dead. After 1930, when Germany came to be ruled more and more by presidential emergency decree, the communists claimed that Germany had already turned into a fascist state, and they agitated for the revolutionary overthrow of the government and the establishment of a "dictatorship of the proletariat." Their standpoints were promoted by the agitprop movement, a form of communist cabaret, and organizations of leftist artists such as the Asso (Assoziation Revolutionärer Künstler Deutschlands) (see Bruno Voigt, *Attack* and *Street Fight*, cat. nos. 150, 151).

An even greater threat to Weimar democracy was arising on the right wing of the political spectrum. The National Socialist German Workers Party (NSDAP), founded by Adolf Hitler in Munich, sought to gain a foothold in Berlin in the mid-1920s. For an outspokenly right-wing group to organize in a self-consciously "red" city would be no easy task, and the Nazis' major theoretician, Joseph Goebbels, was made head of the Berlin NSDAP in November 1926. Goebbels immediately started a policy of gaining attention through provocation: in February 1927 he rented the Pharus Hall, normally the site of communist meetings, for a Nazi assembly. Predictably, this led to clashes with communist followers, and the Nazis were forced to retreat; yet they had succeeded in making the point that they were willing to challenge the communists on their home turf. The number of battles between communists and uniformed Nazi storm troopers (SA) rose prodigiously after 1929, when both parties attracted large followings. These often deadly clashes gave the Nazi leaders material for a new hagiography. When Horst Wessel—a young SA leader, sometime poet, and reputed pimp—was killed by a communist in Berlin in January 1930, Goebbels portrayed the rather unlikely hero as a martyr of the Nazi cause, and the "Horst Wessel Song" became the movement's anthem.

The increasing radicalization toward the Left and the Right was reflected at the polls. In the Reichstag elections of September 14, 1930, the communists received 27.3 percent of the votes in Berlin, narrowly surpassing the socialists, who won 27.2 percent; the Nazis gained almost 15 percent. Two years later, on November 6, 1932, the communists led with 31 percent, while the Nazis (at 26 percent) came in ahead of the socialists (23 percent). If one adds the votes of the

9. Bloch, "Revueform in der Philosophie" (1928), in *Erbschaft dieser Zeit* (orig. ed. 1935; Frankfurt am Main: Suhrkamp, 1962), p. 369.
10. Siegfried Kracauer, "Kult der Zerstreuung" (1926), reprinted in *Das Ornament der Masse* (Frankfurt am Main: Suhrkamp, 1977), pp. 314-15.

right-wing German National People's Party (DNVP), totalling 11 percent, to those of the Nazis and the communists, then one must conclude that nearly 70 percent of Berlin's citizens voted against the Weimar system of parliamentary democracy. Although the Nazis achieved their greatest gains in middle-class neighborhoods in the western and southern areas of the city, where they won 36 percent of the vote, they received 24 percent of the vote in working-class districts as well. The Nazis succeeding in keeping their goals sufficiently nebulous to attract a disparate electorate. Many workers were duped into believing that Hitler was the leader of a truly "National Socialist" party that would aid the proletariat. Indeed, the Nazis occasionally joined the communists in supporting causes like the Berlin public transportation workers' strike in 1932. The middle classes, in contrast, were impressed by the Nazis' nationalism and virulent anti-communism. Only after he had gained power did Hitler's true aims become evident: the creation of a totalitarian dictatorship geared toward waging war on the rest of Europe and fashioning a "racially pure" state.

The Nazi seizure of power was swift and dramatic. Since the Nazis had won a third of the national vote in the elections of November 1932, Hitler was appointed chancellor on January 30, 1933. The SA celebrated the occasion with a lengthy torchlight procession through the Brandenburg Gate. Hermann Goering was made the minister of the interior for Prussia, and thus head of the police. On February 11 he declared the SA to be an "auxiliary police force," an act which inaugurated the "legalization" of terror. The Nazis could now attack their opponents with impunity. They used the burning of the Reichstag on February 27, which they falsely maintained was the signal for a communist uprising, as an excuse to pass emergency decrees that suspended civil rights. Numerous communists, socialists, and trade union leaders were arrested immediately, and many came to be detained in hastily created concentration camps, such as that in Oranienburg outside of Berlin. By summer the Nazis had banned all other political parties, dissolved the trade unions, and forced newspapers to toe the new "official" line. All opposition was brutally suppressed: in June 1933 one hundred Berlin socialists and communists were arrested and tortured to death in the "Köpenick Blood Week."

Although the Nazis moved most swiftly against their enemies on the Left, they rapidly turned against their other intended victims as well. On April 1, 1933, they called for a boycott of Jewish-owned shops and businesses. Six days later a law was passed excluding not only political opponents but also all Jews from the civil service. Soon Jewish professionals, especially doctors and lawyers, also saw their activities sharply curtailed. Although these regulations applied to Germany as a whole, their greatest impact was felt in Berlin: in 1933 some 170,000 Jews—one-third of Germany's Jewish population—lived there. The pre-war culmination of anti-Semitic measures was the "Crystal Night" pogrom of November 9, 1938, when nine of Berlin's twelve synagogues were burned down by the SA, numerous Jewish stores were sacked, and hundreds of Jewish citizens were physically attacked or arrested. Thereafter, Berlin's Jews were ghettoized, and they were prohibited from attending theater and cabaret performances, sports events, museums, public baths and pools, and even walking on central city boulevards like Unter den Linden.

The Nazis also turned against many of the people who had given Berlin its distinctive culture in the 1920s. The burning of "un-German" books before the university on May 10, 1933, was a clear signal of the regime's intentions (fig. 23). Because of their leftist politics, modernist aesthetics, or Jewish ancestry, many of the capital's cultural and scientific luminaries had to flee the country: Albert Einstein, Bertolt Brecht, Walter Mehring, Max Reinhardt, and Kurt Tucholsky

Fig. 23: Book-burning by Nazi students before the university on May 10, 1933, Bildarchiv Preussischer Kulturbesitz.

joined hundreds of other refugees from Germany. Those Jewish or politically suspect artists and writers who remained found themselves purged from public associations (such as the prestigious Prussian Academy of Arts) and unable to display or publish their works. Artists unhappy with the regime could express disaffection only in very general or allegorical ways (e.g., Hofer, *The Prisoners*, cat. no. 158). To be sure, some private galleries in Berlin were able to show expressionist and other modernist works until 1938, when the "Exhibition of Degenerate Art" was moved to Berlin from Munich (where it had opened the previous year). That show, which execrated the culture of the Weimar years, rang the final death-knell for avant-garde tendencies. On March 20, 1939, nearly five thousand modernist paintings and graphics were burned at Berlin's central fire station.

The Nazi leadership actively sought to recast the "red" and "decadent" image of Berlin. Several large official structures were built to house the agencies of the Third Reich, and the events of 1936 required the construction of a massive Olympic stadium as well as various tracks and arenas at the "Reichssportfeld." Albert Speer, in constant discussions with Hitler, drew up plans for a major transformation of the capital. Huge boulevards were to be carved through the center city, and a monumental "Great Hall" with a three-hundred-meter dome was to become the largest building in the world. These megalomaniacal plans would have destroyed much of old Berlin; indeed, the city's name itself was to be changed to "Germania."

The Nazi leadership had reason to remain suspicious of Berlin, since much of the opposition to its rule was centered there. Most resistance came from socialist, communist, and trade union circles. Although persecuted religious groups struggled for survival—not only Jews, but also Jehovah's Witnesses, Quakers, and Baptists—the Nazis encountered little opposition from the established Protestant churches in Berlin; the protests against "Aryan" legislation by Martin Niemöller, a pastor in Dahlem, were exceptional. Somewhat more opposition was heard from Catholic circles after the Nazis infringed upon some

of their prerogatives; bishop Konrad Preysing and provost Bernhard Lichtenberg (who died on a transport train to Dachau in 1943) were especially outspoken in Berlin. The "officers' plot" of July 20, 1944, which sought to bring a hopeless war to an end, was also centered in the capital.

None of these groups and individuals, however heroic, could prevent the final disasters that were visited upon the peoples of Europe, including many citizens of Berlin. The war that Germany had started in September 1939 began to rebound directly on the Berliners in 1940, when the Royal Air Force flew its first bombing missions to the capital. The initial air raids caused relatively little damage, but after November 1943 the massive bombardments of the "Battle of Berlin" wreaked great destruction, as whole neighborhoods went up in flames. Beginning in March 1944 the nighttime raids of the RAF were complemented by daytime missions of the United States Air Force, which often sent off a thousand bombers on a single day. By the end of the war some fifty thousand Berliners had been killed by the air strikes, and about half of all housing and a third of the city's industrial capacity were damaged or destroyed.

While the enemy bombers brought death to thousands of civilians, the Nazi regime was organizing the destruction of even more of its own subjects. Although many of Berlin's Jews had fled abroad in the first years of the Third Reich, there were still some seventy-five thousand of them living in the capital in the summer of 1939. Like millions of their brethren in the captured territories, most of them became victims of the "Final Solution," which was formalized at the Wannsee Conference on January 20, 1942. The deportations from the capital eastward to the concentration camps had commenced already on October 18, 1941. By the end of the war, some fifty thousand of Berlin's Jews had been murdered. Only fifteen hundred of them remained alive in the ruins of the capital when the Nazi troops capitulated to the Soviets.

The Red Army reached the outskirts of Berlin on April 18, 1945. Two weeks of fierce fighting brought the Soviets ever closer to the center of the city, where Hitler and Goebbels committed suicide on April 30. The remaining German troops surrendered May 2. The task of rebuilding the shattered city was formidable, and for several months the women of Berlin provided most of the labor for removing the debris (fig. 24). The political fate of the city lay in the hands of the victorious Allies. The London Protocols of September 1944 had stipulated that Berlin, like the rest of Germany, would be divided into American, English, and Russian sectors; when France joined the ranks of the Allies, it too was included in the agreement. Consequently, American, British, and French troops moved into Berlin in the summer of 1945. Ultimate authority in the city was invested in the Allied Kommandatura. Soon, however, conflicts appeared which eventually turned Berlin into the prime symbol of the Cold War. Even before the arrival of Western troops, the Soviets had created institutions of municipal government and administration, and allowed the revival or formation of "anti-fascist" parties (SPD, KPD, Liberals, Christian Democrats). Over the ensuing months, however, they tried to ensure that city agencies would be dominated by loyal communists. They first sought to fuse the SPD and the KPD. The socialists in the western sectors voted against such a union, but a "Socialist Unity Party" (SED) was formed in the Soviet sector in April 1946. On October 20, 1946, in the only free citywide election held after the war, the SPD won forty-nine percent of the votes for city council, followed by the Christian Democrats (twenty-two percent) and the SED (twenty percent). After this clear defeat for the SED, the Soviets sought to separate their sector administratively from the Western zone, and ultimately to force the other Allies out of the city.

The decisive split came in June 1948, when the inability of the Four Powers to

Fig. 24: Women removing debris in 1945, Bildarchiv Preussischer Kulturbesitz.

agree on a currency for Berlin led to the introduction of the West German mark in the western sectors, and the mark of the Soviet zone in the eastern sector. Since this implied that West Berlin would be integrated into the emerging West German state, the Soviets imposed a blockade around the city. The western Allies had neglected to formalize their rights to land or water access to the city; only three air corridors had been spelled out in a treaty with the Soviet Union. Consequently, the Allies inaugurated a massive airlift. For eleven months the two million citizens of the western zones were dependent upon airplanes for supplies. Despite the hardships, West Berlin ultimately benefitted from the ordeal: it no longer was seen as the defunct capital of the Third Reich, but became a primary symbol of the "Free World," of popular resolve to resist communist pressure. Likewise, the Berliners no longer regarded the western Allied forces as troops of occupation, but rather as protectors of their liberty (*Schutzmächte*).

Although the blockade was lifted in May 1949, disagreement over the status of the city has continued to the present. When the German Democratic Republic was created out of the Soviet Occupation Zone in October 1949, Berlin was proclaimed its capital. Likewise, West Berlin was declared a state of the Federal Republic of Germany in 1950. For practical purposes, those are the realities. The western Allies, however, refuse to recognize East Berlin as a constituent part of the GDR, and argue that the whole city still remains, legally, under Four-Power control. For that same reason, West Berlin is not fully integrated into the Federal Republic: it sends observers, but not voting members, to the parliament in Bonn, and its citizens are not subject to compulsory military service. The Soviets have a different interpretation of Berlin's status: they claim that the three western powers were supposed to be only "temporary" occupiers of Berlin, and contend that the entire city rightfully belongs in the former Russian zone, i.e., the present GDR. In any case, neither the GDR nor the USSR considers West Berlin a constituent part of the Federal Republic in any sense: instead, they treat it as an independent political entity, which they call "Westberlin."

These struggles over the status of the city have been much more than nominal. During the 1950s West Berlin received major subsidies from the Federal Republic and the US-funded Marshall Plan not only to rebuild, but also to turn itself into a "showcase of the West," a city marked by plentiful consumer goods, a free press, and open elections. These benefits could literally be displayed before the eyes of the East Berliners because throughout the 1950s the city's sectors had relatively open borders; tens of thousands of people crossed the line between East and West Berlin in both directions every day. The increasing commercial prosperity of West Berlin stood in marked contrast to conditions in the socialist East, where workers put in longer hours and could purchase few consumer products. After one of several raisings of the work quota, construction workers in East Berlin went on strike on June 17, 1953. Walkouts and demonstrations soon spread throughout the capital, then to other cities of the GDR. Armed police and Soviet tanks were needed to quell the five-day uprising.

Economic and political discontent not only caused the uprising of June 1953, but also led to the emigration of some three million citizens from the GDR to the West during the 1950s. Over half of these people crossed the open border into West Berlin. The defection of such massive numbers of skilled workers and professionals was a crippling blow to the economy of the GDR. To "heal" the "open wound" in the heart of that country, Soviet and East German troops forcibly divided the two halves of Berlin on August 13, 1961. The hastily constructed Berlin Wall, which has undergone periodic "improvements," immediately became a dramatic symbol of communist oppression in the eyes

of the West. To date, over seventy people have been killed while trying to flee East Berlin.

From the official perspective of the GDR, the construction of the wall achieved its major purpose: the exodus of its economically valuable citizens came to a halt, and the ensuing years were marked by sustained growth that translated into an improved standard of living. A decade later, the economic stability of the GDR, as well as the general climate of East-West detente, allowed the signing of the Four-Power Agreement on Berlin in September 1971. Without making any principled concessions regarding the status of Berlin, this treaty confirmed the realities of the status quo. The Soviet Union and, by implication, the GDR recognized the right of West Berlin to develop its ties with the Federal Republic. Subsequent agreements with the GDR guaranteed West Berliners' transit rights to West Germany and simplified regulations governing visitations of East Berlin and the GDR. Although these treaties have not overcome the tragedy of the city's division, they have succeeded in alleviating the tensions that had made Berlin a focal point of international conflict in the postwar years.

The 1960s saw the commencement of renewed political agitation in West Berlin, as many of the city's students were radicalized in opposition to the Vietnam War as well as Western support for right-wing dictators throughout the world. The visit of the Shah of Iran to West Berlin in 1967 triggered massive protests, during which a student was fatally shot in the back by a policeman. That marked the beginning of several years of continual demonstrations. Political opinions and tempers were sharply divided, inasmuch as many older Berliners, who admired the United States for its support of West Berlin's freedom, had no sympathy for the anti-Americanism of student radicals. Tensions mounted even more in the 1970s when the "Red Army Faction," a small spin-off of the protest movement, conducted a series of political kidnappings and murders. By the end of that decade, the student protests had waned, and the leaders of the terrorist group were dead or imprisoned. The early 1980s witnessed a new form of activism, namely the occupation of empty apartment blocks (*Hausbesetzung*) to protest high rents and real estate speculation—problems that have plagued Berlin for well over a century.

The uncertain status of West Berlin made shaping its identity and charting its future problematic. Although it continues to be a major industrial center, its isolated geographic position requires heavy subsidies from the Federal Republic to maintain its economic viability. Since it has lost its political function as capital of a united Germany, it has sought to maintain its international prestige by becoming a center of scholarship and cultural activity. Many of the Federal Republic's most important academic and scientific research institutes are located in the city. It also holds important annual festivals of film, theater, and other arts.

Initially, in the two decades after the war, West Berlin welcomed cultural luminaries of the Weimar era who had fled the Nazi regime. Erwin Piscator managed the Freie Volksbühne, Hans Scharoun designed the Philharmonic Concert Hall (1963) and the State Library (1978), Ludwig Mies van der Rohe designed the National Gallery (1968), and Walter Gropius provided the plans for the Gropiusstadt settlement (constructed in 1964-75). At the same time that this prewar generation was creating its last major works, a new group of young artists appeared on the scene. Inspired in part by their expressionist precursors, they sought to capture the spirit of contemporary Berlin. A work like Karl Hödicke's *Passage V* (cat. no. 70) belongs to the now-established tradition of Berlinscapes that use passing vehicles, shopwindows, and advertisements as signs of the

Fig. 25: The Kurfürstendamm with the ruins of the Kaiser Wilhelm Memorial Church in the background, photograph 1969, Bildarchiv Preussischer Kulturbesitz.

city's hectic tempo and commercial modernity. A much more somber, and specifically postwar message is provided by his *Ministry of War* (cat. no. 172). This stark image of the former Air Minstry of the Third Reich, now the "House of Ministries of the GDR," is viewed over the top of the Berlin Wall; it thus evokes the grimmest hours of the city's past as well as its current division. The Wall is also a pervasive image in the works of Rainer Fetting (see cat. no. 73). While conscious of the city's troubled history and ambiguous present, the "New Fauves" also explore the sensual vitality of West Berlin's youth culture. Middendorf's *Natives of the Big City II* (cat. no. 171) captures the animal energy that lurks within the seemingly anonymous and depersonalized celebrants.

As in earlier ages, West Berlin today stands for a certain quality of life. Commercialism and consumerism still define the city's image—partially as a throwback to the Imperial and Weimar eras, partially as a challenge to its socialist alter ego. Since it lacks a center of political power, the heart of West Berlin is the Kurfürstendamm, the city's traditional locus of shopping and entertainment in the twentieth century. The rush of pedestrians and the perpetual traffic jam prevent the casual visitor from stopping to contemplate the cautionary statement made by the bombed-out ruins of the Kaiser Wilhelm Memorial Church (fig. 25). Besides the "Ku'damm," West Berlin is best known for Kreuzberg, a unique neighborhood that combines generally conservative Turkish families and self-consciously oppositional Germans. This district, now bordering the Wall, arose in the Imperial era as a proletarian neighborhood, complete with rental barracks. When workers from eastern and southern Europe and Anatolia came to seek employment in West Berlin in the 1960s and 1970s, they found cheap housing in that run-down neighborhood. Kreuzberg thus became the center of Berlin's newest colony of immigrants; indeed, of the nearly two million residents of West Berlin registered in 1983, a quarter million were foreigners, and half of them were Turks. In the 1970s Kreuzberg also attracted numerous members of the "alternative scene," and thus became a center of the "counter-culture" as well: for example, the house-occupation movement of the 1980s took place there. The district's reputation for radical activism induced the police to quarantine the whole area during President Ronald Reagan's visit to West Berlin in 1987. That action violated several fundamental civil rights, but at least it paid backhanded homage to Kreuzberg's "alternative" fame.

Despite the dislocations and discontents brought about by the forcible introduction of socialism, East Berlin retains more of Berlin's traditional functions than does its western counterpart, inasmuch as it is the political, economic, and cultural capital of the GDR. Moreover, it encompasses the historic heart of the city, Unter den Linden. At first many of the structures of Berlin's "feudal" and "capitalist" past were an embarrassment to the new rulers; indeed, for ideological reasons they chose to demolish rather than restore the bombed-out Royal Palace in 1951. Since the 1970s, however, they have realized that one way to increase the loyalty of Berliners (and to attract tourists) is to show appreciation for the city's past. Many of its historic landmarks have been restored, and the 1980s saw the inauguration of the centrally located Nikolaiviertel, a historic district of renovated buildings from the eighteenth century.

One can also observe aspects of Berlin's "modern tradition" in the capital of the GDR. Although East Berlin cannot compete commercially with its capitalist neighbor, it is a consumer paradise for the citizens of socialism; the Centrum, the GDR's major department store, is located on the Alexanderplatz. As in the West, the 1920s served as a model for postwar cultural rejuvenation: Bertolt Brecht was the major figure in GDR theater until his death in 1956, and a younger generation of artists has been inspired by the "New Objectivity" of the Weimar years. East Berlin is also the center of the GDR's "counter-culture," inasmuch as Kreuzberg has a counterpart in Prenzlauer Berg. Likewise a working-class neighborhood dating to the Wilhelmine era, it has attracted many youths devoted to "alternative" life-styles.

In 1987 both halves of Berlin competed to appropriate its history during the 750th birthday party. The parallelism of the celebrations indicated that a wall could not divide a common identity. Much of that identity is fixed in buildings, streets, values, language, habits, traditions—and in the works of art that they inspired. In 1928 Bernard von Brentano, a journalist and perceptive observer of Berlin, complained that the tempo of change prevented contemplation of the city's history: "Everything belongs to the present. The past is mute, buried in lost graves; there are not even stones that would have something to say. And the present age has not found its own expression. Nevertheless, as one walks around silently, the hidden city bellows. Who takes note? Who tries to comprehend its new language?"[11] Although many citizens may have been deaf to these signals, artists did take note of them. By contemplating their works, one can begin to comprehend a metropolis whose history embodies the excitement and the terror of the modern age.

11. Bernard von Brentano, *Wo in Europa ist Berlin?* (orig. ed. 1928; Frankfurt am Main: Suhrkamp, 1987), p. 11.

Bibliographical Note

A complete listing of works on the history of Berlin would, of course, have thousands of entries. Fortunately, there is now an up-to-date, scholarly, and eminently readable account with an extensive bibliography: Wolfgang Ribbe, ed., *Geschichte Berlins*, 2 vols. (Munich: C. H. Beck, 1987). For much shorter essays covering Berlin's entire history, compare the differing versions published in East and West on the occasion of the city's 750th birthday celebrations: *750 Jahre Berlin: Thesen* of the Kommitee der Deutschen Demokratischen Republik zum 750jährigen Bestehen von Berlin (Berlin: Dietz Verlag, 1986); and Ulrich Eckhardt, ed., *750 Jahre Berlin: Stadt der Gegenwart* (Frankfurt am Main: Ullstein, 1986). Among older literature, one highly critical and delightfully polemical work stands out: Werner Hegemann, *Das steinerne Berlin: Geschichte der grössten Mietskasernenstadt der Welt* (1930; reprint, Braunschweig: Vieweg & Sohn, 1979). There is no comparable comprehensive history of Berlin in English. For more general works dealing with the Wilhelmine and Weimar eras, see Gerhard Masur, *Imperial Berlin* (New York: Basic Books, 1970); Otto Friedrich, *Before the Deluge: A Portrait of Berlin in the 1920's* (New York: Harper & Row, 1972); and Eberhard Roters et al., *Berlin 1910-1933* (New York: Rizzoli, 1982).

Art and the Course of Empire in Nineteenth-Century Berlin

Françoise Forster-Hahn and Kurt W. Forster

With the Prussian monarchy regaining its authority after 1815, Berlin took on a dual role: as the capital, the city confirmed its traditional identity as governmental and military stronghold; as the fulcrum of administrative reforms and advances in industry and education, it began to exercise new influence even beyond the borders of the state.[1] Impressive developments in both the industrial and commercial spheres fueled bourgeois aspirations and spurred intellectual and artistic developments of great moment. In particular, the administrative reforms initiated by Freiherr vom Stein and Wilhelm von Humboldt laid a new basis for artistic production through their establishment and reorganization of institutions like the University, Academy, Architecture School, Polytechnic Institute, Museum, Theater, and Iron Foundry. These reformers were guided by a keen sense of practicality coupled with the desire to create enduring institutions which could ensure, over time, the success of their educational goals and cultural expectations. The importance of educational institutions manifested itself as well in major architectural projects for new buildings whose character and quality exercised a formative influence on building practices throughout Prussian territories.

But the three decades between the end of the wars of liberation against Napoleon and the revolution of 1848 also saw a sharpening of the contradictions between tradition and innovation, between political conservatism and intellectual progressiveness. The restoration following the Congress of Vienna is usually equated with political and cultural conservatism, with a decisive turn from cosmopolitan openness in the tradition of the Enlightenment toward a closed, provincial, and increasingly nationalistic attitude. In the arts, this general trend came to be identified with the term *Biedermeier*, but in recent

1. Two broadly conceived survey exhibitions, *Kunst in Berlin, 1648-1987* (Berlin-GDR: Staatliche Museen zu Berlin, 1987), and *Stadtbilder: Berlin in der Malerei vom 17. Jahrhundert bis zur Gegenwart* (Berlin-West: Berlin Museum, 1987), cover much pertinent material. The first half of the nineteenth century has been the subject of another exhibition, *Berlin zwischen 1789 und 1848, Facetten einer Epoche* (Berlin-West: Akademie der Künste, 1981). A less pretty picture emerges in Ernst Dronke, *Berlin* (Frankfurt am Main: n.p., 1846; reprint, Darmstadt: Luchterhand, 1974).

Fig. 26: Eduard Gaertner, *View from the Guard House toward the Royal Schloss*, 1849, oil on canvas, Hamburg, Kunsthalle.

Fig. 27: Franz Louis Catel, *Schinkel in Naples*, 1824, oil on canvas, Berlin-West, Staatliche Museen Preussischer Kulturbesitz, Nationalgalerie.

years this stylistic concept has become the subject of scholarly criticism. Originally synonymous with a neat and cozy style of interior decoration, *Biedermeier* tended to frame off images of comfortable family life in frugal interiors, still lifes, and dignified portraits (fig. 27) from the darker realities of the times. It is simply too convenient and one-sided to view the arts of this period as united by a sense of domestic harmony and public modesty, realized in devotion to detail and distanced by decorum. Although the bourgeoisie could certainly recognize itself in images that effectively ignored the increasing disparity between authoritarian and progressive programs, it was precisely these controversies which animated Berlin artists and writers like Heinrich von Kleist, E. T. A. Hoffmann, Gottfried Schadow, and Karl F. Schinkel. In their hands, Berlin would become the fascinating subject of ongoing pictorial and literary documentation, the counter-capital of artistic experiments and reform that Heine described in an excited tumble of fashionable words.[2]

A close correspondence between the purposes of didactic institutions and artistic production around the turn of the nineteenth century had the effect of reinforcing certain aesthetic tendencies, like the ingrained predilection for a highly descriptive, realist view of the world. At the beginning of the century, Johann Gottfried Schadow formulated such a concept for the visual arts when he defended the tradition of Berlin art against Goethe's critique. In 1800, Goethe had taken the "prosaic spirit" of Berlin to task in an essay he published in his journal *Propyläen*, writing that "there seems to be a naturalism indigenous to Berlin with its demand for reality and usefulness, in which the prosaic spirit of the times manifests itself most of all. Poetry is replaced by history; character and the ideal by portrait; symbolic treatment by allegory; landscape by views; the generally humane by the narrowly patriotic. . . ."[3]

In Goethe's view, the ideal of classical antiquity and its concept of beauty transcend national boundaries and thus are cosmopolitan in their values. Schadow reacted to Goethe's observations by inverting the terms of each of his

2. Heinrich Heine, *Sämtliche Werke*, ed. by Hans Kaufmann (Munich: Kindler Verlag, 1964), 6:137-94.

3. Goethe's *Flüchtige Übersicht über die Kunst in Deutschland* appeared in *Propyläen* 3, no. 2 (1800). Reprinted in *Kunsttheorie und Kunstgeschichte des 19. Jahrhunderts in Deutschland: Texte und Dokumente*, ed. by W. Busch and W. Beyrodt (Stuttgart: Reclam, 1982), 1: 91-92. For a discussion of the Goethe-Schadow debate, see F. Forster-Hahn, "Aspects of Berlin Realism: From the Prosaic to the Ugly," in *The European Realist Tradition*, ed. by Gabriel Weisberg (Bloomington: Indiana University Press, 1982), pp. 124-44. All translations are by the authors.

Fig. 28: Christian Daniel Rauch, *Monument to Frederick the Great*, 1838-51, prewar photograph.

4. Schadow's response, "Über einige in den Propyläen abgedruckte Sätze Goethe's, die Ausübung der Kunst in Berlin betreffend," appeared in *Eunomia, eine Zeitschrift des neunzehnten Jahrhunderts, herausgegeben von Fessler und Rhode* 1 (1801). Reprinted in *Kunsttheorie und Kunstgeschichte* 1:92-100.

5. Gottfried Schadow, *Über historisches oder ideales Kostüm*, a lecture given in 1791. Reprinted in *Kunsttheorie und Kunstgeschichte*, ed. by U. Bischoff, 3:30-31. Other texts regarding the *Kostümstreit*, ibid., pp. 27-38. Cf. Johann Gottfried Schadow, *Kunstwerke und Kunstansichten. Ein Quellenwerk zur Berliner Kunst-und Kulturgeschichte zwischen 1780 und 1845. Kommentierte Neuausgabe der Veröffentlichung von 1849 herausgegeben von Götz Eckardt*, 3 vols. (Berlin-GDR: Henschel, 1987).

6. Jutta von Simson, *Das Berliner Denkmal für Friedrich den Grossen* (Frankfurt am Main, Berlin, Vienna: Propyläen Verlag, 1976).

7. Cf. F. Forster-Hahn, "Adolph Menzel's Daguerreotypical Image of Frederick the Great: A Liberal Bourgeois Interpretation of German History," *The Art Bulletin* 59, no. 2 (June 1977): 242-61.

negative comments. In his rebuttal to Goethe's article, Schadow countered that in Berlin "one prefers such works of art as have been made, faithfully and honestly, after a given model; or: here every work of art is treated as a portrait or likeness. I would be glad if we possessed a truly characteristic taste for art, and, although this is relegated by the *Propyläen* to the very bottom of the scale, it is the only thing that will enable us Germans to produce works of art by which we could be recognized for what we are."[4]

Schadow pointedly argued in favor of the specific and individual, not the general and ideal. He not only opposed his definitions of true art to those of Goethe, but he also located them in a different social realm. If Goethe bemoaned the loss of the "generally humane," Schadow argued in favor of the "characteristic" and the "patriotic." What began as a debate resounding from the pages of learned journals took on very specific political meaning within only a few short years. After Napoleon occupied Berlin in 1806, Goethe's ideals seemed to coincide with those of the conqueror. No longer could neoclassical art be dissociated from French culture in general or from Napoleonic programs in particular.

That the dispute between Goethe and Schadow had a direct effect on artistic practice, even beyond the issue of political alignment, was brought home by contemporary controversies over public monuments. Schadow's aesthetic of Berlin "naturalism" moved beyond the realm of a merely theoretical proposition when works of civic prominence were at stake. The so-called *Kostümstreit*—the question whether historical figures should be represented in antique or contemporary garb—compelled Schadow to put into practice what he preached. For his statues commemorating two heroes of the Seven Years' War, *Zieten* (installed on the Wilhelmsplatz in 1794) and *Dessau* (1800), he rejected the hallowed "Roman" tradition, claiming that "these figures in Roman costume seem to have nothing to do with us any longer."[5] According to Schadow, a monument should correspond to the individual character of the hero and impress the viewer, and the nation in general, as a "portrait" rather than as an abstraction. Hence it was only logical to replace the "ideal" with the "authentic."

The controversy came to a head with the plans for one of Berlin's most prominent monuments, the statue commemorating Frederick the Great (fig. 28). Its long and tortuous history reaches back to the 1780s, when Schadow prepared a first model for the project.[6] Christian Daniel Rauch, a student of Schadow's, finally won the commission in 1838, sculpted and executed the statue, and gave it definition as a monument to the bourgeois interpretation of the king rather than as a celebration of monarchy. Since the 1820s Rauch had worked closely with Schinkel on this project, but differences with King Frederick William III delayed its execution for many years. The foundation was set in 1840, the model of the equestrian statue completed in 1843, and the entire monument erected on Unter den Linden in 1851. The program of historical scenes for the base of the monument gave rise to political controversy over whether instances of "heroism in the lower ranks" of the army should be represented or not. Eventually, Adolph Menzel was asked for his opinion and proposed a compromise which the court, its historian, and the artist could all accept.[7] Nor was the statue of the king patterned after ancient precedent. Instead we see the enlightened monarch, characteristically gaunt and almost fragile, in his crumpled Prussian uniform with his head awkwardly turned to the side, a striking "portrait," as closely modeled after the man as possible, and yet as "patriotic" as Schadow would have had it. The *Monument to Frederick the Great*, conceived before but raised after 1848, signals the shift from a monarchic regime capable of a certain political liberality—like that which animated the *Vormärz*—to the authoritarian rule that heralded the empire.

On 8 September 1839, the architect Karl F. Schinkel[8] left his apartment on the third floor of the Academy of Architecture which he directed, crossed the island of the royal palace, which had been completely reshaped according to his plans, and proceeded to call on his old friend Rauch at his studio in the Klosterstrasse. Here, a number of well-known statues for Schinkel's urban projects had been carved over the years, but at the moment Rauch's time was completely occupied by the *Monument to Frederick the Great*. Rauch's atelier was located across the street from the Polytechnic Institute of Schinkel's friend Christian Beuth. Some ten years before, Schinkel had designed the new wing of the Institute. This project represents one of the most advanced buildings completed in Berlin after Beuth and Schinkel returned in 1826 from their extended trip to the British Isles, where they had avidly investigated the latest developments in industry, education, and architecture.

This September day may have been much like the one recorded in the picture that another friend of Schinkel's painted of the Klosterstrasse ten years earlier (fig. 29). Eduard Gaertner[9] had spent a couple of years in Paris when he recorded the Klosterstrasse and inscribed personal and professional relationships on the city's topography, as if giving body to Heinrich Heine's words: "Berlin is less a city than a place where a lot of people, many fine minds among them, congregate, but for whom this place is negligible, for they themselves represent the spirit of Berlin."[10]

Gaertner's urban *veduta* plays up Schinkel's daring addition to Beuth's Polytechnic Institute in its spare character and unflinching standardization of parts—qualities that had lost none of their logic for the young Mies van der Rohe almost a century later. The painting also includes the diminutive figures of Schinkel and Beuth standing in front of their building. Nor did Gaertner fail to include Rauch, his studio to the left, or himself approaching the famous painter Franz Krüger, who is ambling down the middle of the Klosterstrasse on horseback. Gaertner paid homage to the older artist, whom he greatly admired, and by peopling the cityscape with some of its most prominent artists, he mapped Heine's "spirit of Berlin" no less than its architecture. Heine's observation corresponds not only to the view of accomplished painters like Gaertner but also to the private doodles of writers like E. T. A. Hoffmann[11] (fig. 30), who sketched his apartment on the Gendarmenmarkt, opposite the theater, as a veritable box

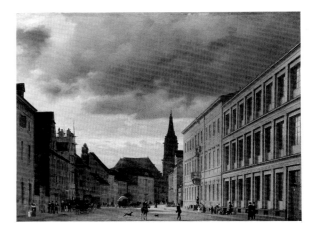

Fig. 29: Eduard Gaertner, *Klosterstrasse*, 1830, oil on canvas, Berlin-West, Staatliche Museen Preussischer Kulturbesitz, Nationalgalerie.

8. The literature on Schinkel is vast, and almost all of it is in German. The Second World War decimated his oeuvre, in both painting and architecture. Schinkel's critical fate has hardly been more fortunate. Only one book has so far been published in English, Hermann G. Pundt's *Schinkel's Berlin, A Study in Environmental Planning* (Cambridge: Harvard U. Press, 1972). Two articles in *Architectural Design*, 49, no. 8/9 (1979): 56-71, and 50, no. 7/8 (1980): 106-13, offer rather general impressions from a distinctly English point of view. A concise account of Schinkel's career and work by Barry Bergdoll is available in the *MacMillan Encyclopedia of Architects*, s.v. "Schinkel." The Schinkel literature is conveniently listed in the above-mentioned catalogues of the centennial exhibitions in Berlin-GDR and Berlin-West of 1981. The biographical details of Schinkel's last lucid day, 8 September 1839, before he suffered a crippling stroke during the night of 8/9 September, are based on the memoirs of two of his close friends: Gustav Friedrich Waagen, "Karl Friedrich Schinkel als Mensch und als Künstler," in *Berliner Kalender*, 1844, pp. 305-428; and Franz Kugler, *Karl Friedrich Schinkel, Eine Charakteristik seiner künstlerischen Wirksamkeit* (Berlin: George Gropius, 1842).

Fig. 30: E. T. A. Hoffmann, *Sketch of his new apartment and its location in Berlin*, 1815, destroyed.

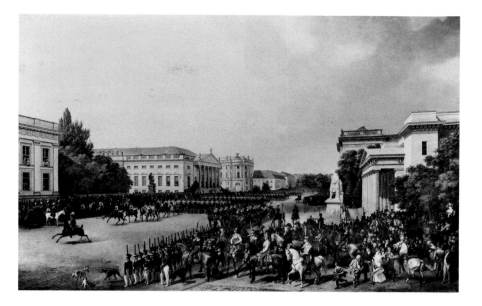

Fig. 31: Franz Krüger, *Parade in the Opera Square in Berlin in 1822*, 1824-29, oil on canvas, Berlin-GDR, Staatliche Museen, Nationalgalerie.

from which to observe *tout* Berlin, its actors, writers, friends, and wits, as they congregated in taverns, made their rounds, like Schinkel, and engaged in banter and spirited discussion.

A metropolitan atmosphere had begun to take hold in Berlin, where swirling crowds, enticing wares, and snazzy cafés frequented by literary figures and artists entranced Heinrich Heine and caused him to experiment with a new genre of literary colportage.[12] He quoted Madame de Staël, who had declared that "Berlin, cette ville toute moderne, quelque belle qu'elle soit, ne fait pas une impression assez sérieuse." Instead of being grave and serious, Berlin life possessed a special spark, a keen curiosity fueled by newspapers and journals, and kept alive not only in conversations in elegant salons but also by feisty wits and street urchins. New institutions like the *Börsenhalle* (Stock Exchange) sported well-stocked newspaper rooms with dozens of German and foreign journals, and cafés outdid each other in the display of reading materials. The miniature painter Gustav F. Taubert caught this mixture of eager naiveté and blasé curiosity in his picture *In the Berlin Reading Café: "Everyone Reads Everything"* (cat. no. 2).

On that September afternoon in 1839, Schinkel walked the length of Unter den Linden, which Franz Krüger had rendered for the second time (fig. 31) in *Parade in the Opera Square* (formerly *Schloss Monbijou*, destroyed), a huge canvas commemorating the visit of grand duke Nicholas of Russia, son-in-law of the Prussian king, which had taken place in 1822.[13] This occasion was only one of many connecting Berlin artists with the czar's court. Just then, in 1839, Gaertner was living in Moscow, training his all-seeing eyes on the cityscape for yet another urban panorama, after the czarina had commissioned a copy of his *Panorama of Berlin*[14] (seen from the roof of Schinkel's church at Werder). The eastern end of Unter den Linden was waiting for its urban capstone in the shape of Rauch's imposing *Monument to Frederick the Great*, whose progress Schinkel had occasion to observe during his morning visit with the sculptor. At its western terminus, the Pariser Platz, the first Berlin exhibition of Constable's paintings was on view in the Hotel de Russie.

Schinkel passed the Brandenburg Gate and strolled into the Tiergarten park, where he ran into the theater intendant Carl Gropius. Schinkel immediately began to describe a grand idea for which Gropius seemed to be the right man.

9. For Gaertner, see especially the exhibition catalogue by Ursula Cosmann, *Eduard Gaertner, 1801-1877* (Berlin-GDR: Märkisches Museum, 1977).
10. Heinrich Heine, *Sämtliche Werke* 6:194.
11. See exhibition catalogue, *E. T. A. Hoffmann –Ein Preusse?* (Berlin-West: Berlin Museum, 1981), pp. 94-97.
12. All passages by Heinrich Heine are taken from his "Briefe aus Berlin, 1822," in *Sämtliche Werke* 6:137-94. These letters, and those of many prominent Berliners of the time, constitute an inexhaustible source of highly individualized views and experiences of *Biedermeier* Berlin. This and all subsequent translations are those of the authors.
13. On Krüger, see Renate Franke, *Berlin vom König bis zum Schusterjungen. Franz Krügers "Paraden": Bilder preussischen Selbstverständnisses* (Frankfurt am Main: Peter Lang, 1984).
14. In 1834 Gaertner painted a very impressive *Panorama of Berlin*, composed of six panels (Berlin-West, Schinkel Pavilion, Staatliche Schlösser und Gärten). The view is taken from a rooftop (here Schinkel's *Werdersche Kirche*) and is similar to the six-partite *Panorama of London*, which was published in six aquatint engravings based on Henry Aston Barker's drawings of 1791: see Richard D. Altick, *The Shows of London* (Cambridge, Mass., and London: Belknap Press, 1978), pp. 130f.

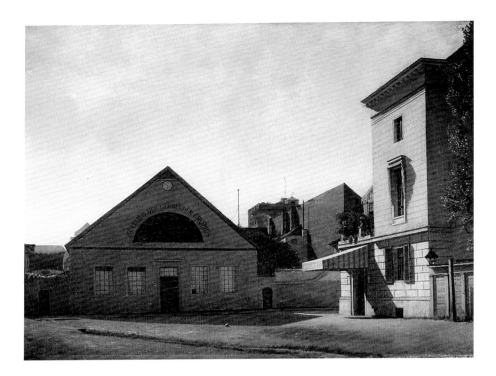

Fig. 32: Eduard Gaertner, *The Atelier and Panorama of the Gropius Brothers*, 1830, oil on canvas, Berlin-West, Staatliche Museen, Preussischer Kulturbesitz, Nationalgalerie.

Schinkel had successfully negotiated many difficult enterprises with Wilhelm Gropius, Carl's father, especially during the years of French administration, when panoramas were all the rage[15] (fig. 32). On that September afternoon, he envisioned a vast panorama installed in a building some ninety feet in diameter, lined with a continuous picture-in-the-round. This canvas would embrace the "main monuments of many countries, from Asia, Egypt, Greece, Rome, and the German middle ages, each sited in its most ideal and appropriate landscape." He proposed to a slightly incredulous Gropius the possibility of his participating personally in its execution if that would ease the financial risk of the project.[16]

Schinkel's idea was both familiar and fresh. His mind wandered back to his earliest successes in Berlin, when, after a two-year study tour of Italy and France, he had returned to a city with no architectural commissions of consequence and a decade of French occupation ahead of it. During those lean years, Schinkel decorated interiors and shop windows, painted panoramas (fig. 33), and prepared stage designs for some of the day's most notable operas and plays. But the panoramas he had helped to popularize in the early years of the century no longer satisfied him; he had long before transferred the concept of a boundless image onto the topography of the city itself.[17] Within the townscape, his own buildings—singly and in calculated ensembles—offered to the urban dweller a kind of visual perch from which to assemble, in a moment's quiet observation and against the urban flux and commotion, a synthetic impression of the city (fig. 34). Schinkel's thoughts now transcended the theatrical means and origins of the panorama and aimed, instead, at a new horizon of culture.

The faithful chronicler of this day in Schinkel's life, the art historian and museum director Gustav Friedrich Waagen, protégé and trusted friend of the architect, grasped the significance of the project Schinkel was outlining to Gropius in the idea of "embracing the culture of different times and civilizations, which he had often tried to express individually, within a totality that would permit the most interesting contrasts and comparisons to emerge, while remaining unified in pictorial terms."[18] Minds as lively and incisive as Schinkel's had begun to recognize that the vastly expanding horizon of their

15. The literature on panoramas is considerable, if highly fragmented and usually rather parochial. The principal items are Germain Bapst, *Essai sur l'histoire des panoramas et des dioramas* (Paris: Imprimerie Nationale, 1891); Alfred Auerbach, *Panorama und Diorama* (Grimmen i.P., 1942); Heinz Buddemeier, *Panorama Diorama, Photographie: Entstehung und Wirkung neuer Medien im 19. Jahrhundert* (Munich: W. Fink, 1970); R. D. Altick, *The Shows of London*, pp. 128ff.
16. Gustav Friedrich Waagen, "Karl Friedrich Schinkel als Mensch und als Künstler," in *Berliner Kalender*, 1844, p. 420.
17. See K. W. Forster, "Schinkel's Panoramic Planning of Central Berlin," in *Modulus* (The University of Virginia Architectural Review) 16 (1983): 62-77.
18. Waagen 1844 (see note 16), p. 420.
19. Hans Mackowsky, *Karl Friedrich Schinkel, Briefe, Tagebücher, Gedanken* (Berlin: Propyläen Verlag, 1922), p. 192.
20. For the *Mausoleum of Queen Luise*, see *K. F. Schinkel 1781-1841* (Berlin-GDR: Staatliche Museen zu Berlin, 1981), pp. 53-57.

Fig. 33: Karl F. Schinkel, *Panorama of Palermo*, 1809, engraving with pen drawing, Berlin-GDR, Schinkel Archive.

world and the new developments in European civilization did not afford the prospect, much less the comfort, of a balance among the forces unleashed by industrial and political powers. In Schinkel's view, only a deeply serious aesthetic vision could sustain the effort of "embracing the culture of different times and civilizations." Like Alexander von Humboldt, who tried to synthesize his globe-girdling explorations in a work entitled simply *Cosmos*, Schinkel wanted to avail himself of the infinite variety of architectural ideas and forms from around the world in order to project into the future a record of their historic origin and evolution.

"By definition, the architect is the ennobler of human conditions; he needs to comprehend all the arts in their effects. Sculpture, painting, and the art of spatial definition will ultimately fuse into one art according to the requirements of moral and reasoning life."[19] With this maxim Schinkel aspires not only to a theoretical aim but he also expresses his vision of an aesthetic totality. Only a few months after the first lithographer set up shop in Berlin, Schinkel described one of his early experiments in drawing on stone as "an attempt to express the sweet, yearning melancholy that seizes the heart upon hearing the sounds from a church service." A theatrical sensibility, suffused with romantic notions of *Stimmung*, also worked to great effect in the first architectural project Schinkel submitted to the Academy exhibition of 1810, the *Mausoleum of Queen Luise*. It was to be grandly framed by "a porch, shaded by the darkest trees. The visitor ascends a flight of steps, enters into the darkness of the porch with a sensation of sweet terror, gazes ahead through triple arches into a lovely hall, like a palm grove, where the recumbent figure, ringed by heavenly hosts, lies in the glow of a rosy morning."[20] These are the words of Schinkel the stage designer, the romantic artist who indulges his desire for control over all aspects and effects of his imagination. Pictorially akin to the works of Caspar David Friedrich, whose *Monk at the Seashore* and *Ruin of a Church in a Wintry Oak Grove* were exhibited, like Schinkel's *Mausoleum*, at the Academy in 1810, Schinkel's drawings extend the contrast between life and death to the rapport of architecture and nature.

In his lithograph of the same year Schinkel shrouded a gothic church almost completely by majestic oak trees (cat. no. 84); his description of the *Mausoleum* similarly evokes a grove of stone pillars lit by the glow of dawn. With the painting *Cathedral* (cat. no. 1), Schinkel shifted the register of this subject from the melancholy to the monumental as he reversed the relationship between trees and architecture: a grandiose cathedral towers over a steep hill, while the viewer travels far across the landscape and roams through infinite details. A supremely collective artifact, the cathedral stands as the crowning achievement of the multitudes that now populate the magnificent site as they ascend stairs, ramps,

Fig. 34: Karl F. Schinkel, *View along the Spree from the Packhof toward the Schloss*, engraving from the *Sammlung Architektonischer Entwürfe von Schinkel* (Berlin, 1828), and recently published in a complete edition in English, K. F. Schinkel, *Collection of Architectural Designs Including Designs Which Have Been Executed and Objects Whose Execution Was Intended* (Chicago: Exedra Books, 1981).

Fig. 35: Karl F. Schinkel, *View from the Vestibule of the Museum*, 1829, pen drawing, Berlin-GDR, Schinkel Archive.

and bridges toward shaded viewing platforms. Schinkel's imagination had begun to associate the cathedral with the embodiment of national fervor and the struggle for political independence. In the year of liberation, 1815, he completed companion paintings of an ancient *Greek City* (destroyed) and a *German Cathedral* which adumbrated the idea he so vividly conveyed to Gropius during their stroll through the Tiergarten park, his vision of "the culture of different times and civilizations . . . within a totality that would permit the most interesting contrasts and comparisons to emerge, while remaining unified in pictorial terms."

What Schinkel proposed was nothing less than a program for German culture, whose capacity to absorb by analysis and create by synthesis he had never doubted since he first packed Fichte's early treatise on the *Wissenschaftssystem*[21] into his travel bag for Italy. If the complexion of a culture was similar to the mind of an individual, then the fundamental paradox of Fichte's conscious mind—its absolute identity, able to distinguish between ego and non-ego, had to recognize by logic, but against its will, that it *was* conditioned after all—would apply to much wider reaches of Schinkel's thinking about the arts and their purpose in the cultural household of his day. Unflagging in his dedication to the teaching of architecture, and increasingly persuaded by Beuth of the necessity of industrial advance,[22] Schinkel entertained, to the last lucid hours of his life, the idea of a true *theatrum civitatis*. Its most complete realization coincided with the plans for a new museum, of which his friend Waagen was appointed director in 1830.

Schinkel's ideas for a new museum in Berlin were controversial from the beginning. Only his tenacity in pursuit of a goal he had chosen for public purpose rather than personal gain won him the commission and enabled him to create a building of singular fame and suggestive power. The architect had to navigate his course among quarrelsome factions, negotiate with long-established commercial interests on the Spree Island, obtain approval from the crown, and finally direct a perilous construction project that strained his imaginative as well as his organizational talents to the utmost.[23] It is little short of miraculous that the outcome possesses all the traits of a singularly accomplished resolution, instantly convincing, yet infinitely rich in its typological qualities. This is all the more remarkable if one keeps in mind that Schinkel's

21. There is an English translation of J. G. Fichte's *Über den Begriff der Wissenschaftslehre* . . . (Weimar, 1794; Jena & Leipzig: Christian Ernst Gabler Verlag, 1798, 1802) by Peter Heath and John Lachs, *The Science of Knowledge* (Cambridge: Cambridge U. Press, 1982). Franz Kugler, *Karl Friedrich Schinkel, Eine Charakteristik seiner künstlerischen Wirksamkeit* (Berlin: George Gropius, 1842), p. 17, makes the interesting observation: "Als ein charakteristischer Zug mag es ferner anzuführen sein, dass Schinkel, inmitten dieser künstlerischen Beschäftigung und unter den Reizen des südlichen Lebens, das Bedürfniss nach einer strengeren Geistesnahrung empfand, wozu ihm die Werke Fichte's, die er mit auf die Reise genommen, Gelegenheit boten."

22. See T. Buddensieg, "Englisches 'Maschinenwesen' und preussischer 'Gewerbefleiss': Goethes Blick auf Wedgwood, Beuth und Schinkel," in *Die Grenzen sprengen. Edzard Reuter zum Sechzigsten* (Berlin-West: Siedler, 1988), 256-88.

23. For the museum, consult especially Paul O. Rave, *Karl Friedrich Schinkel Lebenswerk. Berlin: Erster Teil: Bauten für die Kunst, Kirchen, Denkmalpflege* (Berlin: Deutscher Kunstverlag, 1941), and Hans Ebert, "Daten zur Vorgeschichte und Geschichte des Alten Museums," in *Forschungen und Berichte* (Berlin-GDR: Akademie Verlag, 1980), pp. 9-26.

Fig. 36: Karl F. Schinkel, *Interior of the Museum Rotunda*, engraving, also from the *Sammlung Architektonischer Entwürfe von Schinkel*, as in fig. 34.

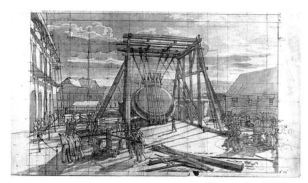

Fig. 37: Johann Erdmann Hummel, *Erection of the Granite Bowl behind the New Packhof*, 1830, drawing, Berlin-GDR, Märkisches Museum.

24. For the early history of museums, see *Glyptothek München, 1830-1980*, ed. by Klaus Vierneisel and Gottlieb Leinz (Munich: Glyptothek München, 1980).

25. Karl Friedrich Schinkel, *Sammlung Architektonischer Entwürfe, enthaltend teils Werke, welche ausgeführt sind, teils Gegenstände, deren Ausführung beabsichtigt wurde*, 28 fascs., 174 pls. (Berlin: L. W. Wittich, 1819-40, and several later editions). Plate numbers are in accordance with the recently published facsimile and study editions (Chicago: Exedra Books, 1981-82). That Schinkel thought very highly of his "perspective view from the staircase gallery in the museum" (pl. 43) is demonstrated by his decision to exhibit it at the *Akademieausstellung* of 1830 in Berlin.

26. See Alfred Hentzen, "Spiegelungen," in *Intuition und Kunstwissenschaft. Festschrift für Hanns Swarzenski zum 70. Geburtstag am 30. August 1973*, ed. by Peter Bloch et al. (Berlin: Gebr. Mann Verlag, 1973), pp. 541-58.

Museum (1823-1850) stands among the very earliest architectural formulations for this novel kind of institution; while there are a few earlier instances, none of them grapples with either the internal complexity or the larger ideological horizon of museums in the culture of the modern city.[24]

Schinkel engineered a solution that enables the Museum to hold a cardinal position among urban institutions, in fact, to enter into the very ambit of crown and church, and fulfill a dual purpose: inside, the display of the collections unfolds the course of civilization, while along its columnar porch and airy vestibule a cycle of continuous wall paintings illustrates the struggle with nature and among peoples; from its vestibule (fig. 35), the Museum also affords a unique view of the contemporary city whose productive life provides the foil for the consumption of ideas. In plan, the Museum encases a central, domed rotunda (fig. 36) within a square block, but in experience, this contrast creates moments of transition and arresting return. In elevation, the columnar porch suggests a generous and effective backdrop for the huge square in front of the royal *Schloss*, but it also reveals upon approach the deep recess of its vestibule and the ceremonial ascent of its double stairs toward a uniquely privileged platform. From this viewing place, the course of civilization, the history of its artifacts, and the juncture between the past and the present achieve a poignancy perhaps found nowhere else in Schinkel's work. His pride in the famous view from the vestibule is altogether justified, for he managed to express in a single image his vision of the city in its physical reality as well as in its cultural life.[25]

Just how calculated Schinkel's pictorial record is becomes apparent when one notices that he revealed a segment of the huge granite basin (fig. 37) in front of the Museum, barely visible beyond the column farthest to the left of the portico. Carved from a giant boulder of Norwegian granite, the basin was slowly ground into shape, and, after Schinkel rejected his original idea of placing it in the rotunda of the Museum, he erected it in the square, where it serves as a kind of urban centerpiece. Passersby and the surroundings are reflected in the flawless polish of the curving surface in a kind of distortion mirror, as recorded by Johann Erdmann Hummel in his painting *The Granite Basin in the Berlin Lustgarten* of 1831[26] (fig. 38). The granite basin serves as a symbolic lens, which gathers the infinite rays of the city, but it also represents the technical process and prowess necessary to transform the recalcitrant block of raw stone, deposited by the glaciers of the ice age, into an object of pristine geometry and luster. The Museum and its surroundings, including the massive customs and warehouse facilities behind it, gave to Berlin a focus through which that "fusion" of the arts, "according to the requirements of moral and reasoning life" assumed reality.

If Schinkel's vision ultimately transcends the physical realm of architecture

Fig. 38: Johann Erdmann Hummel, *The Granite Basin in the Berlin Lustgarten*, 1831, oil on canvas, Berlin-West, Staatliche Museen Preussischer Kulturbesitz, Nationalgalerie.

Fig. 39: Eduard Gaertner, *Unter den Linden*, 1853, oil on canvas, Berlin-West, Staatliche Museen Preussischer Kulturbesitz, National-galerie.

and sculpture and takes form in a union created "in pictorial terms"—as he put it to Gropius in the description of the panorama—then an element of the illusory is part of the vision from its inception, a price Schinkel was willing to pay in order to catch a glimpse of the idea. Thus, the fullest impression of this larger reality can only be created by a calculated exclusion of some of its own characteristics, or, as Alexander von Humboldt put it when he recommended the use of panoramas for the representation of unknown and exotic regions, "the spectator, inclosed, as it were, within a magical circle, and wholly removed from all the disturbing influences of reality, may the more easily fancy that he is actually surrounded by a foreign scene."[27]

Schinkel's Museum amounts to a *summa* of his thinking precisely because it fulfills itself in its ideological and even "pictorial" purposes, while Rauch's contemporaneous efforts for the *Monument to Frederick the Great* bring the questions of public imagery and national identity sharply into view. When the cornerstone of the Museum was laid in 1840, the centenary of Frederick's coronation, the liberal bourgeoisie had come to claim the king for themselves, seeing in him an enlightened monarch intent upon reform and progress. By the time the monument was erected on Unter den Linden in 1851 (fig. 39), the aborted revolution of 1848 compelled King Frederick William IV to take quite a different view: now, he wanted to see the monument as a manifestation of the monarchy's renewed authority and strength, and Frederick the Great as the founder and model of Prussia's political destiny. This amounted to yet another revision in the perception of Frederick's political role. The earlier revision along radical-liberal lines had taken its most radical form in Carl Friedrich Köppen's book celebrating the king as the "advocate of the sovereignty of the people." The book was dedicated to Karl Marx. The opposite extreme in the continuing revision of nationalist myth was reached in April 1945, during Hitler's last days in the bunker, when the Führer sought solace in listening to a reading from Thomas Carlyle's heroicizing *History of Frederick the Great.*[28]

Adolph Menzel, who also served as one of the artistic consultants for the design of Rauch's monument, popularized the new image of Frederick the Great as a "father to his people" in his illustration of Franz Kugler's *Geschichte Friedrichs des Grossen*, one of numerous publications celebrating the king's centenary in 1840.[29] Firmly rooted in the tradition of "prosaic" art, Menzel believed that "art will always respond to the demands of the spirit of the time,"[30] and the present demanded images fashioned with "the greatest possible authenticity."[31] This devotion to the long-established Berlin tradition of the "portrait" and the "patriotic" gained him, at the age of twenty-three, the commission to illustrate Kugler's biography of the king. Menzel laid the foundation for his

27. Quoted after the first American edition of Alexander von Humboldt, *Cosmos* (New York: Harper and Bros., 1845), 2:98. We owe this reference to Professor Angela Miller, who is preparing a book on "*The Imperial Republic*": *Narratives of National Expansion in American Art, 1820-1860.*

28. H. R. Trevor-Roper, *The Last Days of Hitler* (New York: MacMillan Company, 1947), pp. 97-98. It was Goebbels who read aloud from Carlyle.

29. *Geschichte Friedrichs des Grossen, Geschrieben von Franz Kugler, Gezeichnet von Adolph Menzel* (Leipzig: Weber'sche Buchhandlung, 1840). For a detailed discussion of the genesis of the book and its ideological context, see F. Forster-Hahn, "Menzel's Daguerreotypical Image" (see note 7). For a discussion of cultural politics, see Peter Paret, *Art as History* (Princeton: Princeton U. Press, 1988). The literature on Menzel is vast. No catalogue raisonné of his oeuvre exists. The most comprehensive list of the paintings is H. von Tschudi, *Adolph von Menzel, Abbildungen seiner Gemälde und Studien auf Grund der von der Nationalgalerie 1905 veranstalteten Ausstellung* (Munich: F. Bruckmann, 1905); also, Max Jordan and R. Dohme, *Das Werk Adolph Menzels*, 3 vols. (Munich: F. Bruckmann, 1890) and 2 vols. (Munich: F. Bruckmann, 1905). For Menzel's graphic oeuvre, see Elfried Bock, *Adolph Menzel, Verzeichnis seines graphischen Werkes* (Berlin: Amsler & Ruthardt, 1923). Two recent exhibition catalogues reflect modern scholarship and give a good overview of Menzel's life and the general literature: *Adolph Menzel*, ed. by Vera-Maria Ruthenberg (Berlin-GDR: Staatliche Museen, Nationalgalerie, 1980); and *Menzel–der Beobachter*, ed. by Werner Hofmann (Munich: Prestel Verlag, 1982).

30. H. Wolff, *Adolph von Menzel, Briefe*, intro. by Oskar Bie (Berlin: Bard Verlag, 1914), p. 13.

31. Ibid., p. 27.

Fig. 41: Adolph Menzel, *The Round-table of Frederick the Great*, 1850, oil on canvas, destroyed, Berlin-GDR, Staatliche Museen, National-galerie.

artistic reputation with this inventive suite of illustrations, executed in virtuoso wood engravings (fig. 40) and anticipating in miniature format his highly original history paintings of the 1850s. The scenes from the king's life captivate at once by an incisive psychological observation which Kugler defined as the means for the "daguerreotypical reality" of Menzel's images.[32] Like all liberal authors of the 1840s, Menzel saw the king as philosopher on the throne and instigator of liberal reforms, but, like no other painter, he captured the spirit of events in suggestive moments and unconventionally framed scenes. In *The Roundtable of Frederick the Great*, of 1850 (fig. 41), Menzel renders such a telling scene from Frederick's life, an aspect most overtly detested by reactionary critics: the king's friendship with Voltaire and his other associations with freethinkers. The progressive subject of Menzel's images was matched by the "pungency of historical characterization."[33] In the best tradition of Schadow, he rejected the idealized icon of the heroic in favor of the particular, the "portrait," the individual caught *au vif*.

Menzel fashioned a new realist history painting at the very time King William IV, the "romantic" on the Prussian throne, was giving the most important public commissions to Peter Cornelius and Wilhelm von Kaulbach. Cornelius arrived in Berlin only in 1841, where he was to decorate the Campo Santo, the projected burial chapel for the royal family. The ambition of the project may have doomed it from the start, and it was, in fact, never completed. Cornelius executed immense cartoons in preparation for the fresco cycle, whose central theme cast the fate of mankind in the generalized terms of Christian religion, but these grandiloquent compositions and their contrived symbolism never won popular acclaim in Berlin. The revolution of 1848 put an abrupt end to the project, although Cornelius labored on with his designs. Kaulbach was charged with decorating the New Museum, where his version of highlights from human civilization replaced Schinkel's ideas with an eclectic but highly theatrical depiction that kept the painter busy from 1847 to 1863. It was against this background of monumental projects with their highly idealized imagery and hierarchical order that Menzel conceived his progressive moments from Prussian history. Unhampered by the constraints of public commissions, he followed his own liberal inclinations and artistic preferences, guided by his conviction that modern history painting demanded "authenticity" most of all.

Fig. 40: Adolph Menzel, *The Roundtable of Frederick the Great*, 1840, wood engraving for Franz Kugler's *History of Frederick the Great*.

32. Franz Kugler in his review of Menzel's work, *Kunstblatt* 45 (1848): 177. Reprinted in *Kleine Schriften zur Kunstgeschichte* (Stuttgart: Ebner & Seubert, 1854), 3:664.
33. Kugler, *Kleine Schriften* 3:572.

Fig. 42: Adolph Menzel, *The Lying-in-State of the Fallen of the March Revolution*, 1848, oil on canvas, Hamburg, Kunsthalle.

Menzel interrupted his work on the pictures of the history of Frederick the Great only to paint his first canvas of a contemporary political event, *The Lying-in-State of the Fallen of the March Revolution*[34] (fig. 42). He started this small painting under the immediate impact of revolutionary events in the streets of Berlin, as both artistic experiment and political reflection, and, although it is unfinished, Menzel's canvas remains the only truly significant painting of the fateful conclusion of the *Vormärz*. Once the hopes of 1848 were shattered, Menzel found it impossible to finish his painting. Like other Berlin artists, Menzel was deeply affected by the revolutionary events, especially by the funeral the city of Berlin staged for the fallen. He chose not to paint the events leading up to the clashes or the day-long procession of the funerary cortege through the city to the cemetery, which he had witnessed (fig. 43), but instead concentrated on the tense hours of preparation, when the coffins were exhibited during the morning hours on the stairs of the New Church in the Gendarmenmarkt. The bustling crowd in the foreground is separated by the empty space of the square from the monumental pyramid of dark coffins. Members of all classes move about in no apparent order and draw the spectator into the sphere of this historical event. The pictorial order of the image conveys at once the full force of this moment in Berlin history and yet suspends it strangely in time.

During the months following the March revolution, Menzel enthusiastically joined the new organization of artists, the *Vereinigung bildender Künstler in Berlin*, and he participated in the elections. But when class tensions and violence threatened to radicalize the revolution, he distanced himself like so many other bourgeois liberals. His feelings of affinity and support for the revolution gave way to a sense of detachment, resignation, and withdrawal. This fateful shift was paradigmatic of German liberalism and its antagonistic attitude toward the masses. As the historic moment ended in defeat, so Menzel's painting—authentic even in the breach—marks an "artistic defeat" as well and remains, in its unfinished state, a metaphor of the aborted revolution and its impasse.

The appearance of new institutional buildings in Berlin after 1815 and the growing identification they made possible between cultural order and urban reality also gave rise to a remarkable tradition of city views. Franz Krüger

Fig. 43: Adolph Menzel, *Letter to his Friend Arnold in Kassel about the Funeral of the Fallen March Revolutionaries*, dated 23 March 1848, Berlin-GDR, Staatliche Museen, Nationalgalerie, Archives.

34. For a reading of this painting, cf. F. Forster-Hahn, "'Die Aufbahrung der Märzgefallenen': Menzel's Unfinished Painting as a Parable of the Aborted Revolution of 1848," in *Kunst um 1800 und die Folgen, Werner Hofmann zu Ehren*, ed. by C. Beutler, P.-K. Schuster, and M. Warnke (Munich: Prestel Verlag, 1987), pp. 188, 221-32.

Fig. 44: Franz Krüger, *Parade in the Opera Square of Berlin in 1822*, detail of fig. 31: Portraits of Schadow, Schinkel, Rauch, and other prominent Berliners.

transformed the official representation of royal parades into scenes of bourgeois participation (fig. 44, cat. no. 6); Gaertner and Hummel extended descriptive veracity to the portrayal of the cityscape and populated it with diminutive portraits of well-known Berliners.[35] But such "prosaic" chronicles of the workaday appearance of city life did not lack subtle symbolism: Gaertner, to cite just one example, so calculated his *Unter den Linden* (see fig. 39) that the head of the recently completed *Monument to Frederick the Great* just happens to obscure the sun itself, creating an autumnal halo round the king's head and casting a mild glow over the entire cityscape. Menzel's painting of 1848, while respecting the tradition of topographical accuracy, promoted the anonymous crowd to thematic dominance. The city ceases to stand alone as an infinitely detailed stage of infinitely particularized existence—recognizable by the cameo appearances of familiar individuals in public places—and assumes instead the collective character of metropolitan life.

Berlin artists were preoccupied with the representation of the cityscape, where social and economic forces wrought the most tangible changes, but they also fashioned new images in the familiar genre of landscape painting. When Karl Blechen died in 1840, he was praised as the "ingenious inventor of a novel category of 'character studies' in landscape painting."[36] On the recommendation of Schinkel, the painter worked from 1824 to 1827 as a stage designer, and in 1831 became professor of landscape painting at the Academy. Both Blechen and Menzel depicted the powerful intrusion of technology into nature and the transformation of the countryside by industry. In his *Iron Rolling Mill at Neustadt-Eberswalde* (fig. 45) Blechen depicted one of the first centers of metallurgic industry in the Mark Brandenburg. The artist's preparatory drawings vacillated between an unvarnished representation of the industrial site—with cannon balls and cast barrels piled high in the foreground—and the more pastoral version of the executed painting, for which he also changed his viewpoint so as to distance the factory and replace its products with the idyllic scenery of the Finow canal with boats. In 1847, nine years after the first railroad in Prussia started operations between the capital and the royal residence in

Fig. 45: Karl Blechen, *Iron Rolling Mill at Neustadt-Eberswalde*, ca. 1834, oil on canvas, Berlin-West, Staatliche Museen Preussischer Kulturbesitz, Nationalgalerie.

35. For a discussion of these paintings of the cityscape, see F. Forster-Hahn, "Aspects of Berlin Realism" (see note 3), pp. 131-41.
36. In an obituary notice by Ernst Heinrich Toelken. Here quoted from *Kunst in Berlin 1648-1987*, exhibition catalogue (Berlin-GDR: Staatliche Museen, Altes Museum, 1987), p. 222.

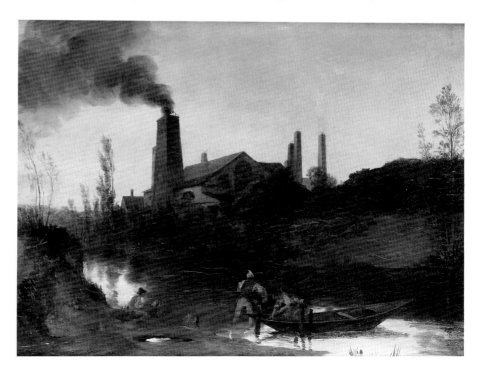

Potsdam, Menzel painted the *Berlin-Potsdam Railroad* (fig. 46). The railroad track cuts through the countryside in a sweeping curve, and its dividing line is counterbalanced only by the tonal continuity of the colors and of atmospheric light. The dynamic line of the tracks seems to propel the train with its steaming engine almost beyond the picture frame, while the skyline of the city dissolves in the haze. The young painter had certainly learned a lesson when he studied Constable's works in their first Berlin exhibition in 1839.

These new "character studies"—cityscapes and landscapes—found their counterpart in numerous "portraits" of domestic interiors. Many of the artists who painted the city, especially Gaertner, Hummel, and Paul Graeb (cat. nos. 10, 105) were also *Zimmermaler* (painters of interiors)[37] recording the intimate environments that reflected every aspect of a neatly chambered life: bedrooms, nurseries, sitting and drawing rooms, libraries and studies. The *Zimmermaler* followed in the footsteps of the aristocratic tradition of recording royal palaces and summer residences, but the visual documentation now came to include the private sphere of modest bourgeois living quarters. Not only Hummel's (cat. no. 87) but also Moritz Hoffmann's interiors reveal the private character of domestic interiors in all their minutiae (cat. nos. 102, 103).

It is striking, however, that the typology of rooms—from corner stoves to curtains—and the token reminders of cultural attachments in the form of copies and plaster casts remain virtually the same in bourgeois apartments and royal residences. A clear preference for intimate proportions and the comforts of bourgeois apartments makes the renovated or newly built quarters of Prussian princes appear surprisingly *bürgerlich*. If the Grimm brothers covered the walls of their studies with closely ranged pictures and an occasional plaster, they did not differ from the king: his study in the *Kronprinzenpalais* included a large oil copy of the *Sistine Madonna*, while Wilhelm Grimm had to make do with just a print of the famed Dresden treasure. As the site of monumental intellectual labor—encyclopedic in scope and speculative in method—the private studies of the Grimms virtually immure the absent scholars in the instruments of their research, like organists who find all the keys, pedals, and stops within arm's length. This moment in the history of intellectual work placed individualized learning on a cusp, and it put a lid on an era when it still seemed possible for a single scholar to encompass the totality of knowledge in his field, or for the king to rule Prussia from his living room.

As "portraits," these interiors are usually untenanted and yet manage to characterize their occupants by the myriad objects they hold. In their pristine and permanent order these rooms arrest the flow of time behind tightly shut windows. But in Adolph Menzel's images it is precisely this earlier sense of identity and permanence that shows signs of insidious disturbance: his *Balcony Room* of 1845 (fig. 47) anticipates impressionism in its uncanny prehension of all that is fleeting. While Menzel gave shape to his progressive interpretation of Prussian history, he also explored contemporary surroundings in novel oil sketches that capture the present with equal freshness. In stark contrast to earlier interiors, Menzel rendered the living room of his modest Berlin apartment not as the highly ordered, permanent space of a well-organized life but as a place where randomness and emptiness prevail. A few pieces of furniture seem haphazardly pushed aside; the sofa is cut off by the frame on the left but reflected in a mirror on the right, which extends the virtual space of the room beyond the edge of the canvas. Sunshine, streaming through the large French windows and filtered by white lace curtains billowing in a gentle breeze, invades the room and opens the interior onto the invisible, yet palpable, outside world. The oblique view of the room accentuates its emptiness, and the fact that the

Fig. 46: Adolph Menzel, *The Berlin Potsdam Railroad*, 1847, oil on canvas, Berlin-West, Staatliche Museen Preussischer Kulturbesitz, Nationalgalerie.

Fig. 47: Adolph Menzel, *The Balcony Room*, 1845, oil on canvas, Berlin-West, Staatliche Museen Preussischer Kulturbesitz, Nationalgalerie.

37. Irmgard Wirth, *Berliner Innenräume der Vergangenheit*, exhibition catalogue, (Berlin: Berlin Museum, 1970); and, for the aristocratic tradition in Berlin, see Helmut Börsch-Supan, *Marmorsaal und Blaues Zimmer, So Wohnten Fürsten* (Berlin: Gebr. Mann, 1976).

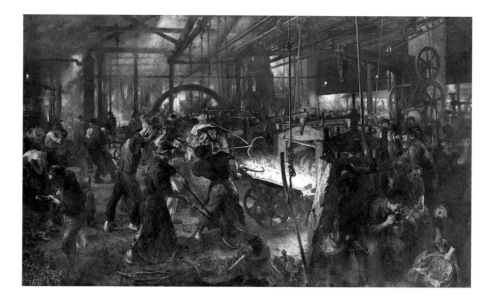

Fig. 48: Adolph Menzel, *The Iron Rolling Mill*, 1872-75, oil on canvas, Berlin-GDR, Staatliche Museen, Nationalgalerie.

painter and the outside are equally excluded from it while they nonetheless condition our view of the interior by means of light and brushwork makes the existence of the invisible tenant fleeting and uncertain.

Throughout the nineteenth century artists from other parts of Germany also contributed to the cultural life of Berlin. During the 1830s and 1840s the Düsseldorf School had a strong presence; in 1853 the young Hans von Marées came to Berlin to study with Steffeck. Beginning in 1860, Arnold Böcklin exhibited in the Academy, and in 1862 Anselm Feuerbach showed his *Iphigenia*. Ludwig Knaus, whose anecdotal genre paintings and portraits had made his international reputation, moved to Berlin in 1874 to teach at the Academy. Throughout the 1870s critics and the public alike regarded Anton von Werner's theatrical staging of German history and Knaus's pleasing genre paintings (cat. no. 106) as the most fitting representation of the young Empire. The subversive qualities of Menzel's paintings set him apart, and despite official recognition, he worked and lived in strange isolation, far removed from the cultural arena in which Knaus and von Werner operated.

In 1875, when Menzel completed his canvas *The Iron Rolling Mill* (fig. 48), Berlin's population reached the one-million mark. The financial crash of 1873 had dealt a serious blow to the boom years of the young Empire. Also in 1875, Anton von Werner assumed the directorship of the Royal Institute for the Fine Arts (Königliche Akademische Hochschule für die Bildenden Künste), a position he would exploit in subsequent years to conduct his aggressive campaigns against modern art. As an influential adviser to William II in artistic matters and as an effective administrator, he came to play a powerful role in cultural politics; as a painter he rose to prominence as the court's favorite chronicler of the Empire.[38] His slick and often anecdotal images, like *Temporary Quarters near Paris* (cat. no. 109), and his grand *Proclamation of the German Empire at Versailles* (destroyed) added theatrical luster to the events of the Franco-Prussian War and the foundation of the Reich.

By contrast, Menzel's reading of the times exposed conflicting tendencies; discordant rather than overtly harmonious relationships prevail in his best paintings of the period. Commissioned by the collector Magnus Herrmann,

38. For the most recent discussion of Anton von Werner, cf. Dominik Bartmann, *Anton von Werner, Zur Kunst und Kunstpolitik im Deutschen Kaiserreich* (Berlin: Deutscher Verlag für Kunstwissenschaft, 1985). For a discussion of the 1870s and 1880s, see Nicolaas Teeuwisse, *Vom Salon zur Secession, Berliner Kunstleben zwischen Tradition und Aufbruch zur Moderne. 1871-1900* (Berlin: Deutscher Verlag für Kunstwissenschaft, 1986).

Fig. 49: Adolph Menzel, *Departure of King William IV to his Army on 31 July 1870*, 1871, oil on canvas, Berlin-West, Staatliche Museen Preussischer Kulturbesitz, Nationalgalerie.

Menzel painted *King William's Departure to the Army on 31 July 1870* (fig. 49) less in terms of the moment it represented in German history than as a scene of the people's reaction to it. An agitated crowd fills the avenue, almost obscuring the tiny figures of the royal couple, who are riding in an open carriage along Unter den Linden toward the Brandenburg Gate. The royal carriage is placed off-center, and while most people are looking or waving toward the monarch, others turn away and disrupt the movement and focus of the crowd. As in his scene of the funeral of the fallen revolutionaries, history manifests itself through the collective experience of the crowd.

In the past, Berlin artists like Blechen and Biermann had painted factories from the outside (fig. 45, cat. no. 7); now Menzel turned his attention to the inside, depicting shift work in heavy industry. He painted his *Iron Rolling Mill* for the banker Liebermann, the uncle of the painter Max Liebermann, and most probably chose the subject himself.[39] The painting shows the manufacture of railroad tracks in the most modern iron rolling mill on the continent, the industrial plant at Königshütte in Upper Silesia (now Poland). The artist was explicit about the precise moment he chose to depict, a short time before the shift change, when some workers wash up in the left middleground, others eat their lunch in the right foreground, and both groups frame the workers in the center who are struggling to push the bloom under the rollers. Menzel's *Iron Rolling Mill* was immediately recognized as a key work of its time and was acquired for the National Gallery within a year of its completion. From its first showing in the artist's studio, the painting drew controversial reactions: did Menzel intend to glorify industrial progress, or did his unvarnished rendering of shift work and labor conditions comment critically on the "social question"?

Menzel was hardly unaware of social conflict at the time, or naive in his observation of the work force. The painting was completed in the same year as the founding of the Socialist Workers Party, and only three years before the advent of Bismarck's anti-socialist laws of 1878. Menzel made hundreds of preparatory studies (cat. no. 99), many of them on the site in Königshütte, where

39. F. Forster-Hahn, "Adolph Menzel's 'Eisenwalzwerk': Kunst im Konflikt zwischen Tradition und sozialer Wirklichkeit," in *Die nützlichen Künste*, ed. by T. Buddensieg and H. Rogge (Berlin: Quadriga, 1981), pp. 122-29.

Fig. 50: Adolph Menzel, *Supper at the Ball*, 1878, oil on canvas, Berlin-West, Staatliche Museen Preussischer Kulturbesitz, National-galerie.

he spent several weeks in 1872, at a moment of severe economic crisis. While Menzel represented workers whose task is dictated by the pace of the machine and the repetitive rhythm of the shift, his friend Paul Meyerheim painted a saga of industrial production in six wall paintings that tell *The History of the Locomotive* for the villa of Albert Borsig, one of Berlin's pioneer industrialists.[40] From the descent into the mine to the finished railroad engine's being shipped overseas, Meyerheim's pictures of heavy industry spoiled no viewer's visit to the Borsig villa, but Menzel's "sooty workers," trapped in exhausting and dangerous work, overcame the public's unease only after the evasive retitling of the painting as *Modern Cyclops*. Only the invocation of ancient mythology could reconcile the audience with the powerful realism of Menzel's view of contemporary industry.

By the late 1870s, Menzel had become the "patriotic" painter of the Empire, and his paintings of royal balls were praised as "ingenious mirror images of Berlin court society."[41] The new Empire was eager to represent itself not only in an increasingly historicist architecture throughout the city, but also in frequent festive spectacles ranging from victory parades to elegant ball suppers. Menzel's *Supper at the Ball* (fig. 50) of 1878 exposes the famed court festivity as a masquerade, fragmented into myriad details and composed of figures who caricature high society's elegant celebrants as they contort themselves, uncomfortably balancing plates and glasses. Menzel's montage of individually studied details produces the illusion of a photographic kaleidoscope in which neither the architecture nor the people assume an authentic presence. If one shares today the Wilhelminean admiration for the *Supper at the Ball*, it is less for its vaunted "realism" than for its more elusive capacity to project an "ingenious mirror image" of the Empire's emerging society. The fact that this society seemed unable to instill in its rapidly diverging classes a common purpose finds its pictorial equivalent in Menzel's montage of fragmentary observations, at once composite and lacking in pictorial coherence.

One of the few perceptive admirers of Menzel was the young Max Liebermann.

40. Most of these monumental paintings, oil on copper, are today in the Märkisches Museum, Berlin-GDR.
41. Max Jordan, "Adolf Menzel," *Die Kunst für Alle* 20 (March 1905): 269; also, F. Forster-Hahn, "Authenticity into Ambivalence: The Evolution of Menzel's Drawings," *Master Drawings* 16, no. 3 (1978): 268-70.

His dark scenes of working life—*Women Plucking Geese* (1872) and *Women Cleaning Vegetables* (1874)—had earned him such sobriquets as "painter of dirt" and "apostle of ugliness."[42] He returned to his native city of Berlin only in 1884, after years of working in Paris, Holland, and Munich. When the French government decided to make the Universal Exhibition of 1889 a centenary celebration of the French revolution, Europe's monarchies decided to boycott the event. But Max Liebermann, who had close ties with Paris, was approached by the French and invited to organize a German art exhibition, an idea that was certainly inspired by the German art section Anton von Werner had mounted at the World's Fair of 1878.[43] At that Exposition, too, the German Reich had officially declined participation but agreed to an art presentation at the last minute, when it seemed opportune for Bismarck to make a gesture of political détente. In 1889, however, the tension between France and the Empire was such that Bismarck regarded any participation whatever as unpatriotic. It was in opposition to Bismarck's explicit policy that Max Liebermann agreed to organize an exhibition of German art. He selected mainly works by younger artists and by those representing the new *plein-air* movement. His choices included works by Leibl, Uhde, Trübner, Kühl, and Ury, as well as Menzel and others. Leibl's and Liebermann's own scenes of peasant life were centerpieces in the show, with Liebermann's Dutch scenes, particularly *The Amsterdam Orphanage* of 1881-1882 (fig. 51), receiving special attention.

The art assembled for the World's Fair represented what was modern in German painting, and the participation of the artists amounted to an act of independence, if not defiance. The official reaction in Berlin was unforgiving, and Liebermann experienced personal vilification and violent defamation. In the end, the Prussian government forbade him to accept the order of the Legion of Honor that was offered to him by the French in recognition of his art and his efforts as the organizer of the show.

While the atmosphere of strident nationalism in an increasingly militaristic Empire politicized any public discussion of modern, and especially French, art, younger artists created their own independent arenas: in 1889 the private gallery of Fritz Gurlitt mounted the first exhibition of Lesser Ury (cat. nos. 12, 108); Otto Brahm and Maximilian Harden,[44] among others, founded the *Freie Bühne*, a stage dedicated to the new realist concept of the theater. Significantly, Ibsen's *Ghosts* was chosen for its inauguration, soon to be followed by the first production of Gerhart Hauptmann's *Before Dawn*. The aged novelist and critic Theodor Fontane, alone among Berlin reviewers, immediately recognized Hauptmann's drama as the harbinger of a new era. Fontane's appreciation of Menzel was equally perceptive; he concluded an amusing poem in celebration of the painter's birthday with the lines:

> . . . the big and the small,
> whether they creep or crawl,
> he holds a mirror to them all.

Perhaps no other site in the city of Berlin illustrates more comprehensively an entire era of cultural development in Germany than the so-called Museum Island. For centuries, an uncomfortable jumble of buildings had occupied the island between the arms of the Spree river in the heart of the city, until Schinkel's plans for the Museum and new customs facilities introduced a modicum of clarity. In the 1820s, Prince Frederick, the future King William IV, nourished plans for a cultural forum and elaborated his ideas in a series of architectural drawings of his own (fig. 52). These designs for a utopian center

Fig. 51: Max Liebermann, *Amsterdam Orphanage*, 1881-82, oil on canvas, Frankfurt am Main, Städelsches Kunstinstitut.

42. For a comprehensive discussion of Liebermann, see *Max Liebermann in seiner Zeit*, exhibition catalogue (Berlin-West: Staatliche Museen Preussischer Kulturbesitz, Nationalgalerie, 1979).

43. For the history of the German art exhibitions at the Paris World's Fairs of 1878 and 1889 and Liebermann's role in the organization of the latter, see F. Forster-Hahn, "'La Confraternité de l'art': Deutsch-französische Ausstellungspolitik von 1871-1914," *Zeitschrift für Kunstgeschichte* 48, no. 1 (1985): 506-37.

44. See *Köpfe* (Berlin: Erich Reiss Verlag, 1910), especially 339ff., where Fontane's poem—cited below—is also reproduced. It opens with the words:
> Ja, wer ist Menzel? Menzel ist
> sehr Vieles,
> Um nicht zu sagen: Alles. . . .

Fig. 52: Frederick William IV, *Sketch for a Center for Science and Art*, 1820s, pencil drawing, Berlin-GDR, Staatliche Museen, Sammlung der Handzeichnungen.

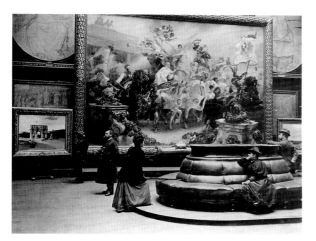

Fig. 53: Photograph of Cornelius Room in the National Gallery in 1897 with Ferdinand Keller's painting, *Emperor William the Victorious*.

45. See Paul Ortwin Rave, *Die Geschichte der Nationalgalerie Berlin* (Berlin: Staatliche Museen Preussischer Kulturbesitz, Nationalgalerie, 1968); also, F. Forster-Hahn, "The Inaugural Installation of the Nationalgalerie in Berlin: National Shrine or International Showcase?" in *Abstracts*, 74th Annual Meeting, College Art Association of America, New York, 1986.
46. Elisabeth Rohde, *Pergamon, Burgberg und Altar* (Munich: C. H. Beck, 1982), especially pp. 89-93, with further bibliography. See also the exhibition catalogue *Die Museumsinsel zu Berlin*, ed. by Günter Schade et al. (Berlin: Henschelverlag Kunst und Gesellschaft, 1987).

exerted an intriguing influence far beyond the prince's youthful fantasies. To the northwest of Schinkel's Museum, in the immediate vicinity of the royal palace and cathedral, the king envisaged a group of classical buildings rising in symmetrical arrangement to form a grandiose scene front opposite the royal *Schloss*. Nothing came of these fantastic plans at the time, but the urban future of the island owes its origin to the prince's vision.

Friedrich August Stüler, a follower of Schinkel's, built the New Museum that opened in 1850, and he also designed the National Gallery in 1862-65. When the National Gallery was inaugurated on the emperor's birthday, on 21 March 1876, more than forty years had passed since the idea of a museum for contemporary art was first put forward in 1835.[45] Originally, the main proponents of the plan were artists animated by democratic ideals and the vision of German unification, but, like the slow evolution of the *Monument to Frederick the Great* during the first half of the century, the halting history of the National Gallery, too, was fraught with ideological vicissitudes. Critics immediately recognized the discrepancy between its architecture, based as it was on an ideal Corinthian temple, and its modern function as a museum gallery. The monumental stairs are dominated by the equestrian statue of Frederick William IV on the square outside, which directs the visitor's eyes to the dedicatory inscription "To German Art 1871" (*Der deutschen Kunst 1871*), and to the pediment sculptures entitled *Germania Protects the Arts*. Elevated on a massive base and girded by a colonnade, the National Gallery towers over the entire island in a dramatic affirmation of a nationalist ideology which had long superseded the cosmopolitan and urbane ideals of Schinkel's "Old" Museum (so renamed after the construction of the "New"). This ideological change was made brutally clear on the inside, where Ferdinand Keller's bombastic canvas *Emperor William the Victorious* was installed right over the cartoons by Cornelius that had formed the original exhibition in the National Gallery's main hall (fig. 53). No museum display could make a more telling case for Berlin's transformation from frugal capital of the Prussian monarchy to ostentatious metropolis of the German Empire.

But the changes on the Spree Island were far from complete. The Kaiser Friedrich Museum (today called Bode Museum) was added to round out the tip of the island to the north with a neo-baroque rotunda (1897-1904), and a special archaeological museum linked up with the New Museum along the waterfront to the west (fig. 54). Eventually known as the Pergamon Museum, it was designed in a deliberately Schinkelesque manner, only to be replaced in the space of a few years by the single most massive structure of the entire museum cluster. It took the archaeologist Theodor Wiegand twenty-one years to see Alfred Messel's plans of 1909 through to completion.

The Pergamon Museum owed its creation to the state-sponsored excavations in Asia Minor which yielded during the late 1870s the spectacular sculptures of an enormous altar on the acropolis of Pergamon.[46] Like Hermann Schliemann before him, the discoverer of Pergamon, the engineer Carl Humann, was an amateur archaeologist whose drive and sense of enterprise were typical of *Gründerjahre* exploits. While Schliemann shifted his activities from Troy to Mycenae, Humann removed one of the largest Hellenistic monuments from Turkey to Berlin, where the new Pergamon Museum had to be built on a scale capable of accommodating three fully reconstructed monuments of the grandest kind: in addition to the Pergamon altar, the imposing *Gates from Miletus* and *Babylon* gave Berliners a taste of bygone empires. If the Elgin marbles—in their shallow relief and linear refinement—seemed the perfect ancient monument for Georgian England, then the dramatically writhing bodies from the *gigantomachia* of Pergamon strike a common chord with the neo-baroque ambitions of

the Wilhelmine Reich.

By 1900, the Spree Island seemed more and more an exclusive enclave of cultural institutions. There was only one rude reminder that even a whole cluster of museums could not entirely displace the present: the elevated tracks of the urban speedrail system cut right along the Pergamon Museum, where the visitor's awed contemplation of vanished grandeur was periodically distracted by trains thundering past the windows. The accumulation of imposing monuments from the far reaches and turbulent phases of ancient history brought a daunting scale and disquieting cast to the storehouses of artistic knowledge. Learning and entrepreneurship joined hands not only with educational institutions but also with national policy. In the meantime, the spirit of contemporary art struggled to escape from the ambit of power in which the museums flourished, headed for confrontation with officialdom long before the catastrophe of mechanized war brought the cultural authority of the Reich to its knees.

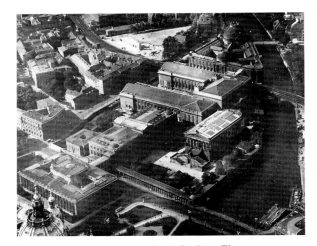

Fig. 54: Aerial photograph of Berlin, The Museum Island, 1920s.

Images of Berlin in the Art of the Secession and Expressionism

Charles W. Haxthausen

Parts of this essay are adapted from my article "'A New Beauty': Ernst Ludwig Kirchner's Images of Berlin," to appear in Charles W. Haxthausen, Heidrun Suhr, eds., *Berlin: Culture and Metropolis* (Minneapolis: University of Minnesota Press, 1990).

1. Georg Hermann, "Um Berlin," *Pan* 2 (22 August 1912): 1101.
2. On the impressionist treatment of Paris, see Theodore Reff, *Manet and Modern Paris* (Chicago: University of Chicago Press, 1982), and T. J. Clark, *The Painting of Modern Life: Paris in the Art of Manet and His Followers* (Princeton: Princeton University Press, 1984).
3. To be sure, this is not the only difference between these German "impressionists" and their French counterparts. As Gert Schiff has written: "It was . . . inevitable that certain critics would compare their respective styles to those of the French impressionists, with whom the German painters shared plein-air subjects, bright tonality, suppression of detail, quick brushwork, and eventually even colored shadows. However, those critics overlooked the fact that the Germans adopted none of the most radical French innovations: the division of color into its spectral constituents, the organization of space by means of color alone, and the dissolution of matter in light." Quoted from his essay "An Epoch of Longing: An Introduction to German Painting of the Nineteenth Century," *German Masters of the Nineteenth Century* (New York: Metropolitan Museum of Art, 1981), p. 34.
4. Liebermann was never interested in modern cityscapes as motifs, although he was drawn to urban recreational scenes of a kind associated with the French impressionists. See, for example, his two Amsterdam scenes *The Parrot Man* and *Parrot Walk*, both of 1902, and his *Summer Evening on the Alster*, painted in 1911, a motif from Hamburg. During the First World War he began painting recreational scenes near his villa in Wannsee, to the southwest of Berlin. For illustrations see the exhibition catalogue *Max Liebermann in seiner Zeit* (Berlin: Nationalgalerie Berlin, 1979), pp. 301, 303, 333, 345.
5. Charles Huard, *Berlin comme je l'ai vu* (Paris: Eugène Rey, 1907), pp. 11f. (my translation).

1. "The capital city of all modern ugliness"

"I don't know why it is," wrote the Berlin novelist Georg Hermann in 1912, "the Berliner is truly ashamed of his city, and the art is especially so."[1] Although Berlin, after the unification of Germany in 1871, had quickly emerged as the cultural and artistic capital of Germany and its only true metropolis, there was at first little reflection of this new urban reality in the art and literature produced there. The contrast with Paris during the same period is striking, for there the 1870s—the years immediately following the Prussian victory over the French—were marked by the ascendancy of impressionism, the first artistic movement of the nineteenth century to embrace contemporary urban reality as subject matter. The works of Manet, Degas, and Monet, to name only the most illustrious, present the recreational life of modern Paris; they offer an affirmative image of this modern urban spectacle, documenting the distinct pleasures offered by the city.[2]

Of Berlin during this same period we see little in the visual arts. To be sure, German impressionism emerged only in the 1890s, a good quarter-century after the beginnings of the French movement; but even then, its leading painters— Max Liebermann, Lovis Corinth, and Max Slevogt—almost totally ignored the city in which they lived and worked.[3] Although Liebermann's studio was housed in the family residence on Pariser Platz, where Unter den Linden, the city's most celebrated avenue, met the Brandenburg Gate, we see neither this Berlin landmark nor any other in his art. Yet Liebermann was not entirely hostile to urban motifs—only to those of Berlin. When he painted cities, he preferred pleasant scenes of Amsterdam or Hamburg.[4]

Why was this so? Why should Berlin, during this period of dynamic economic and political ascendancy, have been *imago non grata* in the visual arts? For one, although the German capital may have been the political counterpart of Paris, it was hardly its equal in other ways. Charles Huard, the French travel writer and illustrator, offered a Parisian perspective on this question in his book *Berlin comme je l'ai vu*, published in 1907. His first chapter, on the capital's most famous street, set the general tone for his sober view of the city:

> What sort of enthusiastic Berliner was it, who, on my departure from Paris, could sing to me the praises of the beauties of the Linden? . . . "You cannot imagine its charm," he said: "It is more discreet, more elegant, more aristocratic than your Parisian boulevards, than Piccadilly, the Corso, than every other vaunted street in the world." I anticipated an admirable avenue decorated with magnificent trees, bounded by the palace and frequented by princely carriages. To be sure, I found a large avenue, but it was planted with ordinary trees, unwelcome chestnuts and lime trees, topped and stunted; unsightly carriages drawn by emaciated, decrepit horses and driven by coarse coachmen rolled along the pavement. Dense, inelegant crowds halted at the intersections, and, docile and superbly trained, stomped along again at the order of the vigilant policemen. My disillusionment was complete.[5]

Such observations abound in Huard's book, and these impressions cannot be dismissed merely as manifestations of French chauvinism or of lingering resentments over the Franco-Prussian War—there were too many similarly negative characterizations of the city by thoughtful Berliners, many of whom considered

it second-rate as a European capital. Even as ardent a nationalist as Heinrich von Treitschke once remarked that the Germans alone among the peoples of the earth had attained the rank of great power without having a great city, although he meant this as a boast.[6]

Karl Scheffler, one of the most influential art critics of the period and author of a book-length historical critique, *Berlin: ein Stadtschicksal* (1910), claimed for the city the distinction of being not only the ugliest in Germany, but "the capital city of all modern ugliness."[7] Like Huard, he measured Berlin against Paris, with depressing conclusions. Architecturally, Scheffler found the city devoid of any properly urban physiognomy. In contrast to the French capital, with its grand design of boulevards, parks, and public monuments, its ordered but dramatic vistas, Berlin was shapeless, confused, and arbitrary. It had grown piece by piece, without any sense of the whole, without any larger urbane vision of what a city should be. Most of its radial arteries, according to Scheffler, tended to "disappear into a tangle of streets on the periphery of the old city, before they have reached its center." There was but one axis of orientation— Unter den Linden. It alone led to the core of the city, and yet it ended drearily in the New Market like a dead-end street.[8] And like Huard, Scheffler found Berlin's population graceless and uncultured: "Nine-tenths of the urban population makes an impression of hopeless inferiority," he lamented. "Not a trace of the born gentleman does one find in the modern Berliner. At times it seems as if the entire male population consisted of building contractors and their assistants."[9] This was a colonial population, "dull and dreary, which . . . had streamed into the city from the eastern plains, lured by the promise of Americanism."[10]

What made Berlin so ugly in the eyes of cultivated observers was above all its flagrant modernity. Even a contemporary Baedeker guide to the city commented that in its visual aspect Berlin suffered from this condition, since "three-quarters of its buildings are quite modern," resulting in "a certain lack of historical interest."[11] This condition was due to Berlin's extraordinary growth: it had burgeoned from a relatively sleepy town of 170,000 inhabitants in 1800 to a city of nearly two million only a century later.[12] In the views of most observers, according to Georg Hermann, Berlin was "in a state of becoming, in constant transformation, and for that reason has as yet no physiognomy."[13] Huard described it as "new, clean, and devoid of character, completely new, too new, newer than any American city, newer than Chicago, the only city in the world with which one can compare it in terms of the incredible rapidity of its growth."[14] Scheffler, too, found Berlin distressingly American in yet other ways: in its diverse migrant population, its robust materialism, its lack of culture, and, for better or worse, its pioneer spirit. It had, he declared, "literally become like a colonial city, like . . . the American and Australian cities that arose deep in the bush."[15] Completing this unappealing urban picture was Berlin's failure to accommodate its expanding population: the city's growth had brought with it scandalous housing conditions—the worst in Europe after Budapest—a situation which led the architectural critic Werner Hegemann to dub it the "largest tenement city in the world."[16]

Berlin's abrupt genesis into a modern metropolis is undoubtedly a central factor in the history of its representation—and, for long periods, its neglect—in the visual arts. The charm of the pre-industrial city had attracted architectural painters such as Eduard Gärtner (1801-77), best known for his gracious views of the official face of Berlin. But as Berlin's character changed, as it grew into a modern industrial city, it seemingly became, in the eyes of its major artists, a subject unworthy of representation. Adolph Menzel (1815-1905), the greatest

6. Werner Hegemann, *Das steinerne Berlin: Geschichte der grössten Mietkasernenstadt der Welt* (Berlin: Verlag Gustav Kiepenheuer, 1930), p. 13.

7. Karl Scheffler, *Berlin: Ein Stadtschicksal*, 2nd ed. (Berlin: Erich Reiss Verlag, 1910), p. 200. Hereafter cited as Scheffler 1910.

8. Ibid., pp. 50, 55ff.

9. Ibid., p. 163.

10. Ibid., p. 190.

11. Karl Baedeker, *Berlin and its Environs: Handbook for Travellers* (Leipzig: Karl Baedeker, 1903), p. 51.

12. In 1800 Berlin had a population of 172,122, including 25,221 military personnel. By 1849, fifteen years after the beginning of Berlin's industrialization, the population had reached 412,154. This figure had exactly doubled twenty-two years later when Berlin became the capital city of the new German Reich with 826,000 inhabitants. By 1895 there were nearly 1.7 million people living in Berlin; in 1905 the figure was 2,040,148. Population figures taken from Wolfgang Ribbe, ed., *Geschichte Berlins* (Munich: C. H. Beck Verlag, 1987), 1:413; 2:661, 697. Hereafter cited as Ribbe.

13. Georg Hermann (see note 1), p. 1101.

14. Huard, p. 33.

15. Scheffler 1910, p. 17.

16. In 1905, for example, over half of Berlin's two million inhabitants lived in dwellings averaging between three and thirteen occupants per heated room. (Forty-two percent of the population lived in one-room dwellings, seventy-five percent in dwellings with two rooms or less.) Berlin had the worst housing conditions of any city in Europe except for Budapest, but masked this condition with the ornate, eclectic facades of four- and five-story buildings. See the data reproduced in Hegemann (see note 6), plates 4, 5.

Berlin painter of the nineteenth century, produced several strikingly modern images of the city in the 1840s, but he rarely chose it as a motif thereafter, except in depicting events of an official nature.[17] I have already noted the neglect of Berlin by its leading impressionist painters. It was not until expressionism, in the years just prior to the outbreak of World War I, that Berlin was embraced as a major theme in the visual arts.

As Jost Hermand has recently observed, expressionism—in literature and in the visual arts—was "the first real urban art in Germany, and for that reason found its logical center in Berlin."[18] The two major painters of urban life identified with this movement—Ludwig Meidner and Ernst Ludwig Kirchner—spent their most productive years in Berlin. It was Kirchner, however, who was justly recognized very early on as *the* artist who best captured the exhilarating *Hektik* of the city during this period. "No other artist experienced the metropolis Berlin, as it was in the last years before the War, so intensely, with every fiber of his being, as did Kirchner," wrote Curt Glaser in the 1920s. "Beyond the ephemeral charm . . . of modish elegance he sensed plastic form in the life of the metropolitan street."[19] But Kirchner and Meidner were by no means the first to discover the city: Liebermann, Corinth, and Slevogt may have ignored the urban landscape of their city, but there were lesser painters, associated like these three with the Berlin Secession, who made it their subject as early as the 1880s.

2. Representations of the city by the artists of the Secession

Among Berlin painters of his generation, Hans Baluschek best captured that considerable segment of the city's life which most of his contemporaries preferred to ignore, an urban reality which they considered too ugly and too banal to paint. Baluschek's importance in this regard was grasped early on by the critic

17. The *Berlin-Potsdam Railway* (1847), which shows a distant panorama of the city with a steaming locomotive in the foreground is one example; the best known is Menzel's unfinished painting inspired by the 1848 Revolution, *The Lying-in-State of the Dead of March 1848* (fig. 42). Although it is in its subject a modern "history painting," its manner of composition and treatment of the subject anticipate French impressionism. For illustrations, see the exhibition catalogue *Menzel der Beobachter*, ed. by Werner Hofmann (Munich: Prestel Verlag, 1982), pp. 38, 83. Significantly, the Menzel paintings which best capture the texture of everyday urban life are scenes of Paris, a city in which modernity presented a more aesthetically pleasing aspect.
18. Jost Hermand, "Das Bild der 'grossen Stadt': im Expressionismus," in Klaus Scherpe, ed., *Die Unwirklichkeit der Städte: Grossstadtdarstellungen zwischen Moderne und Postmoderne* (Reinbek: Rowohlt, 1988), p. 65.
19. Curt Glaser, *Die Graphik der Neuzeit: Vom Anfang des XIX. Jahrhunderts bis zur Gegenwart* (Berlin: Bruno Cassirer, 1923), p. 540.

Fig. 55: Hans Baluschek, *Noon at Borsig*, ca. 1910/11, oil on canvas, Kunstamt Kreuzberg, Berlin.

Hans Mackowsky, who wrote in 1902: "What he is to us today, that he will remain for all times: the painter of that Berlin which became a metropolis overnight, but which, like a lucky speculator, lacks the breeding and culture to play the new role with decorum, without meanness."[20]

Like so many of those who swelled Berlin's population in the Wilhelmine era, Hans Baluschek came from the east, from Breslau (today Wroclaw, Poland). In the mid-1890s, after five years of training at the Berlin Academy, he quickly established himself as the painter of the quotidian life of the working class and petty bourgeoisie who lived and worked on the edge of the expanding city. *Noon at Borsig* (fig. 55), although dating from ca. 1910, could easily be from the 1890s, for his work changed little. As is common in Baluschek's subjects evoking the hardships of the working class, it is a bleak wintry scene. At three minutes before twelve, wives, mothers, and children, bearing baskets containing simple repasts, await the lunch pause of the workers in the courtyard of the Borsig engine works in Tegel, to the north of the city.[21] *Weissbier Idyll* (fig. 56), on the other hand, is a typical Baluschek image of the simple pleasures in Berlin's outer districts. Approaching caricature, yet without condescension, Baluschek portrayed a pair of *Kleinbürger*, dressed in their Sunday best, enjoying a distinctive Berlin specialty in a beer garden, as the woman plucks the petals of a forget-me-not.

Baluschek's figure compositions, which often suffer from an excess of well-meaning sentiment toward his subjects and frequently degenerate into the anecdotal, do not have the expressive power of the early Käthe Kollwitz (who was also inspired by the proletariat without, however, sharing Baluschek's interest in capturing the local color of the Berlin milieu). Nor did Baluschek have Kollwitz's technical gifts and formal strength. The young Max Beckmann, who admired certain aspects of Baluschek's work, regretted that he wasn't a better painter. Writing of a typical Baluschek scene of a dance hall on the edge of the city, he mused: "If only it had been painted with a little more temperament the whole thing would have been like an image from van Gogh's sphere of feeling. It's a shame that as a painter the fellow is such a Philistine."[22]

It was as a painter of industrial landscape, above all of railroads, that Baluschek revealed his greatest strength. The son of a locomotive engineer, he was again and again drawn to this industrial motif. *The Railroad Station* (fig. 57), unfortunately lost in World War II, is one of his most successful and remarkable images.[23] Eschewing the aestheticizing qualities of Monet's Gare St.-Lazare series of a quarter-century earlier, Baluschek rendered an extraordinary industrial landscape of locomotives and freight cars, factories and tenements—a vast panorama choked with steam and smoke, from which every trace of unspoilt nature has been purged. As an image of industry, one observer rightly placed it in the lineage of Menzel's famous *Iron Rolling Mill* of 1875.

The Homeless (cat. no. 115), a work of 1919 documenting the desperate conditions in postwar Berlin, reveals how Baluschek remained true to the spirit of his early work throughout the ascendancy of expressionism. It was a spirit which would at that time, with the rise of the New Objectivity, become a dominant tendency in the art of the Weimar Republic.

Baluschek's proletarian subject matter and his social engagement made him an atypical member of the Berlin Secession, although he was one of its founding members and was elected to its governing body in 1908. As previously noted, the major painters of the Secession—Liebermann, Corinth, and Slevogt—ignored the urban landscape of the city in which they worked. Walter Leistikow, another leading member and one of the strongest painters in the organization, did draw his motifs from Greater Berlin, but preferred to paint suburban lakes such as

Fig. 56: Hans Baluschek, *Weissbier Idyll*, ca. 1902, pastel, Berlinische Galerie, Berlin.

20. Hans Mackowsky, "Hans Baluschek," *Kunst und Künstler* 1 (1902/03): 338.

21. August Borsig built the first factory in Berlin in the 1830s, and in 1839 produced the first locomotive built in Germany. By the end of the nineteenth century, the concern was producing a variety of machines. In 1898 the Borsig Works moved from Moabit to the outlying village of Tegel (today one of the districts of West Berlin). Cf. Annemarie Lange, *Das Wilhelminische Berlin: Zwischen Jahrhundertwende und Novemberrevolution* (Berlin: Dietz Verlag, 1967), pp. 120ff.

22. Quoted from Margrit Bröhan, *Hans Baluschek: 1870-1935* (Berlin: Bröhan-Museum, 1985), p. 59.

23. It was also very well received in the 1904 Secession. See ibid., pp. 80ff.

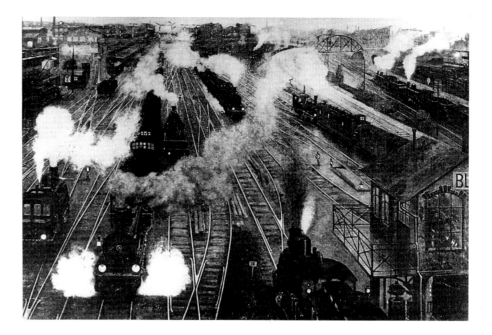

Fig. 57: Hans Baluschek, *The Railroad Station*, 1904, oil on canvas (?), whereabouts unknown.

Grunewaldsee or Schlachtensee (cat. no. 20). He rendered them not as the popular recreational areas which they were, located on the edge of residential neighborhoods and offering restaurants and boats for hire (what Manet or Monet would have done with such motifs!), but as remote natural sanctuaries unspoiled by human presence.[24] His style, too, with its cool, melancholy palette and flattened shapes silhouetted by twilight, seems appropriate to this imagery. Unlike so many of his Secessionist colleagues, who practiced a German version of impressionism, Leistikow was closer to the more rarefied decorative values of *Jugendstil*.

Among the Secessionists there were a few other painters who took the city as their subject, but their work generally presents a different Berlin from Baluschek's. They usually chose their motifs either from Berlin-Mitte—Unter den Linden, Leipzigerstrasse, and Friedrichstrasse—or from the fashionable western districts of the city. The most important of these artists was Lesser Ury. Like Baluschek and Corinth, he came to the city from the eastern provinces, from a predominantly Jewish village in what is today Poland (in the vicinity of Poznan). After the death of his father, his mother moved with her children to Berlin in the early 1870s, just as it had become the capital of the newly unified nation. Before the end of the decade, Ury left the city, while still in his teens, and spent brief periods in Düsseldorf, Brussels, and Paris, devoting himself to painting.[25] It was in Paris that he was first drawn to urban subjects, and there he painted his first street scene, a foggy avenue by night, illuminated by lanterns.[26]

When Ury resettled in Berlin in 1887, he rediscovered such motifs, and they remained his specialty until his death. The city had grown dramatically during his absence—its population now numbered nearly 1.5 million—and in *At the Friedrichstrasse Station* (cat. no. 108), painted just after his return in 1888, he depicted one of the more conspicuous products of that growth. It had been opened only six years earlier as part of the municipal rail network (Stadtbahn), which linked the eastern and western halves of the city.[27] One can sense the influence of French impressionism in this image of nocturnal urban spectacle, with its seemingly random composition and its avoidance of anecdote. But it is not the motifs of industrial progress that are the focus of this picture, as they are in Baluschek's *Railroad Station* of 1904. The locomotive, in the distance, is

24. Cf. Baedeker (see note 11), p. 185f., who mentions restaurants at both lakes and boats for hire at the Schlachtensee.
25. Joachim Seyppel, *Lesser Ury: Der Maler der alten City—Leben, Kunst, Wirkung* (Berlin: Gebr. Mann, 1987), pp. 30ff. et passim.
26. Ibid., pp. 47f. and cat. no. 18 (1882).
27. See Michael Erbe, "Berlin im Kaiserreich (1871-1918)," in Ribbe 2:734 (see note 12).

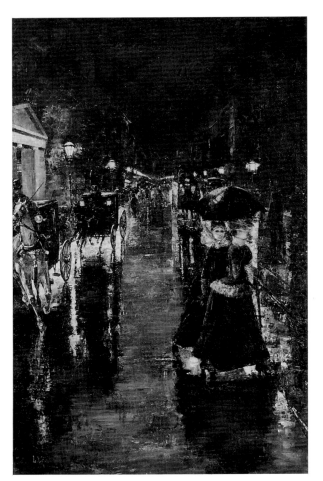

Fig. 58: Lesser Ury, *Berlin Street Scene (Leipzigerplatz)*, 1898, oil on canvas, Berlinische Galerie, Berlin.

partially obscured by its own steam; the station itself is summarily indicated. Here it is above all the wintry nocturnal *Stimmung*, with luminous street lamps, clouds of steam, snowflakes flickering in the dark, that interests Ury—it is the magical transforming effect of the night and of weather on the city. More frequently, Ury combined these nocturnal effects with glistening rain-soaked pavement, as in his *Berlin Street Scene (Leipzigerplatz)* of 1898 (fig. 58), adding a further air of enchantment. A Ury from 1925, *Nollendorf Platz by Night*, shows how faithfully—and agreeably—he pursued this impressionist formula right into the Weimar era.

This "impressionist" aesthetic found verbal expression in the writings of August Endell, best known today as a Jugendstil designer. Like Scheffler and so many others of refined aesthetic sensibility, Endell found the modern architecture of Berlin, including the Friedrichstrasse Station, *"abscheulich"* (abominable). But in the evening, he wrote, when the buildings became darkened masses and the street lamps were lit, the ugliness of the city was redeemed: Berlin was transfigured into the setting for "a fairy tale more colorful and charming than any we were told as children."[28] Weather had the same transfiguring effect: amid the graceless new urban landscape, "in these dreadful heaps of stone, beauty is alive. Here, too, there is nature, there is landscape. The changing weather, the sun, the rain, the fog form out of what is hopelessly ugly an exquisite beauty."[29]

Scheffler, too, found consolation in such impressionistic transfigurations. Berlin's very ugliness intensified those rare aesthetic pleasures to be found in it, he declared. "The less pleasure one derives from the architectural aspect, the

28. August Endell, "Abendfarben," *Die neue Gesellschaft*, 1905, p. 82. I am grateful to John Czaplicka for calling this article to my attention and making a photocopy of it available to me. These observations were further developed three years later in Endell's book, *Die Schönheit der grossen Stadt* (Stuttgart, 1908; reprint, Berlin: Archibook Verlag, 1984). In that book he specifically described the poetic effects of twilight from the platform of the Friedrichstrasse Station, when one could see little of the architecture, and could concentrate on the shimmering color reflections on the glass panels (p. 41 in the 1984 edition).

29. Endell, *Die Schönheit der grossen Stadt*, p. 34. In this discussion of the impressionist vision of Berlin I am indebted to John Czaplicka's unpublished dissertation, "Prolegomena to a Typology of Grossstadt Imageries: The Pictorial Imagery of Berlin, 1870-1930" (Universität Hamburg, 1984), pp. 217ff.

more one feels repulsed by the pervasive artificiality, all the more passionately does one grasp toward the cosmic beauty of light and air."[30] Correspondingly, we actually see relatively little of Berlin in Ury's work; it was precisely these transfigurations of the city which provided the impulse to his art.

In his striking *Railroad Tracks in North Berlin* (cat. no. 19), of ca. 1895, Franz Skarbina carried out such an impressionist transfiguration on a motif closer to Baluschek—a weary proletarian couple making their way by night on a bridge traversing a vast rail yard. Unlike Baluschek's uncompromising *The Railway Station*, this sober industrial landscape is barely intelligible in the darkness; and the motif is transformed by the nocturnal spectacle of the city in the distance—a relatively new visual experience made possible by dramatic progress in the technology of electricity, which at just this time was transforming Berlin into a "city of light."[31]

Such impressionistic images of Berlin, with their suppression of factual detail, form a striking contrast to Julius Jacob's earlier, painstakingly naturalistic images of the city in neutral daylight, of which his *Wilhelmplatz* of 1886 (cat. no. 11) is a fine example. Here the buildings, including the newly opened Hotel Kaiserhof to the right, are rendered with a scrupulous detail reminiscent of Bernardo Bellotto. Jacob's unashamed delight in the physiognomy of the capital city—so atypical among the Berlin artists of his time—seems to reflect the brash self-confidence of the "New Reich."

During the mid-1890s there was a foreign artist working in Berlin who deserves mention in this discussion of urban iconography—Edvard Munch.[32] He lived in the capital intermittently between 1892 and 1895, and again in 1901-02 and 1907-08. During the 1890s, he was part of a circle which included Ibsen, Strindberg, and Richard Dehmel, and produced some of his best work in Berlin, although he did not take up the city as a motif. His subject matter during these extraordinarily fertile years was to a large extent a reworking of past experience in the form of concentrated, simplified memory images (cat. nos. 13-18, 110-112). One of these, inspired by a painful experience of 1890, was a painting of the main thoroughfare in Kristiania (as Oslo was then called), *Evening on Karl Johan Street* (1893), here shown in a unique lithographic impression (cat. no. 13).[33] In this icon of collective anxiety in a city street, Munch left the psychologically detached urban iconography of the French impressionists far behind. Obviously, the work is equally far removed from the aestheticizing veils of the Berlin Secessionists.

Although welcomed by some of the city's progressive painters, Munch had no visible impact on their work. This odd circumstance may be explained by a time warp: he had been in Paris, where he had assimilated certain tendencies of post-impressionism, while the most progressive Berlin painters, on the other hand, were just coming to grips with impressionism. In their gingerly approach to modern life, the Berlin impressionists were just discovering subjects which had been dealt with in France in the 1860s, while in France, on the other hand, impressionism belonged to the past. There was by now a strong Symbolist tendency characterized by anti-naturalist formal practices and a development beyond the iconography of everyday life toward giving visual form to inner experience.

But Munch's work did not remain without resonance in Germany; it became an important stimulus to the next generation—the expressionists. His art was a major formative influence on the early art of Die Brücke, particularly that of Kirchner.[34] The first of Kirchner's urban street scenes, painted in Dresden,[35] was heavily indebted to Munch, and it served as the prototype for the great series of Berlin street scenes of 1913-14, which will be discussed later in this essay.

30. Scheffler 1910, pp. 201f.
31. Berlin was one of the world's leading centers of the electrical industry, and in the 1880s became a leader in the generation of electric power. The electrification of street lighting began in that decade, and in 1894, just before Skarbina painted this nocturnal scene, a decisive reduction in the cost of electric current stimulated a greater use of electricity. See Erbe, in Ribbe 2:713 (see note 27). See also Lange, p.126.
32. In September 1892 the then little known Norwegian painter had been invited by the Verein Berliner Künstler to mount a solo exhibition in the rotunda of the association's headquarters. Munch was but a name to the members, but when the show opened, conservative members of the group were outraged by Munch's paintings, and pressed for a vote to have the exhibition closed, which carried by a majority of 120 to 105 or 104. This action stimulated the first rumblings of secession amidst a faction of the membership which included Liebermann, Skarbina, and Leistikow. The *succès de scandale* was widely covered in the German press, and made Munch, in Lovis Corinth's words, "the most famous man in Germany." For a detailed account of the incident and its aftermath, see Peter Paret, *The Berlin Secession: Modernism and Its Enemies in Imperial Germany* (Cambridge, Mass.: Belknap Press of Harvard University Press, 1980), pp. 50ff.
33. Cf. Reinhold Heller, *Munch: His Life and Work* (Chicago: University of Chicago Press, 1984), pp. 132f. As was so often the case with Munch, the print was a reworking of an earlier painting, dating from 1893 and bearing the same title.
34. See Donald Gordon, "Kirchner in Dresden," *Art Bulletin* 48 (1966): 335ff.
35. *Street*, painted in 1908, and today in the collection of the Museum of Modern Art.

3. Expressionism: Ludwig Meidner's images of the urban "Heimat"

In 1917, in a newspaper article on the "artistic discovery of the big city," Emil Waldmann proposed that what distinguished the expressionist approach to the urban landscape from that of the impressionists was that the former did not seek "to obscure its ugliness with light and color; rather, they have elevated precisely this ugliness to its characteristic feature."[36] This essentially negative view of the expressionist representation of the city, above all of Berlin, has become the dominant one in the art-historical literature since World War II. Art historians, like their colleagues in German literary studies of this period, have tended to see in the artistic treatment of Berlin symptoms of "ein Leiden an der Stadt," a chronic state of suffering and alienation brought on by urban experience.[37]

In art and literature there was indeed an intensified responsiveness to the city: that "blasé outlook," which, according to the sociologist Georg Simmel, the metropolitan type adopted as a defense against "the profound disruptions with which the fluctuations and discontinuities of the external milieu threaten it," was shed as a stultifying bourgeois characteristic.[38] Now the extremes of Berlin were celebrated in a liberation of feeling and instinct. It is true that one product of this intensity was an overtly apocalyptic imagery in the verbal and visual representations of the city—verses such as Georg Heym's "Umbra vitae" and Jakob van Hoddis's "Weltende" (End of the World) are classic literary examples.[39] This foreboding aspect, however, has perhaps been overemphasized, leading many commentators to caricature the relationship of the pre-war expressionist generation to Berlin as a wholly negative one.

This has generally been true of the literature on Ludwig Meidner.[40] He has been viewed almost uniformly as a painter in whom urban alienation was heightened to a form of hysteria. Yet, even as he was producing the drawings and paintings which have inspired such commentary, he published a rhapsodic text—"Anleitung zum Malen von Grossstadtbildern" (Directions for Painting the Big City)—which reads throughout like a paean to the metropolis. Karl Scheffler had declared that "one can establish every kind of relationship to Berlin, it is only loving the city that is impossible";[41] now, in Scheffler's magazine, *Kunst und Künstler*, Meidner proclaimed that that, too, was possible, and he exhorted his fellow artists to embrace their beloved: "We must finally begin to paint our homeland [*Heimat*], the metropolis, for which we have an infinite love."[42] To call the city "Heimat" was to suggest that it had become humanized, that its inhabitants had put down roots and were establishing an urban culture, that Berlin was moving beyond the status of Scheffler's culture-less "Kolonialstadt" of the uprooted.

More significantly, in contrast to the impressionist vision of Scheffler or Endell, the beauty of the metropolis for Meidner was to be found not in the transfiguring effects of natural light and atmosphere, but precisely in what was not natural: in the fabricated environment of the city—the "tumultuous streets, the elegance of iron suspension bridges, the gasometers . . . the howling colors of the autobusses and express locomotives, the rolling telephone wires, the harlequinade of the advertisement pillars."[43] Meidner condemned the impressionistic Paris scenes of Monet and Pissarro; they had painted urban architecture as they painted brooks, and boulevards as if they were flower beds. "A street," Meidner insisted, "is composed not of tonal values, but is a bombardment of whizzing rows of windows, of rushing beams of light between vehicles of many kinds, of a thousand leaping spheres, tatters of people, advertisements and droning, formless masses of color."[44] This urban environment was a product of mathematics, the creation of the engineer. Light remained a major concern

36. Emil Waldmann, "Die künstlerische Entdeckung der Grossstadt," *Vossische Zeitung*, December 2, 1917, Morgenblatt, no. 615. I use the term "expressionism" here for the sake of convenience; it should be understood as synonymous with "German avant-garde" for the period from roughly 1910 to 1920.

37. I have taken the phrase from Andreas Freisfeld's study of the response to urbanization in German literature, *Das Leiden an der Stadt: Spuren der Verstädterung in deutschen Romanen des 20. Jahrhunderts* (Cologne/Vienna: Böhlau Verlag, 1982).

38. Georg Simmel, "The Metropolis and Mental Life," *On Individuality and Social Forms: Selected Writings*, ed. by Donald N. Levine (Chicago: University of Chicago Press, 1971), pp. 325f., 329. Simmel's essay, which at the time was identified with the "impressionist" experience of the city, was first published in 1903.

39. The German texts and English translations can be found in *Twentieth Century German Verse*, ed. by Patrick Bridgwater (Baltimore: Penguin, 1968), pp. 84, 112ff.

40. The major studies are: Thomas Grochowiak, *Ludwig Meidner* (Recklinghausen: Verlag Aurel Bongers, 1966); J. P. Hodin, *Ludwig Meidner: Seine Kunst, seine Persönlichkeit, seine Zeit* (Darmstadt: Justus von Liebig Verlag, 1975); Victor Miesel, "Ludwig Meidner," in *Ludwig Meidner: An Expressionist Master*, exhibition catalogue (Ann Arbor: University of Michigan Museum of Art, 1978); G. Leistner, *Idee und Wirklichkeit: Gehalt und Bedeutung des urbanen Expressionismus in Deutschland, dargestellt am Werk Ludwig Meidners* (Frankfurt am Main/Bern/New York: Peter Lang, 1986).

41. Scheffler 1910, p. 265.

42. Ludwig Meidner, "Anleitung zum Malen von Grossstadtbildern," originally published in *Kunst und Künstler* 12 (1914), 299ff., here and elsewhere quoted from Grochowiak, pp. 78ff. August Endell had already called Berlin "Heimat" in 1908. See August Endell, *Die Schönheit der grossen Stadt* (see note 28), pp. 18f.

43. Meidner, in Grochowiak, p. 80.

44. Ibid., p. 78.

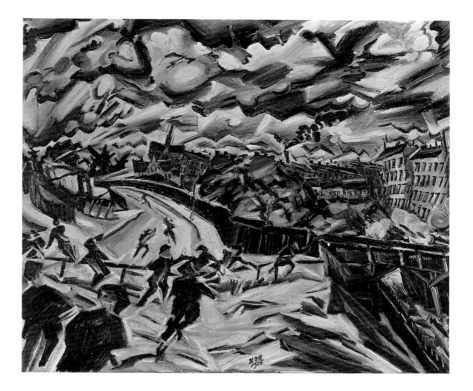

Fig. 59: Ludwig Meidner, *Apocalyptic Landscape*, 1913, oil on canvas, Los Angeles County Museum of Art, gift of Clifford Odets.

(above all electric light); however, it did not soften objects, but was itself transformed by the movement of the city. Meidner's rhetoric is clearly indebted to the texts of the Italian Futurists, which had been published in German translation by 1912, but he looked not to *their* paintings but to Robert Delaunay's cubistic images of the Eiffel Tower as a model of a truly urban art grounded in a new perceptual experience of the modern city.[45]

The relationship between this euphoric text and Meidner's art is problematic. Like the manifestoes of the Futurists, the tone of the article is thoroughly celebratory, without evidence of the *Angst* or of the "apocalyptic" vision which most commentators have found in Meidner's paintings and drawings during the years 1912-14. But it is these images, not Meidner's declaration of an "infinite love" for the urban *Heimat*, which most commentators have taken as expressions of the artist's true attitude toward Berlin, and little attempt has been made to reconcile these two visions. It is symptomatic of this apparent conflict that Thomas Grochowiak, in his pioneering monograph on Meidner, reproduced this text as a chapter in itself, and made no effort even to relate it to his art, which, like most commentators, he consistently read in apocalyptic terms.[46]

Recent scholarship has shown the way toward a resolution of this apparent contradiction. One important discovery concerns the titles of Meidner's urban compositions from the period 1912-14, most of which today have expressly apocalyptic references. An inventory compiled by Meidner in 1915 and published in 1973 contained no such titles, and it is now evident that he retitled many works: sometime prior to his traveling retrospective of 1963-64, he thus converted them into "apocalyptic landscapes," seeking to capitalize retroactively, it seems, on a prophetic gift which was confirmed by two World Wars.[47] Many paintings which had titles referring to specific motifs in Berlin, such as *At Halensee Station* (fig. 59), became "*Apocalyptic Landscapes*," blurring the distinctions between them and paintings of a more fantastic, visionary, and—admittedly—often apocalyptic nature, some of which occur in generic urban settings.

45. For illustrations, see Gustav Vriesen and Max Imdahl, *Robert Delaunay: Light and Color* (New York: Harry N. Abrams, n.d.), pp. 23, 27, 31. On Delaunay's importance for Meidner and the Berlin avant-garde generally, see Thomas Gaehtgens, "Delaunay in Berlin," *Delaunay und Deutschland*, ed. by Peter-Klaus Schuster (Cologne: DuMont Buchverlag, 1985), pp. 264-84.

46. Grochowiak, pp. 78ff. Leistner (pp. 144ff.) finds a relationship between the visual effects described in the text and certain works of Meidner, but declares that the text is not a programmatic key to Meidner's work. J. P. Hodin does not even mention Meidner's essay.

47. The diary entry was published in L. Kunz, ed., *Ludwig Meidner: Dichter, Maler und Cafés* (Zurich: Verlag die Arche, 1973), pp. 48f. Cf. also Miesel, pp. 6f., and Leistner, pp. 118f.

A work like *At Halensee Station*, Victor Miesel contends, "may not seem at all terrifying" if one "ignores for a moment the catastrophic history of modern Germany." Such a painting is "no more apocalyptic than Boccioni's *Laugh* or Balla's *Swifts*"; its "disintegrating forms have less to do with disaster than with futurism's 'whirling life of fever and speed.'"[48] Moreover, this remarkable work relates very closely to the visual effects which Meidner described in his 1914 text:

> Light seems to flow. It hacks things to pieces. . . . Whole complexes heave in light and appear transparent. . . . The sky presses in on us like a waterfall. Its fullness of light explodes what is below. Sharp contours stagger in the harsh glare. . . . The light brings all things into movement. The towers, houses, street lamps seem to hang or to swim.[49]

Here, too, as the abundant but apt metaphors make clear, we are dealing with no less a transfiguration of the city than was the case with impressionism. It is, in reality, the same sun which shone on the impressionist city, but now it does not "naturalize" this constructed world; rather, light itself seems mechanized: it takes on the hectic, agitated qualities of the metropolis. Clearly, the sensations are intense, but they are not for that reason apocalyptic. As Miesel writes of this picture, it "can be experienced rather as a form of report on big city life, though it is life lived at fever pitch."[50]

Two works in the present exhibition belong in this same category of Berlin imagery: *The Church of the Good Shepherd* (cat. no. 34), a site near Meidner's studio in Berlin-Wilmersdorf, and *Street with Pedestrian at Night* (cat. no. 116). The seemingly collapsing buildings on the periphery of the latter work should not necessarily be seen as inspired by a longing for cataclysmic destruction, but as an example of an optical effect which Meidner described in his text. Although houses in the distance may conform to traditional perspective, Meidner wrote, those

> beside us—we sense them with only half an eye—seem to totter and collapse. Here lines which in reality are parallel shoot up steeply and intersect. Gables, chimneys, windows, are dark, chaotic masses, fantastically fore-shortened, ambiguous.[51]

What is striking is the degree to which Meidner's "apocalyptic" style is grounded in perception, in *optical* experience, not merely in psychological reactions to the urban environment. In short, there is a strongly mimetic impulse behind the cubistic distortion and emotional intensity of such images.

Although a drawing, the *Street with Pedestrian at Night* can be fruitfully compared with another nocturnal motif, Lesser Ury's *Berlin Street Scene (Leipzigerplatz)* (fig. 58). In both, artificial light transfigures the street into a fantastic realm, but in Meidner's drawing the light has an aggressive, angular quality. But this, too, should not necessarily be read as an attempt to render the city as a hostile, menacing force, but as an expression of a new aesthetic. "We today, contemporaries of the engineer, feel the beauty of straight lines, of geometric forms," declared Meidner. "In the street, what triangles, polygons, and circles rush in upon us. . . . Even people and animals seem to be geometric constructions."[52]

Nevertheless, some works of Meidner are unquestionably apocalyptic. One such painting is *Apocalyptic City* (fig. 60), which shows burning buildings, ominous, exploding "signs in the sky," and panicked crowds in the streets below. Yet such works—many of which present scenes in relatively open land-scapes—form a different category from those based on Berlin motifs. Gerhard Leistner has persuasively argued that as a group these compositions are inspired by literary sources. Their inspiration was the early expressionist poetry of

48. Miesel, p. 8.
49. Meidner, in Grochowiak, p. 79.
50. Miesel, p. 9.
51. Meidner, in Grochowiak, p. 79.
52. Ibid., p. 80.

Fig. 60: Ludwig Meidner, *Apocalyptic City*, 1913, oil on canvas, Westfälisches Museum für Kunst und Kulturgeschichte, Münster.

Meidner's contemporaries—Jakob van Hoddis, who was his close friend, Gottfried Benn, Georg Heym, Ernst Stadler—and older poets whom he admired such as Alfred Mombert and Walt Whitman, "poet of the foaming urban seas," as Meidner called him.[53] Indeed, in Berlin Meidner was more closely associated with poets than with painters and made numerous portraits of them; he moved in expressionist literary circles at the Café des Westens. And in the nature of his imagery Meidner is nearer to these poets than to other Berlin painters of urban motifs such as Kirchner, Heckel, or the early Beckmann (cat. no. 30).[54]

Leistner has sought to connect a number of Meidner's apocalyptic images with specific texts, but probably Meidner did not approach these sources as an illustrator. Rather, they served him as models of a hallucinatory urban imagery for which he sought a pictorial equivalent. One richly evocative verse by Mombert, for example, describes the distorting shadows of the night in a phantasmagorical imagery very much akin to Meidner's nocturnal cityscapes:

> Nights. Deep chasms sundered the city. On the edges hung narrow laby-
> rinthine streets of ominous, dangerous houses. Across decaying wooden
> footpaths rattling lanterns flickered.[55]

Nevertheless, some of Meidner's images do seem so close to certain poems as to have been directly inspired by particular passages in them. *Apocalyptic City* presents an image which is strikingly similar to the scene conjured up in the opening verse of Heym's "Umbra vitae":

> People draw up in the streets and look upon the great portents in the sky,
> where comets with fiery noses steal threateningly round the serrated
> towers.[56]

Meidner seems to have envied the relative ease with which poets—even mediocre poets—could conjure up strange worlds by the mere combination of words, seemingly at will, compared with the arduous material labors of the painter. He told Thomas Grochowiak that he would like to have been a poet, "but I could not rhyme."[57] In one particularly revealing text, "Salute of the Painter to the Poets," he seemed to admit his frustration with his more resistant, more physical medium:

> Put away your brush, dauber. Enough of these paint-dripping hours, of
> leathery, ponderous canvases. Soar at last out of the cave of your garret into

53. Leistner, p. 124. Meidner's reference to Whitman occurs in his "Gruss des Malers an die Dichter," *Im Nacken das Sternemeer* (Leipzig: Kurt Wolff Verlag, 1918), p. 76, hereafter cited as Meidner 1918. In the same passage he writes of Mombert: "Meteor above the mountains, so much loved by me and celebrated in a picture or two and many resonant drawings!" In 1912 Meidner made a painting of the poet seated in a landscape, *To Alfred Mombert* (Grochowiak, fig. 88), now lost. On Meidner and Mombert, cf. Leistner, p. 122.

54. Meidner had contact with Beckmann and the Brücke artists during these years. Beckmann was still working in an impressionist manner, and, according to Grochowiak (p. 37), Meidner found *Die Brücke* wanting because "das seelische Erleben" (a soulful experience of life) played no role in their art.

55. "Abende," quoted from Dietrich Bode, ed., *Gedichte des Expressionismus* (Stuttgart: Philipp Reclam, 1974), p. 20 (my prose translation).

56. Quoted from Bridgwater (see note 39), p. 112.

57. Grochowiak, p. 47.

the clouded sky and salute the poets! . . . You poets . . . the painter salutes you. He is ashamed of his glutinous paints, of his mute, plodding craft. The painter does not find words adequate to pour out his admiration for you.[58]

For Meidner, this admiration gave birth to literary ambitions, which he began to pursue during the War years when he was unable to draw and paint.[59] His writings took the form of an effusive, bombastic poetic prose, in which he clearly delighted in an extravagant proliferation of images which could not be equaled in painting; he also obviously relished evoking sensations of sound, smell, and touch which also lay beyond the capacities of the painter. Some of these traits are evident in the title essay of his collection *Im Nacken das Sternemeer* (A Sea of Stars in the Back of My Neck), published in 1918, in which Meidner described a walk through the city:

> The city approaches. Already it crackles on my body. Its tittering sears my skin. I hear its explosions echoing into the back of my head.
> The houses approach. Their catastrophes explode from the windows. Stairways silently crash. People laugh among the ruins. . . . The streets gradually become more slippery. Lanterns simply throw away their light rays and every one takes his share. . . . Gradually the streets become filled. The asphalt roars. Frightful turmoil. The noise of machines. . . . The guffaws of derailed streetcars, the sneezes of elderly ladies, and philosophical discussions of cobblers fill the space. . . .[60]

If his "Directions for Painting the Big City" relates closely to Meidner's images of Berlin, this text on the other hand has much in common with—may indeed be seen as a verbal equivalent of—his visionary landscapes of the pre-War years. The structure of the text, with its jarring juxtapositions of bizarre images, also adopts the style, the so-called *Reihungsstil*, of the early expressionist poets whom Meidner so much admired.[61] At the same time, the whimsical, sometimes even humorous imagery—also a feature of Hoddis's "End of the World"—seems in places closer in spirit to the poetry of Arp than to that of Heym or Benn. Should Meidner's text perhaps be regarded above all as an exuberant play with language, as a mischievous dismantling of the rationalized urban milieu through the elastic power of words, rather than as an expression of any particular sentiment toward the city, such as a longing for destruction? In any case, the whimsy in such texts may prompt us to ask whether we have approached some of Meidner's "apocalyptic" images too earnestly.

There are several paintings, such as an *Apocalyptic Landscape* (*sic*) from 1913 (fig. 61), which seem clearly to contain a note of humor, deflating the bombastic rhetoric of the rest of the image. Here, along the bottom edge, the artist has painted an amusingly homely image of himself, bald and abundantly mustachioed, in an attitude which can only be described as a caricature of *Angst*, as he desperately flees from the cataclysm he has created with his brush.

It would be rash—and foolish—to claim that Meidner's fantastic pictorial imagery, with its often undeniably dark, disquieting content, was consistently the product of an ironic posture. Similarly, it would be extreme to argue that he produced such works only in emulation of the effects of expressionist poetry, without a deeper identification with its ominous imagery—even if there *is* an element of humor in some of them. But it is equally unwise to ignore the celebration of urban spectacle in Meidner's "Directions for Painting the Big City," or to explain it away as an imitation of futurist jargon or a mere list of formal recipes with no relation to his underlying attitude toward Berlin.[62] Together, his texts and his art suggest that his relationship to this city was too complex to be reduced to the tiresome monomania of urban anxiety and alienation. Undoubtedly, alienation and anxiety *were* part of Meidner's experi-

58. "Gruss des Malers an die Dichter," in Meidner 1918, pp. 74f.
59. The first of these efforts was *Im Nacken das Sternemeer* (see note 53), followed by *Septemberschrei* (Berlin: Paul Cassirer, 1920).
60. Meidner 1918, p. 27 (my translation).
61. On the "Reihungsstil," see Silvio Vietta, "Grossstadtwahrnehmung und ihre literarische Darstellung: Expressionistischer Reihungsstil und Collage," *Deutsche Vierteljahrsschrift für Literaturwissenschaft und Geistesgeschichte* 48 (1974): 359ff.
62. Cf. Leistner, pp. 141f.

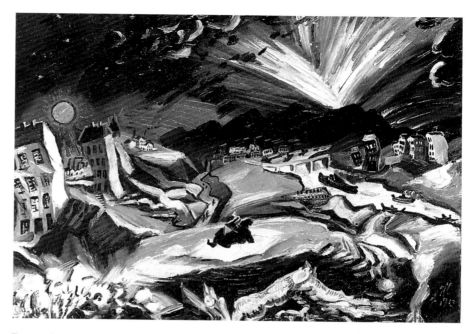

Fig. 61: Ludwig Meidner, *Apocalyptic Landscape*, 1913, oil on canvas, collection of Mr. and Mrs. Marvin L. Fishman, Milwaukee.

63. Quoted in Miesel, p. 33.
64. Quoted from Roy F. Allen, *Literary Life in German Expressionism and the Berlin Circles* (Ann Arbor: UMI Research Press, 1983), pp. 206f.
65. Wolf-Dieter Dube, "The Artists Group *Die Brücke*," in *Expressionism: A German Intuition, 1905-1920* (New York: Solomon R. Guggenheim Museum, 1980), p. 101. Hereafter cited as Dube 1980.
66. Rosalyn Deutsche, "Alienation in Berlin: Kirchner's Street Scenes," *Art in America*, January 1983, p. 69.
67. Donald E. Gordon, *Expressionism: Art and Idea* (New Haven and London: Yale University Press, 1987), p. 139. Hereafter cited as Gordon 1987. Kirchner commentators such as Ewald Rathke, Karlheinz Gabler, and Lucius Grisebach, who have refrained from this type of reading, have generally confined themselves to stressing the formal issues in Kirchner's street scenes. See Ewald Rathke, *Ernst Ludwig Kirchner: Strassenbilder* (Stuttgart: Philipp Reclam Jun., 1969); Karlheinz Gabler, "Die Gemälde Ernst Ludwig Kirchners," in the exhibition catalogue *Ernst Ludwig Kirchner* (Düsseldorf: Kunstverein für die Rheinlande und Westfalen, 1960); and *E. L. Kirchner: Zeichnungen* (Aschaffenburg: Museum der Stadt Aschaffenburg, 1980), pp. 21ff. See Grisebach's catalogue commentaries in *Ernst Ludwig Kirchner, 1880-1938* (Berlin: Nationalgalerie Berlin, 1979), cat. no. 150, pp. 173ff. et passim, hereafter cited as Berlin 1979; and in particular his *Ernst Ludwig Kirchner: Grossstadtbilder* (Munich/Zurich: R. Piper & Co. Verlag, 1979). Anton Henze's brief Kirchner monograph also belongs in this company: *Ernst Ludwig Kirchner: Leben und Werk* (Stuttgart/Zurich: Belser Verlag, 1980), pp. 37ff.

ence of the capital: in 1918, writing in the calmer surroundings of Aschaffenburg, he denounced Berlin as the "guillotine of all my hopes for joy," as a "painful net" in which he had been "trapped,"[63] and he vowed to live henceforth in the county. But a year later he was back in Berlin, where he stayed for sixteen years.

The dominant spirit behind Meidner's images of Berlin is perhaps captured in a later reminiscence of his nocturnal wanderings through the city with Jakob van Hoddis:

> I have fond memories of the hours-long treks which we often took across Berlin at night. This great metropolis was the major experience of those days, and not only for me, born and raised in a small city, but also for Hoddis who was from Berlin. We left the Café des Westens after midnight and marched right off, smartly and somewhat briskly, through the streets, always following our noses. . . . We were 28 years old then and had a lot of endurance, which had not even run out by the time the sun came up. . . . We were so much in love with this city.[64]

4. Ernst Ludwig Kirchner's images of Berlin: "A new beauty"

Kirchner's images of Berlin have been widely interpreted in the same spirit as Meidner's. For Wolf-Dieter Dube the underlying theme of Kirchner's Berlin scenes is "the hectic and unnatural condition of the modern metropolis," revealing "the helpless compulsion, the desolation of the alienated man, which he was himself."[65] Rosalyn Deutsche, in an article on Kirchner's street scenes entitled "Alienation in Berlin," declares these works "immediately recognizable as pictures of an unnatural, thoroughly dehumanized world."[66] And the late Donald Gordon, in his posthumously published study of expressionism, reaffirmed his earlier dark reading of Kirchner's city pictures, calling them images of "a lonely wasteland."[67]

This dark view contrasts strikingly with the predominantly positive reading of these works before 1933. Paul Westheim characterized Kirchner's city images as

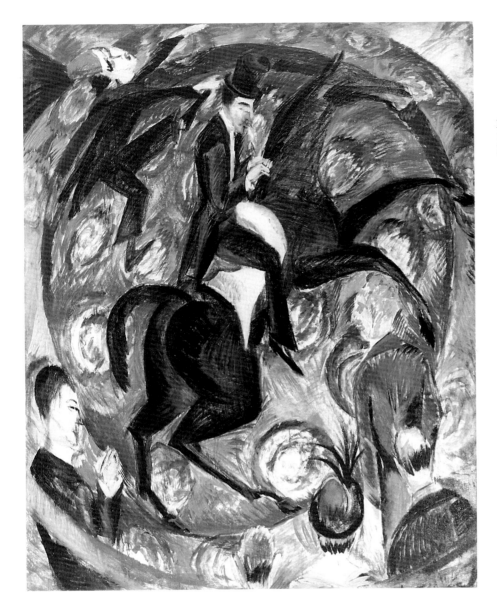

Fig. 62: Ernst Ludwig Kirchner, *Circus Rider*, 1914, oil on canvas, The Saint Louis Art Museum, bequest of Morton D. May.

68. Paul Westheim, *Helden und Abenteurer: Welt und Leben der Künstler* (Berlin: Verlag Hermann Reckendorf, 1931), p. 212. The characterization is, of course, inspired by Walter Ruttman's classic film of 1927, *Berlin, Die Symphonie einer Grossstadt*.

69. Karl Scheffler, "Ernst Ludwig Kirchner," *Kunst und Künstler* 18, no. 5 (1920): 217ff. Evidently, one of the first to make the connection was Wilhelm Hausenstein, in *Die bildende Kunst der Gegenwart* (Stuttgart/Berlin: Deutsche Verlags-Anstalt, 1914), p. 304. See also G. F. Hartlaub's remarks on Kirchner, note 91, below.

70. One finds it in Will Grohmann's monograph of 1958, *E. L. Kirchner* (Stuttgart: W. Kohlhammer, 1958). It is significant in this regard that Grohmann had been a leading proponent of Kirchner's art in the 1920s, publishing the first general monograph on the artist, *Das Werk Ernst Ludwig Kirchners* (Munich: Kurt Wolff Verlag, 1926). Annemarie Dube-Heynig, in her 1961 study of Kirchner's graphic art, echoed Glaser in portraying the artist as the "chronicler of Berlin and its people" in the years before the Great War; Kirchner, she declared, was "the first to give form to lived experience of the large modern city." See *E. L. Kirchner: Graphik* (Munich: Prestel-Verlag, 1961), p. 49. Hereafter cited as Dube-Heynig 1961.

71. See Peter Selz, *German Expressionist Painting* (Berkeley/London: University of California Press, 1957), p. 139; Bernard S. Myers, *The German Expressionists: A Generation in Revolt* (New York: Praeger, 1957), pp. 131f.

72. There have been exceptions to this. Jost Hermand (see note 18), p. 64, has recently offered a fresh look at this issue. He writes, for example, that although Kirchner's street scenes with prostitutes may have been shocking to bourgeois sensibilities, they are not "ripe for collapse (untergangsreif) or apocalyptic." Indeed, he suggests that, contrary to the conventional view, only Ludwig Meidner's urban scenes truly fit into this category. Reinhold Heller has also taken a more nuanced look at Kirchner's urban subjects. Although he does not focus on Kirchner's Berlin imagery, he does write about his first major

a "Symphonie der Grossstadt," a symphony of the metropolis.[68] In 1920 Karl Scheffler, like others before him, stressed Kirchner's affinity with the French impressionists, comparing him to Manet.[69] To be sure, this view can still be found occasionally in the Kirchner literature after 1945;[70] yet, on the whole, following the Second World War a very different Kirchner began to emerge in the critical and scholarly literature: a deeply alienated artist who viewed the city with anxiety and foreboding.[71] Consequently, today his vision of Berlin appears to many viewers as akin to Meidner's apocalyptic nightmares, Beckmann's *Hell* (cat. no. 134), or the frenzied insanity of Grosz's urban pandemonium.[72]

Central to these dark interpretations of Kirchner's urban imagery has been the distinctive style of his Berlin period. Compared to the fluid, curvilinear, fauve-inspired manner that dominated the Dresden period, Kirchner's Berlin painting style is decidedly angular and more tautly schematic in composition. Forms and spaces are subject to often extreme distortions; pulled and stretched by compositional forces, bodies are drastically attenuated, horizontal planes are tilted up at steep angles (see *Nude Woman Combing her Hair*, cat. no. 36, and *Circus Rider*, fig. 62). Yet, for all the carefully calculated, often geometric rigor

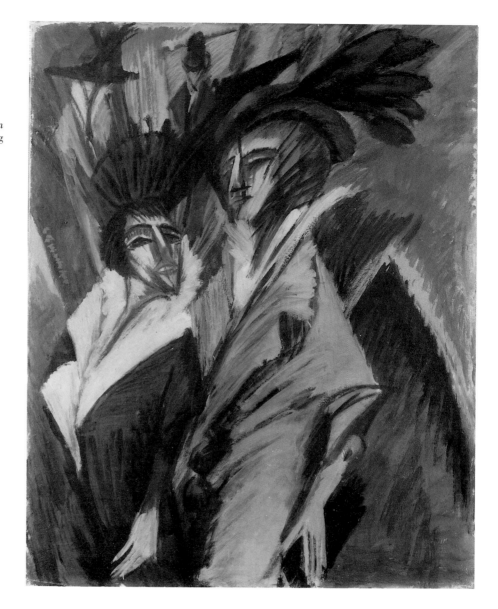

Fig. 63: Ernst Ludwig Kirchner, *Two Women on the Street*, 1914, oil on canvas, Kunstsammlung Nordrhein-Westfalen, Düsseldorf.

street scene, *The Street* (see note 35), executed in Dresden in 1908, and suggests that there are positive as well as negative elements, notably, "a fascination [with] . . . the city's dynamism and intensified life." "'The City is Dark': Conceptions of Urban Landscape and Life in Expressionist Painting and Architecture," in Gertrud Bauer Pickar and Karl Eugen Webb, *Expressionism Reconsidered*, Houston German Studies, vol. 1 (Munich: Wilhelm Fink Verlag, 1979), pp. 50f.

73. See, for example, Deutsche, p. 65, and Gordon 1968, pp. 92ff.

74. Diary entry of 18 February 1926, *E. L. Kirchners Davoser Tagebuch: Eine Darstellung des Malers und eine Sammlung seiner Schriften*, ed. by Lothar Grisebach (Cologne: DuMont, 1968), p. 128. Hereafter cited as *Davoser Tagebuch*.

75. E. L. Kirchner, "Über die Malerei," text of 1913, in Berlin 1979 (see note 67), p. 67.

of their compositions, these pictures convey an effect of excited spontaneity through their rapidly brushed liquid pigment, set down with a nervous, energized graphic *facture* evocative of pastel. In the best of Kirchner's Berlin compositions, such as *Two Women on the Street* (fig. 63) or *Belle-Alliance Platz* (Gordon 371, Nationalgalerie Berlin), this contrast, this sense of raw, animal energy harnessed by uncompromising pressures of pictorial design, produces a tension that is explosive. It is precisely this style which has been widely interpreted as the sign of an aggressively negative attitude toward the city.[73]

Yet, Kirchner himself described his Berlin style not as an expression of his emotional estrangement from his motifs, but as an attempt to capture, in a carefully worked out composition, "the ecstasy of the initial perception."[74] For Kirchner the city was, to be sure, a place of intense sensations, but, in marked contrast to his typical commentators, he consistently described those sensations in positive aesthetic terms. "The sensuous delight in what is seen (die sinnliche Lust am Gesehenen) is the origin of all plastic art from the beginning," he wrote in 1913, near the peak of his Berlin period.[75] Indeed, his accounts of the artistic process are often overtly Dionysian; the "so-called distortions," he wrote, "are

generated instinctively by the ecstasy of what is seen."[76] And there are paeans to the beauty of the modern city, as in a text of 1930:

> The modern light of cities, in combination with the movement of the streets, continually gives me new stimuli. It spreads a new beauty out across the world, one which does not lie in details of the object.[77]

He developed his style of the years 1913-14 out of "the perception of movement," he wrote.[78] And, in one of his most lucid statements on the novel character of urban perception, there is a vivid description of the complex, ever fluctuant tissue of visual reality in the modern city:

> If we see a modern metropolitan street at night with its thousands of light sources, some of them colored, then we must realize that any objective [pictorial] construction is futile, since a passing taxi, a bright or dark evening dress transforms the entire laboriously achieved construction. If we consider the stimulating impact which is produced in us through the sight of unfamiliar effects and which is really the origin of the artist's impression, something quite different comes into being than an exact reconstruction.[79]

At the same time this statement makes an important point that is crucial, I believe, for understanding Kirchner's style: *that the altered nature of modern perception renders traditional modes of representation inadequate.* Accordingly, Kirchner—like Meidner—had to find new means if he wished to render his experience in its fullness. The abstract nature of this pictorial sign is evident from the following Kirchner text, in which he referred to himself in the third person:

> He discovered that the feeling that pervades a city presented itself in the qualities of lines of force (Kraftlinien). In the way in which groups of persons configured themselves in the rush, in the trams, how they moved, this is how he found the means to capture what he had experienced. There are pictures and prints in which a purely linear scaffolding with almost schematic figures nevertheless represents the life of the streets in the most vital way.[80]

In his stress on the qualitative difference of modern urban perception and on the impossibility of rendering that experience by traditional naturalistic means, Kirchner recalls the Italian futurists. As already noted, their manifestoes were published in German (in *Der Sturm*), and their first exhibition, after opening in Paris, was shown in Berlin in March and April 1912, half a year after Kirchner had settled there.[81] Fundamental to this sensation for both the futurists and Kirchner is the experience of movement. Kirchner's formulation is a retrospective one, but it nevertheless is strikingly close to the futurist language of that time. They wrote of translating the fluctuant object according to "the force lines (Linienkräften) which distinguish them," creating a picture that was "a synthesis of the various abstract rhythms of every object, from which there springs a font of pictorial lyricism hitherto unknown."[82] Kirchner declared:

> From [movement] comes the intensified feeling for life which is the origin of the work of art. A body in movement shows me many different aspects, these fuse within me to a *unified* form, to an inner image.[83]

This artistic image is for Kirchner conditioned only partly by mimetic aims. Its "distortions" of natural form are determined by two factors. The first is a non-mimetic compositional logic through which the configurations of individual forms are radically simplified and altered to conform to an overall compositional schema: "The forms emerge and are transformed through working on the surface as a whole," Kirchner wrote in a text of 1920. "It is this that also explains the so-called distortions of the individual forms; the small must subordinate itself to

76. E. L. Kirchner to Eberhard Grisebach, 31 January 1918, as quoted by Hans Bolliger and Georg Reinhardt, "Ernst Ludwig Kirchner 1880-1938: Eine biografische Text-Bild-Dokumentation," in Berlin 1979, p. 77.
77. Berlin 1979, p. 98. Unfortunately, the bulk of Kirchner's published statements on the art of his Dresden and Berlin periods dates from his later residence in Switzerland. Yet, with regard to urban experience, Berlin was clearly the reference, and Kirchner sometimes mentioned his Berlin cityscapes and street scenes in this context. While the later dates of these statements may place their reliability in question, it is striking that despite a wealth of letters and diary entries documenting periods of past and present anguish, such as the difficult war years, there is not a single negative statement about Berlin or urban experience, and there are on the other hand a number, spread over many years, which are positive.
78. Kirchner, "Die Arbeit E. L. Kirchners," published for the first time in E. W. Kornfeld, *Ernst Ludwig Kirchner: Nachzeichnung seines Lebens* (Bern: Verlag Kornfeld & Co., 1979), pp. 332-44. The cited passage can be found on p. 339. The text dates from the mid-1920s. Hereafter cited as "Arbeit ELK."
79. Ibid., p. 341.
80. "Das Werk," text of 1925, *Davoser Tagebuch*, p. 86.
81. In the catalogue of that exhibition, they declared that "there can be no modern painting without the starting point of an absolutely modern sensation." See "The Exhibitors to the Public," quoted from Herschel B. Chipp, *Theories of Modern Art* (Berkeley and London: University of California Press, 1968), pp. 294f.
82. Ibid., p. 298. The shared concept of "lines of force" ("Kraftlinien" in Kirchner's text and "Linienkräften" in the original German translation of the futurist text) is especially striking.
83. Kirchner (1930), in Berlin 1979, p. 97. Emphasis added.

the large."[84] The second factor in these distortions is affective purpose, directed toward what Umberto Eco has called "programmed stimulation" of the viewer.[85] According to Kirchner, the goal of the artistic image (Kunstbild) is to produce in the viewer the interior image (Innenbild) of the artist, that psychological construct of sensual and emotional ecstasy which was the origin of the picture.[86] This result, Kirchner argued, cannot be achieved by a mimetic reconstruction of the original stimulus, but only by the production of "unfamiliar effects" which are truly "the origin of the artistic impression."[87] "The lines of force," intended to convey "the feeling that pervades a city," would be an example of this. It is clear, then, that for all of their carefully calculated effects of spontaneity, the so-called distortions of Kirchner's pictures should not be naively read as merely reactive—as symptoms of alienation, acts of aggression against a hostile milieu, or nightmarish visions of a collapsing world. Like the distortions of his contemporary, Matisse, these are aspects of a sophisticated aesthetic strategy.

But it is not Kirchner's Berlin style alone that has inspired the negative readings of his urban imagery; his street scenes with prostitutes, widely regarded as personifications of urban decadence, have been seen as consummate expressions of the alienation Kirchner experienced in the city. This group of ten paintings, executed in 1913-14, rightly enjoys a privileged place in Kirchner's oeuvre, but it has tended to be the dominant, occasionally even the exclusive focus in discussions of his images of Berlin. Yet these works were created within a period spanning less than a year, while there are other urban subjects which Kirchner drew and painted repeatedly between 1908 and 1915: parks and gardens, rows of houses and railroad bridges (cat. no. 39), dance halls and cafés (cat. nos. 37, 119), *variété* dancers and circus performers (fig. 62). These motifs tend to get perfunctory notice in the discourse on Kirchner's urban anxiety, probably because such subject matter is difficult to reconcile with the currently prevalent "anxious" reading of his art.

Just as these subjects have been neglected, so have the texts which help to illuminate Kirchner's attraction to them. Kirchner was as articulate about his subject matter as he was about his style, and while no text has come to light which supports the moralistic reading of his depictions of prostitutes, there are a number of sources which suggest that he saw his mission as an artist, at least during the decade he spent in Dresden and Berlin, as a commitment to an art based on direct experience, and this of necessity involved urban life. In an autobiographical text from the 1930s, Kirchner recalled how as a student in Munich, in 1904, he had found the Secessionists—the progressive German artists of that era—uninspiring because of their neglect "of the colorful, sunny life outside. And that was what I as a young student would so like to have seen in pictures, our life, movement, color. . . . And I attempted it, drew in the streets and squares, in restaurants and cafés."[88] This same commitment to the vibrancy of contemporary life found expression in two Kirchner texts from the Berlin period. In the "Chronik der Brücke," drafted in early 1913, Kirchner wrote that the goal of the Brücke artists was "to draw their stimulus for creation from life, and to subordinate themselves to lived experience [Erlebnis]."[89] And the brochure for the MUIM Institut (Institute for Modern Instruction in Painting), which Kirchner operated briefly with Pechstein in Berlin in 1911-12, declared: "The life of our new age [das neuzeitliche Leben] is the starting point of artistic creation." The students were to be taught to draw and paint with new means in the new manner, "sketching from life."[90]

If one surveys Kirchner's production in paintings, drawings, prints, and pastels from 1908 to 1914, the life of the "new age"—a certain segment of it, at any rate—is what one finds. Alongside the numerous motifs of nudes, in the

84. Kirchner, writing under the pseudonym "L. de Marsalle," "Zeichnungen von E. L. Kirchner," originally published in *Genius*, 1920, quoted in *Davoser Tagebuch*, p. 185.

85. Umberto Eco, *A Theory of Semiotics* (Bloomington/London: Indiana University Press, 1979), pp. 203f.

86. See "Arbeit ELK," p. 342.

87. Ibid.

88. This is taken from a "Lebensgeschichte" that Kirchner included in a letter to Carl Hagemann, 30 June 1937, quoted from Berlin 1979, p. 48.

89. "Chronik der Brücke," quoted from Berlin 1979, p. 65. An English translation can be found in Chipp (see note 81), pp. 175-78.

90. The text of the brochure is reproduced in Karlheinz Gabler, ed., *E. L. Kirchner-Dokumente: Fotos, Schriften, Briefe* (Aschaffenburg: Museum der Stadt Aschaffenburg, 1980), p. 90. "Sketching from life" (Skizzieren nach dem Leben) should not be confused with what in English is called "life drawing," or drawing from the nude, since there can be no semantic confusion in German, where the latter is "Aktzeichnen." This, too, was central to Kirchner and Die Brücke, but that is not what he meant by "Skizzieren nach dem Leben."

studio or bathing outdoors, which were important to his and the group's ideology of sexual liberation, the dominant subject matter is drawn from the life of the city. Moreover, the majority of Kirchner's urban motifs are the same ones of urban spectacle favored by some of the major French impressionists and post-impressionists.[91] Curt Glaser wrote of him in 1923: "He loved the public places where people gathered, the street itself as well as places of nocturnal amusement, the café or the *Tingeltangel*. . . . Kirchner gave artistic form to this world."[92] Kirchner, like his French precursors, chose "vulgar" entertainments which were genuinely popular; unlike opera or ballet with their courtly origins, they were both products and expressions of modern urban culture. As Peter Jelavich demonstrates in a forthcoming study, the content of these entertainments was explicitly affirmative of that modern Berlin that was ignored by artists and lamented by writers with more traditional aesthetic values.[93] In contrast to the cultivated visual arts, in which, as Georg Hermann lamented, the Berlin artist seemed ashamed of his city, these popular entertainments were at once a manifestation of the new urban culture and an explicit celebration of it. Moreover, the topics of the songs and skits described by Jelavich strikingly coincide with many of Kirchner's motifs, and it is arguable that he conceived of his art in the same spirit. It is precisely the harshly colorful aspects of the city in which Kirchner discovered a new beauty. He did not seek aesthetically to "redeem" such phenomena from their innate "ugliness" by transfiguring them according to impressionist criteria of beauty; his abstraction of the object aimed rather at capturing its raw vitalism. As Dube writes, Kirchner was drawn to "the music hall and circus . . . as expressions of intensified life."[94]

But what of the prostitutes? How can one reconcile a positive reading of Kirchner's Berlin pictures with the subject matter of his most ambitious series of paintings from these years? Clearly they must be central to any reading of Kirchner's Berlin imagery and what it reflects of his attitude toward the city; for that reason I shall need to examine them in some detail. And, as already noted, these are the images that have been the focus of the discourse on urban alienation.[95] But can we be sure that Kirchner regarded his street scenes in this way? If we do accept this reading, we are faced with a contradiction between Kirchner's art during the Berlin period and what he and those closest to him wrote about it, then and later.[96] One cannot, to be sure, accept such sources uncritically, but where they appear to contradict one's own analysis neither should they be ignored.

There is also the problem of documentation concerning Kirchner's attitudes towards prostitutes: Kirchner's known writings and correspondence contain few comments on them. In none of them, however, is there any clear evidence of moral condemnation or of other attitudes attributed to him by the writers I have quoted. On the contrary, his remarks suggest not a revulsion toward the prostitute but a sympathy and perhaps even an identification with her.[97] But however one may interpret these documents, neither they nor any other known statement by Kirchner attest to a clear antipathy toward prostitutes.

If there is scant textual documentation of Kirchner's feelings towards prostitutes, he did write often in later life about the street scenes in which they appear, yet he never did so in the moralistic terms which have become the norm in the recent literature. On the contrary, he wrote about the sensory excitement of the street, about the problems of rendering such dynamism of movement in a static medium, about his geometrical compositional schemas.[98] This discrepancy between Kirchner's words and the ostensible content of these images was noted by Gordon, who seemed mildly puzzled that Kirchner wrote about these Berlin street scenes "more in esthetic than in ethical terms," while remaining

91. This iconographic parallel was noted by G. F. Hartlaub in 1920: "In their subject matter Kirchner, Heckel, Schmidt-Rottluff, and Pechstein have long remained 'impressionists.'" Specifically referring to Kirchner, Hartlaub wrote: "Like his companion Pechstein, the autodidact [Kirchner] also comes out of an admiration for impressionism, above all in that movement's boldest and most daring expressions, in the drawings and prints of a Degas, Lautrec, . . . among others. He in particular has shown a fondness for impressionist subjects. . . ." G. F. Hartlaub, *Die neue deutsche Graphik*, Tribüne der Kunst und Zeit: Eine Schriftensammlung, vol. 14 (Berlin: Erich Reiss Verlag, 1920), pp. 49f., 52f. This relationship was affirmed by other writers of the time, and has been reaffirmed in the Kirchner literature of our own era by Dube-Heynig, p. 54.

92. Glaser (see note 19), p. 540.

93. See Jelavich's forthcoming essay, "Modernity, Civic Identity and Metropolitan Entertainment: Vaudeville, Cabaret and Revue in Berlin, 1900-1933," in Haxthausen, Suhr and Weiss (see note at the beginning of this essay). He writes for example, that in one such revue, "Das muss man seh'n," presented in the Metropol Theater in 1907, "The majority of the numbers praised Berlin for its modernity. The Weltstadt was welcomed with open arms: its vitality, its hectic tempo, its commercialism and consumerism were hailed. In songs and skits, praise was lavished on new urban phenomena ranging from the rapid-transit *Hochbahn* to new forms of mass-cultural entertainment like the Lunapark, cinema and sports events."

94. Dube 1980 (see note 65), p. 98.

95. Wolf-Dieter Dube, borrowing a phrase from the novelist Otto Flake, calls these scenes expressions of the "lovelessness of all toward all" ("Kirchners Bildmotive in Beziehung zur Umwelt," in Berlin 1979, p. 13). For Gordon, Kirchner's prostitutes are "the unconscious agents of urban anxiety"; the street scenes reveal "an active distaste for the image of urban sin. . . . The Dresden champion of instinct in nature has become the Berlin critic of sex in the streets" (Gordon 1968, p. 92; Gordon, "Ernst Ludwig Kirchner: By Instinct Possessed," *Art in America*, November 1980, p. 89). Deutsche (pp. 69, 71), linking the street scenes with the spirit of Simmel's essay on prostitution (1907), attributes a more specific moral critique to Kirchner. In these works, she wrote, the artist "went beyond a mere depiction of alienation to observe its actual cause—the dominance of a money economy. . . . By choosing as his subjects prostitutes and their clients, Kirchner focused on the objectification of human relations inherent in economic exchange."

Fig. 64: Ernst Ludwig Kirchner, *Street, Berlin*, 1913, oil on canvas, The Museum of Modern Art, New York.

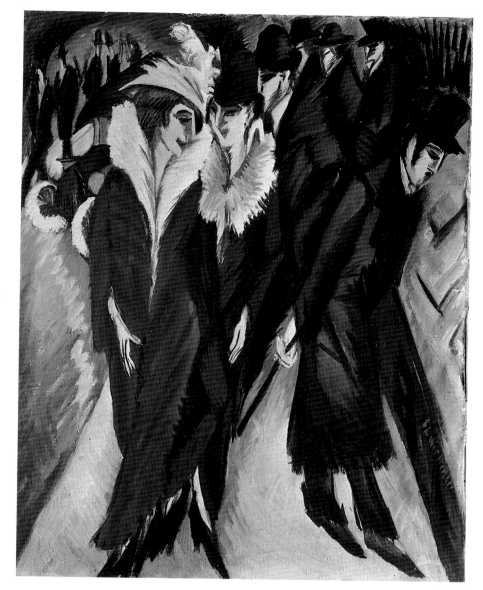

96. The artist's closest friend from these years, the art historian Botho Graef, described Kirchner's art of this period as inspired by a spirit of friendship toward the world. See Graef, "Über die Arbeit von E. L. Kirchner," originally published in 1919 as the foreword to the catalogue of a Kirchner exhibition held at the Galerie Ludwig Schames in Frankfurt, reprinted in Berlin 1979, p. 78. Since Graef died in 1917, the reference is clearly to the works of the artist's Berlin period.

97. Two of these sources date from the winter of 1915-16. Kirchner—ill, tormented by a pathological fear of being recalled to the military, and consequently unable to work—compared the precariousness of his own existence to that of the streetwalkers he painted. See Gordon 1968, p. 27. Kirchner's identification with the vulnerability of the whore to civil authority could have been nurtured by a traumatic incident of August 1914. En route back to Berlin from Fehmarn after war had broken out, Kirchner and his companion, Erna Schilling, were twice briefly detained by police under suspicion of being Russian spies. After this incident, Erna reported, Kirchner suffered from deep anxieties of being arrested again: he developed a phobia toward uniforms, and was afraid to go out of his studio, except at night. This marked the beginning of the psychological deterioration of his last years in Germany. See Kornfeld, pp. 54f., and Kirchner's own mention of the incident in "Arbeit ELK," ibid., p. 337.

98. See above, notes 76, 77, 79, 80.

99. Gordon 1980 (see note 95), p. 95.

100. For an account of the development of prostitution in Berlin see Hans Ostwald, *Kultur–und Sittengeschichte Berlins* (Berlin-Grunewald: Verlagsanstalt Hermann Klemm A. G., n.d. [1924?]), pp. 613-52. For another informative contemporary source, see Robert Hessen, *Die Prostitution in Deutschland* (Munich: Albert Langen, 1910), particularly pp. 107-22.

101. Abraham Flexner, *Prostitution in Europe*, Publications of the Bureau of Social Hygiene (New York: The Century Company, 1920), p. 157. Flexner's book was first published in January 1914, and his account is based on the practice of prostitution in Berlin during the pre-War years, i.e., the years in which Kirchner painted his street scenes. Flexner (pp. 415-19) also publishes the Berlin regulations governing prostitution at that time, which went into effect in February 1912.

silent about "the ambivalent feelings for prostitutes that these pictures revealed."[99] But again, can we be sure that those feelings were Kirchner's own?

One element that has been ignored in discussions of these images is the practice of prostitution itself in Berlin at the time Kirchner painted these works. Berlin differed from Hamburg, Paris, and Vienna in that it was not a brothel city—brothels had been outlawed in the mid-nineteenth century. And since this law was strictly enforced, prostitutes were forced to solicit in the streets, the cafés, taverns, and dance halls.[100] In Kirchner's time prostitution was officially illegal in Berlin, but it was tolerated, and the police sought to regulate it by inscription, or registration. Only a few prostitutes actually followed this procedure, however.[101] An inscribed prostitute was permitted to function under certain conditions set by the police. She had to practice her trade discreetly so as not to give scandal; accordingly, she was forbidden to solicit on major thoroughfares, or in the immediate vicinity of cultural institutions, public parks, railroad stations, or army barracks. A registered prostitute who violated these laws, or an unregistered woman who practiced prostitution under any circumstances—and such prostitutes were many times more numerous—was

liable to arrest and imprisonment. And arrest was a real risk, since the morals police (Sittenpolizei)—two hundred strong—patrolled the Berlin streets under-cover, in pairs. Consequently, the typical prostitute had to be extremely circum-spect in seeking clients. According to one observer, the American Abraham Flexner, the streetwalker was "noticeable by reason of slow gait, furtive expres-sion, and more or less striking garb. Her demeanor is usually restrained. If no response is made to the invitation conveyed in a glance, she passes on; doubtful or encouraged, she stops at a show-window or turns off into a café or street."[102] The undercover agents of the morals police had to be almost equally cautious: since solicitation took discreet and often ambiguous forms, they were, Flexner reports, "bound to proceed with great circumspection. They are indeed instructed that a hundred omissions are preferable to a single error, or apparent error." They dared not touch "the most sophisticated forms of prostitution," because proof was so difficult; consequently, they arrested only "the most obvious and flagrant offenders."[103] As a result, the laws were ineffectual, not only with regard to inscription, but also in interdicting prostitution on the pro-scribed public throughfares.[104] Indeed, some of those places which were inter-dicted became the most notorious sites of prostitution. As Flexner reported, the street-walker sought "by preference the main channels of retail trade."[105]

The restraint necessitated on both sides obviously produced a considerable ambiguity. One could not always be sure: was a glance perhaps innocent? Was a woman perhaps *really* only window-shopping or en route from work or to meet a friend? Dress and demeanor were not always conclusive: some dressed flam-boyantly, others simply; many looked the part, but some looked like respectable girls from bourgeois families.[106]

This ambiguity is a feature of most of Kirchner's street scenes. With one exception, their titles seem innocent enough—*Berlin Street Scene*, *Two Women on the Street* (fig. 63), *The Street* (fig. 64).[107] Can we be sure that the women in each of the street scenes are in fact prostitutes? Many Kirchner commentators have not written about them as such.[108] However, their showy plumed hats—a feature of each of the ten Berlin street scenes—were associated with pros-titutes.[109] And interestingly, the only paintings in the series which bear specific topographical titles—*Friedrichstrasse*, *Potsdamer Platz*, and *Leipzigerstrasse with Electric Tram*—refer to places notorious for prostitution. The Friedrich-strasse had the reputation of being a "public love market," yet, since both it and Potsdamer Platz were officially off limits for prostitution, circumspection was especially in order.[110]

Significantly, none of Kirchner's street scenes show women in the act of overt solicitation[111]—they exchange glances, walk singly or in groups, look in shop windows, or gaze directly at the viewer. Where men figure in the picture, as they do in all but *Five Women on the Street* (see the woodcut version of this motif, cat. no. 118),[112] they are usually relegated to the background. In none of them do we see direct eye contact between a man and a woman, but *The Street* and *Berlin Street Scene* seem to show the prelude to such an encounter. In the former, the woman on the left may be attempting to catch the male window-shopper's eye by means of her reflection in the glass. In several other cases, Kirchner seems to have been specifically interested in the disguises employed by streetwalkers. *Potsdamer Platz* and *Two Women on the Street* (fig. 63) show them in widow's veils, which, after the War began, were adopted by some Berlin prostitutes.[113] These were a novel, opportunistic means of signification which nevertheless retained a particularly delicate ambiguity. They were surely an excellent deterrent to the already cautious morals police, since a false arrest of a genuine war widow would be particularly embarrassing.

102. Ibid., p. 157.
103. Ibid., pp. 146f.
104. Ibid., pp. 160f.
105. Ibid., p. 157.
106. Ostwald, pp. 640f.
107. According to Gordon's catalogue of the paintings (Gordon 1968), it seems that Kirchner gave only one of these works a title with an explicit reference to prostitu-tion *(Street with Red Cocotte*, 1914/25, Gordon 366).
108. For example, in the 1920s, Scheffler (1920), Gustav Schiefler, and Curt Glaser discussed Kirchner's street scenes without any reference to prostitutes. In a long com-mentary on *The Street* (fig. 10), just acquired by the Berlin Nationalgalerie in 1920, Ludwig Justi (the institution's direc-tor), characterized it as a "poem in planes and colors"; there is not a word about "Cocottes." L. Justi, *Neue Kunst: Ein Führer zu den Gemälden der sogenannten Expressionisten in der Nationalgalerie* (Berlin: Julius Bard, 1921), p. 31. Discuss-ing the same work in 1957, Peter Selz (p. 139f.) also omitted any mention of prostitutes, describing the motif as a "per-fectly ordinary scene" of a Berlin street.
109. See George Grosz, *Ein kleines Ja und ein grosses Nein* (Reinbek bei Hamburg: Rowohlt, 1974), p. 98; Ostwald, p. 644; also Hanne Bergius, "Berlin als Hure Babylon," in *Die Metropole: Indus-triekultur in Berlin im 20. Jahrhundert*, ed. by Jochen Boberg, Tilman Fichter, and Eckhart Gillen (Munich: Verlag C. H. Beck, 1986), p. 125.
110. The description of Friedrichstrasse is by Edmund Edel, as cited by Dieter Glatzer and Ruth Glatzer, *Berliner Leben, 1900-1914: Eine historische Reportage aus Erinnerungen und Berichten* (Berlin: Ver-lag das Europäische Buch, 1986), 2:359. Cf. also Grosz, p. 98; Ostwald, pp. 638, 644; and the police regulations in Flexner, p. 416, wherein Potsdamerplatz and Friedrichstrasse are listed among the streets and places forbidden to prostitutes.
111. In his prints, Kirchner does show such episodes. For example, among a series of twelve etchings of the street scene motif from 1914, several show eye contact and verbal exchanges. See Dube R 177 *(Ansprachen auf der Strasse)*, R 179 *(Ansprachen II)*, and R 182 *(Sich anbie-tende Kokotte)*. Cf. also the woodcut of the same year, Dube H 238 *(Am Schaufenster)*.
112. Just as Kirchner's prints are sometimes more explicit than his paintings about the nature of these street encounters (see note 111), so, too, are their titles. In its later

The ambiguities in Kirchner's street scenes, then—ambiguities which led many early critics to overlook the actual subject matter of these works—approximate very closely the contemporary descriptions of the *modus operandi* of prostitution in the capital, and in this sense these pictures seem to be very much a part of Kirchner's program of giving pictorial form to modern urban life. Indeed, for Will Grohmann, who *did* recognize the subjects of these pictures, such images of Berlin were neither celebratory nor critical in spirit; the artist stood outside of his subject matter, merely registering what he saw and giving it artistic form.[114]

But this does not explain why Kirchner would give such images a privileged place in his art of the Berlin period. A recent article by Hanne Bergius may provide a clue. She has written of how precisely Berlin's notorious reputation as "the Whore Babylon" constituted a major part of the city's appeal to artists and writers of Kirchner's generation:

> For many of them this myth, stirred up by the provinces, meant liberation from the narrowness of provincial morality, succumbing to the magic of the urban "femme fatale," instead of dozing eternally at the breast of provincial Mother Nature. Sexual desires and the first experience of the metropolis become interwoven. For at first it was not a moralizing Christian interpretation of the Whore Babylon that characterized the avant-garde artists and literati, but rather a Dionysian avowal of the real, sensual world.[115]

This attitude seems much more consistent with the generally Dionysian tone of Kirchner's descriptions of the city, free of any trace of moralizing, and with his fascination with all manifestations of sexuality. The prostitute, simultaneously threatening and fascinating to fin de siècle artists who treated her as a subversive force within the bourgeois social order, may have appealed to Kirchner for precisely that reason. Robert Hessen wrote that "nowhere does prostitution have as many traits in common with free love as in Berlin."[116] If this reading is correct, Kirchner would not have seen the prostitutes, as did so many males of that era, as "tempting sirens and vampires of the streets.";[117] nor would he have viewed them, as Simmel did, as victims of a degrading, dehumanizing financial transaction which reduced them to sexual commodities. Instead, Kirchner would have seen them as allies in his campaign for the liberation of instinct. What would have attracted him to these subjects, then, was not that sex was being sold like hats and furs and jewels—which, in any case, it was not, for there was no need for circumspection in those trades—but that, through discreet glances and coded words and gestures, the bourgeois city—this world of labor, industry, and commerce, of crowded sidewalks, omnibusses, and automobiles—had been *eroticized*. The prostitutes who promenaded the streets of this clean, orderly, industrious metropolis would thus constitute a kind of erotic epiphany, an irrepressible, triumphant manifestation of the primordial id in an artificial world built by the superego. Kirchner's street scenes would then function not as the negative antithesis of his erotic Baltic idylls but as a glorification of those same primordial energies within the modern metropolis.

To be sure, to present Berlin as Kirchner did during these years was to present it selectively. Clearly Kirchner was not truly interested in being the chronicler of urban life in all of its variety. One need only look at the posthumously discovered photographs of Berlin life by Heinrich Zille from roughly these same years—a far more diverse visual chronicle of the life of "das neuzeitliche Leben"—to realize how narrow was Kirchner's choice of urban motifs.[118] He avoided the horrible poverty, the dreadful housing conditions, the class tensions; he ignored the city at work. His goal was not to document a social reality but an aesthetic one. Berlin for Kirchner was above all a domain of intense sensuous excitement, a

woodcut version, *Five Women on the Street* [*Fünf Frauen auf der Strasse*] became *Five Tarts* [*Fünf Kokotten*]. The titles, first published in Gustav Schiefler's catalog (*Die Graphik Ernst Ludwig Kirchners bis 1916* [Berlin-Charlottenburg: Euphorion-Verlag, 1926]), are assumed to be Kirchner's own or at least to have been approved by him.

113. Gordon 1968, p. 94.
114. Will Grohmann, *E. L. Kirchner* (Stuttgart: W. Kohlhammer, 1958), p. 54.
115. Bergius (see note 109), p. 102.
116. Hessen (see note 100), p. 111.
117. I borrow the phrase from Bram Dijkstra, *Idols of Perversity: Fantasies of Feminine Evil in Fin-de-Siècle Culture* (New York: Oxford University Press, 1986), p. 357.
118. Winfried Ranke, *Heinrich Zille: Photographien, Berlin 1890-1910* (Munich: Wilhelm Heyne Verlag, 1975). Zille's photographs were, however, not published or even known at the time that he made them; they are a posthumous discovery.

stimulus to aesthetic ecstasy. He represented Berlin as a place of vibrant pleasures, a city which up to then—to quote Scheffler once more—had seemed "a place in which there was much work and little enjoyment, good order and discipline, but not the poetry of exuberance."[119] This should in no way diminish Kirchner's achievement. On the contrary, the aestheticization of this "capital of modern ugliness" should be seen as an essential contribution to the historical process of urban socialization, a process furthering the willing acceptance, the embrace, even, of the metropolis as the "Heimat" of modern men and women.

119. Scheffler 1910, p. 100.

Selected Bibliography

Brockhaus, Christoph. "Die ambivalente Faszination der Grossstadterfahrung in der deutschen Kunst des Expressionismus." In *Expressionismus—sozialer Wandel und künstlerische Erfahrung*, ed. by Horst Meixner and Silvio Vietta, pp. 89-106. Munich: Wilhelm Fink Verlag, 1982.

Bröhan, Margrit. *Hans Baluschek: 1870-1935*. Berlin: Bröhan-Museum, 1985.

Deutsche, Rosalyn. "Alienation in Berlin: Kirchner's Street Scenes." *Art in America*, January 1983, pp. 65-72.

Endell, August. *Die Schönheit der grossen Stadt*. Berlin: Archibook Verlag, 1984.

Glatzer, Dieter, and Ruth Glatzer. *Berliner Leben, 1900-1914: Eine historische Reportage aus Erinnerungen und Berichten*. Berlin: Verlag das Europäische Buch, 1986.

Gordon, Donald E. *Ernst Ludwig Kirchner*. Cambridge: Harvard University Press, 1968.

Gordon, Donald E. *Expressionism: Art and Idea*. New Haven and London: Yale University Press, 1987.

Grisebach, Lucius. *Ernst Ludwig Kirchner: Grossstadtbilder*. Munich/Zurich: R. Piper & Co. Verlag, 1979.

Grochowiak, Thomas. *Ludwig Meidner*. Recklinghausen: Verlag Aurel Bongers, 1966.

Haxthausen, Charles W., Heidrun Suhr, and Gerhard Weiss. *Berlin: Culture and Metropolis*. Minneapolis: University of Minnesota Press, 1990.

Heller, Reinhold. "'The City is Dark': Conceptions of Urban Landscape and Life in Expressionist Painting and Architecture." In *Expressionism Reconsidered: Relationships and Affinities*, ed. by Gertrud Bauer Pickar and Karl Eugen Webb, pp. 42-57. Munich: Wilhelm Fink Verlag, 1979.

Lange, Annemarie. *Das Wilhelminische Berlin: Zwischen Jahrhundertwende und Novemberrevolution*. Berlin: Dietz Verlag, 1967.

Leistner, Gerhard. *Idee und Wirklichkeit: Gehalt und Bedeutung des urbanen Expressionismus in Deutschland, dargestellt am Werk Ludwig Meidners*. Frankfurt am Main/Bern/New York: Peter Lang, 1986.

Meidner, Ludwig. "An Introduction to Painting Big Cities." In *Voices of German Expressionism*, ed. by Victor Miesel, pp. 110-15. Englewood Cliffs, N.J.: Prentice-Hall, 1970.

Miesel, Victor. "Ludwig Meidner." In *Ludwig Meidner: An Expressionist Master*, exhibition catalogue, pp. 1-18. Ann Arbor: University of Michigan Museum of Art, 1978.

O'Brien-Twohig, Sarah. "Beckmann and the City." In *Max Beckmann Retrospective*, ed. by Carla Schulz-Hoffmann and Judith C. Weiss, pp. 91-109. Munich: Prestel Verlag, 1984.

Paret, Peter. *The Berlin Secession: Modernism and Its Enemies in Imperial Germany*. Cambridge: Belknap Press of Harvard University Press, 1980.

Ribbe, Wolfgang, ed. *Geschichte Berlins*. 2 vols. Munich: C. H. Beck Verlag, 1987.

Scheffler, Karl. *Berlin: Ein Stadtschicksal*. 2nd ed. Berlin: Erich Reiss Verlag, 1910.

Selz, Peter. *German Expressionist Painting*. Berkeley/London: University of California Press, 1957.

Seyppel, Joachim. *Lesser Ury: Der Maler der alten City—Leben, Kunst, Wirkung*. Berlin: Gebr. Mann, 1987.

The City and Modernity: Art in Berlin in the First World War and Its Aftermath

Clark V. Poling

The catastrophic events of the First World War and the German Revolution of November 1918, as well as the political and economic instability of the early years of the Weimar Republic, are registered in the art of the period from 1914 to the early twenties. Within this historical context, the urban environment prompted particular responses from avant-garde artists in Berlin, which was perceived as the quintessentially modern city. In paintings and graphic art, Expressionists, Dadaists, and Constructivists all reflected on the meaning of the political and social conditions of the time and on the implications of the urban and industrial nature of modern society, though the content of their art—celebratory, satirical, or utopian—varied as much as its style.

Some of the range of this response had already been suggested by Ludwig Meidner in his 1914 essay "An Introduction to Painting Big Cities." Proclaiming the city as the artist's true home, he urged the painter to capture "the glorious and the fantastic, the monstrous and dramatic—streets, railroad stations, factories, and towers."[1] He described the modern city as a convulsive assembly of buildings, vehicles, and people, of light, space, and movement. This characterization conveyed an Expressionist vision of the metropolis, under the acknowledged influence of Italian Futurist manifestoes and of Robert Delaunay's pictures of the Eiffel Tower, and at the same time elements of the essay anticipated the Constructivists' interest in technology.

Meidner declared modern artists "the contemporaries of the engineer."[2] With the exuberant rhetoric of the Futurists and the Expressionists, he pointed to the evidence of the industrial age in the urban environment: "the elegance of iron suspension bridges, gas tanks . . . , the roaring colors of buses and express locomotives, the rushing telephone wires. . . ."[3] Moreover, in comparing artists to engineers he cited the experience of characteristic visual elements in the city: "We see beauty in straight lines and geometric forms. . . . Our big-city landscapes . . . [are] filled with mathematical shapes. What triangles, quadrilaterals, polygons, and circles rush out at us in the streets."[4] Meidner's attitude toward the city thus spanned artistic generations, and accordingly it is interesting that during the war years his studio served as a meeting place for writers and artists representing various points of view, including Expressionists and those who would soon become Dadaists. To cite the latter, Wieland Herzfelde and George Grosz met there in 1915, and Meidner also knew Raoul Hausmann and Johannes Baader, both of whose portraits he drew.[5]

As Meidner's art and that of Ernst Ludwig Kirchner had epitomized Expressionist concepts of the city in the years leading up to the First World War, George Grosz's work was central to the image of the city, both as physical environment and as social milieu, during the war years and into the 1920s. Kirchner's scenes of prostitutes on the street (cat. no. 118) and Meidner's tumultuous cityscapes (cat. nos. 34, 116, 117) provided crucial antecedents for Grosz's paintings, drawings, and prints. However, Kirchner's fascination with streetwalkers and Meidner's cosmic visions of urban upheaval were replaced by Grosz with a cynical social criticism and eventually with a stinging political critique, in imagery that encompassed city dwellers and architectural environment alike in order to convey its pointed messages.

As early as 1915, after his discharge from the military for health reasons,

1. "Anleitung zum Malen von Grossstadtbildern," in "Das neue Programm," *Kunst und Künstler* 12 (1914); in Victor H. Miesel, ed., *Voices of German Expressionism* (Englewood Cliffs, N.J., 1970), p. 111.
2. Miesel, p. 113.
3. Miesel, pp. 114-15.
4. Miesel, p. 113.
5. Beth Irwin Lewis, *George Grosz: Art and Politics in the Weimar Republic* (Madison, 1971), p. 3; University of Michigan Museum of Art, *Ludwig Meidner: An Expressionist Master. Drawings and Prints from the D. Thomas Bergen Collection. Paintings from the Marvin and Janet Fishman Collection*, text by Victor H. Miesel (Ann Arbor, 1978), p. 15 and cat. no. 8.

Grosz's attitude toward modern urban society was expressed in works stylistically allied with Expressionism, such as *The Street* (cat. no. 40). Here the dominant theme is prostitution as a central symbol of human depravity in the city, whose buildings press in on the spaces of street and square. Grosz's graphic art of the war years elaborates this imagery, as exemplified by the *Small Grosz Portfolio* (cat. no. 122), published in 1917 by Herzfelde's Malik Press. Against the Berlin environment of apartment houses, canals, and factories, sexuality is a recurrent motif, from the degenerates in *Café*, to the couple in the window in *Pleasure Street* and the middle class pair in *Strolling*. It appears again in the scene of wartime frenzy and desperation, *Riot of the Insane*.

A compendium of Grosz's urban types is assembled in the 1918 lithograph *Friedrichstrasse* (cat. no. 123): the rich businessman, fashionably attired woman, military officer, bureaucrat, prostitute, street vendor, and beggar. The intensity of this scene of a jostling crowd on a major street in central Berlin is heightened by the densely arranged buildings, streetlights, advertising signs, and the girder of a railway bridge. The crude drawing on the cracked wall at the lower right not only is a telling feature of the modern city but also acknowledges that graffiti were a source for the formal and expressive qualities of Grosz's graphic works. A later statement explains the attitude toward his subjects that prompted him to choose such sources:

> In order to achieve a style which would . . . reproduce the drastic, unadorned hardness and unsentimentality of my subjects, I studied the immediate manifestations of the art instinct: I copied folkloric drawings in toilet stalls, which seemed to me the most immediate expression and direct translation of strong feelings. Children's drawings also inspired me to this knife-sharp style of drawing, which I required to transmit my observations, dictated at that time by absolute misanthropy.[6]

Grosz's cynicism about German society was fueled by his own bitter, though brief, experience of military service and by witnessing wartime profiteering, hunger, and other suffering. His anti-war position led him to change his first name to its English version in 1916, and he joined the Dada movement when it was formed in Berlin in early 1918, having aligned himself with the politically radical part of the group, Herzfelde and his brother John Heartfield, who also had Americanized his name. The three soon joined the recently founded German Communist party, at the end of 1918.

The Berlin Dadaists' stance was aggressively anti-Expressionist, opposing the subjectivism of the Expressionists and turning instead to a socially based satire. Max Beckmann also criticized Expressionism, particularly for its sentimentality and mysticism, though the style of his works from the end of the war to the early twenties was in many ways Expressionist. His own shattering experiences at the front, as a medical orderly at the beginning of the war, had affected both the style and the content of his art. In spatially compressed compositions of angular and distorted forms he sought to express his love of humanity and empathy for its suffering. In these difficult times, he wrote, artists must remain among people, in the city, and "must share in all the misery to come. We must sacrifice our hearts and our nerves to poor deceived humanity's horrible screams of pain. . . . That is the only thing that can motivate our quite superficial and selfish existence. That we give to people a sign of their fate."[7]

Though residing in Frankfurt during the postwar years, Beckmann had lived in Berlin before the war, and he revisited the capital and drew on it for the thematic material of a series of graphic works between 1918 and 1923.[8] Among these, the portfolio *Hell* of 1919 (cat. no. 134) was based on a visit in March of that year and provides striking images of political conditions and human

Fig. 65: Max Beckmann, *The Way Home*, lithograph from portfolio *Hell*, 1919.

Fig. 66: Max Beckmann, *The Family*, lithograph from portfolio *Hell*, 1919.

6. "Abwicklung," *Das Kunstblatt* 7 (1924); in Hanne Bergius, "Berlin: A City Drawn—From the Linear Network to the Contour," in Harvard University Art Museums, Busch-Reisinger Museum, *German Realist Drawings of the 1920s*, ed. by Peter Nisbet (Cambridge, 1986), p. 25.

7. In *Schöpferische Konfession*, 1920; in Charles Werner Haxthausen, *Modern German Masterpieces from the Saint Louis Art Museum* (St. Louis, 1986), p. 10.

8. Sarah O'Brien-Twohig, "Beckmann and the City," in Saint Louis Art Museum, *Max Beckmann Retrospective*, ed. by Carla Schulz-Hoffman and Judith C. Weiss (St. Louis, 1984), pp. 101ff.

Fig. 67: Max Beckmann, *The Ideologues*, lithograph from portfolio *Hell*, 1919.

Fig. 68: Max Beckmann, *The Last Ones*, lithograph from portfolio *Hell*, 1919.

Fig. 69: Max Beckmann, *Martyrdom*, lithograph from portfolio *Hell*, 1919.

9. This painting provided the title for the exhibition at the Berlinische Galerie, *Ich und die Stadt: Mensch und Grossstadt in der deutschen Kunst des 20. Jahrhunderts*, ed. by Eberhard Roters and Bernhard Schulz (Berlin, 1987); see p. 88.
10. Berlinische Galerie, *Ich und die Stadt*, entry for *Die Hölle*, by Bernhard Schulz, p. 148.
11. *Schöpferische Konfession*, in Haxthausen, p. 10.

suffering during the period of the German Revolution and its aftermath. Placing his self-portrait on the title page and in several of the prints in the portfolio and depicting his family in two of the images, Beckmann shows his personal involvement in the events and conditions of the time, witnessing and participating in the agony of the city. Such subjective identification of the artist with his urban context was presaged by Meidner in his 1913 self-portrait entitled *I and the City*, in which the artist's head looms against the agitated background of a city view.[9]

In the first and last prints in the portfolio, Beckmann presents his own encounter with the results of the war, confronting a horribly maimed war cripple on the street at night, in *The Way Home* (fig. 65), and witnessing his son holding two hand grenades, as prize playthings, in *The Family* (fig. 66). The suffering of the poor under the unstable economic conditions of the postwar years is shown in the other image of his family, *Hunger*, while a manic gaiety appears in *Malepartus*, a scene of the rich dancing in a nightclub. *The Ideologues* (fig. 67) and *The Last Ones* (fig. 68) depict the situation of left-wing intellectuals and activists in the tumultuous months following the overthrow of the Kaiser and the establishment of the Weimar Republic in November 1918. The latter image is a scene of last-ditch resistance by Communists during the vicious street fighting of early 1919, when the ruling Social Democrats called in the right-wing Free Corps to quell the workers' demonstrations and general strike. Other evidence of these struggles is presented in *Martyrdom* (fig. 69), evoking the assassination of the Communist leader Rosa Luxemburg, and *The Street*, which probably includes the figure of the slain leader of the short-lived Munich Soviet Republic, Kurt Eisner.[10] A sense of lawlessness and personal agony is further expressed in *The Night*, which repeats the image of Beckmann's painting of the same title of 1918-19. The event is a brutal attack on a family in their attic living quarters, an allegory of political hooliganism in a tenement environment that fulfills Beckmann's goal to "give to people a sign of their fate."

Such allegorizing of the modern human condition characterized the "transcendental objectivity" that Beckmann sought to achieve.[11] The concern for the harsh realities of the contemporary world was shared by artists of the second

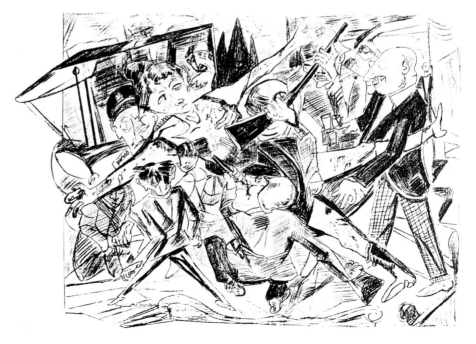

generation of Expressionism, with their increased emphasis on social and political issues.[12] Ultimately, divested of Expressionist subjectivism and stylistic distortion, these interests led to the social criticism of artists associated with the realism of the art of New Objectivity (Neue Sachlichkeit) in the mid-twenties. A presentiment of this stark style and content is found in Grosz's *The End of the Day* of ca. 1919 (cat. no. 124), from early in the period of his commitment to the German Communist Party. The drawing depicts workers trudging homeward against the background of one of Berlin's dreary industrial quarters.

The importance of the metropolis for the Dadaists was expressed by Richard Huelsenbeck in his description of the impact Berlin had on him when he returned from Switzerland in January 1917. After smug and prosperous wartime Zurich, Berlin struck him as "a street full of electric signs, shouting hawkers, and auto horns." "The Dadaist . . . loves the noises of the Metro," he declared, and he proclaimed the vitality he experienced in the simultaneous occurrence of "the everyday events surrounding me (the big city, the Dada circus, crashing, screeching, steam whistles, house fronts, the smell of roast veal)."[13]

In the stylistically radical imagery of Berlin Dada, the modern big city is embodied in a number of ways. Most obviously, fragmentary views of city streets and buildings appear in many of the works by artists such as Grosz (see cat. no. 49), Hausmann, and Hannah Höch. The most spectacular example is Höch's large photomontage of 1919, *Cut with the Kitchenknife Dada through the Last Weimar Beer-Belly Cultural Epoch of Germany* (fig. 70). Views of crowded streets, demonstrations, and American high-rise buildings make clear the urban context, which is elaborated through numerous images of the industrial age: locomotive and train car, automobile, airplane, bridge struts, wheels, ball bearings, a giant gear, and other bits of machinery including a machine gun. Government, the military, and business are also part of this compendium, the last satirized by the line "Invest your money in Dada," clipped from a Dada publication. The assembly of images in works such as *Cut with the Kitchenknife* served to ridicule established social and economic institutions and the traditional artistic media they embraced.

For the Berlin Dadaists, the modern world was equated with the city, the embodiment of industrial mechanization, and Berlin was the paradigmatic industrial city. The Dadaists adopted machine imagery ambivalently, however, both to satirize capitalist society and to propose a new, modern human being. The machine man, one of whose roles is to substitute for the sentimental beings of the Expressionists, inhabits collages by Grosz from around 1920, in which an urban setting is indicated by a street view in the background (fig. 71). At the First International Dada Fair, an exhibition held in Berlin in the summer of 1920, one of the slogans was "Art is dead. Long live the new machine art of Tatlin," referring to the Russian Constructivist sculptor. Hausmann's photomontage of the same year, *Tatlin at Home*, with the figure's cranium constituted by machinery, presents the Dadaists' "new man," the beneficiary of the transformative power of modern technology.[14]

Beyond the specific imagery of Dada works, their techniques, materials, and sources testified to the centrality of the modern industrialized city to the artists' thinking. They developed the photomontage to renounce the personal handling of traditional artistic media and instead to incorporate the modern, mechanical media of typography and photography. They found the fragmentary elements for their works in the popular press, a mass-produced medium centered in the metropolitan environment. As early as 1918, Hausmann had called for the use of "real materials" like "wire, glass, cardboard, and tissue,"[15] which can be associated with the everyday urban context. Later, at the Dada Fair of 1920, the

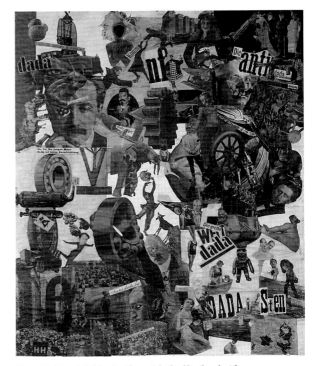

Fig. 70: Hannah Höch, *Cut with the Kitchenknife Dada through the Last Weimar Beer-Belly Cultural Epoch of Germany*, 1919, collage, Staatliche Museen Preussischer Kulturbesitz, Nationalgalerie, Berlin.

12. Stephanie Barron, Introduction, in Los Angeles County Museum of Art, *German Expressionism 1915-1925: The Second Generation*, ed. by Stephanie Barron (Los Angeles, 1988), p. 11.

13. "En Avant Dada: A History of Dadaism" (1920), in Robert Motherwell, ed., *The Dada Painters and Poets: An Anthology* (New York, 1951), p. 39 and pp. 28, 36.

14. Timothy O. Benson, *Raoul Hausmann and Berlin Dada* (Ann Arbor, 1987), pp. 185-86.

15. In his Dada proclamation, "Das neue Material in der Malerei," quoted in Benson, p. 80.

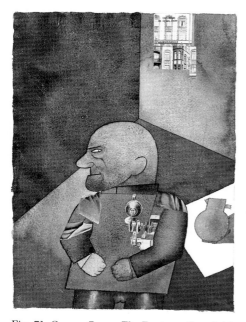

Fig. 71: George Grosz, *The Engineer Heartfield*, 1920, watercolor and collage, Museum of Modern Art, New York.

assemblages that dominated the exhibition realized this goal of incorporating a wide range of substances to embody a new materialism.[16]

A biting satire of bourgeois life and culture was part of the intention of these constructions. Moreover, the businessman and politician were parodied by such Dada ploys as publicizing a "central office" of Dada and "world services."[17] Commercial techniques of advertising and promotion were appropriated by the Dadaists in their publications, announcements, posters, and slogans.[18] The aping of business and mass production was also exemplified by the formation in 1919 of the collaboration designated by the title "Grosz-Heartfield mont."– abbreviating *monteur*, for assembler or fitter–and by Grosz's use of a stamp with his name and address in 1920, instead of signing his works.[19]

Later, in his costume designs of 1922 for Iwan Goll's play *Methusalem or the Eternal Bourgeois*, Grosz created a satirical image of the owner of a shoe factory, the patriarchal capitalist named in the play's title (cat. no. 125).[20] A Dada assemblage of materials utilizing Constructivist geometric forms, the costume is one of the life-sized props that the actors were to carry in the original plan for the play. The image is chock-full of signs of his character and his social, political, and familial position. His boarded-over head, from which a crank handle projects, suggests a faceless, mechanical figure. He is for the most part formally attired, though his slippered foot indicates the domestic context of the scene and his other bandaged gouty foot and raised wine goblet suggest his self-indulgence, as does the phallic emblem of a spigot from a wine-cask. His authority is shown by the over-sized Henckels carving knife and his politics by the military iron cross and the Weimar flag motifs. The design thus bears the full ideological weight of Grosz's social criticism and can be juxtaposed with the view of the urban proletariat given in his drawing *The End of the Day* (cat. no. 124).

An intersection of artistic movements in Berlin during the years immediately following the war is evident not only in the Dadaists' admiration for the "machine art" of Russian Constructivism but in other connections as well. Dadaists and Expressionists had joined in the founding of the November Group in December 1918, endorsing the November Revolution, although the Dadaists were prominent among those who were soon to protest that the group had abandoned political goals to become merely a society for aiding its members' artistic careers.[21] Second-generation Expressionists in the November Group included some artists who formulated an "abstract Expressionism" incorporating stylistic features of Cubism and Futurism. Their work included imagery celebrating the modern urban environment. Otto Möller's *City*, of 1921, adopted elements of Delaunay's earlier city views to evoke the density of Berlin, with its traffic, signs, and towers (cat. no. 141). Moriz Melzer, in his *Bridge-City* of 1923, joined to the architectural imagery the motif of a railway bridge, showing the added influence of Constructivism in subject as well as style (cat. no. 45).[22]

The stylistic divergence between Dadaists and Constructivists masked significant shared interests and beliefs. Their mutual contacts are attested, for example, by the fact that Hausmann, Höch, El Lissitzky, and Hans Richter all frequented the studio of László Moholy-Nagy and his wife, the photographer Lucia Moholy, in the early twenties.[23] With Hausmann and Hans Arp, Moholy and the Russian Suprematist Ivan Puni (see cat. no. 142) published the "Manifesto of Elemental Art" in 1921, affirming "the dynamism of our era" and calling for an innovative art based on the elements of form.[24] Most of the Berlin Dadaists and the Constructivists held generally leftist political views and a shared focus on urban phenomena and the characteristics of modernity.

Richter made the transition from Zurich Dada to the international movement

16. For documentation on the Erste Internationale Dada-Messe and its contents, see Berlinische Galerie, *Stationen der Moderne: die bedeutenden Kunstausstellungen des 20. Jahrhunderts in Deutschland* (Berlin, 1988), pp. 156-83.
17. Hanne Bergius, "Dada à Berlin, de l'esthétique du laid à la beauté révolutionnaire," in Centre National d'Art et de Culture Georges Pompidou, *Paris-Berlin 1900-1933: rapports et contrasts France-Allemagne* (Paris, 1978), p. 134.
18. Benson, pp. 168, 171.
19. Benson, pp. 109, 111; Irwin, p. 97.
20. See Andrew DeShong, *The Theatrical Designs of George Grosz* (Ann Arbor, 1982), pp. 35-44.
21. Eberhart Roters, "Prewar, Wartime, and Postwar: Expressionism in Berlin from 1912 to the Early 1920s," in Los Angeles County Museum of Art, pp. 52-53.
22. Regarding the pictures by Melzer and Möller, see Kurt Winkler, "Abbilder Berlins–Spiegelbilder der Metropole: Die Darstellung Berlins in der Malerei von 1920 bis 1945," in Berlin Museum, *Stadtbilder: Berlin in der Malerei vom 17. Jahrhundert bis zur Gegenwart* (Berlin, 1987), pp. 328-30.
23. Sophie Lissitzky-Küppers, *El Lissitzky: Life, Letters, Texts* (London, 1968), p. 26.
24. "Aufruf zur elementaren Kunst," *De Stijl*, 1921; in Krisztina Passuth, *Moholy-Nagy* (London and New York, 1985), p. 286.

of geometric abstraction as early as 1919. Having returned to the Berlin region from Switzerland, he worked on *Präludium* (cat. no. 138), which was to be the first of a series of scrolls presenting permutations of elementary geometric forms developed along the length of the works. Collaborating with the Swedish painter Viking Eggling, he thus developed scores for abstract films, a pioneering endeavor that paralleled the Constructivists' interest in art that incorporated movement and time.

The desire to embody the character of modern technology and to formulate a universal visual language was central to non-objective art derived from Russian Constructivism. These goals were intertwined with the artists' sense of the industrial city and the mass society which it symbolized. El Lissitzky, who left Russia for Berlin at the end of 1921 and was an influential spokesman for the new art,[25] exemplified this thinking in writings such as "Suprematism in World Reconstruction" of 1920.[26] His view encompassed the rapid forms of modern transportation, the development of electricity and radio, and a dynamic architecture utilizing spatial diagonals, all of these subsumed in the new urban environment. The technological nature of this world, he concluded, had led artists to emulate the engineer and "take ruler and compass . . . in our hands."[27]

In works from late 1919 to 1920, Lissitzky used the geometric forms generated by these drafting instruments to produce non-objective images (fig. 72), to which he gave explicitly architectural and urbanistic titles, such as *Town*, *Bridge*, and *Moscow*.[28] His interest in modern spatial dynamism prompted him later to design a room for the Great Berlin Art Exhibition of 1923, whose title, *Proun Room*, incorporated the name Lissitzky used for his works, an acronym for "Project for the Affirmation of the New" (cat. nos. 139, 140). The four walls, floor, and ceiling of this space all bore interrelated mural paintings and reliefs, and thus the viewer was involved in a fully three-dimensional experience.

Of the numerous Eastern European artists drawn to Berlin in the immediately postwar years,[29] Moholy-Nagy was especially active as both practitioner and proselytizer for Constructivism, in the latter capacity as Berlin editor for the Hungarian periodical *MA*, beginning in June 1921. Having left Hungary following the collapse of its revolution in 1919, he retained his social radicalism, at least during the early twenties, as indicated in his essay "Constructivism and the Proletariat," of 1922:

> There is no tradition in technology, no consciousness of class or standing This is the root of socialism. . . . It is the machine that woke up the proletariat. . . . This is our century—technology, machine, socialism.[30]

That it was the city that focused this view of the new age is demonstrated by Moholy's outline of 1921-22 for the never-realized film *Dynamics of a Metropolis*. The project can be read as a kind of manifesto, comparable to Meidner's essay of 1914, particularly in their common emphasis on light and movement in the city.[31] As shown in the visual elements he chose for the film, Moholy's conception of the city embraced transportation, industry, and commerce, as well as modern means of communication.[32] He saw the urban fabric as made up of streetlights and illuminated signs, in addition to buildings, bridges, and cranes. Moreover, sports and entertainment, as well as social critique through images of prostitutes, policemen, and garbage, are themes suggestively included in the outline for the film.

Imagery similar to that planned for the film had already been incorporated in some of Moholy's paintings of around 1920-21, such as the fragments of railway cars and trestles in *Bridges* (fig. 73) and the suggestions of telegraph poles and wires in *Large Railway Painting*. By 1922, he had thoroughly absorbed the

Fig. 72: El Lissitzky, *Proun 1 E* from the *First Proun Portfolio*, 1921, George Costakis Collection (owned by Art Co. Ltd.).

25. Christina Lodder, *Russian Constructivism* (New Haven and London, 1983), p. 227.
26. Lissitzky-Küppers, pp. 327-29.
27. See also his lecture on "New Russian Art," given in Berlin in 1922; Lissitzky-Küppers, pp. 34, 330-32.
28. Harvard University Art Museums, Busch-Reisinger Museum, *El Lissitzky, 1890-1941*, catalogue by Peter Nisbet (Cambridge, 1987), p. 20.
29. Passuth, "Berlin centre de l'art est-européen," in Centre National d'Art et de Culture Georges Pompidou, pp. 222-31.
30. *MA*, May 1922; in Richard Kostelanetz, ed., *Moholy-Nagy* (New York, 1970), p. 185.
31. See Andreas Haus, *Moholy-Nagy: Photographs and Photograms* (New York, 1980), pp. 21-22.
32. Kostelanetz, pp. 118-23; see also Passuth, *Moholy-Nagy*, plates 81-84.

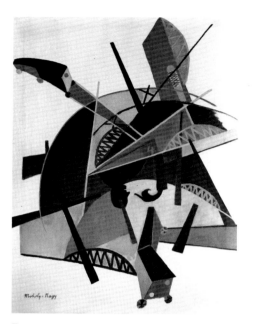

Fig. 73: László Moholy-Nagy, *Bridges*, 1920, oil on canvas, Saarland Museum Saarbrücken in der Stiftung Saarländischer Kulturbesitz.

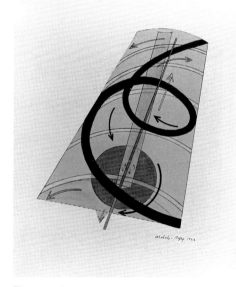

Fig. 74: László Moholy-Nagy, *Kinetic Constructive System*, 1922, watercolor and collage, Bauhaus-Archiv, Berlin.

33. Passuth, *Moholy-Nagy*, pp. 28, 31.
34. Passuth, *Moholy-Nagy*, pp. 22-24.
35. For example, those of Paul Scheerbart and Adolf Behne, and some of the contemporary work of Mies van der Rohe and Bruno Taut.
36. "Dynamisch-konstruktives Kraftsystem," *Der Sturm*, no. 12 (1922); in Passuth, *Moholy-Nagy*, p. 290.
37. Passuth, *Moholy-Nagy*, pp. 53-55.

influence of Constructivism, so that his works were non-objective. Dada as well as Constructivist ideas informed his so-called "Telephone Pictures," ordered from a sign factory and executed in enamel on sheetmetal. With a wittiness inspired by the *Dada Almanach* of 1920, these pictures underline the industrial nature of the modern world, and their precision and formal logic characterize the ideal of the artist as engineer.[33] Also in 1922, Moholy created paintings (see cat. no. 46) that can be described as "glass architecture," after the title of one of the works.[34] The spare geometric elements and suggestions of transparency and ambiguous space in these works create a quality of dematerialization, which may be indebted to contemporary architectural theories that were particularly current in Berlin.[35]

Such paintings convey an idealized, utopian view of modernity, to be distinguished from the social criticism of Dada and the functionalism or productivism toward which the Russian Constructivists had by then developed. Moholy's attitude was also apparent in his goal of incorporating modern dynamism in his work. His watercolor entitled *Kinetic Constructive System*, of 1922, is a schematic vision of complex movement in space, which he hoped to realize in three-dimensional form (fig. 74). It was thus inspired by Russian works, in particular, Tatlin's *Monument to the Third International* and Naum Gabo's *Kinetic Construction*, both of 1920. The 1922 essay that Moholy co-authored with his compatriot Alfred Kemeny, "Dynamic-Constructive System of Forces," articulates the theory underlying his watercolor.[36] They advocated the "creation of freely moving . . . works of art," based on experiments with suspended sculpture and "film as projected spatial movement." The resulting dynamic constructions would organize relationships of forces and thereby embody the principle of "vital constructivity" inherent in all life.

Moholy did not achieve his goal of kinetic construction until the end of the decade, when he created a "light prop for an electrical stage," entitled the *Light Display Machine* or *Light-Space Modulator*.[37] With this device he made the abstract film *Light Display: Black-White-Gray*, completed in 1930 (see cat. nos. 143, 144). The metal and plastic elements brought the transparency and reflectivity of modern materials into complex sequences of movement. Thus, both in sculpture and in film, he captured the spirit of technology and the architectural effects of the modern period.

Moholy's construction can be seen as a culmination of the view of the modern world initiated by the Futurists and crystallized in Meidner's manifesto on the city, an urbanistic conception of multi-directional movement in an environment of light, encompassing the rushing tempo and density of modern life, as well as the technological and industrial character of the era. Between the 1914 publication of Meidner's essay and the twenties, however, a major transformation had occurred in the concept of modernity. The vastly destructive power of the machine and of human nature itself had fundamentally undermined the celebratory view of the city held by some Expressionists, as well as the visionary mysticism of others like Meidner. Beckmann's compassionate pessimism was an apt response to the war and its harsh aftermath. The Dadaists' ridicule of rationality and other moral and cultural values of bourgeois society was a more radical reaction, as was their dedication to anarchism and Communism. In its allusions to urban modernity, their work was charged with ambiguity and irony, though some like Hausmann harbored the hope that a new human being could arise from the modern context.

The utopianism in Moholy's work from 1922 on, as in that of other Constructivists, represented a restored faith in rationality and technology, within the sobered atmosphere of the period following the failure of the Central European

revolutions. Modern urban values were reflected in the rational, non-objective art of international Constructivism, paralleling the geometry and functionalism of utilitarian and architectural design of the twenties. These movements flourished in the period from late 1923 on, when the Weimar Republic achieved economic and political stability. New Objectivity was a term used to characterize the culture as a whole during these years, and also to designate a revival of realism in art, some representatives of which continued the social criticism of the immediately postwar period. Realism and Constructivism remained separate styles, however, unlike the movements during the tumultuous late teens and early twenties. The intermixing of artistic and thematic strains in the earlier period reflected its social upheavals and produced the range of critical commentaries on the modern self and its urban context discussed here.

Selected Bibliography

Benson, Timothy O. *Raoul Hausmann and Berlin Dada*. Ann Arbor, 1987.

Berlin Museum. *Stadtbilder: Berlin in der Malerei vom 17. Jahrhundert bis zur Gegenwart*. Berlin (West), 1987.

Berlinische Galerie. *Ich und die Stadt: Mensch und Grossstadt in der deutschen Kunst des 20. Jahrhunderts*. Ed. by Eberhard Roters and Bernhard Schulz. Berlin (West), 1987.

_____. *Stationen der Moderne: die bedeutenden Kunstausstellungen des 20. Jahrhunderts in Deutschland*. Berlin (West), 1988.

Centre National d'Art et de Culture Georges Pompidou. *Paris-Berlin 1900-1933: rapports et contrasts France-Allemagne*. Paris, 1978.

DeShong, Andrew. *The Theatrical Designs of George Grosz*. Ann Arbor, 1982.

Harvard University Art Museums. Busch-Reisinger Museum. *El Lissitzky, 1890-1941*. Catalogue by Peter Nisbet. Cambridge, 1987.

_____. *German Realist Drawings of the 1920s*. Ed. by Peter Nisbet. Cambridge, 1986.

Haus, Andreas. *Moholy-Nagy: Photographs and Photograms*. New York, 1980.

Haxthausen, Charles Werner. *Modern German Masterpieces from the Saint Louis Art Museum*. St. Louis, 1986.

Kostelanetz, Richard, ed. *Moholy-Nagy*. New York, 1970.

Lewis, Beth Irwin. *George Grosz: Art and Politics in the Weimar Republic*. Madison, 1971.

Lissitzky-Küppers, Sophie. *El Lissitzky: Life, Letters, Texts*. London, 1968.

Lodder, Christina. *Russian Constructivism*. New Haven and London, 1983.

Los Angeles County Museum of Art. *German Expressionism 1915-1925: The Second Generation*. Ed. by Stephanie Barron. Los Angeles, 1988.

Miesel, Victor H., ed. *Voices of German Expressionism*. Englewood Cliffs, N.J., 1970.

Motherwell, Robert, ed. *The Dada Painters and Poets: An Anthology*. New York, 1951.

Passuth, Krisztina. *Moholy-Nagy*. London and New York, 1985.

Roters, Eberhard. *Berlin, 1910-1933*. New York, 1982.

Saint Louis Art Museum. *Max Beckmann Retrospective*. Ed. by Carla Schulz-Hoffmann and Judith C. Weiss. St. Louis, 1984.

Staatliche Museen zu Berlin. Altes Museum. *Kunst in Berlin, 1648-1987*. Berlin (GDR), 1987.

University of Michigan Museum of Art. *Ludwig Meidner: An Expressionist Master. Drawings and Prints from the D. Thomas Bergen Collection. Paintings from the Marvin and Janet Fishman Collection*. Text by Victor H. Meisel. Ann Arbor, 1978.

Willett, John. "Art in Berlin 1900-1937." In *Berlinart 1961-1987*, by The Museum of Modern Art, pp. 23-35. New York, 1987.

From New Objectivity to Nazi Order

Gudmund Vigtel

The emergence of *die Neue Sachlichkeit*—"New Objectivity," as it is called in the United States—is seen as a reaction to expressionist excesses and the rather studied iconoclasm of Dada.[1] Neue Sachlichkeit is also perceived as part of a general turn to realism that took place in Europe during the 1920s and 1930s. In Germany, postwar exhaustion was acute after a decade of wild emotional upheavals—from the heady national mood at the outbreak of World War I in 1914, to the despair caused by Germany's defeat four years later and the subsequent economic devastation resulting from the most unrelenting inflation the world had ever seen.

Expressionism in Germany was a deliberate effort to shed the stifling conservatism of the art academies and to uphold free expression and the sanctity of the individual. The expressionists hoped to improve the social order with their work. The movement had at first an apolitical program, and a number of the avant-garde artists were seized by the swell of patriotism when German soldiers marched off to war. Later, when the ghastly casualties returning from the front could no longer be concealed and shortages were beginning to seriously affect the population, expressionist artists became committed pacifists and active commentators on the national suffering.

With the reverses in the war, socialism became a principal factor in German politics. The military defeat and the abdication of Kaiser Wilhelm revealed indisputably the inadequacies of the national leadership and the system's vulnerability to ruthless opportunists. Revolution broke out when the communists made power plays in the confusion. Conservative forces in the leadership (helped, undoubtedly, by the Germans' inherent respect for authority) put down the uprisings, and a peace of sorts was maintained by a coalition government dominated by moderate socialists guided by strongly conservative motivations. It was at this time, in 1919, that the German National Assembly was moved to Weimar as a precaution. Although policy-making and intellectual life continued to be centered in Berlin, Weimar gave its name to the period between 1918 and 1933, when Hitler seized power.

The expressionist, liberal artists participated generally on the losing side, that is, on the side of the revolutionary communists. They dedicated their creative work to pacifism, to humanitarian idealism, and, as bitter disappointment set in, to increasingly strident criticism of the ruling classes. With order the goal, the rulers turned to the military and the *Freikorps* to put out the revolutionary fires set by radical leftists in Berlin, Munich, and elsewhere. The Freikorps were well-armed, loose bands of reactionary ex-officers and soldiers from the war joined by lawless adventurers who hired out to the rightist forces in national and regional governments to suppress the communists. Their murderous practices and even their favored symbol—the swastika—were harbingers of things to come. Political murders and other crimes made a demoralized populace even more miserable, and the cynicism of the leadership was underscored by the courts. Freikorps depredations were punished with mere slaps on the wrist while transgressions by the radical opposition were prosecuted to the full extent of the law.

In such an atmosphere, the protests and the impassioned social criticism on the part of the artists required considerable commitment and courage. The

1. The new movement was given its name by Gustasv Hartlaub, the director of the Kunsthalle in Mannheim, who staged the first major exhibition of this new realistic art in 1925. He distinguished between the radical, politically involved form of Neue Sachlichkeit, which he called Verism, and a less committed, more conservative, classicist version. See John Willett, *German Realism of the Twenties* (Minneapolis: Minneapolis Institute of Arts, 1980), p. 32.

expressionists' campaign against the suffering of the largely defenseless proletariat, the war cripples, and the victims of war generally produced a body of paintings and graphic work which in its radical political commitment has hardly any equal. The horrors of war had turned expressionism from a relatively optimistic, nature-loving vision dedicated to renewal and hope toward a relentlessly harsh commentary on the military and the profiteers and their indifference to the working class and the lot of the war veterans. George Grosz, Otto Dix, and Max Beckmann were among the most prominent and eloquent champions against war. They were joined by the nihilistic social critics of the Dada movement in Berlin, which sought to shatter old traditions and to renew society through the most extreme rejection of conventional artistic vehicles.

It is a cruel irony that the avant-garde failed to win popular support, not only because their subjects offended bourgeois sensibilities but especially because they deliberately rejected artistic conservatism in their unblinking depictions of the dreadful consequences of war. The working class could not understand these departures from academic tradition and heartily disliked them for that reason. The ruling class was, of course, outraged by the attacks on its own position and on common propriety. In short, the avant-garde was met with what John Willett refers to as "primitive-conservative resentments."[2] Even as respected a spokesman for modernism as Julius Meier-Graefe wrote about Otto Dix's 1923 painting *Trench* that it made him want to throw up.

In these hard times Berlin attracted a large number of intellectuals and artists, writers, actors, musicians, and cabaret performers. During the Weimar years, dozens of theatres, concert halls, and operas flourished in Berlin. Experimentation was the mark of the time. There were countless movie and variety theatres and cabarets where Broadway-style shows were edged with biting irony.[3] It was a period of remarkable creativity in architecture and modern industrial design inspired by social idealism. It all came to an end in the 1930s, condemned by Adolf Hitler as communist schemes to undermine German culture. But before that interruption, "artist after artist reflected the city" in an extraordinary outburst of modern genius.[4]

After war, defeat, and revolution, there was yet another blow: inflation, an inflation that devastated an economy already on the edge of disaster, that wiped out the savings of the middle class and whatever narrow margin against starvation the poor still had. It was brought on by the government's arrogant failure to finance the war with taxes and, of course, by the general ruination of industry and the work force. The inflation and war reparations set by the victorious Allied nations brought about an unprecedented economic hemorrhage that lasted until the end of 1923. Alarm at this debilitating development in one of Europe's most important markets led to a program of loans instituted by American financial interests in an effort to rescue the German economy. The policy had swift results. It ended inflation and, coupled with a moderate pragmatic government, produced half a decade of relatively prosperous stability. It was to be a brief respite.

The artists, too, seemed to turn from revolutionary battle cries and overt confrontations to introspection. While the artists forsook strident criticism for crisp descriptions of observable fact based on earlier traditional objectivity, their work was by no means free of commentary, sometimes of a particularly acidic kind. The artists assumed a cool, analytical attitude which must be said to characterize die Neue Sachlichkeit: on the one hand a closely observed objectivity, on the other an implicit rejection of the way things were.

Much of this new direction was drawn from Italian surrealism and French cubism as well as the highly original abstract work of the Russian constructivists. However, the heart and hand of Neue Sachlichkeit were to be found among

2. John Willett, *The Weimar Years, A Culture Cut Short* (London: Thames and Hudson, 1984), p. 7.
3. See Wolfgang Bethke, *Berlins Geschichte im Überblick* (Berlin: Gebrüder Holzapfel, 1987), p. 103-4.
4. John Willett, *Art and Politics in the Weimar Period* (New York: Pantheon Books, 1978), p. 101-4.

the keen observers of post-revolutionary society in Germany, and especially in Berlin. They included artists such as George Grosz, Otto Dix, and Rudolf Schlichter, who had been among the flaming revolutionaries. For all of their calm reflection, the artists of the Neue Sachlichkeit (especially Grosz and Dix) never entirely suppressed the urge to expressionist commentary.

Max Beckmann was an outsider who had begun as a brilliant observer of the urban landscape with expressionist undertones (cat. no. 30). After his harrowing experiences at the front, he increasingly focused on mystical interpretations of human existence and a profound compassion for his fellow beings (cat. no. 134). Käthe Kollwitz was another compelling observer of German society who eschewed the protest of the expressionists for deeply felt interpretations of the tragedies of hunger, loss, and death (cat. no. 156).

George Grosz saw life with the eye of a merciless prosecutor, and there was little in German capitalist society which escaped his wrath—neither the harsh military men, the well-fed profiteers, nor their lewd women. As might be expected, Grosz ran afoul of the courts for offending public sensibilities. Only the crippled veterans and the street beggars seemed to arouse his compassion. Grosz moved from full-bodied painterly expressionism (cat. no. 40) to the most incisive, spare, and unfailingly accurate description of human affairs (cat. no. 50). He was a member of Berlin Dada and he engaged briefly in a precisionist surrealism. His relationship to Neue Sachlichkeit must be seen in his inextricable involvement with contemporary urban life and social commentary even though he never adopted the movement's cool, exacting manner.

Like Grosz, Otto Dix was fully involved in the expressionists' commentaries on the devastating effects of the war. (A 1920 painting by Conrad Felixmüller of Dix before his easel (fig. 75) shows him in the combative stance of a prize-fighter.) The early works from the war years and immediately afterwards are marked by a very strong cubist and futurist influence, which by the early 1920s gives way to visceral, direct expression. When Dix moved to Berlin in 1925 he began a series of works that reflect a more reserved, skeptical outlook. The *Self-Portrait* of 1926 (cat. no. 147) is precise and free of expressionist gesture, but the severe scowl reveals the artist's inner tension. His great triptych of 1927/28, *Metropolis* (see cat. no. 148), shows a similar severity in the formulation of detail in the central panel of rather joyless partygoers, while the side panels are energized by the demonic revellers' confrontation in the streets with crippled war veterans. A similarly disturbing undercurrent sharpens the depiction of *Three Streetwalkers* (cat. no. 48).

Carl Hubbuch's *Self-Portrait* (cat. no. 145) is marked by the forced scowl seen in Dix's visage (cat. no. 147), which injects Hubbuch's simple, almost artless drawing with great energy. Neue Sachlichkeit was more than objectivity; it was realism penetrated by knowing observation. This is nowhere more evident than in Rudolf Schlichter's revealing portrait of the playwright Bertold Brecht (cat. no. 47). The shrewd, direct glance, the restless movement frozen in a tense stance, the crackling highlights, suggest a formidable personality. Schlichter was an early member of Berlin Dada and a dedicated communist who depicted proletarians with a pronounced sympathy for their inner dignity. The maimed worker's wife (cat. no. 146) is, for all her misfortunes, nevertheless possessed of a calm, easy friendliness, endowed, as Schlichter portrays her, with great human worth.

Because acute observation was such a central aspect of Neue Sachlichkeit, the choice of subject matter could be of particular significance for reflections on contemporary mores. Christian Schad's portraits are striking representations of people of the time who are defenseless under the artist's intense scrutiny. They

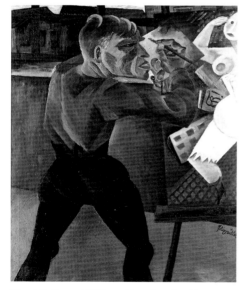

Fig. 75: Conrad Felixmüller, *Otto Dix Painting*, 1920, oil on canvas, Staatliche Museen Preussischer Kulturbesitz, Nationalgalerie, Berlin.

are shown almost as specimens dissected in a vacuum, isolated from their environment in an empty, closed space. *Count St. Genois d'Anneaucourt* (cat. no. 53) seems unsettlingly still, standing watch with his reptilian companions in a nocturnal stage-like setting. The protagonists in *Agosta the Birdman and Rascha the Black Dove* (cat. no. 54) are by contrast much more accessible psychologically. What sets them apart are his deformity and her race. Agosta made his living as a circus exhibit and Rascha as a snake dancer from Madagascar. For all their exoticism they were, according to Schad, simple, solid citizens.

The freedom of sexual expression had been a major subject for the expressionists. Women of the night had been of great interest to the Brücke artists. Grosz and Dix showed women as corrupting elements in society, Dix pursuing that subject almost obsessively in the later 1920s. Both artists tended to show women as predatory and generally repulsive. Richard Ziegler on the other hand painted women as objects of secret desires. His voyeuristic *Widow* (cat. no. 52) presents the subject as a siren, a sinister and dangerous temptation. August Dressler's gentle *Lovers* (cat. no. 149) seems almost an anachronism in its innocence, but its unaffected objectivity is in keeping with the manner of Neue Sachlichkeit.

As might be expected, the prosperity of the mid-twenties tended to weaken the extremes on both right and left in the German political spectrum and undoubtedly influenced the perceptible moderation in the visual arts.[5] Then came the crash of 1929 and the loans made to Germany during the mid-twenties were called in by foreign investors. Unemployment shot up and tax revenues dropped sharply. The communists took to the streets again and were met, not by the Freikorps (who had been disbanded years before) but by their heirs, the Nazi stormtroopers. Hunger and unrestrained violence again were part of Berlin's daily life and forced repeated changes of government until the National Socialists, Adolf Hitler's party, gained a larger number of votes nationally than any other party. The old and deteriorating president of the Republic, Paul von Hindenburg, was persuaded to choose Hitler to form a government in January 1933.

There were signs already by that time that the sting was going out of Neue Sachlichkeit. The activists among the artists were perhaps worn down and anxious to find stability in their personal lives. Some turned to a bland apolitical realism, others left the country in anticipation of things to come with the Nazis in power. Avant-garde expression saw its existence cut off as though by an executioner's sword. Modern artists were forbidden to show their work and even to paint, and soon public art was subjected to Hitler's taste-makers, whose ideas of good art were the conservative traditions of the nineteenth century with all sense of modern concerns squeezed out. Art was to recall "the good old days," when life was untainted by those dens of sin, the sprawling cities inhabited by radical intellectuals who were forever undermining law and order—that is, the Nazi order.

In spite of bans against their work, artists continued to create in secret. Carl Hofer, among the most prominent, actually continued to produce a substantial body of work with dark reflections on the artistic and spiritual freeze (cat. nos. 56, 57, 158, 159). His studio was destroyed during Allied bombings of Berlin, but he continued to paint, obstinately, clandestinely, throughout the Nazi terror. Max Beckmann's work became increasingly introspective and insulated. His work *The King* (cat. no. 55), painted in 1937, may suggest a self-portrait of the artist in regal isolation, the artist as spiritual leader, vulnerable and shielded from external threats that menace his noble calling. German artists were by that time in dire danger, and conditions in Germany led Beckmann to depart in

5. See Willett, *The Weimar Years, A Culture Cut Short*, p. 56.

1937, first for Holland and England, and finally on to the United States. Modern art in Germany in all of its manifestations was brought to a halt for the twelve-year duration of the Nazis' total rule.

After Hitler seized power in January 1933, he lost little time in laying out his views of what contemporary art should be in Germany, and he left no doubt about his withering scorn for modern art as it had emerged in Berlin. Hitler had developed an unrelenting hatred for radical intellectualism. With his racist paranoia, he saw the scathing social criticism by Berlin artists and writers as a conspiracy against German patriotism, and he blamed his archenemies, the communists. Modern art in Berlin, or "urban art" as Charles Haxthausen describes it, "which had presented unpleasant truths about modern reality, was condemned as a symptom of the cultural decay for which National Socialism, with its return to 'healthy' German values, was the ostensible cure. Imagery of the modern city disappeared from the officially sanctioned painting of the Third Reich. . . . The 'new' art offered an escapism. . . ."[6]

For Hitler, the escape from the harsh ridicule of bourgeois standards by the avant-garde was to be found in conservative Munich, which was so close to his own Austrian origins, both geographically and culturally. Munich had been the famous seat of the great Academy where some of the most revered German realist masters of the nineteenth century had worked. A tradition of nationalist realism lingered on, in contrast to the international modernism of the Capital.

Early on, Hitler planned to move the seat of official German art to Munich. Art was to reflect "the good old days," to be devoid of contemporary concerns, technically correct and superficially pretty. This program, in fact, followed Hitler's petit bourgeois taste for what we know as calendar art, based on anti-intellectual values and an escape from everyday life. Long before Hitler, modern artists, especially in Berlin, had been subjected to attacks, and much of the Nazis' criticism of modern art echoed and extended earlier insults levelled at the expressionists and non-objective artists.

Hitler's goal for native German art was twofold: To build a *Haus der Deutschen Kunst* (House of German Art) in Munich which would make that ancient city the art capital of the Third Reich, and to eradicate, once and for all, the expressionist, Dada, and non-objective movements. To this end, he had already begun to work on a plan for such a museum in the 1920s with the architect and party-member Paul Ludwig Troost. Hitler had not been in power for more than a few months when his men successfully extracted funds from bankers, industrialists, and governmental departments, all in the name of the German people, for the purpose of building the Haus der Deutschen Kunst (fig. 76). Some of these financial leaders were to discover too late that their pledges were not used for the promotion of the best in German art, but for the destruction of it.[7]

The opening of the Haus der Deutschen Kunst was set for July 18, 1937, and the *Grosse Deutsche Kunstausstellung* (Great German Art Exhibition) was to mark this momentous event. Twenty-five thousand invitations were sent out a year in advance, encouraging artists to submit their newest work to a jury of their peers. No less than fifteen thousand entries were received in Munich and the jury set to work. It became clear to the party men in charge of the project, however, that the initial selections of fifteen hundred paintings and sculptures did not conform to Hitler's idea of what German art should be, and the artists on the jury were replaced with party stalwarts who began to sift out works that were "almost as good as photographs."[8]

Although the most elaborate administrative structure was devised for the

Fig. 76: Procession with the model of the Haus der Deutschen Kunst to observe the laying of the cornerstone, October 1933.

6. Charles W. Haxthausen, *Berlin: Art and Metropolis, Works on Paper* (Minneapolis: University of Minnesota, 1987), n. pag.
7. See Peter-Klaus Schuster, *National-sozialismus und Entartete Kunst* (Munich: Prestel-Verlag, 1987), p. 56-69.
8. Ibid., p. 44.

Fig. 77: Exhibition gallery of the *Grosse Deutsche Kunstausstellung*, 1937.

organization of the Haus and the massive exhibition, it was clear from the start that all decisions were under the control of Hitler's propaganda chief, Joseph Goebbels. It was equally clear to Goebbels that his controls were subject to the whims of the Führer. When Hitler and Goebbels came to inspect the Haus (fig. 77), which Goebbels described in his diary as "beautiful as a dream,"[9] Hitler flew into a towering rage when he saw the selections for the exhibition. He proceeded to throw out the "dung," as Goebbels described it, until "quite pleased" by the exhibition.[10] The illustrated catalogue suggests an exhibition of remarkably tame academic work, in stark contrast to what Hitler called "the passionate will of the Third Reich" with which these choices and events were brought into being (fig. 78).

An immense amount of effort and money lay behind the final presentation. The opening celebration, the *Tag der Deutschen Kunst* (Day of German Art) on July 18, 1937, began with an elaborate parade of thirty floats with the theme of two thousand years of German culture (figs. 79 and 80) and five thousand participants, including five hundred on horseback, trailed by detachments of the armed forces, the S.S., and the "brown-shirts." The parade illustrated more

Fig. 78: Richard Klein, *The Awakening*, oil on canvas, included in the *Grosse Deutsche Kunstausstellung*, 1937.

Fig. 79: A float from the procession on the Tag der Deutschen Kunst, 1937.

9. Ibid., p. 44.
10. Ibid., p. 48.

eloquently the taste of the Nazi regime than did the gargantuan House of German Art with its barren exhibition. The cardboard versions of historical monuments floating through the streets of Munich, the costumes of Germanic warriors and maidens (fig. 81), the racist symbolism (fig. 82), and the participation of the military and the stormtroopers give a memorable picture of the Nazi art program.

Meanwhile, just a few blocks away, Goebbels's people were getting another exhibition ready for the next day's opening—an exhibition which had far more sinister implications for German art.[11] The Nazis wanted to underscore the significance of what they thought was great by comparing it to what they considered to be worthless and degenerate in contemporary German art. Working feverishly on the exhibition *Entartete Kunst (Degenerate Art)*, they pulled together some six hundred works by more than a hundred Germans and a few foreigners, including such important artists as Ernst Barlach, Willi Baumeister, Herbert Bayer, Max Beckmann, Heinrich Campendonk, Marc Chagall, Lovis Corinth, Heinrich Davringhausen, Otto Dix, Max Ernst, Lyonel Feininger, Conrad Felixmuller, Otto Freundlich, Werner Gilles, George Grosz, Raoul Hausmann, Erich Heckel, Karl Hofer, Johannes Itten, Alexej Jawlensky, Wassily Kandinsky, Ernst Ludwig Kirchner, Paul Klee, Oskar Kokoschka, Wilhelm Lehmbruck, El Lissitsky, Franz Marc, Ludwig Meidner, Jean Metzinger, Laszlo Moholy-Nagy, Piet Mondrian, Otto Mueller, Erich Nagel, Ernst Wilhelm Nay, Emil Nolde, Max Pechstein, Hans Purrmann, Christian Rohlfs, Hans Richter, Oskar Schlemmer, Rudolf Schlichter, Karl Schmidt-Rottluff, Kurt Schwitters, and others.

Preparation had also been in progress since the year Hitler grasped power for regional exhibitions of modern art—events the Nazis called "exhibitions of shame" and "chambers of horrors"—which were seen as forerunners of the major exhibition of degenerate art. These events were accentuated by "actions of purification" by the Nazis—the systematic removal and confiscation of modern art from German museums. The museums, generally, had had a distinguished record of acquiring works by modern artists and the Nazi confiscations produced huge holdings of paintings, graphics, and sculpture which became the source of works for the Munich exhibition. *Degenerate Art* opened to the public on July 19, 1937, the day after the great "Day of German Art." In installing their exhibition, Goebbels's staff had made every effort to present the modern works in an extremely crowded and chaotic arrangement (fig. 83), in contrast to the cool and spacious presentation of the Great German Art Exhibition. They had gone to a great deal of trouble to cull quotes from Hitler's speeches, from unfavorable criticism, and even from the radical and satirical writings by the artists themselves, all of which were plastered in great profusion on the walls among the paintings and sculptures.

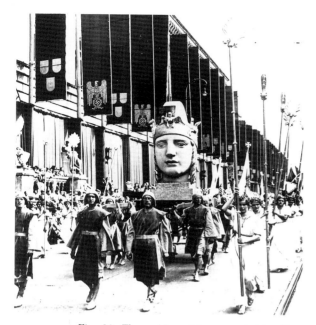

Fig. 80: The goddess Athena carried by Germanic characters in the 1937 procession.

Fig. 81: Participant in the Munich Parade, 1937.

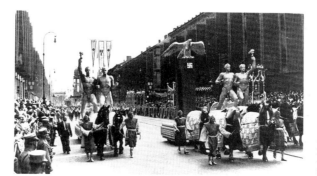

Fig. 82: The float "The New Period—Faith and Loyalty" in the 1937 procession.

11. Ibid., pp. 44, 45.

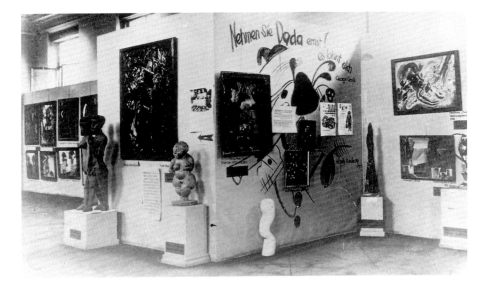

Fig. 83: Installation view of *Entartete Kunst* (*Degenerate Art*), 1937, with a quote by George Grosz, "Take Dada seriously! It pays off."

Fig. 84: Hubert Lanzinger, *Portrait of the Führer*, oil on canvas, included in the *Grosse Deutsche Kunstausstellung*, 1937.

No effort or expense was spared in getting the public to attend the free exhibition, with the added "attraction" that minors were not allowed. Bright red handbills were distributed with phrases such as "Tortured Canvas," "Spiritual Decay," and "Lunatic Non-Achievers," heavily larded with anti-Semitism. The Nazis succeeded spectacularly, with an attendance of two million in Munich during the four months before the show went on the road. Ironically, the Great German Art Exhibition in the brand new House of German Art attracted only one-third as many. Nevertheless, the exhibition was to be carried on annually. The new building became known as "Palazzo Kitschi."[12]

The works of art from these two projects were to have strange fates. While much of the confiscated art had been destroyed publicly by the time the war was over, a number of the most important modern works survived. Some were sold abroad by the Nazis and can now be seen in European and American museums as well as some museums in Germany. What had remained in Munich became a treasure trove of German expressionists on view in Munich's State Gallery of Modern Art, located in what had once been Hitler's dream for the future of German culture, and what is now known as the Haus der Kunst.

Hitler's favorites, some of which were presented in 1937 with such bombast in that temple for art, wound up in large numbers in Allied hands but were eventually returned to West Germany. The final irony is the fact that these Nazi treasures have been kept under lock and key by the authorities as a national embarrassment from a period which almost destroyed the cultural life of Germany.

12. See *Museen in München* (Munich: Prestel-Verlag), 1983/84.

Selected Bibliography

Berlin Museum. *Stadtbilder: Berlin in der Malerei vom 17. Jahrhundert bis zur Gegenwart*. Berlin, 1987.

Berlinische Galerie. *Ich und die Stadt: Mensch und Grossstadt in der deutschen Kunst des 20. Jahrhunderts*. Ed. by Eberhard Roters and Bernhard Schulz. Berlin, 1987.

Gay, Peter. *Weimar Culture: The Outsider as Insider*. New York, 1970.

Minneapolis Institute of Arts. *Realism of the Twenties: The Artist as Social Critic*. Minneapolis, 1980.

Schuster, Peter-Klaus, ed. *Nationalsozialismus und Entartete Kunst*. Munich, 1987.

Staatliche Museen zu Berlin. Altes Museum. *Kunst in Berlin, 1648-1987*. Berlin, GDR, 1987.

Willett, John. *Art and Politics in the Weimar Period*. New York, 1978.

Willett, John. *The Weimar Years. A Culture Cut Short*. London, 1984.

Art in Berlin From 1945 to the Present

Eberhard Roters

Nazi Germany was conquered in May 1945, the Second World War came to end, and the artistic life of Berlin—which had been holding its breath—came alive again. The city's cultural forces had been suppressed by every available means for the twelve years' duration of the "Thousand Year Reich." Those who had survived the Terror stood ready to resume cultural leadership. It was a matter of finding the right direction under the circumstances. There were not many men and women in a position to redirect the cultural orientation, but there were enough; in fact, there were more than might have been expected. Artists throughout Berlin got together without knowing what was going on in other parts of the devastated city and founded groups which showed works under headings such as "The Young Generation." Among the younger generation were people in their forties who had not been allowed to exhibit in the early stages of their careers and who had labored in secret because their work was unacceptable to the Nazis. Most of them had served in the armed forces, and it was only after the war that they were able to show their work for the first time.

The most important event of those early months was the exhibition *Modern French Painting*, organized by the educational and cultural affairs division of the Groupe Français du Conseil de Contrôle and shown in 1946 in the National Palace (which has since been demolished). The Berliners, who had not seen modern art for a very long time, came in droves and formed lines kilometers long to admire the van Goghs, Gauguins, Matisses, Renoirs, and Picassos which had been denied them for so long.

The very first postwar exhibition in Berlin took place in the early summer of 1945 in the facilities of the public education department of the Steglitz district. It was organized by the sculptor Hans Uhlmann, who sought out works that had not been shown during the Nazi period. Jeanne Mammen, Oskar Nerlinger, Renee Sintenis, and Georg Tappert were among the exhibitors.

Hans Uhlmann belonged to the Galerie Rosen stable of artists. Gerd Rosen, a Berliner, opened the first postwar German private gallery on the Kurfürstendamm in August 1945. Under the circumstances, it was a bold undertaking which seemed optimistic almost to the point of lunacy. The Kurfürstendamm, which had once been the magnificent boulevard of Berlin's Neue Westen ("New West"), lay in ruins. (The "Old West" was the district of patrician homes in central Berlin around the great park known as the Tiergarten). Not a building remained untouched and the Kurfürstendamm looked like a landscape of ruins. Rosen established his gallery in the middle of the ruins in a former clothing store for the military. The debris was cleaned out and the windows fitted with patched glass panels. The former superintendent of art of the Weimar Republic, Edwin Riedslob, gave the opening speech, on "The Future of Art."[1] He had been the first high-ranking art official to be fired in 1933 by Hitler's regime. Rosen's move into the ruins of Kurfürstendamm was not a casual decision but a carefully considered act, calculated to show that the spirit of modernity had once again taken possession of the Neue Westen. The area became the birthplace of Berlin's postwar artistic development.

The Neue Westen (the area around the Kurfürstendamm, the Tauentzienstrasse, and the Kaiser Wilhelm Memorial Church) had become a fashionable cultural district by the turn of the century. The capital of the Hohenzollern

1. The art historian Edwin Riedslob was one of the founders of the Berlin newspaper *Der Tagesspiegel* in 1946 and was a founding director of the Berlin Free University.

empire, Berlin had outgrown its old boundaries by 1900 because of an immense expansion in business and finance, and had spread far into the surrounding countryside. The Neue Westen was settled primarily by liberal and progressive citizens who had been made prosperous by new business and technological enterprises and were interested in a modern way of life and in modern art. The conservative aristocracy, established in the center of town close to the imperial family, found the Neue Westen an abomination. The district was considered disreputable, libertine, and "red." It was on the Kurfürstendamm that the Berlin Secession under Max Liebermann built their exhibition hall, and it was here that young artists and writers met in the Café des Westens and later on in the Romanischen Café across the street from the Memorial Church. The district became filled with well-known galleries, right up to where the diplomats and bankers lived on the edge of the Tiergarten.

Places like the Kurfürstendamm don't lose their reputations easily. West Berlin inherited the district with the partition of the city after the war, and it seized on this heritage. West Berlin became the city of the Neue Westen, and avant-garde galleries are again located around the "Ku-Damm," as that great boulevard is known. East Berlin, by contrast, did not become the art center of the German Democratic Republic (East Germany) in spite of its National Gallery, the Academy of Art, and Institute of Art in Weissensee. Instead, the action centered in cities such as Halle, Leipzig, Dresden, and Rostock. The opening of Rosen's gallery was, for all its risks, a well-thought-out and forward-looking act.

The painter Heinz Trökes, who was the gallery's first director of exhibitions, reminisces:

> Talk of a new gallery actually took place before the war ended, in a house in Dahlem, where people who had been especially invited were able to buy books out of what the Nazis would have considered a "trunk of poison," i.e., writings by immigrants, works by Jewish authors, and books on modern art. We found a suitable facility in a former shop for military equipment on the Kurfürstendamm, after the smoke of battle had cleared in the city and people dared to walk in the streets again. But we had more. There was all manner of material for bartering—officers' underpants, leather boots, wool socks, for which we got vodka and cigarettes from Russian soldiers on the black market near the former Reichstag. These in turn were exchanged for window panes, shelves, display cases, and picture frames. . . . There was an immense spiritual hunger. Young and old thronged together during discussions and lectures and there were hot debates for or against modern art. . . . There were some young American poets working as interpreters for the Allied Control Commission who put forth a new literary magazine called *The Plumb Line*. There were performances in the cold theaters of contemporary plays such as *We Made It Again* by Thornton Wilder, *The Madwoman of Chaillot* by Giraudoux, or Sartres's *The Flies*. They were sensational successes. There was also *Mother Courage* by Bert Brecht, whose work could not be performed until 1945. . . .[2]

On June 18, 1945, a few months after the ruination of the city, the Institute for Visual Art reopened in its old facilities on Steinplatz in the Charlottenburg district. Carl Hofer was the founding director. A combative democrat and stubborn fighter for figurative art, Hofer followed his own dictates in pursuing a dour expressionism. He had been forbidden to paint or exhibit by the Nazis, and the content of his pictures had changed. Instead of painting bright landscapes and serene groups of young women, he used darkly glowing colors to grapple with the troubled times in works such as *The Jobless* (1932), *The Prisoners* (1933, cat. no. 158), *The Night of the Black Moon* (1944, cat. no. 56), *Alarm* (1945, cat. no. 159), and *Dance of Death* (1946, cat. no. 57), powerful examples of

2. Heinz Trökes, "In Berlin after Zero Hour," unpublished manuscript.

subversive political symbolism.

Similarly, the early postwar works of the artists of the Galerie Rosen showed a specifically German style which had emerged in secret in the early forties. The style had not existed before that time, nor did it create a school. It was in some ways like the work of Max Ernst; it can be described as "skeptical surrealism." With the exception of the work of Edgar Ende from Munich, this style is peculiar to Berlin and the period immediately after the war. The artists felt as if they were awakening in the chill of an inhospitable moonscape, and their pictures reflect the pitifully inadequate materials and equipment which could be "scrounged" at that time. Heinz Trökes's painting *The Moon Cannon* (1946, cat. no. 58) caused a furor although it is modest in size and seems to us almost impoverished in appearance, painted as it was on the back of a masonite panel. It was reproduced regularly in the press and prompted countless arguments about art because it had become a reflection of the intellectuals' view of life in postwar Germany. In 1946 Trökes put together at the Galerie Rosen an exhibition with that theme which was called *Fantasten* and included works by Hans Thiemann, Hannah Höch, Jeanne Mammen, and Mac Zimmermann. The theme of big-city loneliness in a landscape of ruins was expressed in the melancholy paintings of Werner Heldt and Alexander Camaro (see cat. nos. 60-62) in which the emptiness of the landscape is emphasized by occasional wooden shacks and the firewalls of huge apartment blocks.

In 1948 artists from the Rosen stable formed a group called Zone 5, which held a September exhibition at the Galerie Franz. The members of the group were Heinz Trökes, Jeanne Mammen, Hans Thiemann, Mac Zimmermann, and the sculptors Karl Hartung and Hans Uhlmann. The name Zone 5 referred to the four occupation zones of Berlin and sarcastically declared art to be an autonomous fifth zone. (By the same token, the title of Trökes's surreal painting *Between the Blocks* (1947, cat. no. 160) is a joke on the political situation of Berlin.)

In 1949 satirical sketches were performed at a club called The Bathtub by an artists' cabaret of the same name. The skeptical surrealism of the programs was similar to that seen in the visual arts. Artistic life in Berlin after the war began with much promise—the young artists were full of enthusiasm. However, the sharpening conflict among the Allies soon had an impact on Berlin's cultural life. The partition of the city by two contrasting ideologies was reflected in the art of Berlin. Trökes reported:

> Once the contrasting perceptions of art and culture in East and West became increasingly evident, the public discussions on this topic turned fiercer and more adversarial. Expressions began to be tossed about such as "bourgeois decadence" and "disguised cultural reaction." Chagall was accused of "spiritual formalism" and an exhibition of the younger generation which the city administration organized was called the "younger degeneration" by the other side. Indeed, on the occasion of a large 1946 exhibition of Russian contemporary art, the following entry appeared in the guestbook in the House of Soviet Culture: "This exhibition is a good overview of 19th century bourgeois art." (All of Cézanne's efforts seem to have been in vain.)
>
> The importation of social realism from Russia was by no means received with undivided approval. There were sharp debates over the role of the artist and of art in society. On the one hand it was argued that art should have political intent and that it would only be progressive if its contents were progressive. This claim was rejected sharply by many intellectuals who for their part stood for the autonomy of art. Thus began the spiritual division in Germany just a few years after the war and long before the Wall was erected.[3]

3. Ibid.

The emergence of two separate German states—the Federal Republic of

Germany and the German Democratic Republic—had immediate and profound cultural ramifications. The Germans of the German Democratic Republic, in the Soviet zone, turned of course to the East in their cultural and ideological orientation, while the Germans of the Federal Republic and West Berlin turned to the West. After the early postwar years the rest of the world began to open up for the Germans, who began to reacquaint themselves with what they had missed during the twelve years of Hitler's empire. They needed to acquire new information, to re-orientate themselves, to join the present. This was promoted by contacts with the intellectual institutions of the "favored" nations at first and later by interchanges with countries allied in business and cultural partnerships. Art publications, exchanges, scholarships, and exhibitions in growing numbers all contributed to this process. Those artists who did not care for the ideology where they happened to find themselves after the war had long since gone to the other side.

West Berlin is especially interesting in this context, since it has until now been the most permeable place in the cultural exchange between East and West, an exchange which has been for the most part adversarial but not without benefits for both sides. As would be expected, German artists grappled for a long time with absorbing and reworking new directions from the West. And though they embraced the new developments, they did not lose their independence, as could be seen later. During the first half of the fifties, the School of Paris determined the general style of the regained modernism. In the second half of the decade *Tachisme*[4] and, more than anything else, American action painting, were influential. The exhibitions *Jackson Pollock* and *The Abstract Expressionists*, presented in 1958 by New York's Museum of Modern Art at the Berlin Institute of Art, were revelations, especially to the younger German artists.

Two circumstances in particular influenced the German contribution to abstract expressionism and to *art informel*.[5] For one thing, the debate about abstract painting had already begun in Germany in 1910 with the nonobjective works of the Russian Wassily Kandinsky, who was living in Munich. Then, in 1933, just as the succeeding generation were ready to develop abstract art, Nazi politics cut them off radically. It was only after the war that artists like Willi Baumeister, Fritz Winter, E. W. Nay, and Theodor Werner, for example, were able to pick up again what they had been forced to discontinue. And secondly, many German artists developed such an antipathy to the Nazis' bland, figurative allegories that they turned away from realistic art entirely. They found in abstraction and *art informel* a means to express their artistic independence from the official style. Hann Trier and Fred Thieler, two of the most influential German painters who dedicated their work to *art informel*, are represented in this exhibition (cat. nos. 63-65). Both taught at the Institute of Art, and many of the young artists who established themselves in the sixties were among their students.

The sculptors Bernhard Heiliger and Hans Uhlmann came from the Galerie Rosen circle (cat. nos. 161-164). Uhlmann ran the Rosen exhibition program for a while. Both began their early work with motifs based on the human head and proceeded from there to abstraction. Heiliger's abstract yet accurate portrait likenesses first became known in the fifties. Uhlmann arrived at constructivist form via his sculpted heads. The development of this particular sculptor exemplifies the problems faced by a young artist who refused to follow the Nazi line. Uhlmann was originally an engineer. He began to teach in 1926 at the Technical Institute at Berlin-Charlottenburg, but he was fired in 1933 because of his socialist principles. He was arrested in October 1933 for distributing

4. *Tachisme* became a generic term for the European equivalent of Abstract Expressionism.

5. *Art Informel* was a term coined by French critic Michel Tapié to describe spontaneous, non-geometric, abstract painting in postwar Europe. *Art Informel* and *Tachisme* are more or less synonymous.

handbills opposing the Nazi regime and was turned over to the Gestapo and given a jail sentence of one and a half years for high treason. He developed the drawings for his first wire sculptures in the Tegel prison. This was to be the start of his career as a sculptor. His *Female Head* (cat. no. 157) was done in 1940. It is the earliest postwar piece in the exhibition and was included in this group of works because Uhlmann had no opportunity to show it until his first solo exhibition at the Galerie Rosen in 1947. His exceptionally consistent artistic development began at that point with his constructivist steel sculptures, such as a twenty-meter-high work in front of the Berlin Opera.

The progress of art in Berlin since the fifties has not been straightforward. Furious debates have occurred between the proponents of figurative art and those who pursued abstraction. The smouldering arguments turned into a pitched battle in 1953, conducted in art publications and in the daily press. The spokesman for the figurative cause was Carl Hofer, and Will Grohmann supported the abstractionists. Grohmann was at that time a leading German critic and a knowledgeable and articulate defender of international avant-garde art.

Berliners are a literary people; they have more talent for listening and reading than for seeing. They have less feeling for the painterly than Rhinelanders (for example), who tend to be oriented toward France. Berliners love conflict and like for visual expression to have a story, preferably antagonistic and energetic. In short, Berliners tend to prefer the figurative. For that reason, the sensuous, figurative works by the Brücke artists as well as those of the artists of Neue Sachlichkeit set the tone for art in the teens and twenties—an art of combative social criticism. This was true above all of the work of Grosz, Dix, Schad, and Schlichter. After 1960 works by two important artists appeared, the painter Walter Stöhrer and the sculptor Rolf Szymanski (cat. nos. 165, 167). Artists of the generation following that of Thieler, Trier, Heiliger, and Uhlmann, they had profited by the lessons of *art informel* but rejected abstraction. They understood how to evoke the figurative with a pronounced expressive manner by means of gestural handling of their media. Both Stöhrer and Szymanski tend to be motivated by literature, e.g., French *fin de siècle* or surrealist or existentialist writings. Both attempt to come to grips with erotic themes through passionate engagement with their material, be it paint or clay.

The years 1963 and 1964 were the stylistic watershed for the generation which today is in its fifties. (That was also the time of incubation for the student revolution which broke out in 1968.) Those young artists who had just left the Institute of Art were for the most part students of *art informel* painters. The *tachiste* trend, however, had become fashionable by that time, and the students were fed up with it. The students respected their teachers, but they wanted to get away from *Tachisme*, they wanted to express their own feelings, they wanted something concrete, something bold and irreverent, something that would make one's eyes sting.

A 1964 exhibition at the Academy of Art, *New Realism and Pop Art*, gave the young artists the impetus to do what they wanted to do. A few of them had founded an artists' cooperative gallery early that year which was named Grossgörschen 35 for the street where it was located. The gallery became a rallying point for the entire group, which included Karl Horst Hoedicke, Hans-Jürgen Diehl, Ulrich Baehr, Bernd Koberling, Wolfgang Petrick, Markus Lüpertz, Peter Sorge, and Lambert Maria Wintersberger.

The talent explosion of which the critics took note at the time released impulses which continue to influence the art of Berlin to this day. The Berlin art scene has enormous variety precisely because of its experimental spirit. It is not easy even for an insider to maintain a good overview. It would require many

times as much space as this exhibition affords to survey this many-sided variety. The selection offered in this exhibition is no more than an *aperçu*. Much had to be left out, such as, for example, the highly interesting development of a poetic object art and installations. Experimental photography is another omission. The exhibition includes a selection of paintings which typifies the realistic and expressionistic tendencies in the art of postwar Berlin. One may, in fact, speak of an expressive realism. For all their differences, expressive realism characterizes the work of Baselitz (cat. no. 66) as well as of Petrick (cat. nos. 81-83), of Lüpertz (cat. nos. 68, 69, 168), and of Stöhrer. In recent years, however, new directions have emerged as artists have realized increasingly contradictory interpretations. These differences have led to even more new developments because the artists have painted against each other, so to speak, in an unspoken but nevertheless intense competition. This was not the case when these artists first appeared in 1963 and 1964—at that time they were united above all in their awareness of what they were *against*. What they were *for*, not even they knew for certain. That emerged later.

The young Berlin artists were impressed by pop art. It seemed like a door that had suddenly been torn open, with a fresh wind whistling through it. They were gripped, above all, by the insolence which dared to present trivial consumer goods as art in commercial and equally trivial forms but with great virtuosity. But Berlin artists were not especially attracted to the "cool" in pop art; they liked it hot. This was the difference between the Berliners and the Americans.

In 1961 two young Berlin painters held a "Pandämonium" in their studio in an inner-city tenement building. It went pretty much unnoticed, and in 1962 they held a second. Georg Baselitz, who had been a student of Hann Trier, and Eugen Schönebeck were loners who had no connection with the Grossgörscheners. The art critic Martin G. Buttig, who was one of the few who had taken up the challenge by the two artists to come to the second "Pandämonium," wrote about it in his foreword to the catalogue of the first Baselitz exhibition in 1963 in the Galerie Werner and Katz:

> I had received a number of requests in my mail to see art under disquieting circumstances (while drinking tea or in basement parties or in some unnamed place.) So I wasn't really surprised that two unknown painters invited me to a place where nothing had ever been shown. . . . The print, however, with which those two had conveyed their invitation fascinated me to the point that, in the end, I halfway decided to have a look at it. At any rate, I found myself one foggy evening in front of a house in a deserted downtown street which the painters had given me as an address. I looked up at the second floor where a dim light in a long row of dirty window panes melted into the fog. (Everything else about that house front was dark.) I surmised, correctly, that this was where the exhibition was. Steep steps led up to the echoing staircase, where no light switch was to be found. My feet found more steps in deep darkness and then a landing, as well as the hoped-for button which might operate either the light or the doorbell. I pressed for good luck and as luck would have it, the light went on and I saw immediately in front of me a man who had just moved. Thinking of all the stories I had read about muggings, I was determined to strike back—just as I recognized myself, my reflection, strange and flat, hanging before me in a mirror made of green glass framed in gold. Up there, behind the half-open door where there still hung a rug dealer's sign, I reacted with dismay and very little else to the first impression: light bulbs which tickled the eyeballs rather than offering light were hung randomly; where there should have been floorboards, strips had been laid with tar dripped casually between them. Newspaper clippings, some with pictures of poets and writings on some of them—to me a special horror—were stuck to the walls. No one was to be seen. This was where I, for the first time, was convinced that I had seen a painter, probably an epoch-making one.[6]

6. Martin G. Buttig, "Meeting Baselitz," in *Georg Baselitz* exhibition catalogue, (Berlin: Galerie Werner & Katz, 1963).

This is a real Berlin impression. It reveals the background of the emergence of a new kind of painting. It speaks of an aggression born out of rage against the paternal, against siblings, against whatever, a provocative use of the human image and the expressive impulse of painterly action which led to an emotional explosion which was then brand new. Baselitz's pictures got under one's skin. They shocked the public when they were seen for the first time in the Galerie Werner and Katz on the Kurfürstendamm. Two pictures in particular, *Naked Man* and *Big Night in the Bucket*, caused a scandal that made the artist well known: a charge of pornography was thrown out in a precedent-setting court case. One of the gallery partners, Michael Werner, had started his career as an assistant to Rudolf Springer and then moved to Cologne, where he opened his own gallery and took under contract artists of expressive realism, notably Baselitz and Lüpertz. With admirable skill and great persistence, he launched the artists who are internationally known today as the fathers of Die Jungen Wilden (The Young Wild Ones).

The development which art in Berlin has seen would be unthinkable without the involvement of the city's gallery operators and avant-garde dealers. They took on the risk of young and unknown artists who "weren't worth anything yet," often more out of love for the cause than with any hope for profits. The liveliness of the Berlin art scene owes as much to the activities of the art dealers as it does to the efforts of the artists. Walter Schüler and Rudolf Springer are the old-timers among Berlin art dealers. Schüler, who opened his first gallery in 1947, concentrated especially on the artists of abstract expressionism and *art informel*. Georg Nothelfer has since taken up this effort. Springer came out of the Galerie Rosen and is a man of extreme curiosity who has promoted the neo-expressionism of the young, among other things. Other galleries emerged in the early sixties in response to the new artistic impulses. Günter Meisner exhibited the Zero artists in his Galerie Diogenes. René Block brought happenings and conceptual art to Berlin with the program of his Galerie Fluxus, which he opened in 1965. He was the organizer of Joseph Beuys's spectacular *Berlin Actions*. We can thank him for the fact that Wolf Vostell created his first Berlin works in 1964 and finally moved to Berlin, attracted by the stimulating political and social turmoil of the city which has had such an extraordinary influence on its artists.

In 1968 Eva Poll opened her first gallery on Niebuhrstrasse with a Peter Sorge exhibition. The date is important: it was the year of the student revolution in Berlin. Above all, the Galerie Poll is the representative of the Berlin critical realists. This group came out of the exhibition cooperative Grossgörschen 35. Influenced by the idealism of the student movement, those artists involved themselves with the development of social themes through works on paper with an emphasis on realism. They touched a nerve in Berlin because Dix, Grosz, and Schlichter and the Dada-photomontage movement of the twenties had created a tradition which these critical realists revived. Wolfgang Petrick, Jürgen Diehl, Peter Sorge, and Ulrich Baehr formed the Sezession Grossgörschen. Later came Maina-Miriam Munsky, Hermann Albert, and Klaus Vogelgesang. The critical realists named themselves Gruppe Aspekt after 1972. With the relaxation of social and political tensions and the appearance of a benevolent neoconservatism with a youthful and dynamic style, critical realism lost its drive and the artists of this group have since dispersed. Petrick's works are an example of the marriage of realist and expressionist elements from which passionate fire and visionary imagination are born. The co-founders of Galerie Grossgörschen, Hödicke and Koberling, are the painterly opposites (cat. nos. 70, 172, 75). They reflect their impressions of their environment in

their own ways as painters. The intentions of their painting rest, as do those of Dieter Hacker (cat. no. 173), on the gestural juxtaposition of technical contradictions: their sensibility expressed in terse, gestural brushstrokes.

Grossgörschen 35 was the mother of the Berlin cooperative galleries. The Galerie am Moritzplatz was opened in an old factory in the Kreutzberg district in 1977, close to the Wall and the crossing at Heinrich Heinestrasse. The gallery was the breeding ground of the Neuen Wilden (New Wild Ones), from which Fetting, Middendorf, Salomé, and Zimmer emerged. Students of Wolfgang Petrick founded the studio cooperative Kulmerstrasse in 1978 in the rear of an old tenement in the Schöneberg district. The cooperative gallery 1/16 organized an opening show in a factory in Kreutzberg which has since been torn down. The exhibition included works by Frank Dornseif, Ter Hell, Elke Lixfeld, Rainer Mang, Reinhard Pods, and Gerd Rohling. Finally, in 1981, an artists' group opened the Quergalerie in the back of a factory in the district of Wedding.

None of these cooperatives exists now. They lasted only a few years, only as long as the young artists needed them. It would be possible to dream up an interesting exhibition of works by the artists who came out of each of these groups. The liveliness of the Berlin art scene has been determined essentially by this succession of exhibiting groups and spaces. Indeed, this survey might close with a rhetorical question: what would Berlin's art have been without the city's apartment blocks, backyards, and old factories?

Translated by Gudmund Vigtel

Selected Bibliography

Bartels, Daghild, ed. *Aspekt Grossstadt*. Berlin, 1977.

Berlinische Galerie. *Ich und die Stadt. Mensch und Grossstadt in der deutschen Kunst des 20. Jahrhunderts*. Ed. by Eberhard Roters and Bernhard Schulz. Berlin: Nicolaische Verlagsbuchhandlung, 1987.

Berlinische Galerie. *Kunst in Berlin von 1960 bis heute*. Ed. by Ursula Prinz and Eberhard Roters. Berlin, 1979.

Berlinische Galerie. *Kunst in Berlin von 1930 bis 1960*. Ed. by Ursula Prinz and Eberhard Roters. Berlin, 1980.

Berlinische Galerie (Helmut Geisert) and Museumspädagogischer Dienst, Berlin (Eckhart Gillen, Elisabeth Moortgat, and Gerhard Riecke), eds. *Kunst in Berlin von 1970 bis Heute. Sammlung Berlinische Galerie*. Berlin: Argon Verlag, 1986.

DAAD (Deutscher Akademischer Austauschdienst). *Prinzip Realismus. Malerei, Plastik, Graphik*. Ed. by Peter Hielscher and Lothar C. Poll. Berlin, 1973.

Gesellschaft zur Förderung der Künste im Martin Gropius-Bau. *Der unverbrauchte Blick. Kunst unserer Zeit aus Berliner Sicht. Ausstellung aus Privatsammlungen in Berlin*. Ed. by Christos M. Joachimides. Berlin, 1987.

Institute of Contemporary Arts. *Berlin, A Critical View. Ugly Realism 20s-70s*. Ed. by Sarah Kent and Eckart Gillen. London, 1978.

Kestner-Gesellschaft. *Neue Malerei Berlin*. Ed. by Carl Haenlein. Hannover, 1984.

Kunstverein München. *Gefühl und Härte. Neue Kunst in Berlin*. Ed. by Ursula Prinz and Wolfgang Jean Stock. Munich, 1982.

Museum of Modern Art, New York. *Berlinart 1961-1987*. Ed. by Kynaston McShine. Munich: Prestel Verlag, 1987.

Nationalgalerie der Staatlichen Museen Preussischer Kulturbesitz. *1845-1985. Kunst in der Bundesrepublik Deutschland*. Ed. by Dieter Honisch and Lucius E. Grisebach. Berlin, 1985.

Neuer Berliner Kunstverein im Martin-Gropius-Bau. *Zeitgeist*. Ed. by Christos M. Joachimides and Norman Rosenthal. Berlin: Fröhlich & Kaufmann, 1982.

Palais des Beaux Arts. *Die wiedergefundene Metropole. Neue Malerei in Berlin*. Ed. by Christos Joachimides. Brussels, 1984.

Wargin, Ben, ed. *Kunst in Berlin 1945 bis heute*. Berlin: Belser Verlag, 1969.

Catalogue of the Exhibition

Illustrations of the works in the exhibition are arranged in loose chronological order with the color reproductions first, then those in black and white. Dimensions are given height before width. In the captions and checklist which follow, "Berlin" means West Berlin, Federal Republic of Germany. Portfolios have been assigned a single catalogue number.

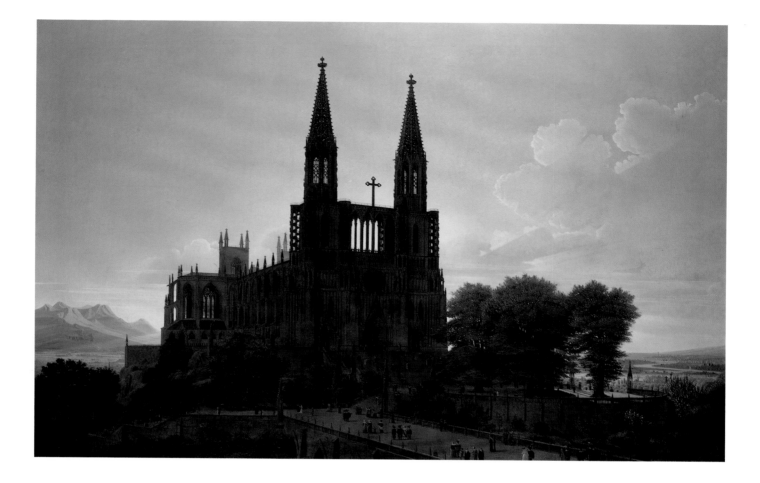

1. Karl Friedrich Schinkel, *Cathedral (Kathedrale)*, ca. 1811, oil on canvas, 54⁵/₁₆ x 81⁵/₁₆ inches, Staatliche Schlösser und Gärten, Berlin.

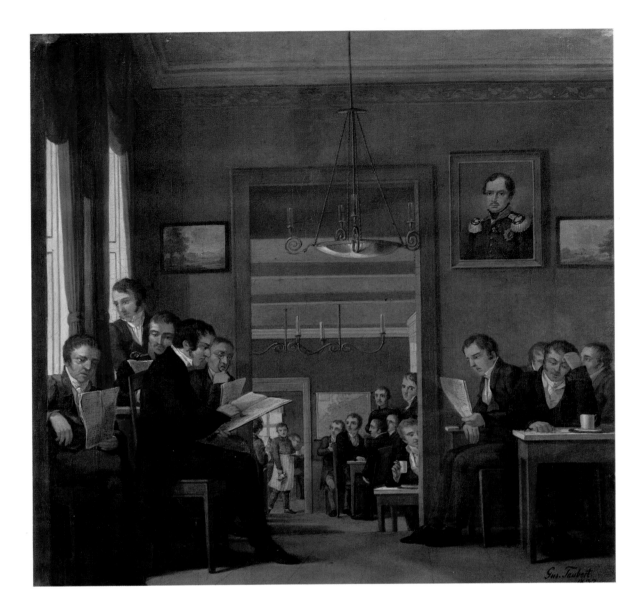

2. Gustav Friedrich Taubert, *In the Berlin Reading Café: "Everyone Reads Everything"* (*"Alles liest alles,"* Berliner Lesecafé), 1832, oil on canvas, 15⅛ x 15⅛ inches, Berlin Museum.

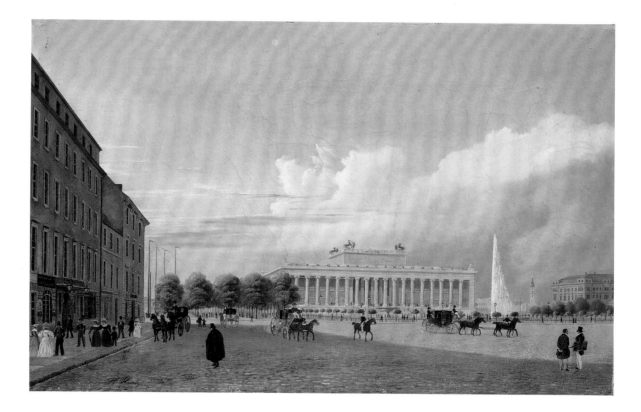

3. Johann Heinrich Hintze, *The Royal Museum* (*Das Alte Museum von der Schlossfreiheit aus gesehen*), ca. 1832, oil on canvas, 12⅛ x 18½ inches, Berlin Museum.

4. Eduard Gaertner, *View of the Friedrichsforum from the Roof of the Friedrich-werder Church* (*Blick vom Dach der Friedrichwerderschen Kirche auf das Friedrichsforum*), 1835, oil on canvas, $36^{13}/_{16}$ x $57^{7}/_{8}$ inches, Berlin Museum.

5. Eduard Gaertner, *The Palace Bridge* (*Schlossbrücke*), 1861, oil on canvas, 35⁷/₁₆ x 49 inches, SKH Dr. Louis Ferdinand, Prinz von Preussen, Berlin.

6. Franz Krüger, *Parade in Potsdam*, ca. 1849, oil on paper, laid on cardboard, 14 x 21⅝ inches, Kunsthalle Bremen.

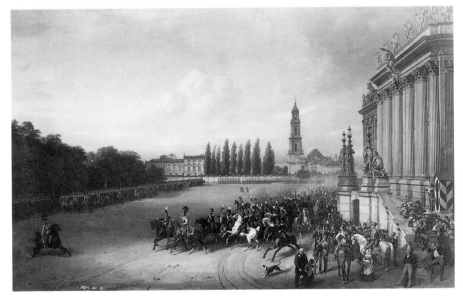

Fig. 85: Franz Krüger, *Parade in Potsdam*, 1848/49, oil on canvas, 98 x 149½ inches, Staatliche Museen, Nationalgalerie, Berlin, GDR.

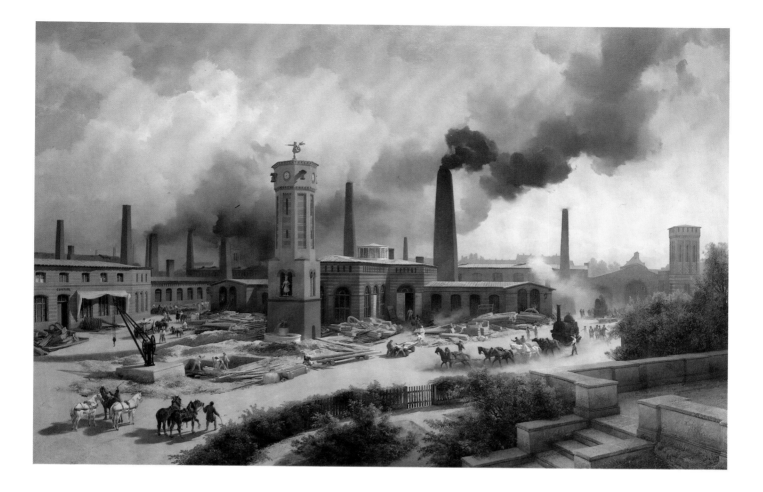

7. Carl Eduard Biermann, *Borsig's Machine Hall in Berlin* (*Borsig's Maschinen-bauanstalt zu Berlin*), 1847, oil on canvas, 43⁵/₁₆ x 45⁷/₈ inches, Berlin Museum, A. Borsig Archive.

8. Adolph von Menzel, *Back Yard* (*Hinterhaus und Hof*), ca. 1845, oil on canvas, 17 x 24 inches, Staatliche Museen Preussischer Kulturbesitz, Nationalgalerie, Berlin.

9. Adolph von Menzel, *Meissonier's Studio*, ca. 1880-89, oil on panel,
8¾ x 11¾ inches, The Fine Arts Museums of San Francisco, Jacob Stern
Family Loan Collection.

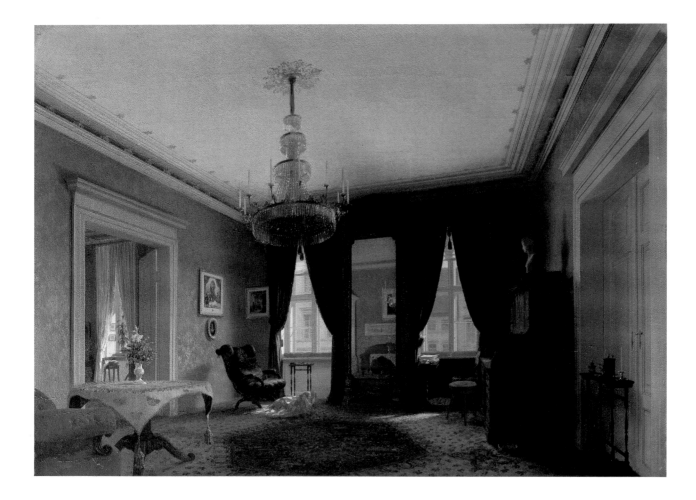

10. Paul Graeb, *Room in Berlin* (*Berliner Zimmer*), 1865, oil on canvas, 11³⁄₈ x 15 inches, Staatliche Museen Preussischer Kulturbesitz, National-galerie, Berlin.

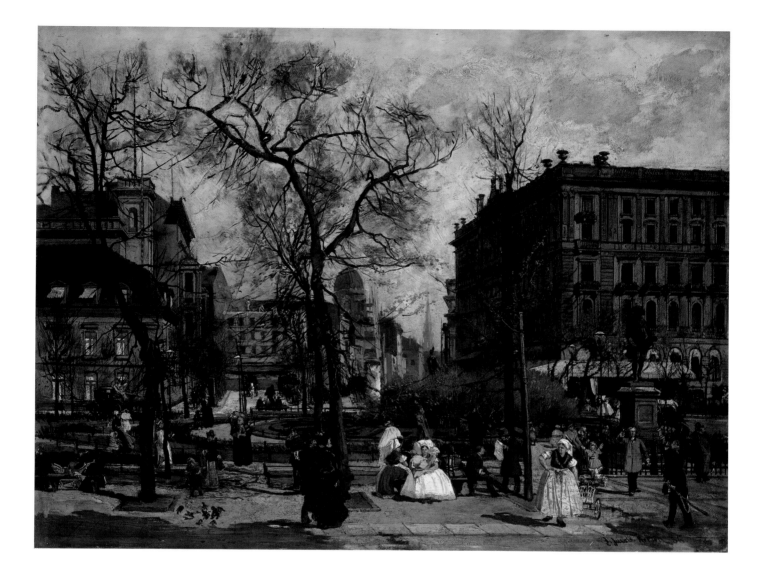

11. Julius Jacob, *Wilhelmplatz with the Kaiserhof Hotel* (*Der Wilhelmplatz mit dem Hotel Kaiserhof*), 1886, oil on panel, 18¾ x 23¹³⁄₁₆ inches, Berlin Museum.

12. Lesser Ury, *Evening on the Landwehrkanal* (*Abend am Landwehrkanal*),
1889, oil on canvas, 29½ x 41⅜ inches, Galerie Pels-Leusden-Villa
Grisebach, Berlin.

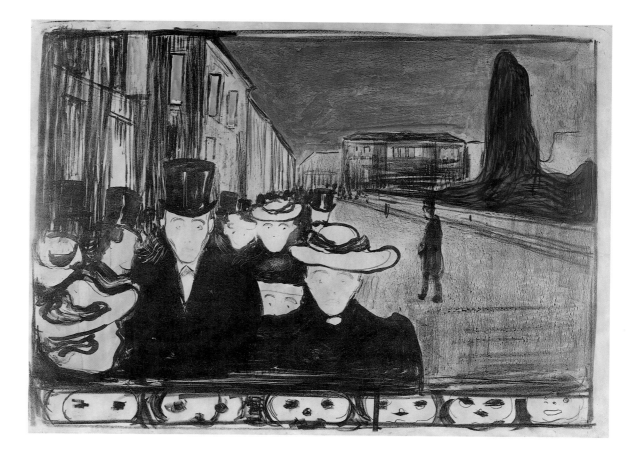

13. Edvard Munch, *Evening on Karl Johan Street*, 1896, lithograph on paper, 15½ x 20½ inches, Nelson Blitz, Jr., and Catherine Woodard, New York.

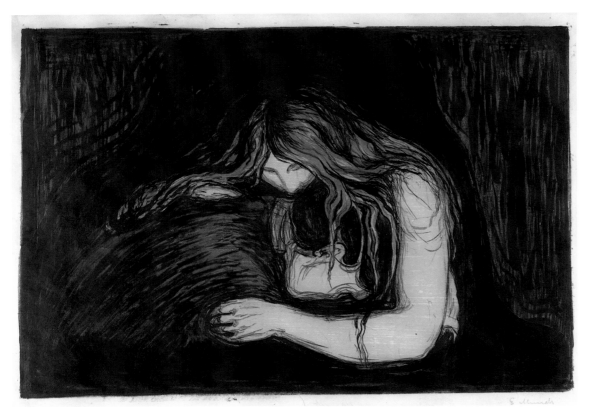

14. Edvard Munch, *Vampire*, 1895/96, lithograph and woodcut on paper, 15 x 21⅝ inches, Nelson Blitz, Jr., and Catherine Woodard, New York.

15. Edvard Munch, *Evening (Melancholy)*, 1896, woodcut on paper, 15 x 17¾ inches, Nelson Blitz, Jr., and Catherine Woodard, New York.

16. Edvard Munch, *The Lonely One*, 1896, mezzotint and drypoint on paper, 11¼ x 8½ inches, Nelson Blitz, Jr., and Catherine Woodard, New York.

17. Edvard Munch, *Two Women on the Shore*, 1898, woodcut on paper, 18 x 20¼ inches, Nelson Blitz, Jr., and Catherine Woodard, New York.

18. Edvard Munch, *Madonna*, 1895-1902, lithograph on paper, 23⅝ x 17⅜
inches, Nelson Blitz, Jr., and Catherine Woodard, New York.

19. Franz Skarbina, *Railroad Tracks in North Berlin* (*Gleisanlagen im Norden Berlins*), ca. 1895, pastel, gouache, and watercolor on paper, 28¼ x 35¹³/₁₆ inches, Berlin Museum.

20. Walter Leistikow, *Lake Grunewald* (*Grunewaldsee oder Schlachtensee*), oil on canvas, 30⅞ x 46⅞ inches, Bröhan-Museum, Berlin.

21. Max Liebermann, *House on Wannsee* (*Haus am Wannsee*), 1926, oil on panel, 12⅜ x 16⅛ inches, Staatliche Museen Preussischer Kulturbesitz, National-galerie, Berlin.

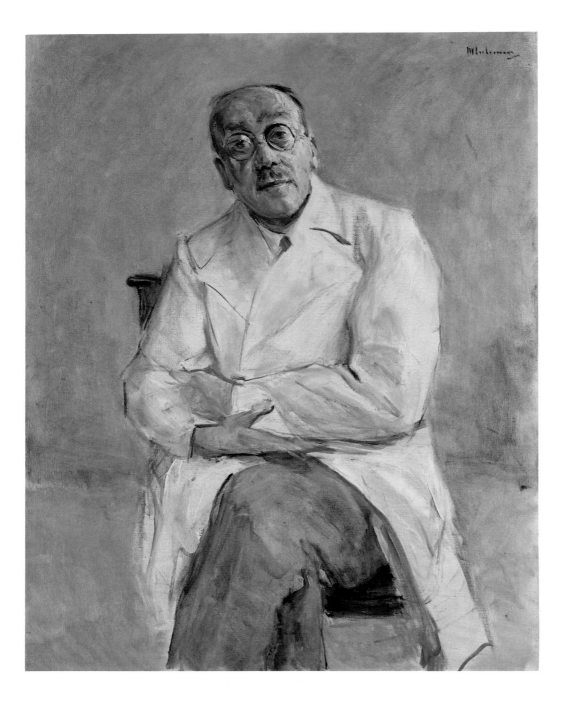

22. Max Liebermann, *The Surgeon Ferdinand Sauerbruch (Der Chirurg Ferdinand Sauerbruch)*, 1932, oil on canvas, 46⅛ x 35¼ inches, Hamburger Kunsthalle, Hamburg.

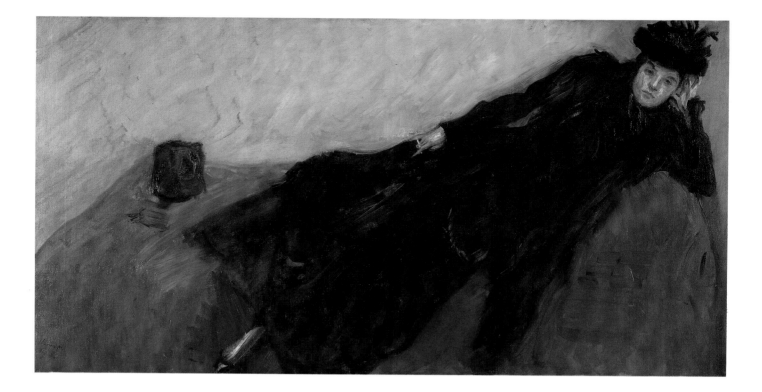

23. Max Slevogt, *Nini in a Black Dress on a Red Sofa* (*Nini im schwarzen Kleid auf rotem Sofa*), 1902, oil on canvas, 27⁹/₁₆ x 52³/₈ inches, Landesmuseum Mainz.

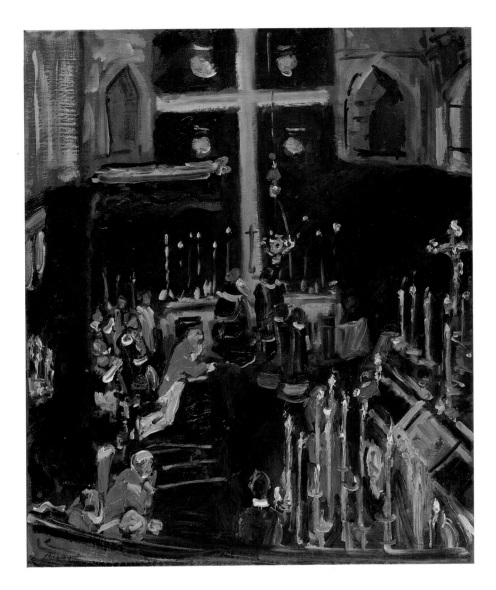

24. Max Slevogt, *Mass of the St. George Order* (*Messe der St. Georgsritter*), 1908, oil on canvas, 22⅞ x 18⅛ inches, Staatliche Museen Preussischer Kulturbesitz, Nationalgalerie, Berlin.

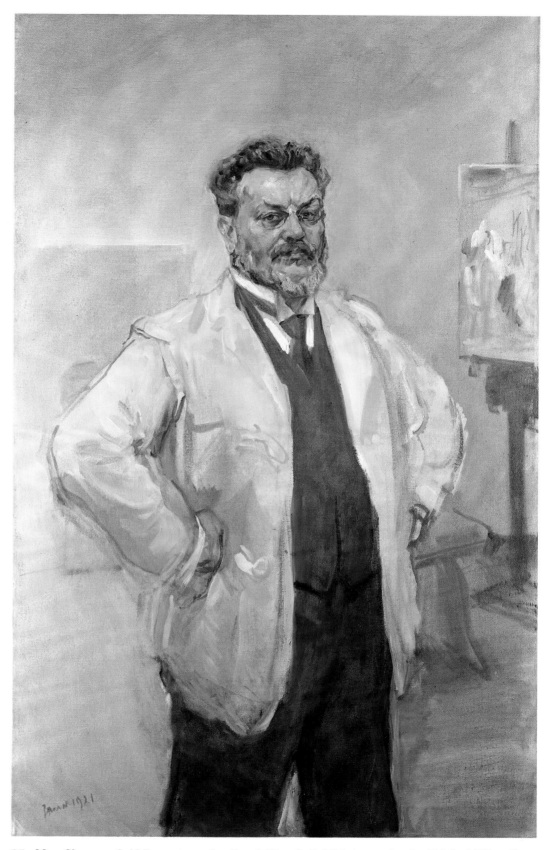

25. Max Slevogt, *Self Portrait at the Easel (Das Selbtbildnis an der Staffelei)*, 1921, oil on canvas, 57¼ x 35⁷⁄₁₆ inches, Städtische Galerie im Städelschen Kunstinstitut, Frankfurt am Main.

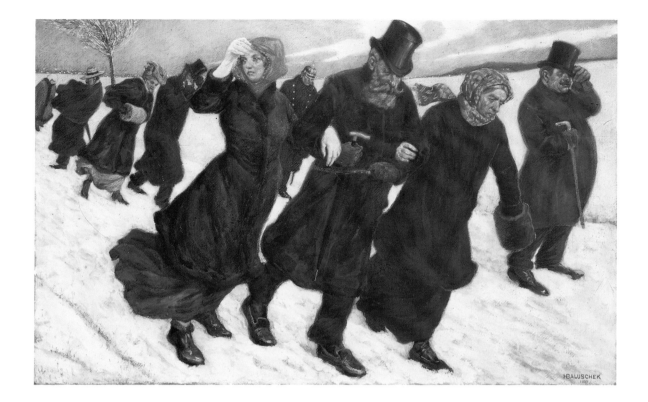

26. Hans Baluschek, *Winter Wind* (*Winterwind*), 1907, chalk and watercolor on cardboard, 24¹³⁄₁₆ x 38 inches, Bröhan-Museum, Berlin.

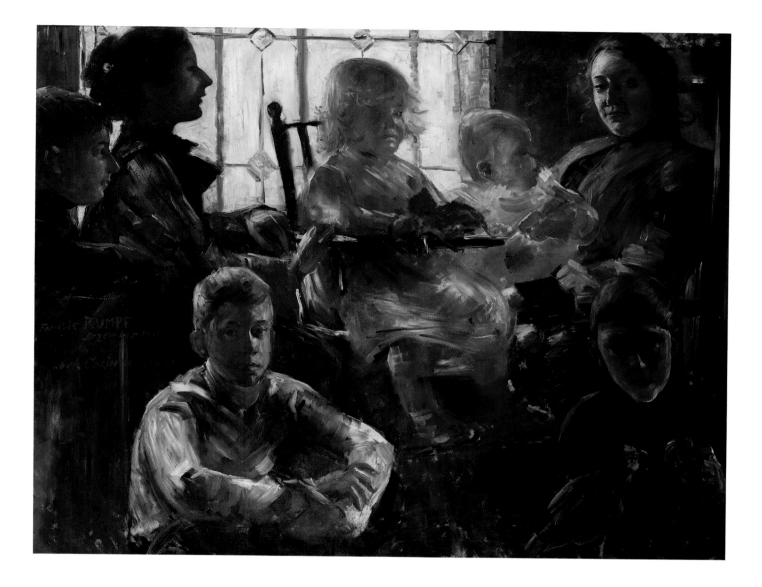

27. Lovis Corinth, *The Family of the Painter Fritz Rumpf* (*Die Familie des Malers Fritz Rumpf*), 1901, oil on canvas, 44½ x 55⅛ inches, Staatliche Museen Preussischer Kulturbesitz, Nationalgalerie, Berlin.

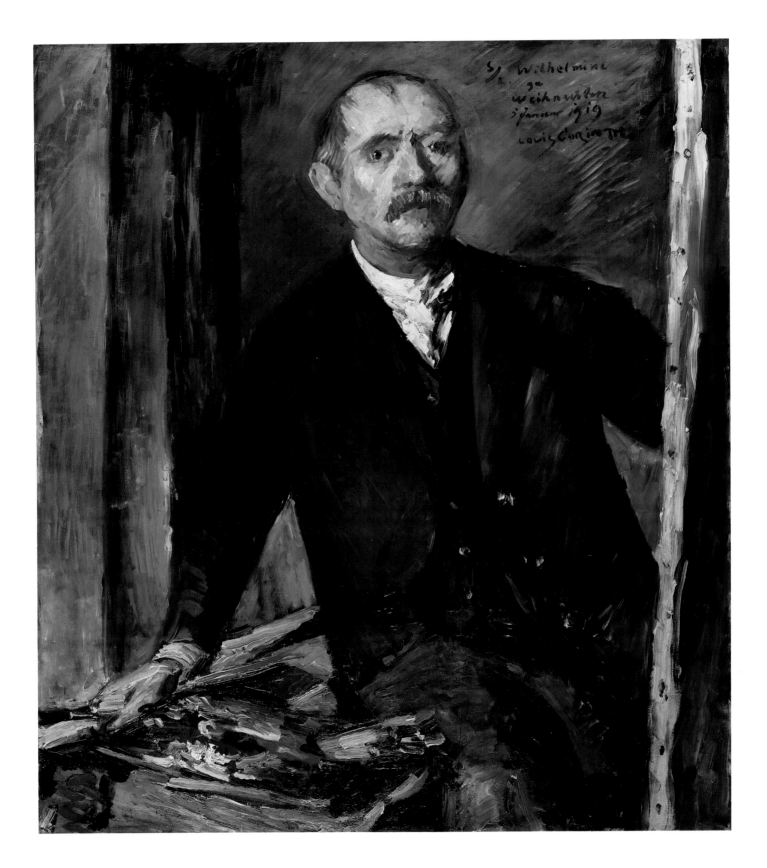

28. Lovis Corinth, *Self Portrait at the Easel (Selbstbildnis vor der Staffelei)*, 1919,
oil on canvas, 49⅝ x 41⅝ inches, Staatliche Museen Preussischer Kulturbesitz,
Nationalgalerie, Berlin.

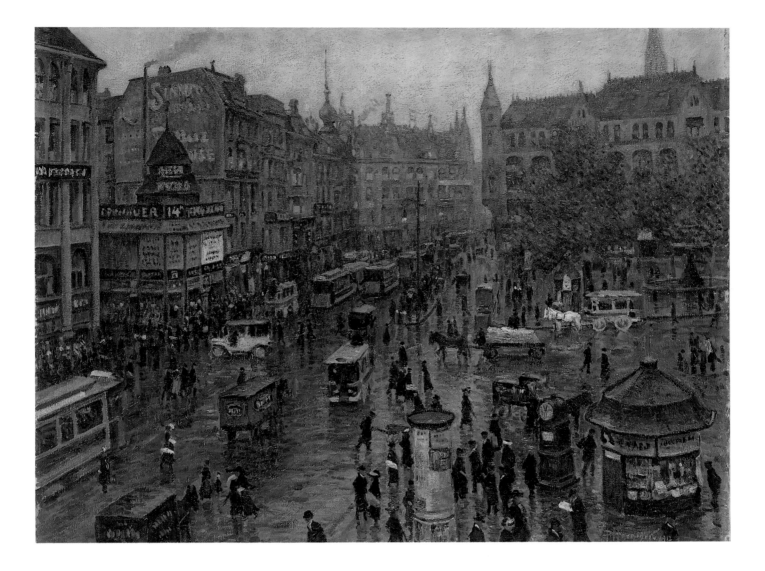

29. Paul Hoeniger, *The Spittel Market (Der Spittelmarkt)*, 1912, oil on canvas, 29⅛ x 36⅝ inches, Berlin Museum.

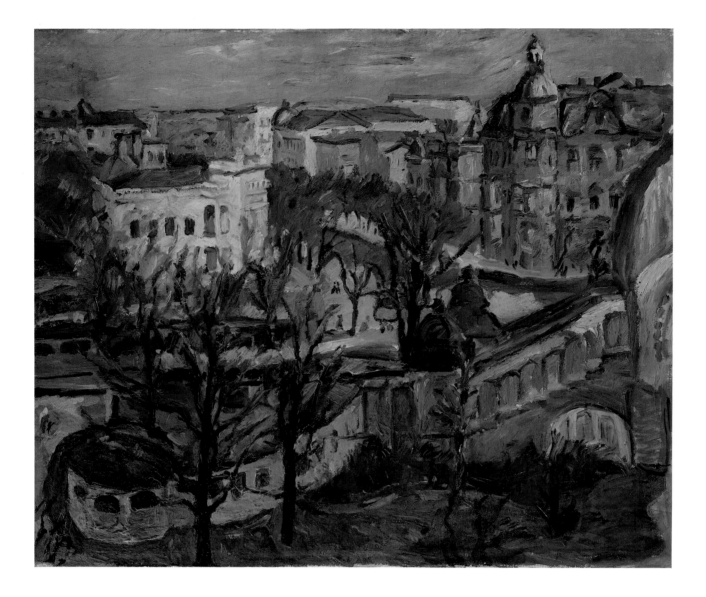

30. Max Beckmann, *View of Nollendorfplatz* (*Blick auf den Nollendorfplatz*),
1911, oil on canvas, 26 x 30⅛ inches, Berlin Museum.

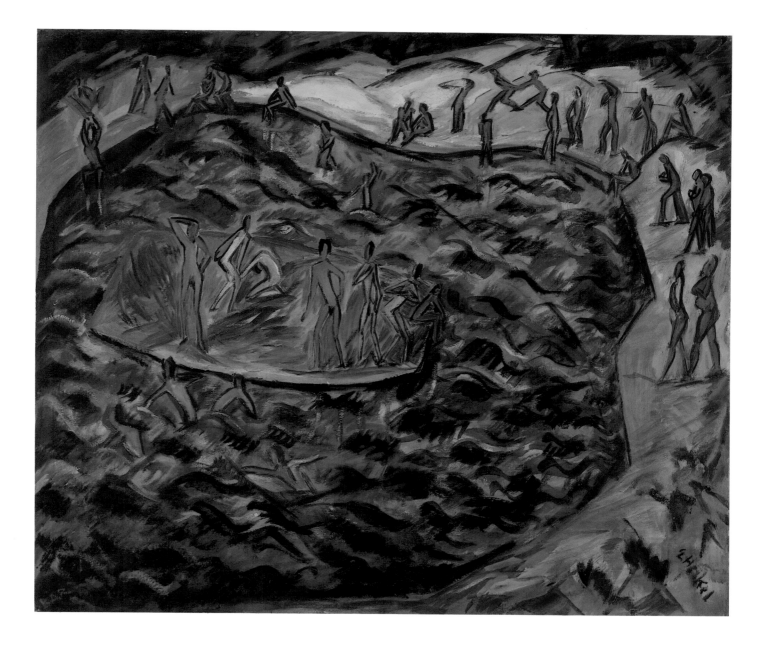

31. Erich Heckel, *Bathers*, ca. 1912-13, oil on canvas, 32 x 37½ inches, The Saint Louis Art Museum, Missouri, bequest of Morton D. May.

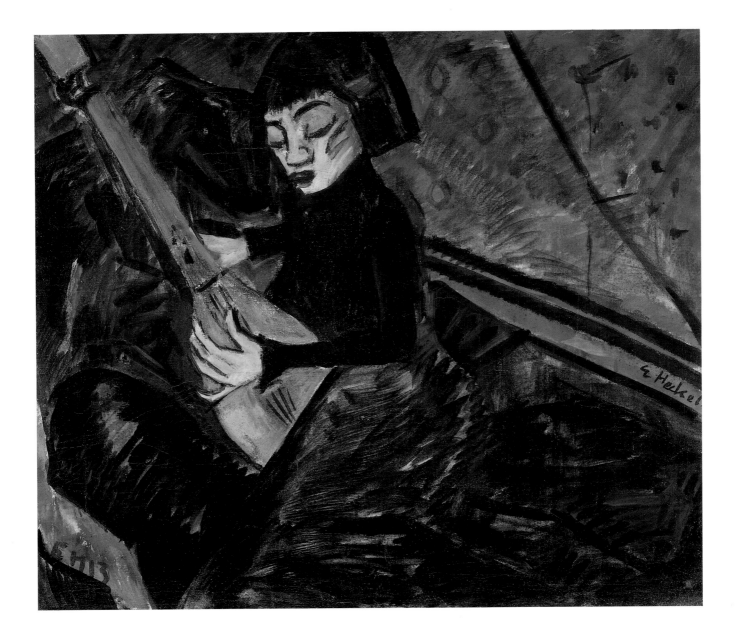

32. Erich Heckel, *Girl Playing the Lute* (*Lautespielendes Mädchen*), 1913, oil on
canvas, 28⅜ x 31⅛ inches, Brücke-Museum, Berlin.

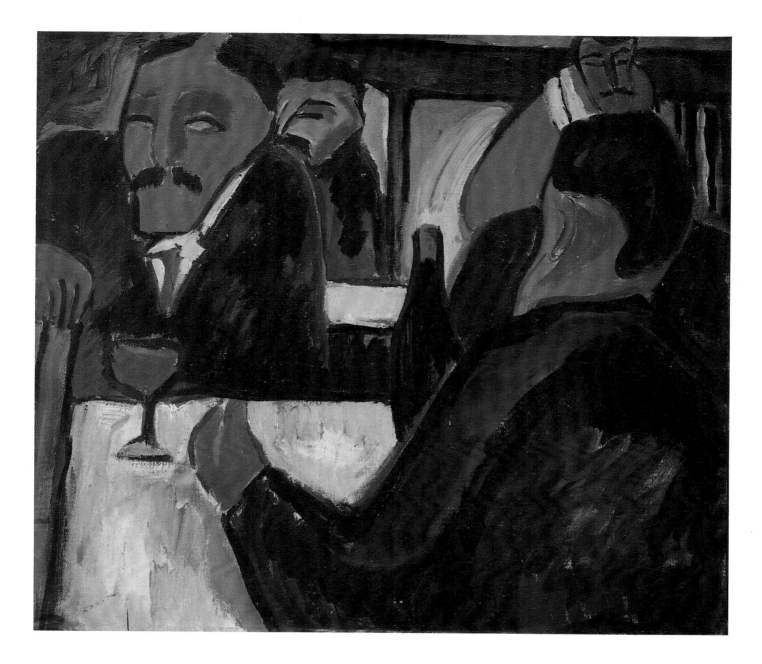

33. Karl Schmidt-Rottluff, *Tavern* (*Weinstube*), 1913, oil on canvas, 30 x 33 inches, Brücke-Museum, Berlin.

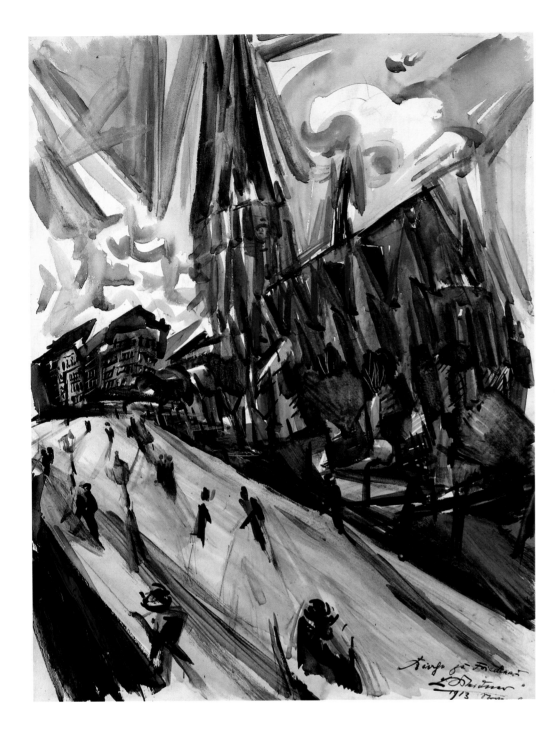

34. Ludwig Meidner, *The Church of the Good Shepherd on Friedrich-Wilhelm-Platz in Friedenau (Die Kirche "Zum guten Hirten" auf dem Friedrich-Wilhelm-Platz in Friedenau)*, 1913, watercolor on paper, 24 x 17 inches, Berlin Museum.

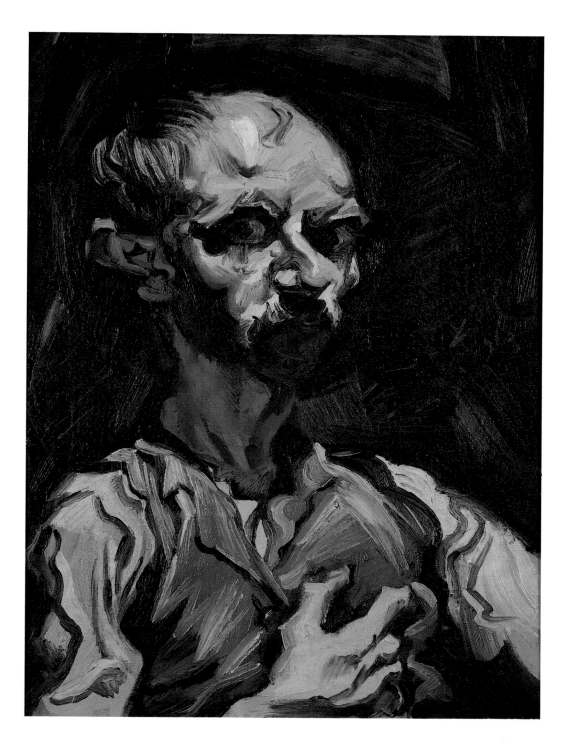

35. Ludwig Meidner, *My Night Visage* (*Mein Nachtgesicht*), 1913, oil on canvas, 26¼ x 19¼ inches, Marvin and Janet Fishman, Milwaukee, Wisconsin.

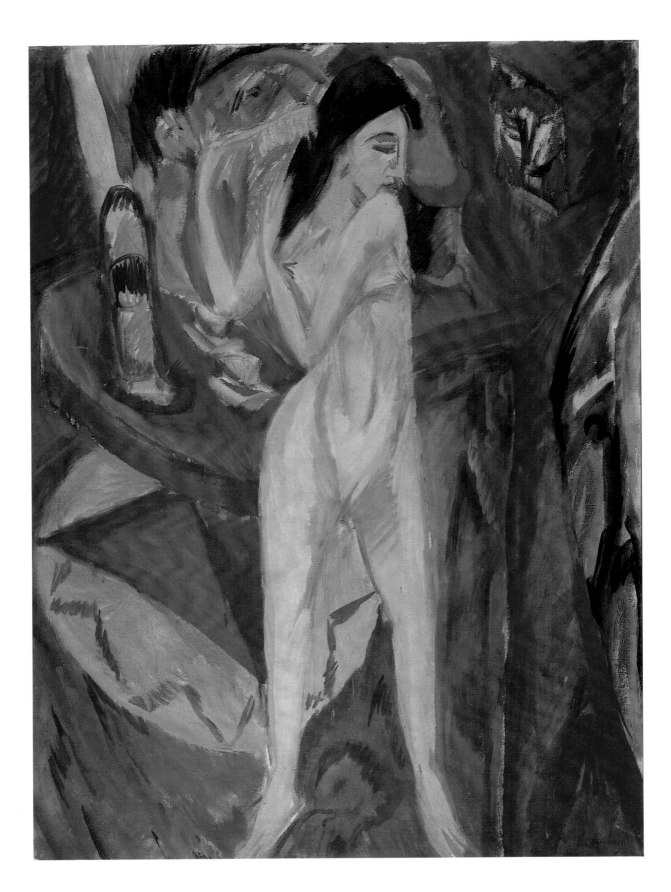

36. Ernst Ludwig Kirchner, *Nude Woman Combing Her Hair* (*Sich kämmender Akt*), 1913, oil on canvas, 49¼ x 35⁷⁄₁₆ inches, Brücke-Museum, Berlin.

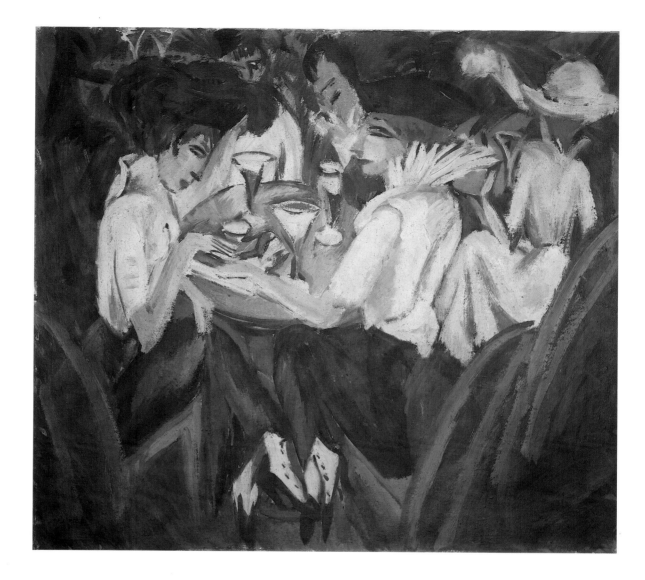

37. Ernst Ludwig Kirchner, *In the Café Garden (Im Cafégarten)*, 1914, oil on canvas, 27¾ x 30 inches, Brücke-Museum, Berlin.

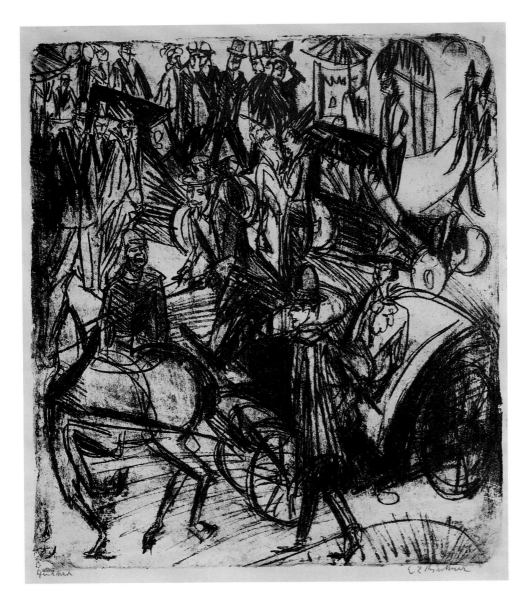

38. Ernst Ludwig Kirchner, *Leipziger Strasse, Intersection* (*Leipziger Strasse, Kreuzung*), 1914, lithograph on yellow paper, 23¼ x 19¾ inches, Nelson Blitz, Jr., and Catherine Woodard, New York.

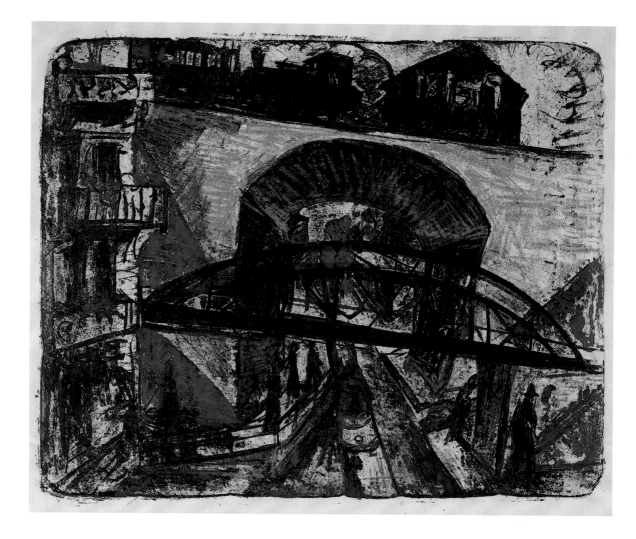

39. Ernst Ludwig Kirchner, *The Tramway Arch* (*Stadtbahnbogen*), 1915, four-color lithograph on paper, 19½ x 23⅛ inches, Nelson Blitz, Jr., and Catherine Woodard, New York.

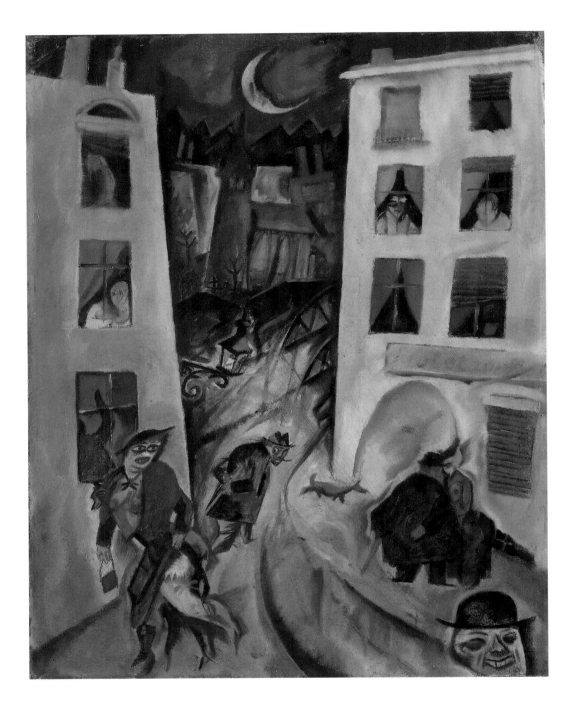

40. George Grosz, *The Street* (*Die Strasse*), 1915, oil on canvas, 17⅞ x 14 inches, Staatsgalerie Stuttgart.

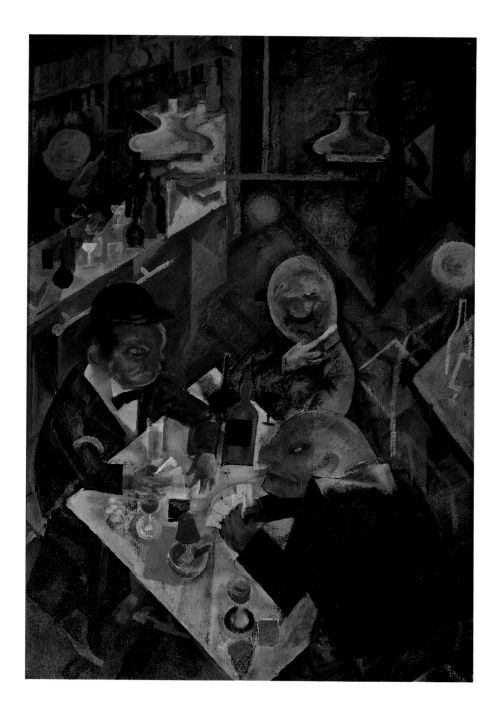

41. George Grosz, *Café*, 1916, oil on canvas, 19 x 12⅞ inches, The Saint Louis Art Museum, Missouri, bequest of Morton D. May.

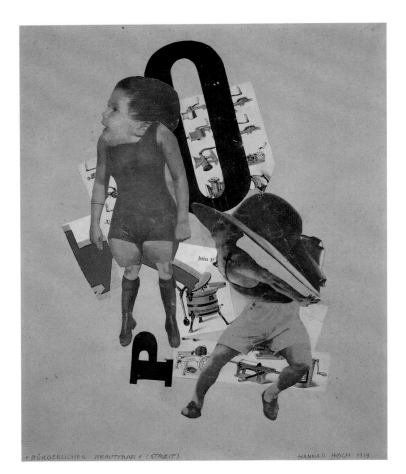

42. Hannah Höch, *Bourgeois Couple (The Fight)* (*Bürgerliches Brautpaar [Streit]*), 1919, collage on paper, 15 x 12⅛ inches, private collection, Hamburg.

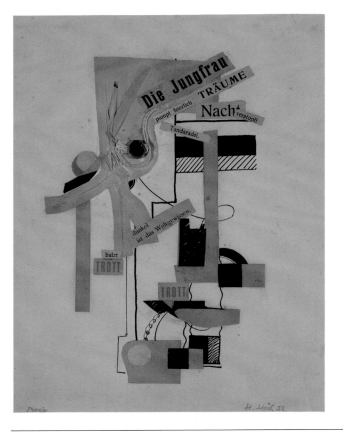

43. Hannah Höch, *Poetry* (*Poesie*), 1922, collage and drawing on paper, 10 x 7⅝ inches, private collection, Hamburg.

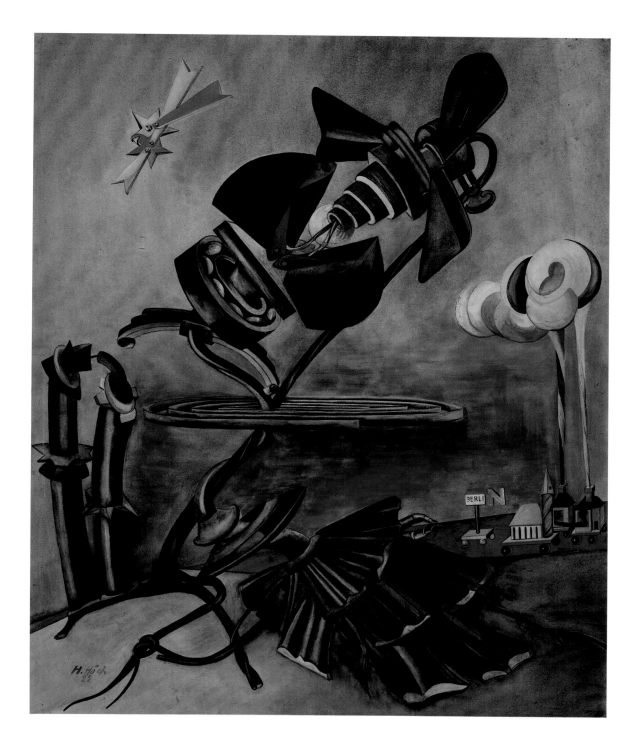

44. Hannah Höch, *Union* (*Vereinigung*), 1922, watercolor on paper, 26¾ x 21⅝ inches, private collection, Hamburg.

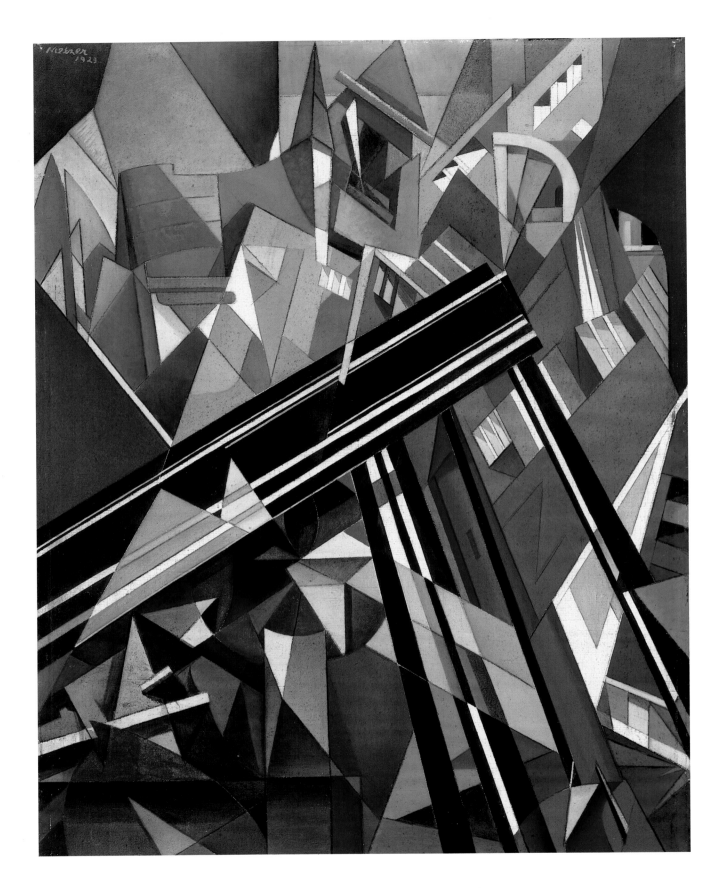

45. Moriz Melzer, *Bridge-City (Brücke-Stadt)*, 1923, oil on canvas, 51⅝ x 38¾ inches, Berlin Museum.

46. László Moholy-Nagy, *Z III*, 1922, oil on canvas, 37¹³/₁₆ x 29¼ inches, anonymous loan, Cologne.

47. Rudolf Schlichter, *Bert Brecht*, 1926, oil on canvas, 29¾ x 18⅛
inches, Städtische Galerie im Lenbachhaus, Munich.

48. Otto Dix, *Three Street Walkers* (*Drei Dirnen auf der Strasse*), 1925, oil on plywood, 37⅜ x 39⅜ inches, private collection, Hamburg.

49. George Grosz, *Sunday Family Walk*, ca. 1923, collage, pen, and watercolor on paper, 11 x 8⅜ inches, Marvin and Janet Fishman, Milwaukee, Wisconsin.

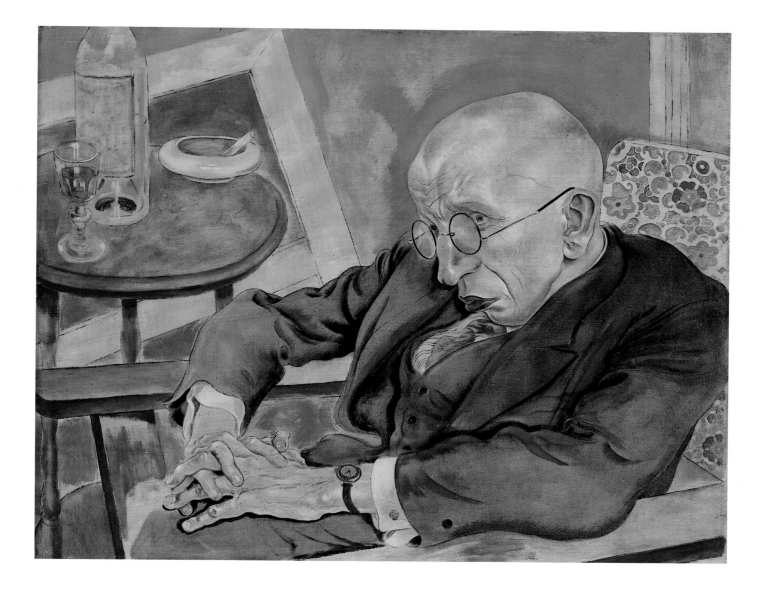

50. George Grosz, *The Poet Max Herrmann-Neisse*, 1927, oil on canvas, 23⅜ x 29⅛ inches, The Museum of Modern Art, New York, purchase.

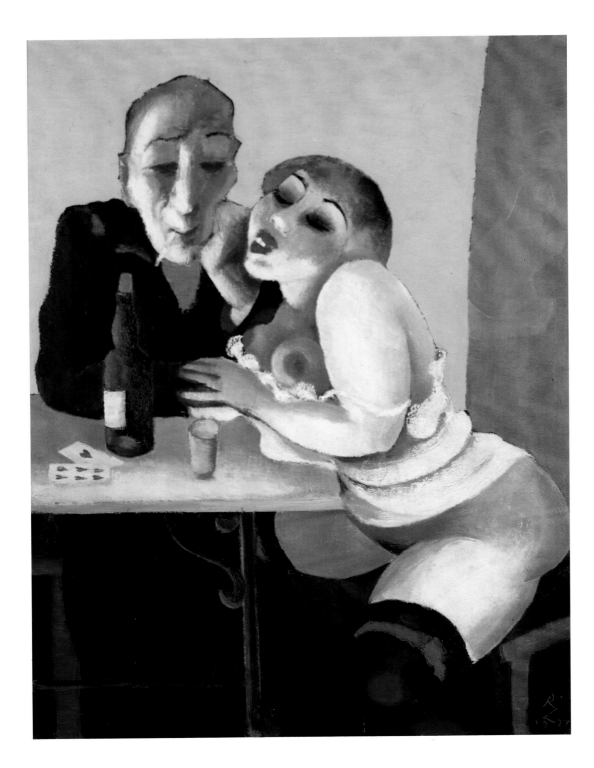

51. Richard Ziegler, *Couple in Café (Paar am Café)*, 1927, oil on canvas,
39⅜ x 29½ inches, Marvin and Janet Fishman, Milwaukee, Wisconsin.

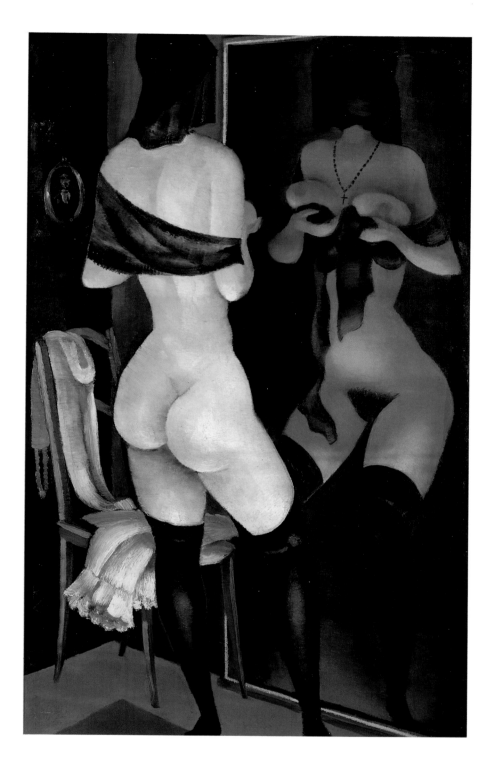

52. Richard Ziegler, *Widow (Witwe)*, 1925, oil on canvas, 40⅛ x 24 inches, Marvin and Janet Fishman, Milwaukee, Wisconsin.

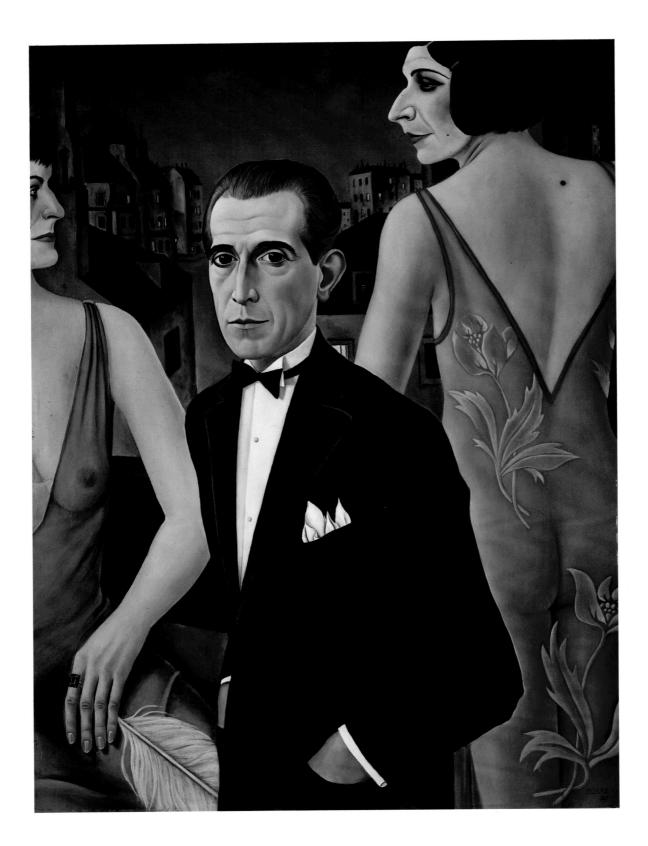

53. Christian Schad, *Count St. Genois d'Anneaucourt (Graf St. Genois d'Anneaucourt)*, 1927, oil on panel, 33⅞ x 24¾ inches, private collection, Hamburg.

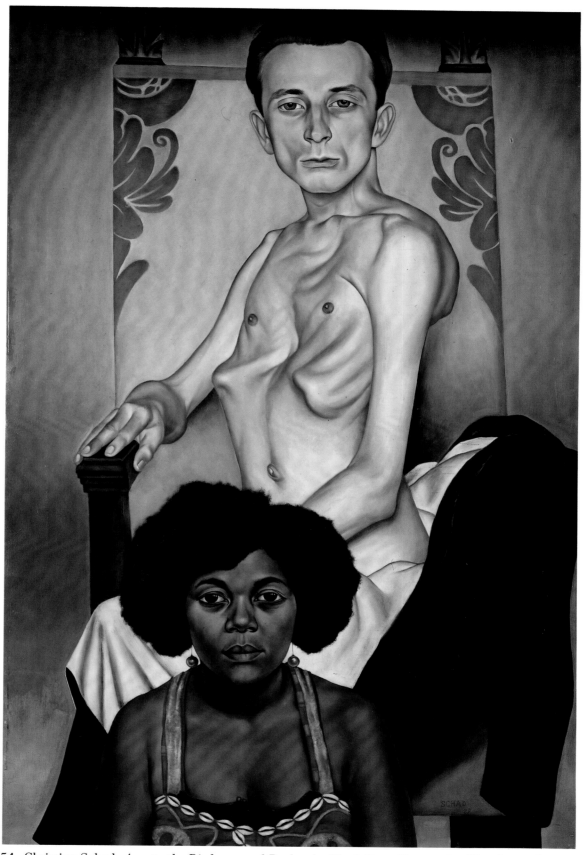

54. Christian Schad, *Agosta the Birdman and Rasha the Black Dove* (*Agosta der Flügelmensch, und Rasha, die schwarze Taube*), 1929, oil on canvas, 47¼ x 31½ inches, private collection, Munich.

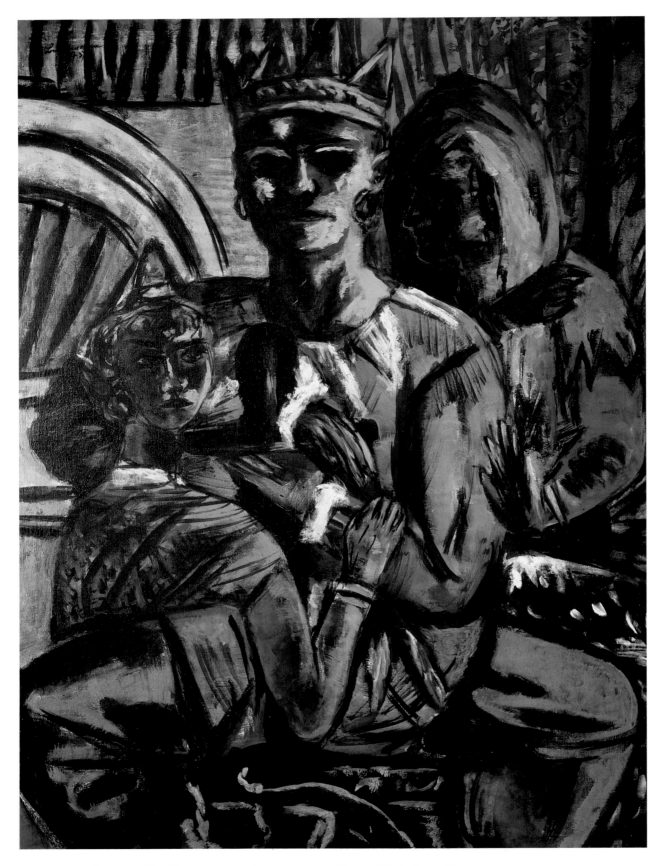

55. Max Beckmann, *The King*, 1937, oil on canvas, 53⅛ x 39⅜ inches, The
Saint Louis Art Museum, Missouri, bequest of Morton D. May.

160

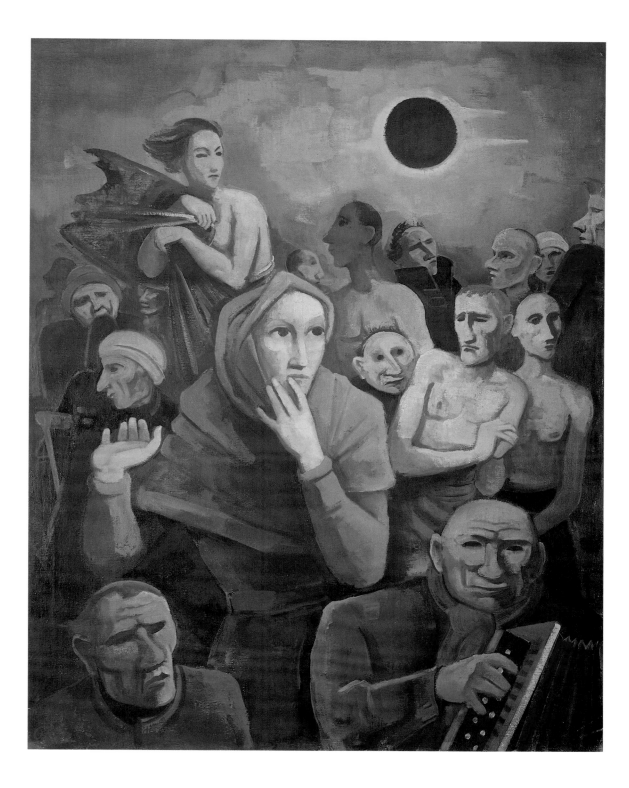

56. Carl Hofer, *Night of the Black Moon* (*Schwarzmondnacht*), 1944, oil on canvas, 44⁷⁄₈ x 35⁷⁄₁₆ inches, Berlinische Galerie, Berlin.

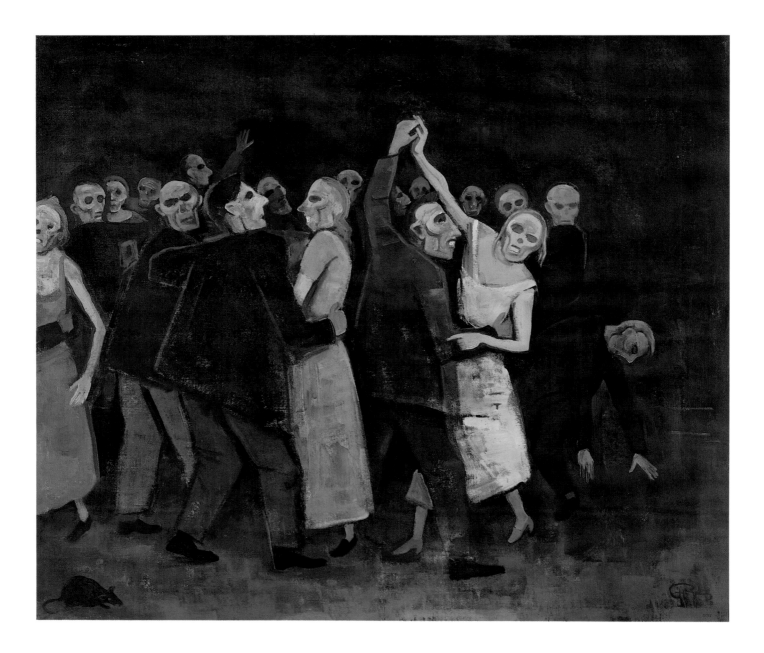

57. Carl Hofer, *Dance of Death* (*Totentanz*), 1946, oil on canvas, 37⅜ x 42⅞
inches, Berlinische Galerie, Berlin.

58. Heinz Trökes, *The Moon Cannon* (*Die Mondkanone*), 1946, oil on canvas, mounted on cardboard, 15¾ x 18⅞ inches, Berlinische Galerie, Berlin.

59. Heinz Trökes, *Terrain of the Cosmologists* (*Terrain der Kosmologen*), 1948, oil on canvas, 23⅝ x 19¹¹/₁₆ inches, collection of the artist, Berlin.

60. Alexander Camaro, *Suburban Movie Theatre* (*Vorstadtkino*), after 1945, oil on pressed board, 24⅜ x 34¼ inches, Berlinische Galerie, Berlin.

61. Werner Heldt, *Saturday Afternoon (Sunday Afternoon)* (*Samstagnachmittag* [*Sonntagnachmittag*]), 1952, oil on canvas, 23⅝ x 39⅜ inches, Collection B, Berlin.

62. Werner Heldt, *Sunday Afternoon* (*Sonntagnachmittag*), 1952, oil on canvas, 24¾ x 42⅞ inches, Berlinische Galerie, Berlin.

63. Hann Trier, *Vibrations VIII* (*Vibrationen VIII*), 1957, oil on canvas,
57½ x 37¾ inches, Berlinische Galerie, Berlin.

64. Fred Thieler, *Mutabor*, 1962, mixed media on canvas, 74¾ x 158 inches, Berlinische Galerie, Berlin.

65. Fred Thieler, *Inbild DI/75*, 1975, mixed media on canvas, 57⅛ x 57⅛ inches, Collection Franke, Berlin.

66. Georg Baselitz, *Dog with Two Children* (*Chien avec deux enfants*), ca. 1966, oil on canvas, 63 x 51⅛ inches, Galerie Springer Berlin.

67. Eugen Schönebeck, *The Crucified* (*Der Gekreuzigte*), 1964, oil on canvas,
63¾ x 51¼ inches, private collection, New York.

68. Markus Lüpertz, *Roof Tile* (*Dachziegel*), ca. 1965, acrylic on canvas, 56⅞ x 56⅞ inches, Galerie Eva Poll, Berlin.

69. Markus Lüpertz, *House-Style* (*Haus-Stil*), 1976, oil on canvas, 78¾ x 98⅜ inches, Collection Stober, Berlin.

70. K. H. Hödicke, *Passage V*, 1964, oil on canvas, 59 x 63 inches, private collection, Düsseldorf.

71. Christa Dichgans, *Germany* (*Deutschland*), 1976, acrylic on canvas,
46 x 46 inches, President of the German Parliament, Bonn.

72. Salomé, *Self Portrait* (*Selbstportrait*), 1976, synthetic resin on canvas, 78¾ x 120 inches, Collection Stober, Berlin.

73. Rainer Fetting, *Van Gogh and Wall V* (*Van Gogh und Mauer V*), 1978, oil on
canvas, 79⅛ x 98⅞ inches, Collection Marx, Berlin.

74. Rainer Fetting, *Moritzplatz 1*, 1980, dispersion on unprimed canvas, 68⅞ x 86⅝ inches, Collection Marx, Berlin.

75. Bernd Koberling, *Under the Trees* (*Unter den Bäumen*), 1979, synthetic resin and oil on burlap, 68⅞ x 88⅝ inches, Berlinische Galerie, Berlin.

76. Heike Ruschmeyer, *Sunbath* (*Sonnenbad*), 1980, synthetic resin on natural fiber canvas, 74¹³/₁₆ x 94½ inches, Berlinische Galerie, Berlin.

77. Max Neumann, *Untitled (Ohne Titel)*, 1984, Japan color and acrylic on natural fiber canvas, 102⅜ x 59 inches, Berlinische Galerie, Berlin.

78. Gerd Rohling, *Untitled*, 1986, plastic and lead, 51⅛ x 23⅝ x 23⅝ inches, collection of the artist, Berlin.

79. Gerd Rohling, *Untitled*, 1986, plastic and wood, 35⁷⁄₁₆ x 22½ x 22½ inches, collection of the artist, Berlin.

80. Marwan, *Head* (*Kopf*), 1986, oil on canvas, 102³⁄₈ x 76³⁄₄ inches,
Berlinische Galerie, Berlin.

81. Wolfgang Petrick, *Ascent (Aufstieg)* from *Knight, Death and the Devil (Ritter, Tod und Teufel)*, 1988-89, collage, tempera, and oil on canvas, 118 x 37⅜ inches, collection of the artist, Berlin.

82. Wolfgang Petrick, *Night Rider (Nachtritt)* from *Knight, Death and the Devil (Ritter, Tod und Teufel)*, 1988-89, collage, tempera, and oil on canvas, 118 x 37⅜ inches, collection of the artist, Berlin.

83. Wolfgang Petrick, *Manuel Plays the Knight (Manuel spielt Ritter)* from *Knight, Death and the Devil (Ritter, Tod and Teufel)*, 1988-89, collage, tempera, and oil on canvas, 118 x 37⅜ inches, collection of the artist, Berlin.

84. Karl Friedrich Schinkel, *Gothic Church Behind Oak Trees* (*Gotische Kirche hinter einem Eichenhain mit Gräbern*), 1810, lithograph on paper, 19³/₁₆ x 13½ inches, Staatliche Museen Preussischer Kulturbesitz, Kupferstichkabinett, Berlin.

85. Karl Friedrich Schinkel, *Monument to Prince Louis Ferdinand* (*Das Grabmal des Prinzen Louis Ferdinand*), 1821, lithograph on paper, 13⅝ x 9¹/₁₆ inches, Staatliche Museen Preussischer Kulturbesitz, Kupferstichkabinett, Berlin.

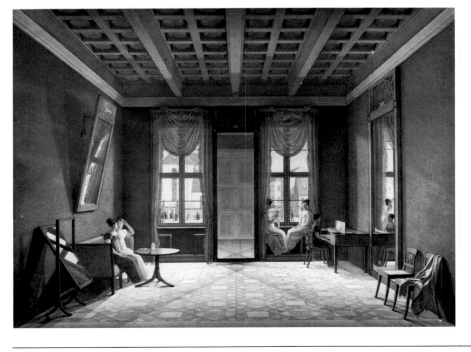

86. F. Riegel after Karl Friedrich Schinkel, from *Examples of Exalted Architecture* (*Werke der höheren Baukunst*), 1848-50, album of lithographs on paper, 31½ x 22⅞ inches, Staatlichen Schlösser und Gärten, Berlin.

87. Johann Erdmann Hummel, *Berlin Living Room* (*Berliner Wohnzimmer*), 1820, watercolor on paper, 16 x 20¾ inches, Museum für Kunsthandwerk, Frankfurt.

88. Karl Wilhelm Kolbe, *German Knights Tending the Sick in Jerusalem* (*Deutsch-Ordensritter bei der Krankenpflege in Jerusalem*), 1824, oil on canvas, 20½ x 15⅜ inches, Staatliche Museen Preussischer Kulturbesitz, National-galerie, Berlin.

89. Carl Begas, *Self Portrait* (*Selbstbildnis*), ca. 1820, oil on canvas, 23⅝ x 19¼ inches, Staatliche Museen Preussischer Kulturbesitz, Nationalgalerie, Berlin.

90. Carl Begas, *The Artist's Parents* (*Die Eltern des Künstlers*), after 1826, oil on canvas, 16 x 31⅞ inches, Staatliche Museen Preussischer Kulturbesitz, Nationalgalerie, Berlin.

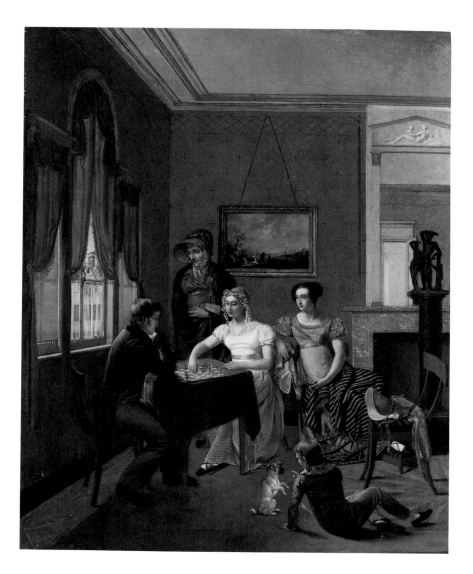

91. Gustav Friedrich Taubert, *The Artist and His Family* (*Der Künstler und seine Familie*), 1830, oil on canvas, 29¾ x 23¹³/₁₆ inches, Staatliche Museen Preussischer Kulturbesitz, National-galerie, Berlin.

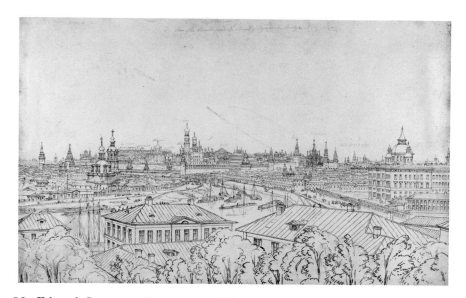

92. Eduard Gaertner, *Panorama of Moscow*, 1838, pen and brown ink over pencil on paper, 13¾ x 20⅝ inches, private collection, Los Angeles.

93. Franz Krüger, *Equestrian Portrait of Baron von Willisen* (*Reiterbildnis Freiherr von Willisen*), 1835, oil on canvas, 22½ x 17⅛ inches, Staatsgalerie Stuttgart.

94. Wilhelm Brücke, *The Old City Hall* (*Das alte Berliner Rathaus*), 1840, oil on canvas, 19⅛ x 21⅝ inches, Berlin Museum.

95. Wilhelm Brücke, *View of the Neue Wache in Berlin* (*Ansicht der Neuen Wache zu Berlin*), 1842, oil on canvas, 28 x 41¾ inches, Niedersächsisches Landesmuseum Hannover.

96. Adolph von Menzel, *Study of a Male Model in Back View, Taking Off His Coat*, chalk heightened with yellow and orange on paper, 9½ x 6⅝ inches, Stanford University Museum of Art, California, The Mortimer C. Leventritt Fund, 73.21.

97. Adolph von Menzel, *Study of a Partridge*, ca. 1848-50, pastel on brown paper, 4¾ x 7½ inches, Jill Newhouse, New York.

98. Adolph von Menzel, *Lady with a Fan*, study for *Episode at a Ball*, 1888, pencil on paper, 5 x 8½ inches, private collection, New York.

99. Adolph von Menzel, *Head of a Workman*, study for *Iron Rolling Mill*, ca. 1870-75, pencil on paper, 7¹⁵⁄₁₆ x 5 inches, private collection, New York.

100. Friedrich Eduard Meyerheim, *Portrait of Adolph Menzel* (*Bildnis Adolph Menzel*), oil on canvas, 16½ x 14⅜ inches, Staatliche Museen Preussischer Kulturbesitz, National-galerie, Berlin.

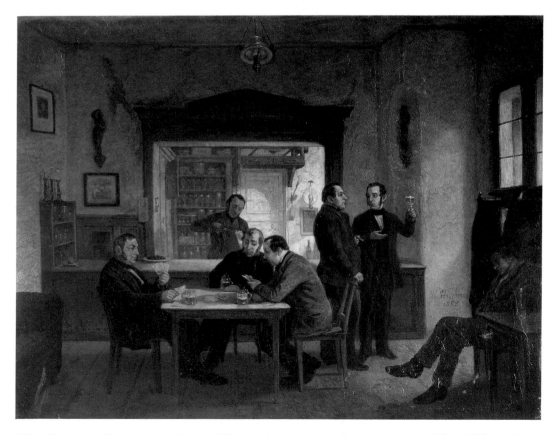

101. Theodor Hosemann, *Tavern* (*Weinstube*), 1858, oil on canvas, 14⅜ x 18⁵⁄₁₆ inches, Staatliche Museen Preussischer Kulturbesitz, Nationalgalerie, Berlin.

102. Moritz Hoffmann, *Jacob Grimm's Study* (*Arbeitszimmer von Jacob Grimm*), 1860, watercolor on paper, 14 x 17⅝ inches, Germanisches National-museum, Nuremberg.

103. Moritz Hoffmann, *Wilhelm Grimm's Study* (*Arbeitszimmer von Wilhelm Grimm*), 1860, watercolor on paper, 14 x 17¾ inches, Germanisches Nationalmuseum, Nuremberg.

104. Carl Steffeck, *Portrait of Ernst Lau and His Family* (*Porträt Ernst Lau mit seiner Familie*), 1865, oil on canvas, 18⁹⁄₁₆ x 22³⁄₄ inches, Staatliche Museen Preussischer Kulturbesitz, National-galerie, Berlin.

105. Paul Graeb, *Room in Berlin* (*Berliner Zimmer*), 1885, oil on canvas, 13³⁄₈ x 11³⁄₄ inches, Staatliche Museen Preussischer Kulturbesitz, Nationalgalerie, Berlin.

106. Ludwig Knaus, *Portrait of the Banker Itzinger* (*Bildnis des Bankiers Itzinger*), 1885, oil on canvas, 26¾ x 21⅝ inches, Staatliche Museen Preussischer Kulturbesitz, National-galerie, Berlin.

107. Julius Jacob and Wilhelm Herwarth, *Railroad Tracks at the Jannowitz Bridge* (*Die Stadtbahnanlage an der Jannowitzbrücke*), ca. 1891, pen, watercolor, and gouache on brown paper, 45¹³⁄₁₆ x 87¼ inches, Berlin Museum.

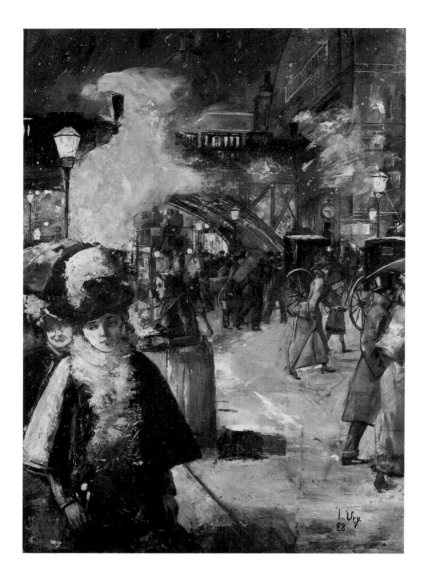

108. Lesser Ury, *At the Friedrichstrasse Station (Am Bahnhof Friedrichstrasse)*, 1888, gouache on paper, 25⅝ x 17¾ inches, Berlin Museum.

109. Anton von Werner, *In Temporary Quarters near Paris* (*Im Etappenquartier vor Paris*), 1894, oil on canvas, 47¼ x 62¼ inches, Staatliche Museen Preussischer Kulturbesitz, Nationalgalerie, Berlin.

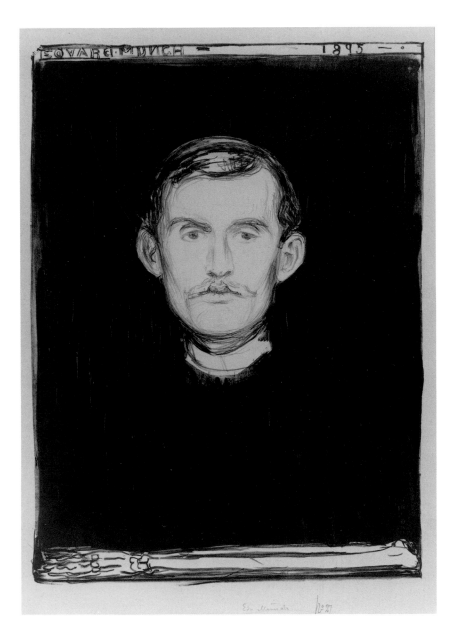

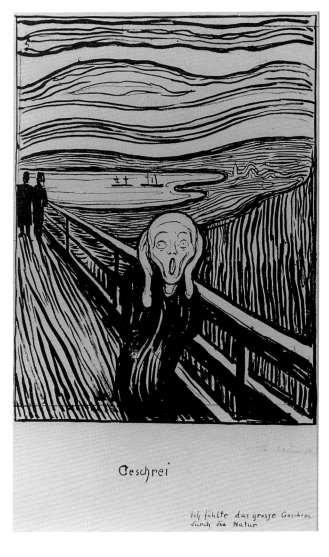

Geschrei

Ich fühlte das grosse Geschrei
durch die Natur

110. Edvard Munch, *Self Portrait with Skeleton Arm*, 1895, lithograph on paper, 17⅞ x 12⅝ inches, Nelson Blitz, Jr., and Catherine Woodard, New York.

111. Edvard Munch, *The Scream*, 1895, lithograph on paper, image 13⅞ x 10 inches, Nelson Blitz, Jr., and Catherine Woodard, New York.

112. Edvard Munch, *Death in the Sick Room*, 1896, lithograph on paper, 20¼ x 23¾ inches, Nelson Blitz, Jr., and Catherine Woodard, New York.

113. Max Liebermann, *In the Bath House* (*Im Schwimmbad*), 1875-78, oil on canvas, 71¼ x 88⅝ inches, Dallas Museum of Art, Foundation for the Arts Collection, Mrs. John B. O'Hara Fund.

114. Max Liebermann, *Self Portrait* (*Selbstporträt*), 1929, oil on panel, 19¹¹/₁₆ x 15⁹/₁₆ inches, Berlin Museum.

115. Hans Baluschek, *The Homeless* (*Obdachlose*), 1919, chalk and watercolor on cardboard, 38⅝ x 26⅝ inches, Bröhan-Museum, Berlin.

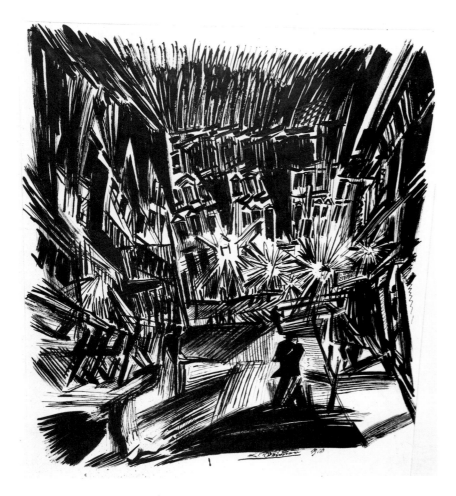

116. Ludwig Meidner, *Street with Pedestrian at Night*, 1913, ink and pencil on paper, 23¾ x 18⅛ inches, Marvin and Janet Fishman, Milwaukee, Wisconsin.

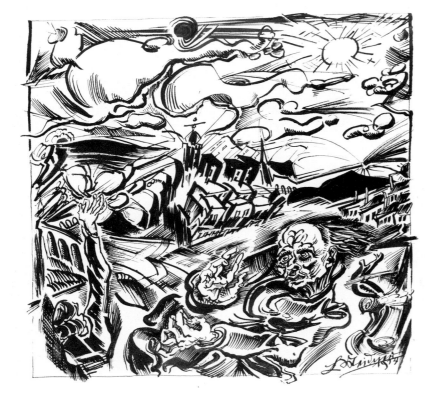

117. Ludwig Meidner, *Self Portrait with Landscape*, 1914, pen and ink on paper, 19½ x 16½ inches, Marvin and Janet Fishman, Milwaukee, Wisconsin.

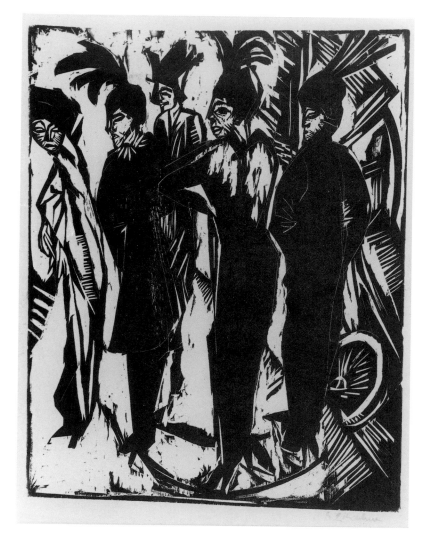

118. Ernst Ludwig Kirchner, *5 Tarts (Fünf Kokotten)*, 1914, woodcut on paper, 19½ x 14¾ inches, Nelson Blitz, Jr., and Catherine Woodard, New York.

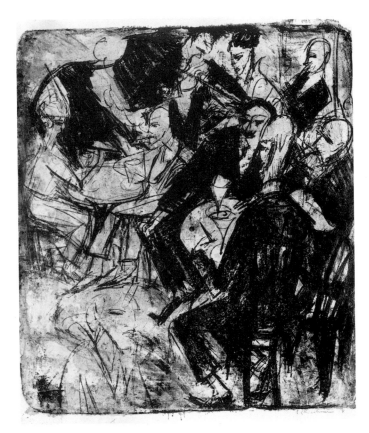

119. Ernst Ludwig Kirchner, *Music Café* (*Musikrestaurant*), 1914, lithograph on yellow paper, 23¼ x 19¾ inches, Nelson Blitz, Jr., and Catherine Woodard, New York.

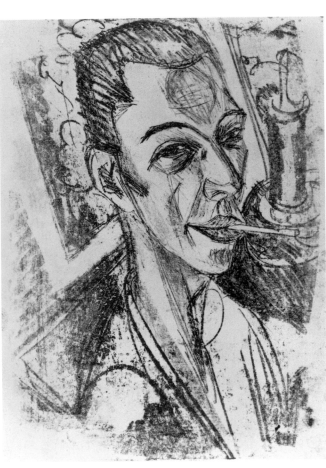

120. Ernst Ludwig Kirchner, *Self Portrait with Cigarette* (*Selbstbildnis mit Zigarette*), 1915, lithograph on yellow paper, 23¼ x 17 inches, Nelson Blitz, Jr., and Catherine Woodard, New York.

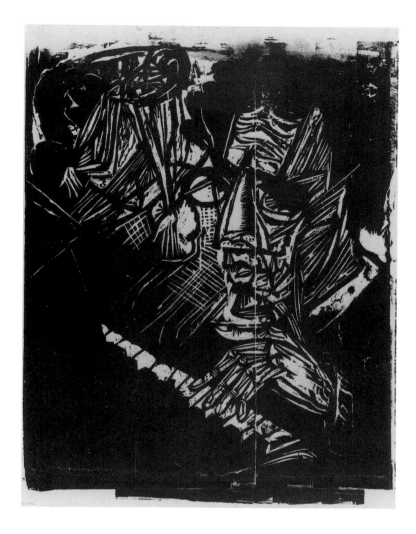

121. Ernst Ludwig Kirchner, *Klemperer the Composer* (*Komponist Klemperer*), 1916, woodcut on paper, 21½ x 16½ inches, Nelson Blitz, Jr., and Catherine Woodard, New York.

Young Woman with Admirer (Fräulein und Liebhaber)

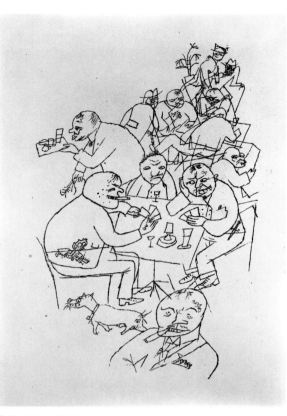

Coffee House (Kaffeehaus)

Riot of the Insane (Krawall der Irren)

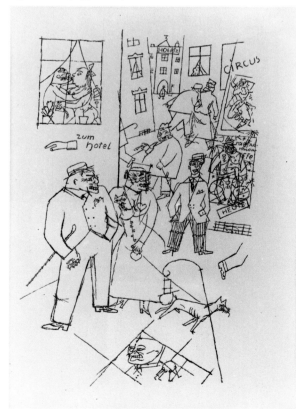

Pleasure Street (Strasse des Vergnügens)

122. George Grosz, *Small Grosz Portfolio* (*Kleine Grosz-Mappe*), 1917, from a portfolio of lithographs on paper, 11³⁄₈ x 8⁵⁄₈ inches, Berlinische Galerie, Berlin.

Café

Strolling (Spaziergang)

Houses Along the Canal (Häuser am Kanal)

The Factories (Die Fabriken)

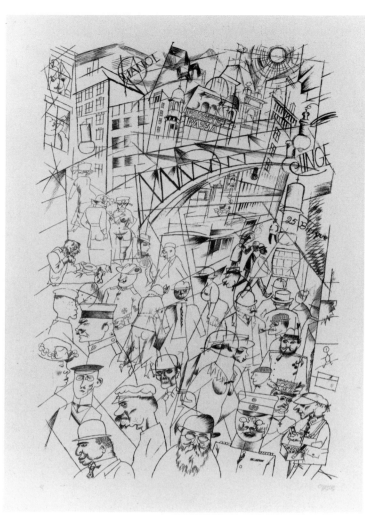

124. George Grosz, *The End of the Day*, ca. 1919, pen and brush and ink on paper, 18¾ x 14¾ inches, The Museum of Modern Art, New York, A. Conger Goodyear Fund.

123. George Grosz, *Friedrichstrasse*, 1918, lithograph on paper, 24¼ x 19⁵/₁₆ inches, anonymous loan, London.

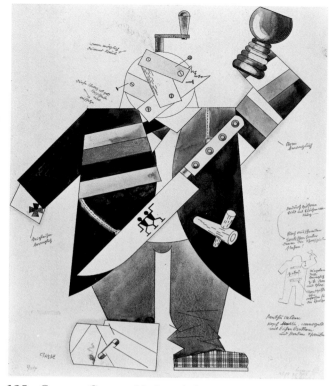

125. George Grosz, *Methuselah*, 1922, watercolor, metallic paint, pen and ink, and pencil on paper, 20¾ x 16¼ inches, The Museum of Modern Art, New York, Mr. and Mrs. Werner E. Josten Fund.

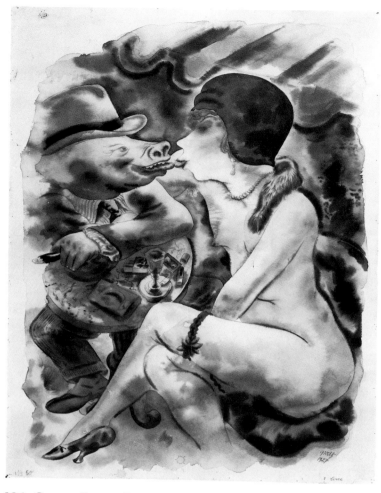

126. George Grosz, *Circe*, 1927, watercolor, pen and ink, and pencil on paper, 25⅞ x 19⅛ inches, The Museum of Modern Art, New York, gift of Mr. and Mrs. Walter Bareiss and an anonymous donor (by exchange).

127. George Grosz, Raoul Hausmann, and John Heartfield, *The First International Dada Fair* (*Erste Internationale Dada-Messe*), 1920, cover for catalogue, 12¼ x 15⅛ inches, Collection Timothy Baum, New York.

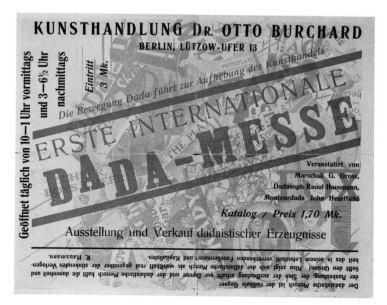

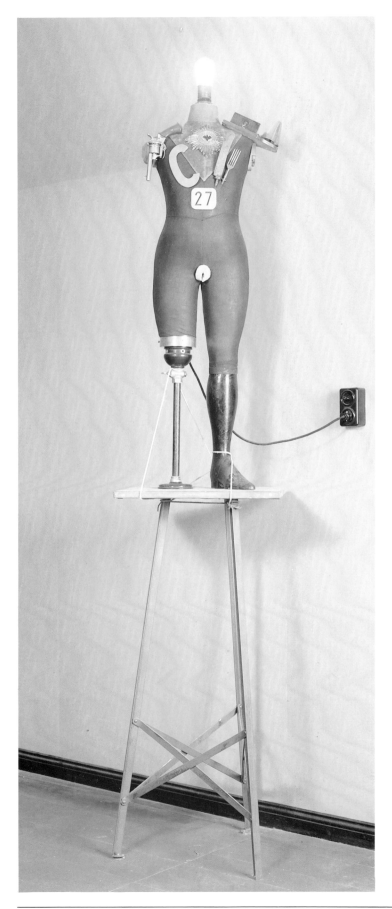

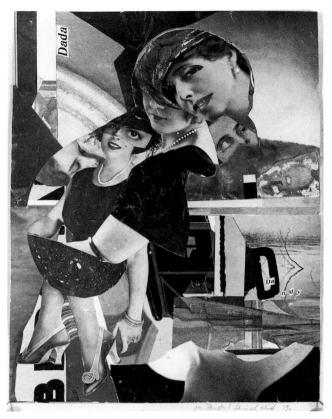

129. Hannah Höch, *DADA-Dandy*, 1919, collage on paper, 11¾ x 9½ inches, private collection, Hamburg.

128. George Grosz and John Heartfield, *The Philistine Heartfield Gone Wild*, 1920, reconstruction 1988, mixed media, 51¼ inches, Berlinische Galerie, Berlin.

130. Hannah Höch, *Golden Moon* (*Goldener-Mond*), 1923, collage and gouache on black construction paper, 8⅛ x 11 inches, private collection, New York.

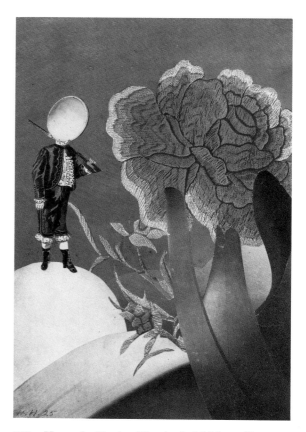

131. Hannah Höch, *Watched*, 1925, collage on paper, 10⅛ x 6¾ inches, The Museum of Modern Art, New York, Joseph G. Mayer Foundation fund in honor of Rene d'Harnoncourt.

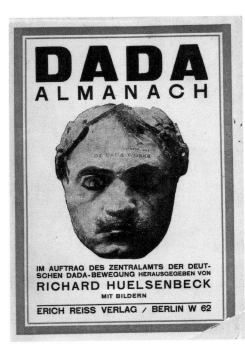

132. Richard Huelsenbeck, *Dada Almanach*, 1920, original edition book, 7³/₁₆ x 5³/₈ inches, Collection Timothy Baum, New York.

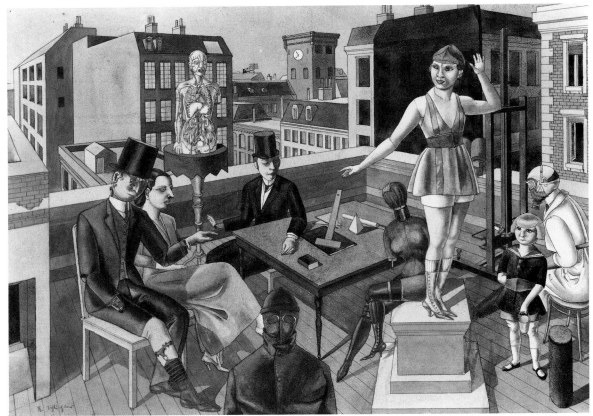

133. Rudolf Schlichter, *DA-DA-Roof Studio* (*DA-DA-Dachatelier*), ca. 1920, watercolor and pen on paper, 18 x 25⅛ inches, Galerie Nierendorf, Berlin.

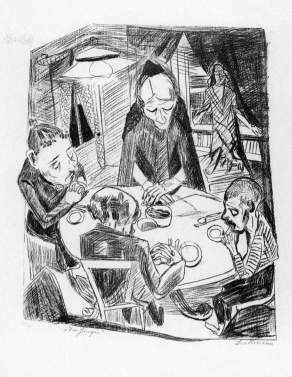

134. Max Beckmann, *Hunger* (*Der Hunger*) from *Hell* (*Die Hölle*), 1919, a portfolio of lithographs on paper, 24⅝ x 19¾ inches, Allan Frumkin, New York.

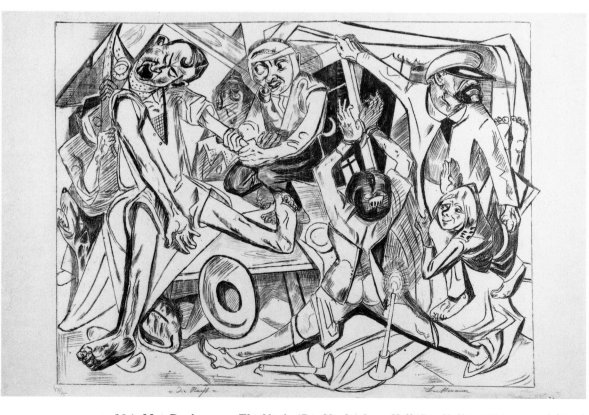

134. Max Beckmann, *The Night* (*Die Nacht*) from *Hell* (*Die Hölle*), 1919, a portfolio of lithographs on paper, 21⅞ x 27½ inches, Allan Frumkin, New York.

135. Max Beckmann, *Eden Bar*, 1923, woodcut on paper, 20¾ x 20⅝ inches,
Nelson Blitz, Jr., and Catherine Woodard, New York.

136. Conrad Felixmüller, *Self Portrait* (*Selbstportrait*), 1922, oil on canvas, 19¹¹⁄₁₆ x 15¾ inches, private collection, Hamburg.

137. Albert Birkle, *Berlin Street Scene* (*Berlin Strassenszene*), 1922, charcoal on paper, 28½ x 39½ inches, Marvin and Janet Fishman, Milwaukee, Wisconsin.

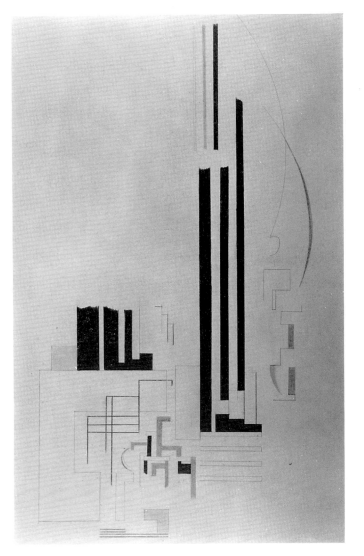

138. Hans Richter, Designs for the abstract film *Präludium*, 1919, pencil on paper, 39⅜ x 22⅞ inches, Staatliche Museen Preussischer Kulturbesitz, Kupferstichkabinett, Berlin.

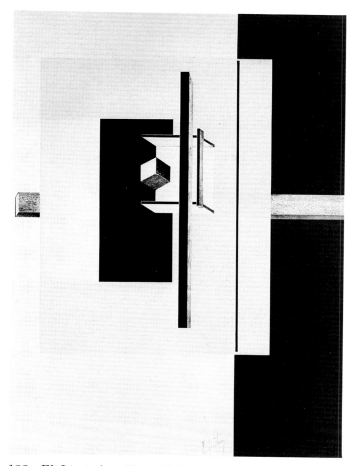

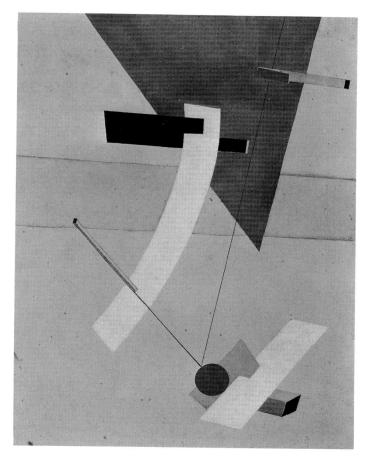

139. El Lissitzky, Plate V from *Proun*, *Kestnermappe*, 1919-23, a portfolio of lithographs on paper, 23⅝ x 17⅛ inches, Fogg Art Museum, Harvard University, Cambridge, Massachusetts, gift of Mr. and Mrs. Arthur Vershbow.

140. El Lissitzky, *Proun 12E*, 1923, oil on canvas, 22½ x 16¾ inches, Busch-Reisinger Museum, Harvard University, Cambridge, Massachusetts, Museum Purchase Association.

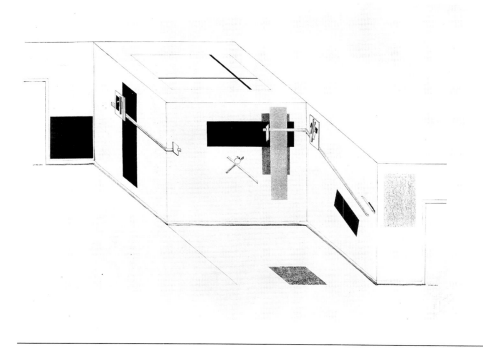

139. El Lissitzky, Plate VI from *Proun*, *Kestnermappe*, 1919-23, a portfolio of lithographs on paper, 17¼ x 23¾ inches, Fogg Art Museum, Harvard University, Cambridge, Massachusetts, gift of Mrs. Irving M. Sobin.

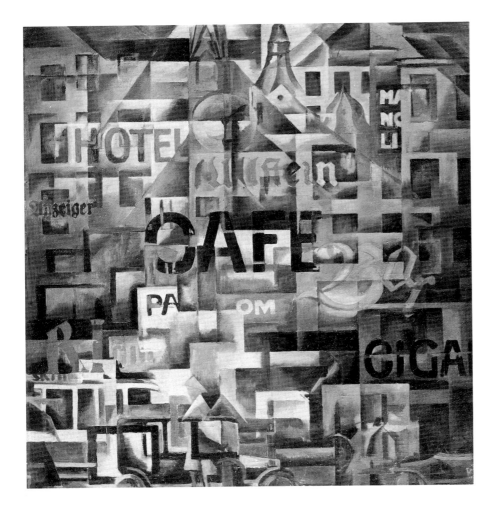

141. Otto Möller, *City* (*Stadt*), 1921, oil on canvas, 36 x 32⅛ inches, Staatliche
Museen Preussischer Kulturbesitz, Nationalgalerie, Berlin.

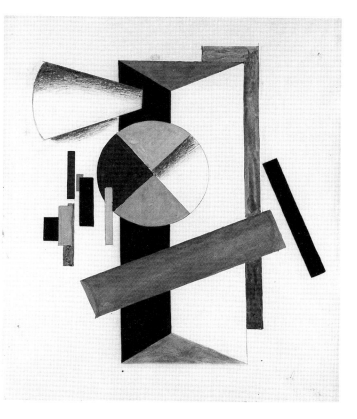

142. Ivan Puni, *Suprematist Drawing #3*, ca. 1920-21, pencil, gouache, and ink on paper, 24⅜ x 18¹¹/₁₆ inches, Yale University Art Gallery, New Haven, Connecticut, gift of the Collection Société Anonyme.

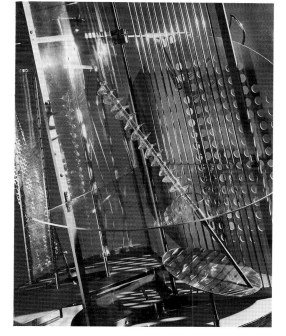

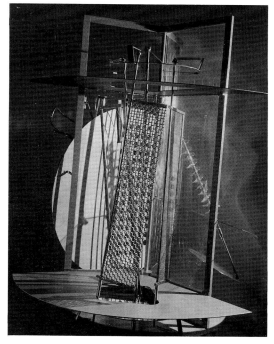

143. László Moholy-Nagy, *Light Play: Black-White-Gray*, ca. 1930, gelatin-silver print on paper, 14¹¹/₁₆ x 10¹³/₁₆ inches, The Museum of Modern Art, New York, gift of the photographer, 295.37.

144. László Moholy-Nagy, *Light Play: Black-White-Gray*, ca. 1930, gelatin-silver print on paper, 14¹¹/₁₆ x 10⅞ inches, The Museum of Modern Art, New York, gift of the photographer, 296.37.

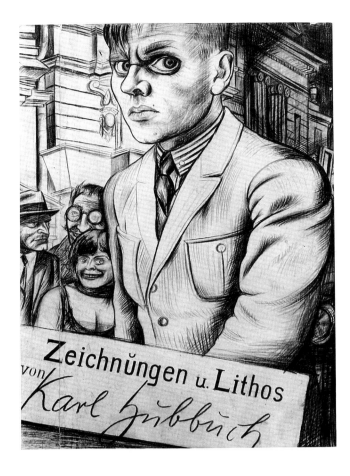

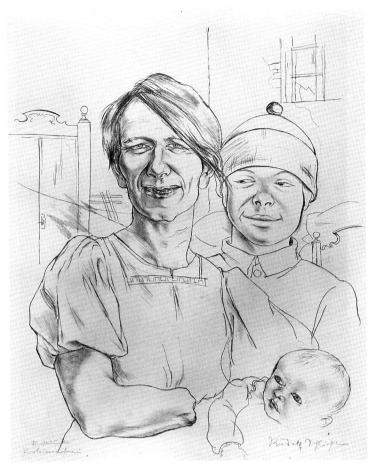

145. Karl Hubbuch, *Self Portrait (Selbstportrait)*, 1924, pencil on paper, 20½ x 14⅜ inches, Marvin and Janet Fishman, Milwaukee, Wisconsin.

146. Rudolf Schlichter, *Maimed Woman of the Proletariat (Verstümmelte Proletarierfrau)*, ca. 1924, pencil on paper, 24¹³/₁₆ x 18⅞ inches, Berlinische Galerie, Berlin.

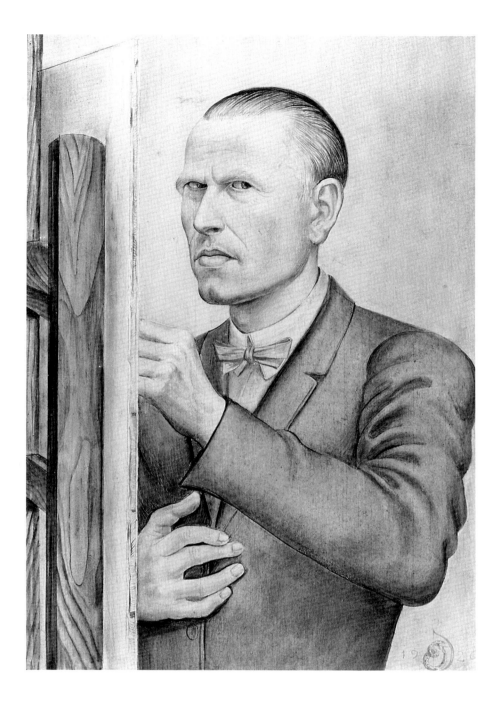

147. Otto Dix, *Self Portrait with Easel* (*Selbstbildnis mit Staffelei*), 1926, oil on panel, 31¾ x 21⅞ inches, Leopold-Hoesch-Museum der Stadt Düren.

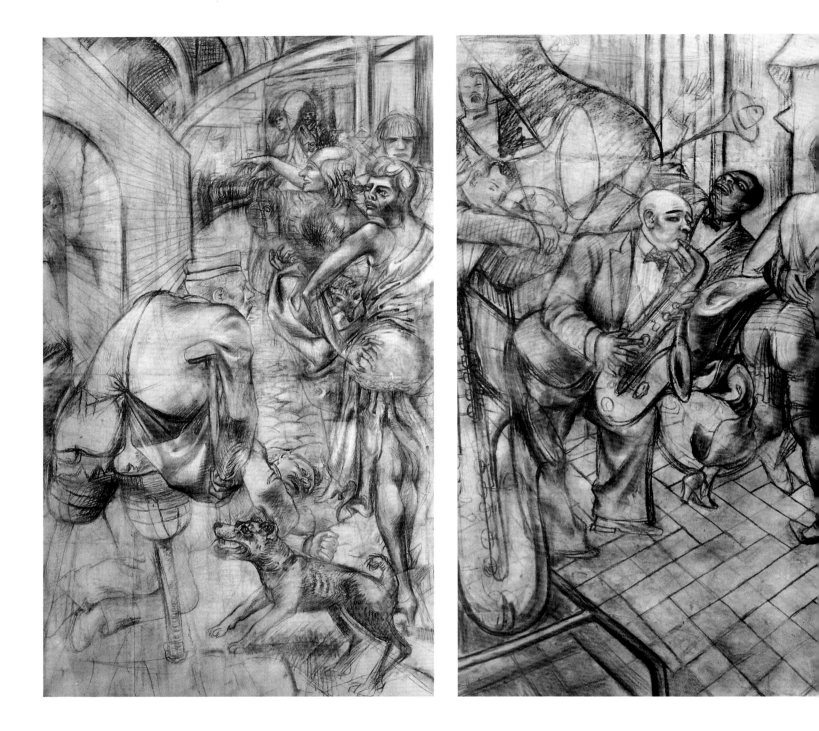

148. Otto Dix, cartoon for *Metropolis* (*Grossstadt*), 1927/28, three panels with charcoal, gouache, pencil, and chalk on paper, laid on canvas, 70⅞ x 40¾, 70⅞ x 79⅞, 70½ x 39¾ inches, Galerie der Stadt Stuttgart.

149. August Wilhelm Dressler, *Lovers* (*Liebespaar*), 1927, oil on canvas,
33⅞ x 23⅝ inches, private collection, Hamburg.

150. Bruno Voigt, *Attack (Angriff)*, 1932, watercolor and ink on paper, 18 x 11½ inches, Marvin and Janet Fishman, Milwaukee, Wisconsin.

151. Bruno Voigt, *Street Fight (Strassenkampf)*, 1932, watercolor and ink on paper, 19⅞ x 14⅛ inches, Marvin and Janet Fishman, Milwaukee, Wisconsin.

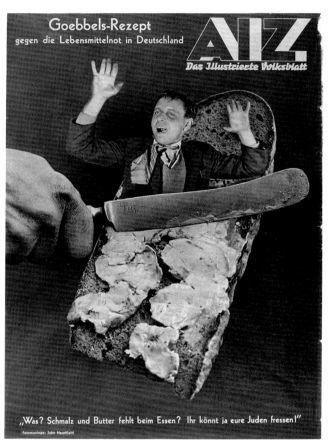

152. John Heartfield, *His Majesty Adolf. I lead you on to glorious bankruptcy!*, 1932, offset version of photomontage on paper, 14⅜ x 10⅝ inches, Akron Art Museum, Ohio, Museum Acquisition Fund.

154. John Heartfield, *Goebbels recipe against Germany's food shortages. "What? No lard and butter? Just eat your Jews!,"* 1935, offset version of photomontage on paper, 14½ x 10⅜ inches, Akron Art Museum, Ohio, Museum Acquisition Fund.

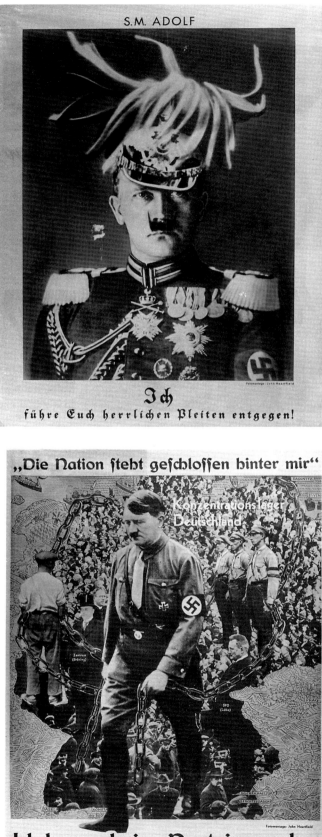

153. John Heartfield, *"The Nation stands behind me in closed ranks." Germany the concentration camp. I no longer know parties, I only know prisoners!*, 1933, offset version of photomontage on paper, 15 x 11⅛ inches, Akron Art Museum, Ohio, Museum Acquisition Fund.

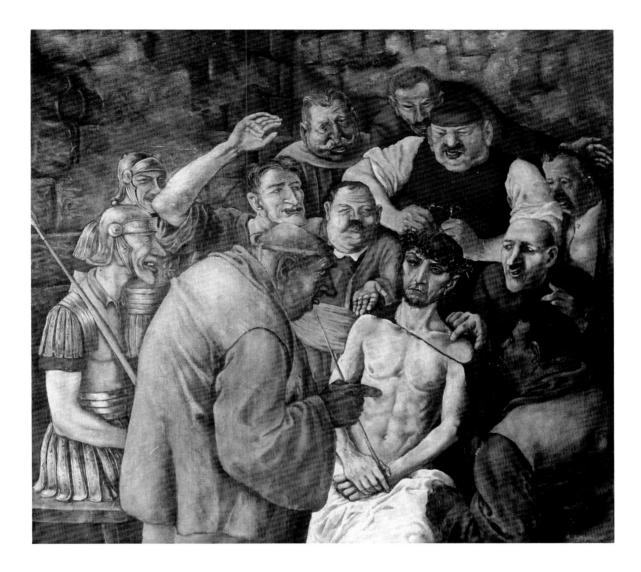

155. Rudolf Schlichter, *The Mocking of Christ* (*Die Verspottung Christi*), 1933, oil on canvas, 27¾ x 30¾ inches, Galerie der Stadt Stuttgart.

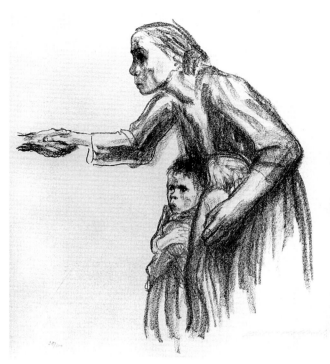

Woman Welcoming Death (Frau reicht dem Tod die Hand),
18⅛ x 15½ inches.

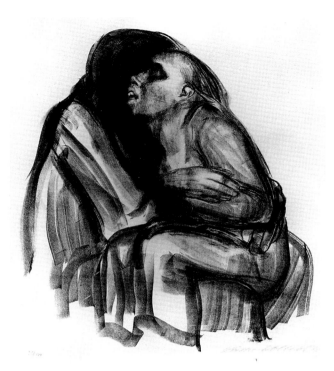

Girl Held in the Lap of Death (Tod mit Mädchen im Schoss),
17⅛ x 14⅞ inches.

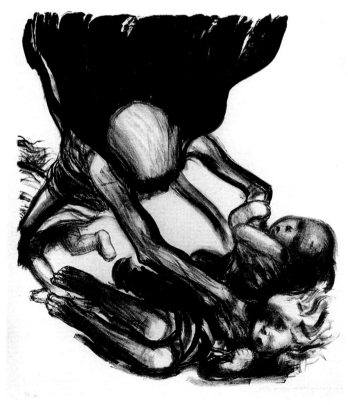

Death Reaching into a Group of Children (Tod greift in eine Kinderschaar),
19¾ x 16½ inches.

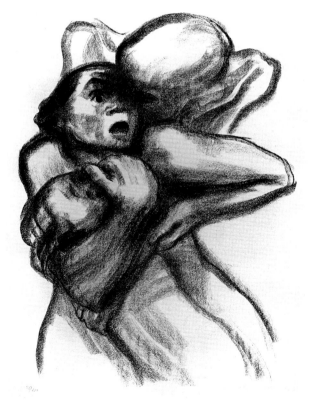

Woman Seized by Death (Frau wird vom Tod gepackt),
20 x 14⅜ inches.

156. Käthe Kollwitz, *Death (Der Tod)*, 1934/35, portfolio of lithographs on
paper, 25⅝ x 21⅞ inches, Berlinische Galerie, Berlin.

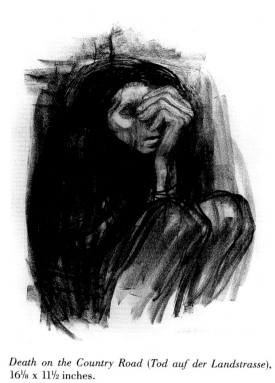

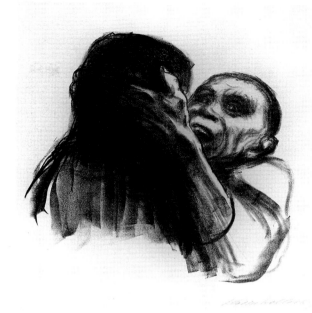

Death Seen as a Friend (Tod wird als Freund erkannt),
12⅜ x 12⅞ inches.

Death on the Country Road (Tod auf der Landstrasse),
16⅛ x 11½ inches.

The Call of Death (Ruf des Todes), 15 x 15⅛ inches.

Death in the Water (Der Tod im Wasser), 19⅛ x 15⅛ inches.

157. Hans Uhlmann, *Female Head* (*Weiblicher Kopf*), 1940, tin, 16⅜ x 6¾ x 7¹¹⁄₁₆ inches, Berlinische Galerie, Berlin.

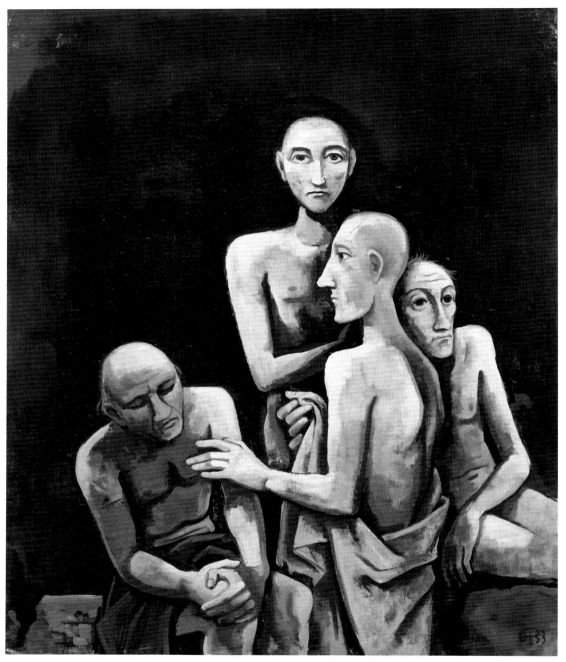

158. Carl Hofer, *The Prisoners* (*Die Gefangenen*), 1933, oil on canvas, 61⅜ x 50⅜ inches, Berlinische Galerie, Berlin.

159. Carl Hofer, *Alarm*, 1945,
oil on canvas, 41 x 31½ inches,
Berlinische Galerie, Berlin.

160. Heinz Trökes, *Between the Blocks*
(*Zwischen den Blöcken*), 1947, oil on canvas,
22 x 17⅛ inches, collection of the artist,
Berlin.

161. Bernhard Heiliger, *Ernst Reuter*, 1954, bronze, 15⅞ x 12 x 15 inches with base, The Museum of Modern Art, New York, Matthew T. Mellon Foundation Fund.

163. Hans Uhlmann, *Steel Sculpture in Three Colors* (*Dreifarbige Stahlskulptur*), 1951, steel and aluminum, 52⅜ inches, Wilhelm-Lehmbruck-Museum der Stadt Duisburg.

162. Bernhard Heiliger, *Head of Kurt Martin*, 1959, plaster, 12½ inches, Solomon R. Guggenheim Museum, New York, gift of Staempfli Gallery, New York, 1962.

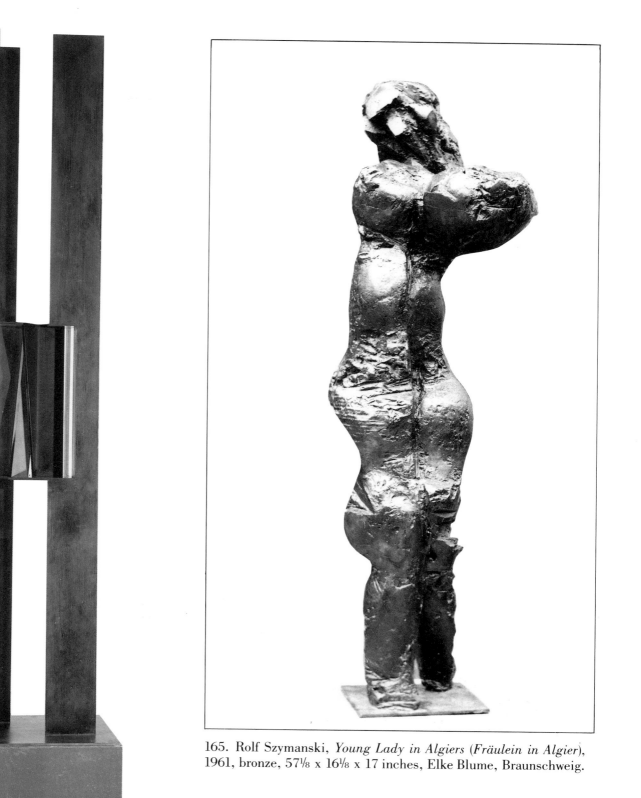

165. Rolf Szymanski, *Young Lady in Algiers (Fräulein in Algier)*, 1961, bronze, 57⅛ x 16⅛ x 17 inches, Elke Blume, Braunschweig.

164. Hans Uhlmann, *Tower (Turm)*, 1961, painted steel, 78¾ inches, Staatliche Museen Preussischer Kulturbesitz, Nationalgalerie, Berlin.

166. Joseph Beuys and Henning Christiansen, *I'm Going to Let (Make) You Free* (*Ich versuche dich freizulassen* [*machen*]), photographs of the Fluxus concert, February 27, 1969, Akademie der Künste, Berlin. The photographs document the disruption of the concert by the audience. Estate of Joseph Beuys, Eva, Wenzel, and Jessyka Beuys, courtesy of Bild-Kunst, Frankfurt am Main.

167. Walter Stöhrer, *Large Woman Full of Cosmetics and Industry, Homage to Brinkmann* (*Grosse Weiber voll Kosmetik und Industrie, Hommage à Brinkmann*), 1967, oil on canvas, 78¾ x 68⅞ inches, Berlinische Galerie, Berlin.

168. Markus Lüpertz, *Dithyramb* (*Dithyrambe*), 1964, oil on canvas, 59 x 59 inches, Collection Stober, Berlin.

169. Wolf Vostell, *Alcantara* from the *Extremadura* series, 1975, mixed media on canvas, 78¾ x 78¾ x 5½ inches, Galerie van de Loo, Munich.

170. Klaus Vogelgesang, *Contrapposto* (*Standbein-Spielbein*), 1976, lead and colored pencils on paper, 77⅛ x 57½ inches, Berlinische Galerie, Berlin.

171. Helmut Middendorf, *Natives of the Big City II* (*Grossstadteingeborene II*), 1979, mixed media on canvas, 74⅝ x 110¼ inches, Berlinische Galerie, Berlin.

172. K. H. Hödicke, *Ministry of War* (*Kriegsministerium*), 1977, synthetic resin on canvas, 72⅝ x 106¼ inches, Berlinische Galerie, Berlin.

173. Dieter Hacker, *Gestapo*, 1984, oil on canvas, 75⅝ x 112⅝ inches, Deutsches Architekturmuseum, Frankfurt.

174. Edward Kienholz and Nancy Reddin-Kienholz, *The Pawn Boys*, 1983, fifty-two bricks, each with a photograph, Berlinische Galerie, Berlin.

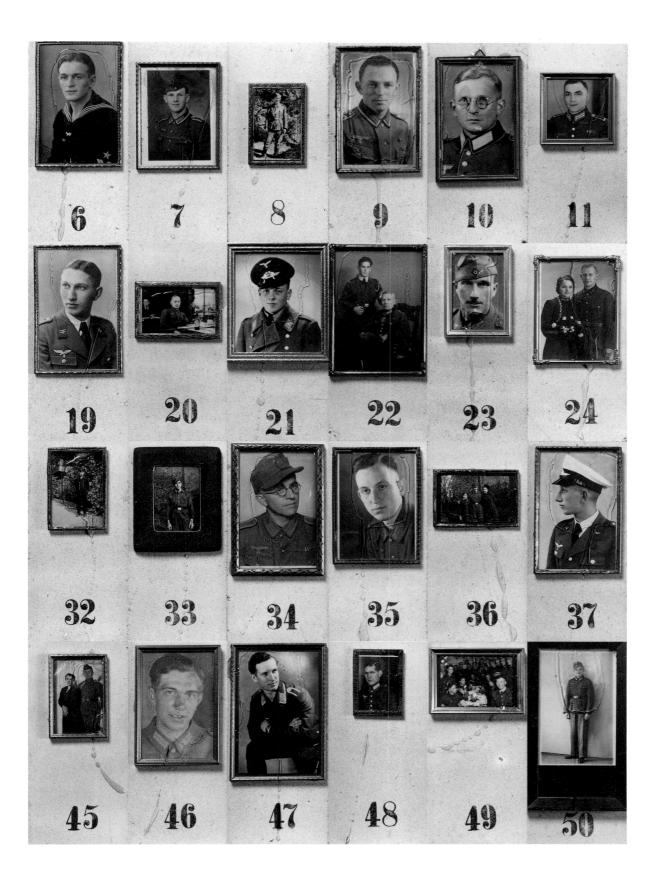

6 7 8 9 10 11

19 20 21 22 23 24

32 33 34 35 36 37

45 46 47 48 49 50

Lenders to the Exhibition

Akron Art Museum, Ohio
Anonymous loan, London
Anonymous loan, Cologne
Timothy Baum, New York
Berlin Museum
Berlinische Galerie, Berlin
Nelson Blitz, Jr., and Catherine Woodard, New York
Elke Blume, Braunschweig
Bröhan Museum, Berlin
Brücke Museum, Berlin
Busch-Reisinger Museum, Harvard University, Cambridge
Collection B, Berlin
Collection Franke, Berlin
Collection Marx, Berlin
Collection Stober, Berlin
Dallas Museum of Art
Deutsches Architekturmuseum, Frankfurt
Estate of Joseph Beuys, Eva, Wenzel, and Jessyka Beuys
SKH Dr. Louis Ferdinand, Prinz von Preussen, Berlin
The Fine Arts Museum of San Francisco
Marvin and Janet Fishman, Milwaukee, Wisconsin
Fogg Art Museum, Harvard University, Cambridge
Allan Frumkin, New York
Galerie Eva Poll, Berlin
Galerie Nierendorf, Berlin
Galerie Pels-Leusden-Villa Griesebach, Berlin
Galerie Springer Berlin
Galerie der Stadt Stuttgart
Galerie van de Loo, Munich
Germanisches Nationalmuseum, Nuremberg
Hamburger Kunsthalle, Hamburg
Kunsthalle Bremen
Landesmuseum Mainz
Leopold-Hoesch-Museum der Stadt Düren
Museum für Kunsthandwerk, Frankfurt
The Museum of Modern Art, New York
Jill Newhouse, New York
Niedersächsisches Landesmuseum
Wolfgang Petrick
President of the German Parliament, Bonn
Private collection, Dusseldorf
Private collection, Hamburg
Private collection, Los Angeles

Private collection, Munich
Private collection, New York
Private collection, New York
Gerd Rohling, Berlin
The Saint Louis Art Museum, Missouri
Siemens Aktiengesellschaft, Berlin
Solomon R. Guggenheim Museum, New York
Staatlichen Schlösser und Gärten, Berlin
Staatliche Museen Preussischer Kulturbesitz, Kupferstichkabinett, Berlin
Staatliche Museen Preussischer Kulturbesitz, Nationalgalerie, Berlin
Staatsgalerie Stuttgart
Städtische Galerie im Lenbachhaus, Munich
Städtische Galerie im Städelschen Kunstinstitut Frankfurt am Main
Stanford University Museum of Art, California
Heinz Trökes, Berlin
Wilhelm-Lehmbruck-Museum der Stadt Duisburg
Yale University Art Gallery, New Haven

Checklist of the Exhibition

Hans Baluschek, 1870-1935

Winter Wind (Winterwind), 1907
Chalk and watercolor on cardboard
24¹³/₁₆ x 38 inches (63 x 96.5 cm)
Bröhan-Museum, Berlin
Cat. no. 26

The Homeless (Obdachlose), 1919
Chalk and watercolor on cardboard
38⅝ x 26⅝ inches (98 x 67.5 cm)
Bröhan-Museum, Berlin
Cat. no. 115

Georg Baselitz, born 1938

Dog with Two Children (Chien avec deux enfants),
 ca. 1966
Oil on canvas
63 x 51⅛ inches (160 x 130 cm)
Galerie Springer Berlin
Cat. no. 66

Max Beckmann, 1884-1950

*View of Nollendorfplatz (Blick auf den
 Nollendorfplatz)*, 1911
Oil on canvas
26 x 30⅛ inches (66 x 76.5 cm)
Berlin Museum
Cat. no. 30

Hell (Die Hölle), 1919
Portfolio of eleven lithographs on paper
Allan Frumkin, New York
 Self Portrait (Selbstbildnis), 15⅛ x 11⅞ inches
 (38.5 x 30.2 cm)
 The Way Home (Der Nachhauseweg), 29 x 19
 inches (73.5 x 48.3 cm)
 The Street (Die Strasse), 26⅝ x 21¼ inches
 (67.5 x 53.9 cm)
 Martyrdom (Das Martyrium), 21½ x 29⅝ inches
 (54.7 x 75.2 cm)
 Hunger (Der Hunger), 24⅝ x 19¾ inches
 (62.6 x 50.1 cm)
 The Ideologues (Die Ideologen), 28⅛ x 19⅞
 inches (71.4 x 50.5 cm)
 The Night (Die Nacht), 21⅞ x 27½ inches
 (55.5 x 69.8 cm)
 Malepartus, 26⅞ x 16⅜ inches (68.2 x 41.6 cm)

MAX BECKMANN, 1884-1950

The Patriotic Song (Das patriotische Lied),
30⅝ x 21½ inches (77.7 x 54.5 cm)
The Last Ones (Die Letzten), 26¼ x 18⅝ inches
(66.7 x 47.4 cm)
The Family (Die Familie), 29⅞ x 18⅛ inches
(76 x 46.5 cm)
Cat. no. 134

Eden Bar, 1923
Woodcut on paper
20¾ x 20⅝ inches (52.7 x 52.4 cm)
Nelson Blitz, Jr., and Catherine Woodard,
New York
Cat. no. 135

The King, 1937
Oil on canvas
53⅛ x 39⅜ inches (135 x 100 cm)
The Saint Louis Art Museum, Missouri
Bequest of Morton D. May
Cat. no. 55

CARL BEGAS, 1794-1854

Self Portrait (Selbstbildnis), ca. 1820
Oil on canvas
23⅝ x 19¼ inches (60 x 49 cm)
Staatliche Museen Preussischer Kulturbesitz,
Nationalgalerie, Berlin
Cat. no. 89

The Artist's Parents (Die Eltern des Künstlers), after
1826
Oil on canvas
16 x 31⅞ inches (40.7 x 81 cm)
Staatliche Museen Preussischer Kulturbesitz,
Nationalgalerie, Berlin
Cat. no. 90

JOSEPH BEUYS, 1921-1986
HENNING CHRISTIANSEN

*I'm Going to Let (Make) You Free (Ich versuche dich
freizulassen [machen])*
Photographs of the Fluxus concert, February 27,
1969
Estate of Joseph Beuys, Eva, Wenzel, and Jessyka
Beuys
Courtesy of Bild-Kunst, Frankfurt am Main
Cat. no. 166

CARL EDUARD BIERMANN, 1803-1892

*Borsig's Machine Hall in Berlin (Borsig's
Maschinenbauanstalt zu Berlin)*, 1847
Oil on canvas
43⁵⁄₁₆ x 45⅞ inches (110 x 116.5 cm)
Berlin Museum, A. Borsig Archive
Cat. no. 7

ALBERT BIRKLE, 1900-1986

Berlin Street Scene (Berlin Strassenszene), 1922
Charcoal on paper
28½ x 39½ inches (72.4 x 100.3 cm)
Marvin and Janet Fishman, Milwaukee, Wisconsin
Cat. no. 137

WILHELM BRÜCKE, 1800-1874

The Old City Hall (Das alte Berliner Rathaus), 1840
Oil on canvas
19⅛ x 21⅝ inches (48.5 x 55 cm)
Berlin Museum
Cat. no. 94

*View of the Neue Wache in Berlin (Ansicht der Neuen
Wache zu Berlin)*, 1842
Oil on canvas
28 x 41¾ inches (71 x 106 cm)
Niedersächsisches Landesmuseum Hannover
Cat. no. 95

ALEXANDER CAMARO, born 1901

Suburban Movie Theatre (Vorstadtkino), after 1945
Oil on pressed board
24⅜ x 34¼ inches (62 x 87 cm)
Berlinische Galerie, Berlin
Cat. no. 60

LOVIS CORINTH, 1858-1925

*The Family of the Painter Fritz Rumpf (Die Familie
des Malers Fritz Rumpf)*, 1901
Oil on canvas
44½ x 55⅛ inches (113 x 140 cm)
Staatliche Museen Preussischer Kulturbesitz,
Nationalgalerie, Berlin
Cat. no. 27

*Self Portrait at the Easel (Selbstbildnis vor der
Staffelei)*, 1919
Oil on canvas
49⅝ x 41⅝ inches (126 x 105.8 cm)
Staatliche Museen Preussischer Kulturbesitz,
Nationalgalerie, Berlin
Cat. no. 28

CHRISTA DICHGANS, born 1940

Germany (Deutschland), 1976
Acrylic on canvas
46 x 46 inches (117 x 117 cm)
President of the German Parliament, Bonn
Cat. no. 71

OTTO DIX, 1891-1969

Three Street Walkers (Drei Dirnen auf der Strasse), 1925
Oil on plywood
37⅜ x 39⅜ inches (95 x 100 cm)
Private collection, Hamburg
Cat. no. 48

Self Portrait with Easel (Selbstbildnis mit Staffelei), 1926
Oil on panel
31¾ x 21⅞ inches (80.5 x 55.5 cm)
Leopold-Hoesch-Museum der Stadt Düren
Cat. no. 147

Cartoon for *Metropolis (Grossstadt)*, 1927/28
Three panels with charcoal, gouache, pencil, and chalk on paper, laid on canvas
70⅞ x 40¾, 70⅞ x 79⅞, 70½ x 39¾ inches
(180 x 103.5 cm, 180 x 203 cm, 179 x 101 cm)
Galerie der Stadt Stuttgart
Cat. no. 148

AUGUST WILHELM DRESSLER

Lovers (Liebespaar), 1927
Oil on canvas
33⅞ x 23⅝ inches (86 x 60 cm)
Private collection, Hamburg
Cat. no. 149

CONRAD FELIXMÜLLER, 1897-1977

Self Portrait (Selbstportrait), 1922
Oil on canvas
19¹¹⁄₁₆ x 15¾ inches (50 x 40 cm)
Private collection, Hamburg
Cat. no. 136

RAINER FETTING, born 1949

Van Gogh and Wall V (Van Gogh und Mauer V), 1978
Oil on canvas
79⅛ x 98⅞ inches (201 x 251 cm)
Collection Marx, Berlin
Cat. no. 73

Moritzplatz 1, 1980
Dispersion on unprimed canvas
68⅞ x 86⅝ inches (175 x 220 cm)
Collection Marx, Berlin
Cat. no. 74

EDUARD GAERTNER, 1801-1877

View of the Friedrichsforum from the Roof of the Friedrichwerder Church (Blick vom Dach der Friedrichwerderschen Kirche auf das Friedrichsforum), 1835
Oil on canvas
36¹³⁄₁₆ x 57⅞ inches (93.5 x 147 cm)
Berlin Museum
Cat. no. 4

Panorama of Moscow, 1838
Pen and brown ink over pencil on paper
13¾ x 20⅝ inches (35 x 52.5 cm)
Private collection, Los Angeles
Cat. no. 92

The Palace Bridge (Schlossbrücke), 1861
Oil on canvas
35⁷⁄₁₆ x 49 inches (90 x 124.5 cm)
SKH Dr. Louis Ferdinand, Prinz von Preussen, Berlin
Cat. no. 5

PAUL GRAEB, 1842-1892

Room in Berlin (Berliner Zimmer), 1865
Oil on canvas
11⅜ x 15 inches (29 x 38 cm)
Staatliche Museen Preussischer Kulturbesitz, Nationalgalerie, Berlin
Cat. no. 10

Room in Berlin (Berliner Zimmer), 1885
Oil on canvas
13⅜ x 11¾ inches (34 x 29.8 cm)
Staatliche Museen Preussischer Kulturbesitz, Nationalgalerie, Berlin
Cat. no. 105

GEORGE GROSZ, 1893-1959

The Street (Die Strasse), 1915
Oil on canvas
17⅞ x 14 inches (45.5 x 35.5 cm)
Staatsgalerie Stuttgart
Cat. no. 40

GEORGE GROSZ, 1893-1959

Café, 1916
Oil on canvas
19 x 12⅞ inches (48.3 x 33.7 cm)
The Saint Louis Art Museum, Missouri
Bequest of Morton D. May
Cat. no. 41

Small Grosz Portfolio (Kleine Grosz-Mappe), 1917
From a portfolio of twenty lithographs on paper
11⅜ x 8⅝ inches (29 x 22 cm)
Berlinische Galerie, Berlin
Young Woman with Admirer (Fräulein und Liebhaber)
Coffee House (Kaffeehaus)
Riot of the Insane (Krawall der Irren)
Pleasure Street (Strasse des Vergnügens)
Café
Strolling (Spaziergang)
Houses Along the Canal (Häuser am Kanal)
The Factories (Die Fabriken)
Cat. no. 122

Friedrichstrasse, 1918
Lithograph on paper
24¼ x 19⁵⁄₁₆ inches (61.6 x 49 cm)
Anonymous loan, London
Cat. no. 123

The End of the Day, ca. 1919
Pen and brush and ink on paper
18¾ x 14¾ inches (47.6 x 37.4 cm)
The Museum of Modern Art, New York
A. Conger Goodyear Fund
Cat. no. 124

Methuselah, 1922
Watercolor, metallic paint, pen and ink, and pencil on paper
20¾ x 16¼ inches (52.6 x 41.1 cm)
The Museum of Modern Art, New York
Mr. and Mrs. Werner E. Josten Fund
Cat. no. 125

Sunday Family Walk, ca. 1923
Collage, pen, and watercolor on paper
11 x 8⅜ inches (28 x 21.3 cm)
Marvin and Janet Fishman, Milwaukee, Wisconsin
Cat. no. 49

Circe, 1927
Watercolor, pen and ink, and pencil on paper
25⅞ x 19⅛ inches (66 x 48.6 cm)
The Museum of Modern Art, New York
Gift of Mr. and Mrs. Walter Bareiss
and an anonymous donor (by exchange)
Cat. no. 126

The Poet Max Herrmann-Neisse, 1927
Oil on canvas
23⅜ x 29⅛ inches (59.4 x 74 cm)
The Museum of Modern Art, New York
Purchase
Cat. no. 50

GEORGE GROSZ, 1893-1959
RAOUL HAUSMANN, 1886-1971
JOHN HEARTFIELD, 1891-1968

The First International Dada Fair (Erste Internationale Dada-Messe), 1920
Cover for catalogue
12¼ x 15⅛ inches (31.1 x 38.4 cm)
Collection Timothy Baum, New York
Cat. no. 127

GEORGE GROSZ, 1893-1959
JOHN HEARTFIELD, 1891-1968

The Philistine Heartfield Gone Wild, 1920, reconstruction 1988
Mixed media
51¼ inches (130 cm)
Berlinische Galerie, Berlin
Cat. no. 128.

DIETER HACKER, born 1942

Gestapo, 1984
Oil on canvas
75⅝ x 112⅝ inches (192 x 286 cm)
Deutsches Architekturmuseum, Frankfurt
Cat. no. 173

JOHN HEARTFIELD, 1891-1968

His Majesty Adolf. I lead you on to glorious bankruptcy! (S. M. Adolf. Ich führe Euch herrlichen Pleiten entgegen!), 1932
Offset version of photomontage on paper
14⅜ x 10⅝ inches (36.5 x 27 cm)
Akron Art Museum, Ohio
Museum Acquisition Fund
Cat. no. 152

"The Nation stands behind me in closed ranks." Germany the concentration camp. I no longer know parties, I only know prisoners! ("Die Nation steht geschlossen hinter mir." Konzentrationslager Deutschland. Ich kenne keine Parteien mehr, Ich kenne nur noch Gefangene!), 1933
Offset version of photomontage on paper

15 x 11⅛ inches (38 x 28.2 cm)
Akron Art Museum, Ohio
Museum Acquisition Fund
Cat. no. 153

Goebbels recipe against Germany's food shortages. "What? No lard and butter? Just eat your Jews!" (Goebbels-Rezept gegen die Lebensmittelnot in Deutschland. "Was? Schmalz und Butter fehlt beim Essen? Ihr könnt ja eure Juden fressen!"), 1935
Offset version of photomontage on paper
14½ x 10⅜ inches (36.8 x 26.3 cm)
Akron Art Museum, Ohio
Museum Acquisition Fund
Cat. no. 154

ERICH HECKEL, 1883-1970

Bathers, ca. 1912-13
Oil on canvas
32 x 37½ inches (81.2 x 95.2 cm)
The Saint Louis Art Museum, Missouri
Bequest of Morton D. May
Cat. no. 31

Girl Playing the Lute (Lautespielendes Mädchen), 1913
Oil on canvas
28⅜ x 31⅛ inches (72 x 79 cm)
Brücke-Museum, Berlin
Cat. no. 32

BERNHARD HEILIGER, born 1915

Ernst Reuter, 1954
Bronze
15⅞ x 12 x 15 inches (40.1 x 30.3 x 38.2 cm) with base
The Museum of Modern Art, New York
Matthew T. Mellon Foundation Fund
Cat. no. 161

Head of Kurt Martin, 1959
Plaster
12½ inches (31.8 cm)
Solomon R. Guggenheim Museum, New York
Gift of Staempfli Gallery, New York, 1962
Cat. no. 162

WERNER HELDT, 1904-1954

Saturday Afternoon (Sunday Afternoon) (Samstagnachmittag [Sonntagnachmittag]), 1952
Oil on canvas

23⅝ x 39⅜ inches (60 x 100 cm)
Collection B, Berlin
Cat. no. 61

Sunday Afternoon (Sonntagnachmittag), 1952
Oil on canvas
24¾ x 42⅞ inches (63 x 109 cm)
Berlinische Galerie, Berlin
Cat. no. 62

JOHANN HEINRICH HINTZE, 1800-1862

The Royal Museum (Das Alte Museum von der Schlossfreiheit aus gesenhen), ca. 1832
Oil on canvas
12⅛ x 18½ inches (30.8 x 47 cm)
Berlin Museum
Cat. no. 3

HANNAH HÖCH, 1889-1978

DADA-Dandy, 1919
Collage on paper
11¾ x 9½ inches (30 x 24 cm)
Private collection, Hamburg
Cat. no. 129

Bourgeois Couple (The Fight) (Bürgerliches Brautpaar [Streit]), 1919
Collage on paper
15 x 12⅛ inches (38 x 30.8 cm)
Private collection, Hamburg
Cat. no. 42

Poetry (Poesie), 1922
Collage and drawing on paper
10 x 7⅝ inches (25.5 x 19.5 cm)
Private collection, Hamburg
Cat. no. 43

Union (Vereinigung), 1922
Watercolor on paper
26¾ x 21⅝ inches (68 x 55 cm)
Private collection, Hamburg
Cat. no. 44

Golden Moon (Goldener-Mond), 1923
Collage and gouache on black construction paper
8⅛ x 11 inches (20.6 x 28 cm)
Private collection, New York
Cat. no. 130

Watched, 1925
Collage on paper
10⅛ x 6¾ inches (25.7 x 17.1 cm)
The Museum of Modern Art, New York
Joseph G. Mayer Foundation fund in honor of Rene d'Harnoncourt
Cat. no. 131

K. H. HÖDICKE, born 1938

Passage V, 1964
Oil on canvas
59 x 63 inches (150 x 160 cm)
Private collection, Düsseldorf
Cat. no. 70

Ministry of War (Kriegsministerium), 1977
Synthetic resin on canvas
72⅝ x 106¼ inches (184.5 x 270 cm)
Berlinische Galerie, Berlin
Cat. no. 172

PAUL HOENIGER, 1865-1925

The Spittel Market (Der Spittelmarkt), 1912
Oil on canvas
29⅛ x 36⅝ inches (74 x 93 cm)
Berlin Museum
Cat. no. 29

CARL HOFER, 1878-1955

The Prisoners (Die Gefangenen), 1933
Oil on canvas
61⅜ x 50⅜ inches (156 x 128 cm)
Berlinische Galerie, Berlin
Cat. no. 158

Night of the Black Moon (Schwarzmondnacht),
 1944
Oil on canvas
44⅞ x 35⁷⁄₁₆ inches (114 x 90 cm)
Berlinische Galerie, Berlin
Cat. no. 56

Alarm, 1945
Oil on canvas
41 x 31½ inches (104 x 80 cm)
Berlinische Galerie, Berlin
Cat. no. 159

Dance of Death (Totentanz), 1946
Oil on canvas
37⅜ x 42⅞ inches (95 x 109 cm)
Berlinische Galerie, Berlin
Cat. no. 57

MORITZ HOFFMANN

*Jacob Grimm's Study (Arbeitszimmer von Jacob
 Grimm)*, 1860
Watercolor on paper
14 x 17⅝ inches (35.7 x 44.8 cm)
Germanisches Nationalmuseum, Nuremberg
Cat. no. 102

*Wilhelm Grimm's Study (Arbeitszimmer von Wilhelm
 Grimm)*, 1860
Watercolor on paper
14 x 17¾ inches (35.8 x 45 cm)
Germanisches Nationalmuseum, Nuremberg
Cat. no. 103

THEODOR HOSEMANN, 1807-1875

Tavern (Weinstube), 1858
Oil on canvas
14⅜ x 18⁵⁄₁₆ inches (36.5 x 46.5 cm)
Staatliche Museen Preussischer Kulturbesitz,
Nationalgalerie, Berlin
Cat. no. 101

KARL HUBBUCH, 1891-1979

Self Portrait (Selbstportrait), 1924
Pencil on paper
20½ x 14⅜ inches (52 x 36.4 cm)
Marvin and Janet Fishman, Milwaukee, Wisconsin
Cat. no. 145

RICHARD HUELSENBECK, 1892-1974

Dada Almanach, 1920
Original edition book
7³⁄₁₆ x 5⅜ inches (18.2 x 13.6 cm)
Collection Timothy Baum, New York
Cat. no. 132

JOHANN ERDMANN HUMMEL, 1769-1852

Berlin Living Room (Berliner Wohnzimmer), 1820
Watercolor on paper
16 x 20¾ inches (40.7 x 52.8 cm)
Museum für Kunsthandwerk, Frankfurt
Cat. no. 87

JULIUS JACOB, 1842-1929

*Wilhelmplatz with the Kaiserhof Hotel (Der
 Wilhelmplatz mit dem Hotel Kaiserhof)*, 1886
Oil on panel
18¾ x 23¹³⁄₁₆ inches (47.7 x 60.5 cm)
Berlin Museum
Cat. no. 11

JULIUS JACOB, 1842-1929
WILHELM HERWARTH, 1853-1916

*Railroad Tracks at the Jannowitz Bridge (Die
 Stadtbahnanlage an der Jannowitzbrücke)*,
 ca. 1891
Pen, watercolor, and gouache on brown paper

45¹³/₁₆ x 87¼ inches (116.3 x 221.5 cm)
Berlin Museum
Cat. no. 107

EDWARD KIENHOLZ, born 1927
NANCY REDDIN-KIENHOLZ, born 1944

The Pawn Boys, 1983
Fifty-two bricks, each with a photograph
Berlinische Galerie, Berlin
Cat. no. 174

ERNST LUDWIG KIRCHNER, 1880-1938

Nude Woman Combing Her Hair (Sich kämmender Akt), 1913
Oil on canvas
49¼ x 35⁷/₁₆ inches (125 x 90 cm)
Brücke-Museum, Berlin
Cat. no. 36

5 Tarts (Fünf Kokotten), 1914
Woodcut on paper
19½ x 14¾ inches (49.5 x 37.5 cm)
Nelson Blitz, Jr., and Catherine Woodard,
 New York
Cat. no. 118

In the Café Garden (Im Cafégarten), 1914
Oil on canvas
27¾ x 30 inches (70.5 x 76 cm)
Brücke-Museum, Berlin
Cat. no. 37

Leipziger Strasse, Intersection (Leipziger Strasse, Kreuzung), 1914
Lithograph on yellow paper
23¼ x 19¾ inches (59 x 50.2 cm)
Nelson Blitz, Jr., and Catherine Woodard,
 New York
Cat. no. 38

Music Café (Musikrestaurant), 1914
Lithograph on yellow paper
23¼ x 19¾ inches (59 x 50.2 cm)
Nelson Blitz, Jr., and Catherine Woodard,
 New York
Cat. no. 119

Self Portrait with Cigarette (Selbstbildnis mit Zigarette), 1915
Lithograph on yellow paper
23¼ x 17 inches (59 x 43.2 cm)
Nelson Blitz, Jr., and Catherine Woodard,
 New York
Cat. no. 120

The Tramway Arch (Stadtbahnbogen), 1915
Four-color lithograph on paper
19½ x 23⅛ inches (49.5 x 58.7 cm)
Nelson Blitz, Jr., and Catherine Woodard,
 New York
Cat. no. 39

Klemperer the Composer (Komponist Klemperer), 1916
Woodcut on paper
21½ x 16½ inches (54.6 x 42 cm)
Nelson Blitz, Jr., and Catherine Woodard,
 New York
Cat. no. 121

LUDWIG KNAUS, 1829-1910

Portrait of the Banker Itzinger (Bildnis des Bankiers Itzinger), 1885
Oil on canvas
26¾ x 21⅝ inches (68 x 55 cm)
Staatliche Museen Preussischer Kulturbesitz,
Nationalgalerie, Berlin
Cat. no. 106

BERND KOBERLING, born 1938

Under the Trees (Unter den Bäumen), 1979
Synthetic resin and oil on burlap
68⅞ x 88⅝ inches (175 x 225 cm)
Berlinische Galerie, Berlin
Cat. no. 75

KARL WILHELM KOLBE, 1781-1853

German Knights Tending the Sick in Jerusalem (Deutsch-Ordensritter bei der Krankenpflege in Jerusalem), 1824
Oil on canvas
20½ x 15⅜ inches (52 x 39 cm)
Staatliche Museen Preussischer Kulturbesitz,
Nationalgalerie, Berlin
Cat. no. 88

KÄTHE KOLLWITZ, 1867-1945

Death (Der Tod), 1934/35
Portfolio of lithographs on paper
Berlinische Galerie, Berlin
 Woman Welcoming Death (Frau reicht dem Tod die Hand), 18⅛ x 15½ inches (46 x 39.5 cm)
 Girl Held in the Lap of Death (Tod mit Mädchen im Schoss), 17⅛ x 14⅞ inches (43.4 x 37.8 cm)
 Death Reaching into a Group of Children (Tod greift in eine Kinderschaar), 19¾ x 16½ inches (50 x 42 cm)

KÄTHE KOLLWITZ, 1867-1945

Woman Seized by Death (Frau wird vom Tod gepackt), 20 x 14⅜ inches (51 x 36.5 cm)
Death on the Country Road (Tod auf der Landstrasse), 16⅛ x 11½ inches (41 x 29.2 cm)
Death Seen as a Friend (Tod wird als Freund erkannt), 12⅜ x 12⅞ inches (31.5 x 32.8 cm)
Death in the Water (Der Tod im Wasser), 19⅛ x 15⅛ inches (48.5 x 38.4 cm)
The Call of Death (Ruf des Todes), 15 x 15⅛ inches (38 x 38.3 cm)
Cat. no. 156

FRANZ KRÜGER, 1797-1857

Equestrian Portrait of Baron von Willisen (Reiterbildnis Freiherr von Willisen), 1835
Oil on canvas
22½ x 17⅛ inches (57.2 x 43.4 cm)
Staatsgalerie Stuttgart
Cat. no. 93

Parade in Potsdam, ca. 1849
Oil on paper, laid on cardboard
14 x 21⅝ inches (35.5 x 55 cm)
Kunsthalle Bremen
Cat. no. 6

WALTER LEISTIKOW, 1865-1908

Lake Grunewald (Grunewaldsee oder Schlachtensee)
Oil on canvas
30⅞ x 46⅞ inches (78.5 x 119 cm)
Bröhan-Museum, Berlin
Cat. no. 20

MAX LIEBERMANN, 1847-1935

In the Bath House (Im Schwimmbad), 1875-78
Oil on canvas
71¼ x 88⅝ inches (181 x 225 cm)
Dallas Museum of Art
Foundation for the Arts Collection, Mrs. John B. O'Hara Fund
Cat. no. 113

House on Wannsee (Haus am Wannsee), 1926
Oil on panel
12⅜ x 16⅛ inches (31.5 x 41 cm)
Staatliche Museen Preussischer Kulturbesitz,
Nationalgalerie, Berlin
Cat. no. 21

Self Portrait (Selbstporträt), 1929
Oil on panel
19¹¹⁄₁₆ x 15⁹⁄₁₆ inches (50 x 39.5 cm)
Berlin Museum
Cat. no. 114

The Surgeon Ferdinand Sauerbruch (Der Chirurg Ferdinand Sauerbruch), 1932
Oil on canvas
46⅛ x 35¼ inches (117.2 x 89.4 cm)
Hamburger Kunsthalle, Hamburg
Cat. no. 22

EL LISSITZKY, 1890-1941

Plate V from *Proun, Kestnermappe*, 1919-23
From a portfolio of lithographs on paper
23⅝ x 17⅛ inches (60.1 x 43.6 cm)
Fogg Art Museum, Harvard University,
 Cambridge, Massachusetts
Gift of Mr. and Mrs. Arthur Vershbow
Cat. no. 139

Plate VI from *Proun, Kestnermappe*, 1919-23
From a portfolio of lithographs on paper
17¼ x 23¾ inches (44 x 60.3 cm)
Fogg Art Museum, Harvard University,
 Cambridge, Massachusetts
Gift of Mrs. Irving M. Sobin
Cat. no. 139

Proun 12E, 1923
Oil on canvas
22½ x 16¾ inches (57.1 x 42.5 cm)
Busch-Reisinger Museum, Harvard University,
 Cambridge, Massachusetts
Museum Purchase Association
Cat. no. 140

MARKUS LÜPERTZ, born 1941

Dithyramb (Dithyrambe), 1964
Oil on canvas
59 x 59 inches (150 x 150 cm)
Collection Stober, Berlin
Cat. no. 168

Roof Tile (Dachziegel), ca. 1965
Acrylic on canvas
56⅞ x 56⅞ inches (144.5 x 144.5 cm)
Galerie Eva Poll, Berlin
Cat. no. 68

House-Style (Haus-Stil), 1976
Oil on canvas
78¾ x 98⅜ inches (200 x 250 cm)
Collection Stober, Berlin
Cat. no. 69

MARWAN, born 1934

Head (Kopf), 1986
Oil on canvas
102⅜ x 76¾ inches (260 x 195 cm)
Berlinische Galerie, Berlin
Cat. no. 80

LUDWIG MEIDNER, 1884-1966

The Church of the Good Shepherd on Friedrich-Wilhelm-Platz in Friedenau (Die Kirche "Zum guten Hirten" auf dem Friedrich-Wilhelm-Platz in Friedenau), 1913
Watercolor on paper
24 x 17 inches (61 x 43 cm)
Berlin Museum
Cat. no. 34

My Night Visage (Mein Nachtgesicht), 1913
Oil on canvas
26¼ x 19¼ inches (66.7 x 48.9 cm)
Marvin and Janet Fishman, Milwaukee, Wisconsin
Cat. no. 35

Street with Pedestrian at Night, 1913
Ink and pencil on paper
23¾ x 18⅛ inches (60.3 x 46 cm)
Marvin and Janet Fishman, Milwaukee, Wisconsin
Cat. no. 116

Self Portrait with Landscape, 1914
Pen and ink on paper
19½ x 16½ inches (49.5 x 42 cm)
Marvin and Janet Fishman, Milwaukee, Wisconsin
Cat. no. 117

MORIZ MELZER, 1877-1966

Bridge-City (Brücke-Stadt), 1923
Oil on canvas
51⅝ x 38¾ inches (131 x 98.3 cm)
Berlin Museum
Cat. no. 45

ADOLPH VON MENZEL, 1815-1905

Back Yard (Hinterhaus und Hof), ca. 1845
Oil on canvas
17 x 24 inches (43 x 61 cm)
Staatliche Museen Preussischer Kulturbesitz,
Nationalgalerie, Berlin
Cat. no. 8

Study of a Male Model in Back View, Taking Off His Coat
Chalk heightened with yellow and orange on paper
9½ x 6⅝ inches (24 x 16.8 cm)

Stanford University Museum of Art, California
The Mortimer C. Leventritt Fund, 73.21
Cat. no. 96

Study of a Partridge, ca. 1848-50
Pastel on brown paper
4¾ x 7½ inches (12 x 19 cm)
Jill Newhouse, New York
Cat. no. 97

Head of a Workman, study for *Iron Rolling Mill*, ca. 1870-75
Pencil on paper
7¹⁵⁄₁₆ x 5 inches (20.2 x 12.7 cm)
Private collection, New York
Cat. no. 99

Meissonier's Studio, ca. 1880-89
Oil on panel
8¾ x 11¾ inches (22.2 x 29.8 cm)
The Fine Arts Museums of San Francisco
Jacob Stern Family Loan Collection
Cat. no. 9

Lady with a Fan, study for *Episode at a Ball*, 1888
Pencil on paper
5 x 8½ inches (12.7 x 21.6 cm)
Private collection, New York
Cat. no. 98

FRIEDRICH EDUARD MEYERHEIM, 1808-1879

Portrait of Adolph Menzel (Bildnis Adolph Menzel)
Oil on canvas
16½ x 14⅜ inches (42 x 36.5 cm)
Staatliche Museen Preussischer Kulturbesitz,
Nationalgalerie, Berlin
Cat. no. 100

HELMUT MIDDENDORF, born 1953

Natives of the Big City II (Grossstadteingeborene II), 1979
Mixed media on canvas
74⅝ x 110¼ inches (189.5 x 280 cm)
Berlinische Galerie, Berlin
Cat. no. 171

LÁSZLÓ MOHOLY-NAGY, 1895-1946

Z III, 1922
Oil on canvas
37¹³⁄₁₆ x 29¼ inches (96 x 74.3 cm)
Anonymous loan, Cologne
Cat. no. 46

LÁSZLÓ MOHOLY-NAGY, 1895-1946

Light Play: Black-White-Gray, ca. 1930
Gelatin-silver print on paper
14¹¹⁄₁₆ x 10¹³⁄₁₆ inches (37.3 x 27.5 cm)
The Museum of Modern Art, New York
Gift of the photographer, 295.37
Cat. no. 143

Light Play: Black-White-Gray, ca. 1930
Gelatin-silver print on paper
14¹¹⁄₁₆ x 10⅞ inches (37.3 x 27.6 cm)
The Museum of Modern Art, New York
Gift of the photographer, 296.37
Cat. no. 144

OTTO MÖLLER, 1883-1964

City (Stadt), 1921
Oil on canvas
36 x 32⅛ inches (91.3 x 81.5 cm)
Staatliche Museen Preussischer Kulturbesitz,
Nationalgalerie, Berlin
Cat. no. 141

EDVARD MUNCH, 1863-1944

The Scream, 1895
Lithograph on paper
Image 13⅞ x 10 inches (35.2 x 25.4 cm)
Nelson Blitz, Jr., and Catherine Woodard,
 New York
Cat. no. 111

Self Portrait with Skeleton Arm, 1895
Lithograph on paper
17⅞ x 12⅝ inches (45.4 x 31.2 cm)
Nelson Blitz, Jr., and Catherine Woodard,
 New York
Cat. no. 110

Vampire, 1895/96
Lithograph and woodcut on paper
15 x 21⅝ inches (38 x 55 cm)
Nelson Blitz, Jr., and Catherine Woodard,
 New York
Cat. no. 14

Madonna, 1895-1902
Lithograph on paper
23⅝ x 17⅜ inches (60 x 44.1 cm)
Nelson Blitz, Jr., and Catherine Woodard,
 New York
Cat. no. 18

Death in the Sick Room, 1896
Lithograph on paper
20¼ x 23¾ inches (51.4 x 60.3 cm)

Nelson Blitz, Jr., and Catherine Woodard,
 New York
Cat. no. 112

Evening (Melancholy), 1896
Woodcut on paper
15 x 17¾ inches (38 x 45 cm)
Nelson Blitz, Jr., and Catherine Woodard,
 New York
Cat. no. 15

Evening on Karl Johan Street, 1896
Handcolored lithograph on paper
15½ x 20½ inches (39.4 x 52 cm)
Nelson Blitz, Jr., and Catherine Woodard,
 New York
Cat. no. 13

The Lonely One, 1896
Mezzotint and drypoint on paper
11¼ x 8½ inches (28.5 x 21.6 cm)
Nelson Blitz, Jr., and Catherine Woodard,
 New York
Cat. no. 16

Two Women on the Shore, 1898
Woodcut on paper
18 x 20¼ inches (45.7 x 51.5 cm)
Nelson Blitz, Jr., and Catherine Woodard,
 New York
Cat. no. 17

MAX NEUMANN, born 1949

Untitled (Ohne Titel), 1984
Japan color and acrylic on natural fiber canvas
102⅜ x 59 inches (260 x 150 cm)
Berlinische Galerie, Berlin
Cat. no. 77

WOLFGANG PETRICK, born 1939

Ascent (Aufstieg) from *Knight, Death and the Devil
 (Ritter, Tod und Teufel)*, 1988-89
Collage, tempera, and oil on canvas
118 x 37⅜ inches (295 x 95 cm)
Collection of the artist, Berlin
Cat. no. 81

Night Rider (Nachtritt) from *Knight, Death and the
 Devil (Ritter, Tod und Teufel)*, 1988-89
Collage, tempera, and oil on canvas
118 x 37⅜ inches (295 x 95 cm)
Collection of the artist, Berlin
Cat. no. 82

Manuel Plays the Knight (Manuel spielt Ritter) from *Knight, Death and the Devil (Ritter, Tod and Teufel)*, 1988-89
Collage, tempera, and oil on canvas
118 x 37⅜ inches (295 x 95 cm)
Collection of the artist, Berlin
Cat. no. 83

IVAN PUNI, 1894-1956

Suprematist Drawing #3, ca. 1920-21
Pencil, gouache, and ink on paper
24⅜ x 18¹¹⁄₁₆ inches (62 x 47.6 cm)
Yale University Art Gallery, New Haven
Gift of the Collection Société Anonyme
Cat. no. 142

HANS RICHTER, 1888-1976

Designs for the abstract film *Präludium*, 1919
Pencil on paper
39⅜ x 22⅞ inches (100 x 58 cm)
Staatliche Museen Preussischer Kulturbesitz,
Kupferstichkabinett, Berlin
Cat. no. 138

F. RIEGEL AFTER KARL FRIEDRICH SCHINKEL

Examples of Exalted Architecture (Werke der höheren Baukunst), 1848-50
Album of lithographs on paper
31½ x 22⅞ inches (80 x 58 cm)
Staatlichen Schlösser und Gärten, Berlin
Cat. no. 86

GERD ROHLING, born 1946

Untitled, 1986
Plastic and lead
51⅛ x 23⅝ x 23⅝ inches (130 x 60 x 60 cm)
Collection of the artist, Berlin
Cat. no. 78

Untitled, 1986
Plastic and wood
35⁷⁄₁₆ x 22½ x 22½ inches (90 x 57 x 57 cm)
Collection of the artist, Berlin
Cat. no. 79

HEIKE RUSCHMEYER

Sunbath (Sonnenbad), 1980
Synthetic resin on natural fiber canvas
74¹³⁄₁₆ x 94½ inches (190 x 240 cm)
Berlinische Galerie, Berlin
Cat. no. 76

SALOMÉ, born 1954

Self Portrait (Selbstportrait), 1976
Synthetic resin on canvas
78¾ x 120 inches (200 x 300 cm)
Collection Stober, Berlin
Cat. no. 72

CHRISTIAN SCHAD, 1894-1982

Count St. Genois d'Anneaucourt (Graf St. Genois d'Anneaucourt), 1927
Oil on panel
33⅞ x 24¾ inches (86 x 63 cm)
Private collection, Hamburg
Cat. no. 53

Agosta the Birdman and Rasha the Black Dove (Agosta der Flügelmensch, und Rasha, die schwarze Taube), 1929
Oil on canvas
47¼ x 31½ inches (120 x 80 cm)
Private collection, Munich
Cat. no. 54

ANTON SCHEURITZEL, 1874-?

Siemensstadt, ca. 1930
Oil on canvas
62¼ x 124 inches (158 x 310 cm)
Siemens Aktiengesellschaft, Berlin
Fig. no. 3

KARL FRIEDRICH SCHINKEL, 1781-1841

Gothic Church Behind Oak Trees (Gotische Kirche hinter einem Eichenhain mit Gräbern), 1810
Lithograph on paper
19³⁄₁₆ x 13½ inches (48.7 x 34.3 cm)
Staatliche Museen Preussischer Kulturbesitz,
Kupferstichkabinett, Berlin
Cat. no. 84

Cathedral (Kathedrale), ca. 1811
Oil on canvas
54⁵⁄₁₆ x 81⁵⁄₁₆ inches (138 x 206.5 cm)
Staatlichen Schlösser und Gärten, Berlin
Cat. no. 1

Monument to Prince Louis Ferdinand (Das Grabmal des Prinzen Louis Ferdinand), 1821
Lithograph on paper
13⅝ x 9¹⁄₁₆ inches (34.5 x 23 cm)
Staatliche Museen Preussischer Kulturbesitz,
Kupferstichkabinett, Berlin
Cat. no. 85

RUDOLF SCHLICHTER, 1890-1955

DA-DA-Roof Studio (DA-DA-Dachatelier), ca. 1920
Watercolor and pen on paper
18 x 25⅛ inches (45.8 x 63.8 cm)
Galerie Nierendorf, Berlin
Cat. no. 133

Maimed Woman of the Proletariat (Verstümmelte Proletarierfrau), ca. 1924
Pencil on paper
24¹³⁄₁₆ x 18⅞ inches (63 x 48 cm)
Berlinische Galerie, Berlin
Cat. no. 146

Bert Brecht, 1926
Oil on canvas
29¾ x 18⅛ inches (75.5 x 46 cm)
Städtische Galerie im Lenbachhaus, Munich
Cat. no. 47

The Mocking of Christ (Die Verspottung Christi), 1933
Oil on canvas
27¾ x 30¾ inches (70.5 x 78 cm)
Galerie der Stadt Stuttgart
Cat. no. 155

KARL SCHMIDT-ROTTLUFF, 1884-1976

Tavern (Weinstube), 1913
Oil on canvas
30 x 33 inches (76 x 84 cm)
Brücke-Museum, Berlin
Cat. no. 33

EUGEN SCHÖNEBECK, born 1936

The Crucified (Der Gekreuzigte), 1964
Oil on canvas
63¾ x 51¼ inches (162 x 130.1 cm)
Private collection, New York
Cat. no. 67

FRANZ SKARBINA, 1849-1910

Railroad Tracks in North Berlin (Gleisanlagen im Norden Berlins), ca. 1895
Pastel, gouache, and watercolor on paper
28¼ x 35¹³⁄₁₆ inches (71.7 x 91 cm)
Berlin Museum
Cat. no. 19

MAX SLEVOGT, 1868-1932

Nini in a Black Dress on a Red Sofa (Nini im schwarzen Kleid auf rotem Sofa), 1902
Oil on canvas
27⁹⁄₁₆ x 52⅜ inches (70 x 133 cm)

Landesmuseum Mainz
Cat. no. 23

Mass of the St. George Order (Messe der St. Georgsritter), 1908
Oil on canvas
22⅞ x 18⅛ inches (58 x 46 cm)
Staatliche Museen Preussischer Kulturbesitz,
Nationalgalerie, Berlin
Cat. no. 24

Self Portrait at the Easel (Das Selbtbildnis an der Staffelei), 1921
Oil on canvas
57¼ x 35⁷⁄₁₆ inches (145.5 x 90 cm)
Städtische Galerie im Städelschen Kunstinstitut
Frankfurt am Main
Cat. no. 25

CARL STEFFECK, 1818-1890

Portrait of Ernst Lau and His Family (Porträt Ernst Lau mit seiner Familie), 1865
Oil on canvas
18⁹⁄₁₆ x 22¾ inches (47.1 x 57.8 cm)
Staatliche Museen Preussischer Kulturbesitz,
Nationalgalerie, Berlin
Cat. no. 104

WALTER STÖHRER, born 1937

Large Woman Full of Cosmetics and Industry, Homage to Brinkmann (Grosse Weiber voll Kosmetik und Industrie, Hommage à Brinkmann), 1967
Oil on canvas
78¾ x 68⅞ inches (200 x 175 cm)
Berlinische Galerie, Berlin
Cat. no. 167

ROLF SZYMANSKI, born 1928

Young Lady in Algiers (Fräulein in Algier), 1961
Bronze
57⅛ x 16⅛ x 17 inches (145 x 41 x 43 cm)
Elke Blume, Braunschweig
Cat. no. 165

GUSTAV FRIEDRICH TAUBERT, 1755-1839

The Artist and His Family (Der Künstler und seine Familie), 1830
Oil on canvas
29¾ x 23¹³⁄₁₆ inches (77.5 x 60.5 cm)
Staatliche Museen Preussischer Kulturbesitz,
Nationalgalerie, Berlin
Cat. no. 91

In the Berlin Reading Café: "Everyone Reads Everything" ("Alles liest alles," Berliner Lesecafé), 1832
Oil on canvas
15⅛ x 15⅛ inches (38.5 x 38.5 cm)
Berlin Museum
Cat. no. 2

FRED THIELER, born 1916

Mutabor, 1962
Mixed media on canvas
74¾ x 158 inches (190 x 395 cm)
Berlinische Galerie, Berlin
Cat. no. 64

Inbild DI/75, 1975
Mixed media on canvas
57⅛ x 57⅛ inches (145 x 145 cm)
Collection Franke, Berlin
Cat. no. 65

HANN TRIER, born 1915

Vibrations VIII (Vibrationen VIII), 1957
Oil on canvas
57½ x 37¾ inches (146 x 96 cm)
Berlinische Galerie, Berlin
Cat. no. 63

HEINZ TRÖKES, born 1913

The Moon Cannon (Die Mondkanone), 1946
Oil on canvas, mounted on cardboard
15¾ x 18⅞ inches (40 x 48 cm)
Berlinische Galerie, Berlin
Cat. no. 58

Between the Blocks (Zwischen den Blöcken), 1947
Oil on canvas
22 x 17⅛ inches (56 x 43.5 cm)
Collection of the artist, Berlin
Cat. no. 160

Terrain of the Cosmologists (Terrain der Kosmologen), 1948
Oil on canvas
23⅝ x 19¹¹⁄₁₆ inches (60 x 50 cm)
Collection of the artist, Berlin
Cat. no. 59

HANS UHLMANN, 1900-1975

Female Head (Weiblicher Kopf), 1940
Tin
16⅜ x 6¾ x 7¹¹⁄₁₆ inches (41.5 x 17 x 19.5 cm)
Berlinische Galerie, Berlin
Cat. no. 157

Steel Sculpture in Three Colors (Dreifarbige Stahlskulptur), 1951
Steel and aluminum
52⅜ inches (133 cm)
Wilhelm-Lehmbruck-Museum der Stadt Duisburg
Cat. no. 163

Tower (Turm), 1961
Painted steel
78¾ inches (200 cm)
Staatliche Museen Preussischer Kulturbesitz, Nationalgalerie, Berlin
Cat. no. 164

LESSER URY, 1861-1931

At the Friedrichstrasse Station (Am Bahnhof Friedrichstrasse), 1888
Gouache on paper
25⅝ x 17¾ inches (65 x 45 cm)
Berlin Museum
Cat. no. 108

Evening on the Landwehrkanal (Abend am Landwehrkanal), 1889
Oil on canvas
29½ x 41⅜ inches (75 x 105 cm)
Galerie Pels-Leusden-Villa Grisebach, Berlin
Cat. no. 12

KLAUS VOGELGESANG, born 1945

Contrapposto (Standbein-Spielbein), 1976
Lead and colored pencils on paper
77⅛ x 57½ inches (196 x 146 cm)
Berlinische Galerie, Berlin
Cat. no. 170

BRUNO VOIGT, 1912-1988

Attack (Angriff), 1932
Watercolor and ink on paper
18 x 11½ inches (45.7 x 29.2 cm)
Marvin and Janet Fishman, Milwaukee, Wisconsin
Cat. no. 150

Street Fight (Strassenkampf), 1932
Watercolor and ink on paper
19⅞ x 14⅛ inches (50.5 x 36 cm)
Marvin and Janet Fishman, Milwaukee, Wisconsin
Cat. no. 151

WOLF VOSTELL, born 1932

Alcantara from the *Extremadura* series, 1975
Mixed media on canvas
78¾ x 78¾ x 5½ inches (200 x 200 x 14 cm)
Galerie van de Loo, Munich
Cat. no. 169

ANTON VON WERNER, 1843-1915

In Temporary Quarters near Paris (*Im
 Etappenquartier vor Paris*), 1894
Oil on canvas
47¼ x 62¼ inches (120 x 158 cm)
Staatliche Museen Preussischer Kulturbesitz,
Nationalgalerie, Berlin
Cat. no. 109

RICHARD ZIEGLER, born 1891

Widow (*Witwe*), 1925
Oil on canvas
40⅛ x 24 inches (102 x 61 cm)
Marvin and Janet Fishman, Milwaukee, Wisconsin
Cat. no. 52

Couple in Café (*Paar am Café*), 1927
Oil on canvas
39⅜ x 29½ inches (100 x 75 cm)
Marvin and Janet Fishman, Milwaukee, Wisconsin
Cat. no. 51

Photo Credits

Renate Altenrath, Hannover: 165.

Jörg P. Anders, Berlin: 8, 10, 21, 24, 27, 28, 84, 85, 86, 88, 89, 90, 91, 100, 101, 104, 105, 106, 109, 122, 138, 141, 164.

Hans-Joachim Bartsch, Berlin: 3, 4, 19, 29, 30, 34, 94, 107.

Bildarchiv Foto Marburg: 157, 158.

D. James Dee, New York: 13, 14, 15, 16, 17, 18, 38, 39, 110, 111, 112, 118, 119, 120, 121, 135.

Petra Grosskopf, Berlin: 166.

Foto-Studio-Grünke, Hamburg: 43, 44, 53, 149.

Udo Hesse, Berlin: 57, 58, 62, 63, 64, 75, 76, 77, 80, 146, 156, 159, 167, 170, 172, 174.

Phil Hofstetter: 9.

Hermann Kiessling, Berlin: 60, 171.

Bernd Kirtz BFF, Duisburg: 163.

J. Littkemann, Berlin: 68, 69, 71, 72, 81, 82, 83, 168.

Michael McKelvey, Atlanta: 46, 123.

Nathan Rabin, New York: 127, 130, 132.

Friedrich Rosenstiel, Cologne: 61.

Dedra M. Walls: 150.